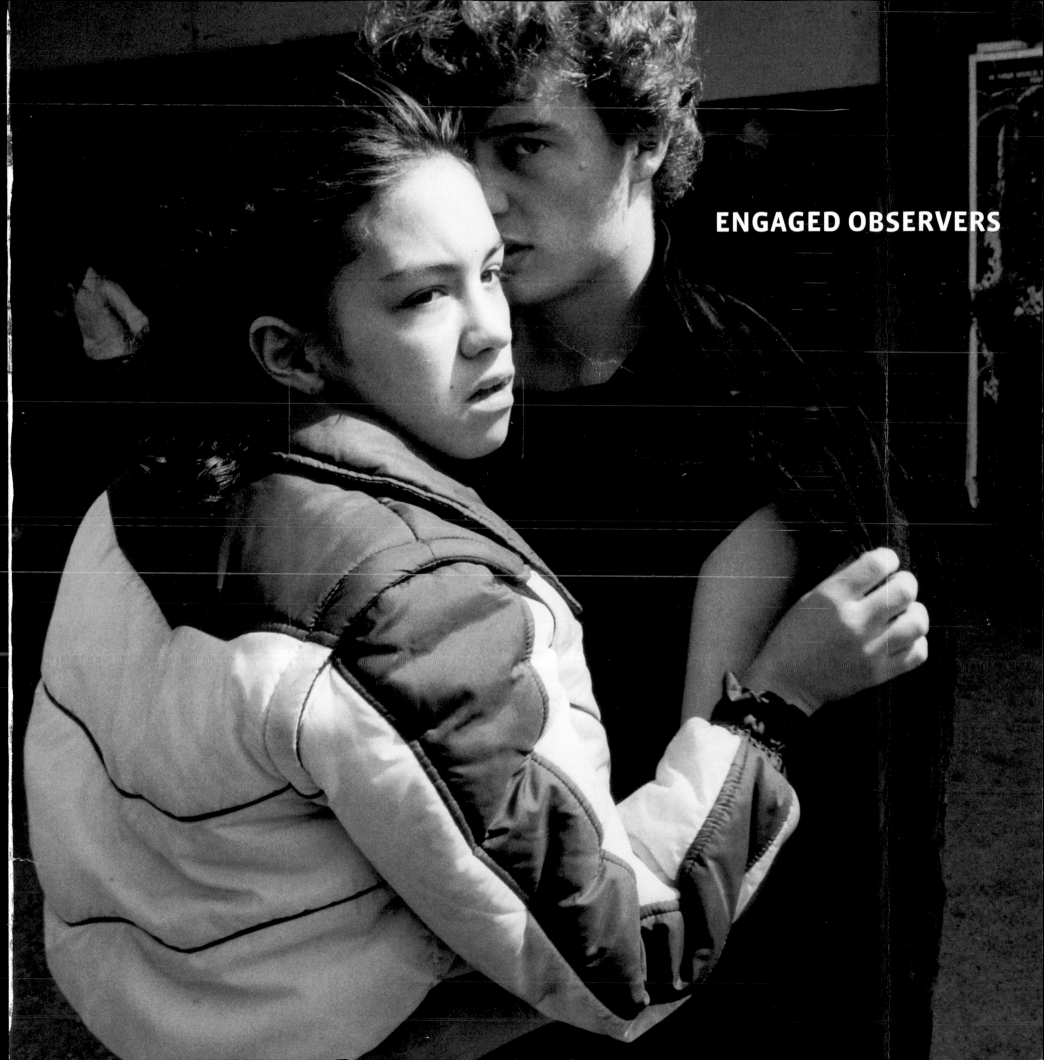

ENGAGED OBSERVERS

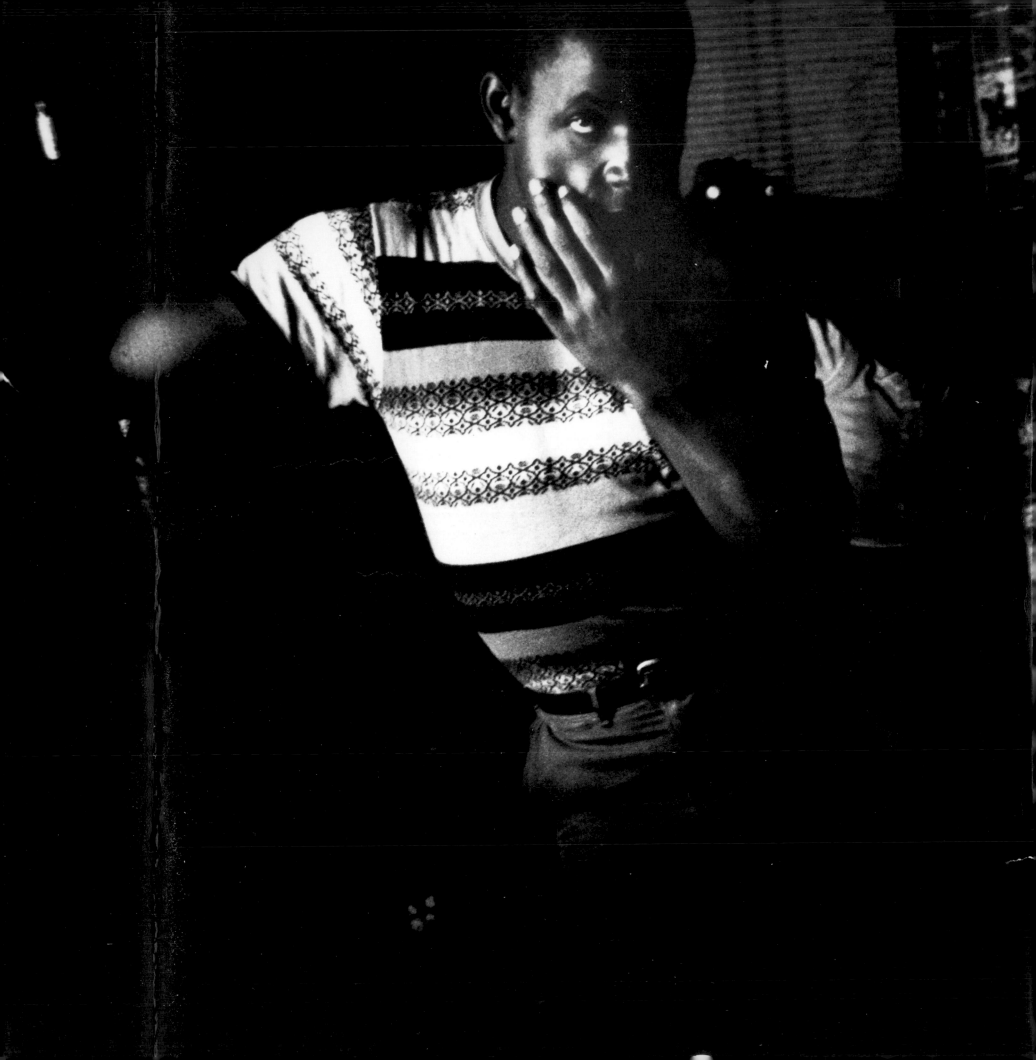

ENGAGED OBSERVERS

DOCUMENTARY PHOTOGRAPHY
SINCE THE SIXTIES

BRETT ABBOTT

THE J. PAUL GETTY MUSEUM, LOS ANGELES

This volume is published on the occasion of the exhibition **Engaged Observers: Documentary Photography since the Sixties**, on view at the J. Paul Getty Museum, Los Angeles, June 29–November 14, 2010.

© 2010 The J. Paul Getty Trust

Published by the J. Paul Getty Museum
Getty Publications
1200 Getty Center Drive, Suite 500
Los Angeles, California 90049-1682
www.gettypublications.org

Gregory M. Britton, PUBLISHER

John Harris, EDITOR
Jane Hyun, MANUSCRIPT EDITOR
Stuart Smith, DESIGNER
Elizabeth Burke Kahn, PRODUCTION COORDINATOR
Stacey Rain Strickler, Rebecca Vera-Martinez,
and Tricia Zigmund, IMAGE TECHNICIANS
Holly Ortiz, PHOTO RESEARCHER

Color separation and press supervision
by Robert J. Hennessey and Sue Medlicott
Printed in China by Wai Man Book Binding

Library of Congress Cataloging-in-Publication Data

Abbott, Brett,
 Engaged observers : documentary photography since the
sixties / Brett Abbott.
 p. cm.
 "Accompanies the exhibition Engaged Observers:
Documentary Photography since the Sixties,
held at the J. Paul Getty Museum, Los Angeles, June 29–
November 14, 2010."
 Includes index.
 ISBN 978-1-60606-022-3 (hardcover)
1. Documentary photography—Exhibitions. I. J. Paul Getty
Museum. II. Title.
 TR820.5.A25 2010
 779—dc22
 2009045712

COVER: Philip Jones Griffiths, *Vietnam*, 1967 (detail, pl. 35)

HALF-TITLE PAGE: Mary Ellen Mark, *"Patti and Munchkin,"
Seattle*, 1983 (detail, pl. 101)

TITLE PAGE: Leonard Freed, *South Carolina*, 1965 (detail, pl. 16)

PAGE VI: Lauren Greenfield, *Swimming period at weight-loss
camp, Catskills, New York. Many kids love to swim at camp but
will not swim or wear a bathing suit at home.*, 2001 (printed
2002) (detail, pl. 111)

PAGE IX: W. Eugene Smith, *Fishing in Minimata Bay*, ca. 1972
(detail, pl. 63)

PAGE X: Larry Towell, *Capulín (Casas Grandes Colonies),
Chihuahua, Mexico*, 1999 (detail, pl. 128)

Works in the collection of the J. Paul Getty Museum,
Los Angeles, are listed with the initials "JPGM."

CONTENTS

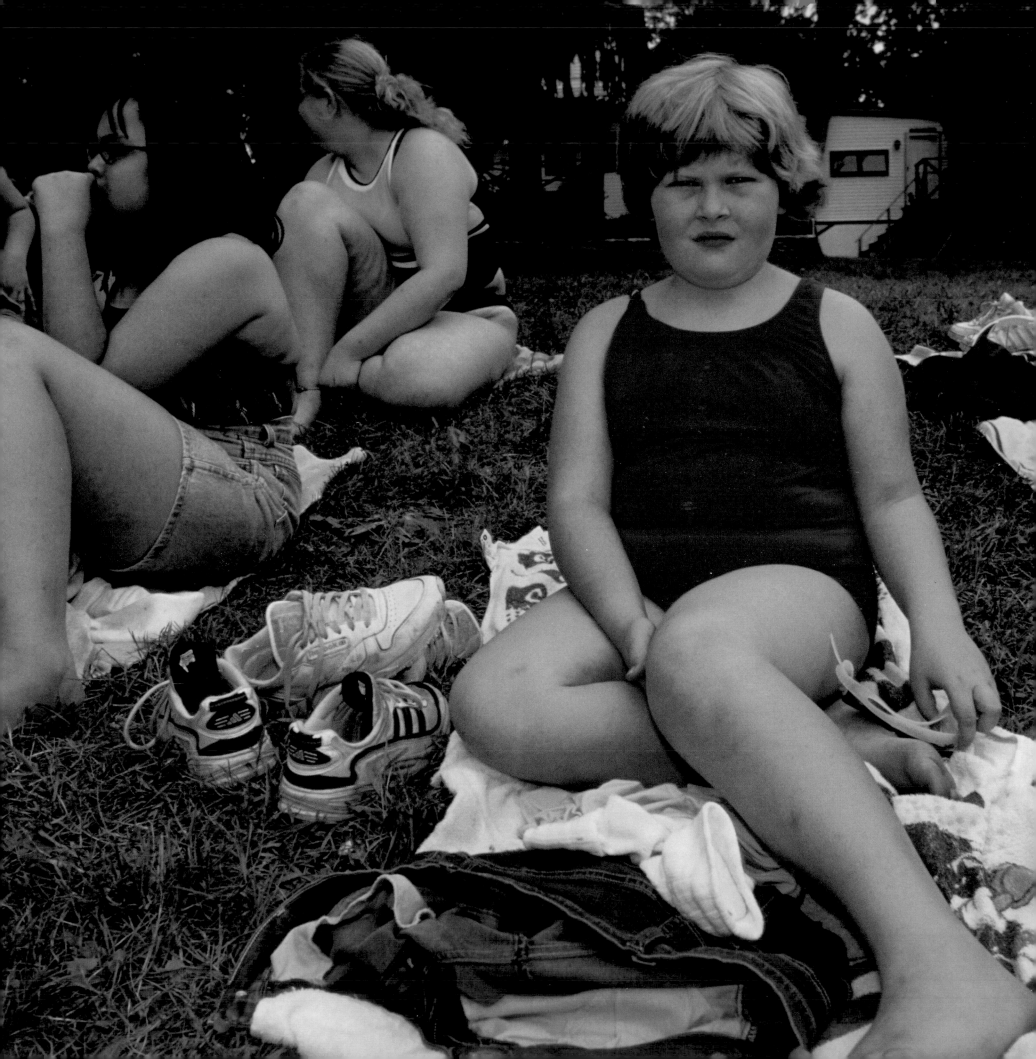

FOREWORD

The Getty Museum has long made a special commitment to the documentary tradition in photography. In 1984, the Museum amassed the most important and comprehensive holding of Walker Evans photographs in the United States. That collection has since been complemented by strong groups of work by other significant social documentarians from the first half of the twentieth century, including Horace Bristol, Lewis Hine, Dorothea Lange, and August Sander. Examples of their nineteenth-century predecessors, such as John Thomson and Felice Beato and early war photographers Roger Fenton and Alexander Gardner, are similarly held in depth. Indeed, the Getty's manner of collecting photographs, which has traditionally focused on acquiring groups of prints by significant artists in order to represent the breadth of their particular approaches to the world, is well suited to the serial nature and essay format of documentary studies.

In the last five years, the Museum has begun acquiring works of photojournalism and documentary photography from the late twentieth and early twenty-first centuries. *Engaged Observers: Documentary Photography since the Sixties* demonstrates our commitment to collecting, exhibiting, and publishing the socially engaged photography of our own time. We are proud to present an exhibition and scholarly catalogue that set this aspect of the social documentary tradition within its historical context.

I would especially like to thank associate curator Brett Abbott, who conceived and organized the project, wrote the insightful essays that follow, and spearheaded the new acquisitions and loans we present here. My heartfelt appreciation also goes to senior curator Judith Keller, who has shown remarkable leadership in developing this area of the collection: the exhibition and this catalogue were generated through her efforts and those of her colleagues in the Department of Photographs.

Finally, my sincere thanks go to those who made and facilitated loans to this project. Their expertise and willingness to lend were critical components of the endeavor.

David Bomford, Acting Director
THE J. PAUL GETTY MUSEUM

ACKNOWLEDGMENTS

This exhibition and catalogue came together through the concentrated efforts of many dedicated people. I owe deep thanks to the photographers and their families, collectors, and agents, who generously facilitated loans and gifts and served as important resources in the project's development: Allison Amon and Lisa Mehling; Sarah Newby and Trinity Parker at the Center for Creative Photography; David Fahey and his colleagues at the Fahey/Klein Gallery; Peter Fetterman and his gallery staff; Brigitte Freed and Elke Susannah Freed; Lauren Greenfield, Frank Evers, and Rebecca Horn; the estate of Philip Jones Griffiths; Christopher Luce; Robert Mann and his gallery staff; Mark Lubell and Jennifer Tripp at Magnum Photos (the latter of whom deserves special recognition for the time, diligence, and care she put into coordinating Magnum's significant contributions to the project); Mary Ellen Mark and Meredith Lue; Susan Meiselas; James Nachtwey and studio manager Rebecca Alperstein; Sebastião and Lélia Salgado; Aileen Smith and Michiko Kimura of the Aileen Archive; and Larry Towell. This project would not have been possible without their passion and contributions.

At the J. Paul Getty Museum, I extend sincere appreciation to Michael Brand, former director, and David Bomford, acting director, for their enthusiastic support of this project. Enormous thanks go to Judith Keller, senior curator in the Department of Photographs, for giving me the opportunity to pursue this endeavor and whose guidance and encouragement were absolutely critical to its success. I am equally grateful to all of my current and former colleagues in the department who provided assistance in the form of counsel or other essential tasks, including Lindsay Blumenfeld, Cheryl Coulter, Erin Garcia, Michael Hargraves, Virginia Heckert, Karen Hellman, Anne Lacoste, Anne Lyden, Weston Naef, Marisa Weintraub, Edie Wu, and departmental interns Linde Brady, Elizabeth DePonte, Samantha Smith, Petra Trnkova, and Alana West. In the Department of Paper Conservation, Marc Harnly, senior conservator, along with Chris Cook, Sarah Freeman, Stephen Heer, Lynne Kaneshiro, Ernie Mack, and Ron Stroud, diligently and expertly prepared the prints for exhibition and publication.

I similarly owe thanks to colleagues outside the Getty who generously gave their time to help with my research, including David Coleman of the Harry Ransom Center; Sean Corcoran at the Museum of the City of New York; Julian Cox of the High Museum of Art; Whitney Gaylord at the Museum of Modern Art; Bill Hunt; David Knaus; Robert Norton; Carolyn Peter of the Laband Art Gallery; Eugene Richards and Janine Altongy; Bruce Silverstein; and Anne Tucker and Del Zogg at the Museum of Fine Arts, Houston. I also appreciate the enthusiasm and thoughts expressed by members of the Getty Museum's Photographs Council.

All aspects of the accompanying exhibition were facilitated by Quincy Houghton, assistant director of exhibitions, and Amber Keller. Michael Lira and Christina Webb created the striking design scheme. Cherie Chen, Grace Murakami, and Kathleen Ochmanski provided loan and copyright support. Mary Beth Carosello, Mara Gladstone, Laurel Kishi, Clare Kunny, Sarah McCarthy, and Peter Tokofsky coordinated educational and public programming. Paco Link, Anne Martens, Lien Nguyen, and Keeli Shaw created the audio guide. Catherine Comeau conscientiously edited texts. Bruce Metro's team of preparators provided the highest standards of installation and finishing for the show. Michael Smith, Stacey Rain Strickler, Rebecca Vera-Martinez, and Tricia Zigmund perfected digital imaging of the Museum's collection in anticipation of both the exhibition and this book. Their excellent work is much appreciated.

I also wish to thank Gregory Britton, publisher, and to acknowledge the efforts of his fine team in Getty Publications that brought this catalogue together: John Harris for his careful editorial oversight; Stuart Smith for his sensitive design of the book; Elizabeth Kahn, Stacy Miyagawa, and Karen Schmidt for its conscientious production; former editor in chief Mark Greenberg for his enthusiasm and encouragement; as well as Jane Hyun for her skillful copyediting and Holly Ortiz for assembling reproductions and permissions.

Most of all, I thank my parents, siblings, and wife, Anissa, whose constant and loving support inspires my own engagement with the world.

Brett Abbott

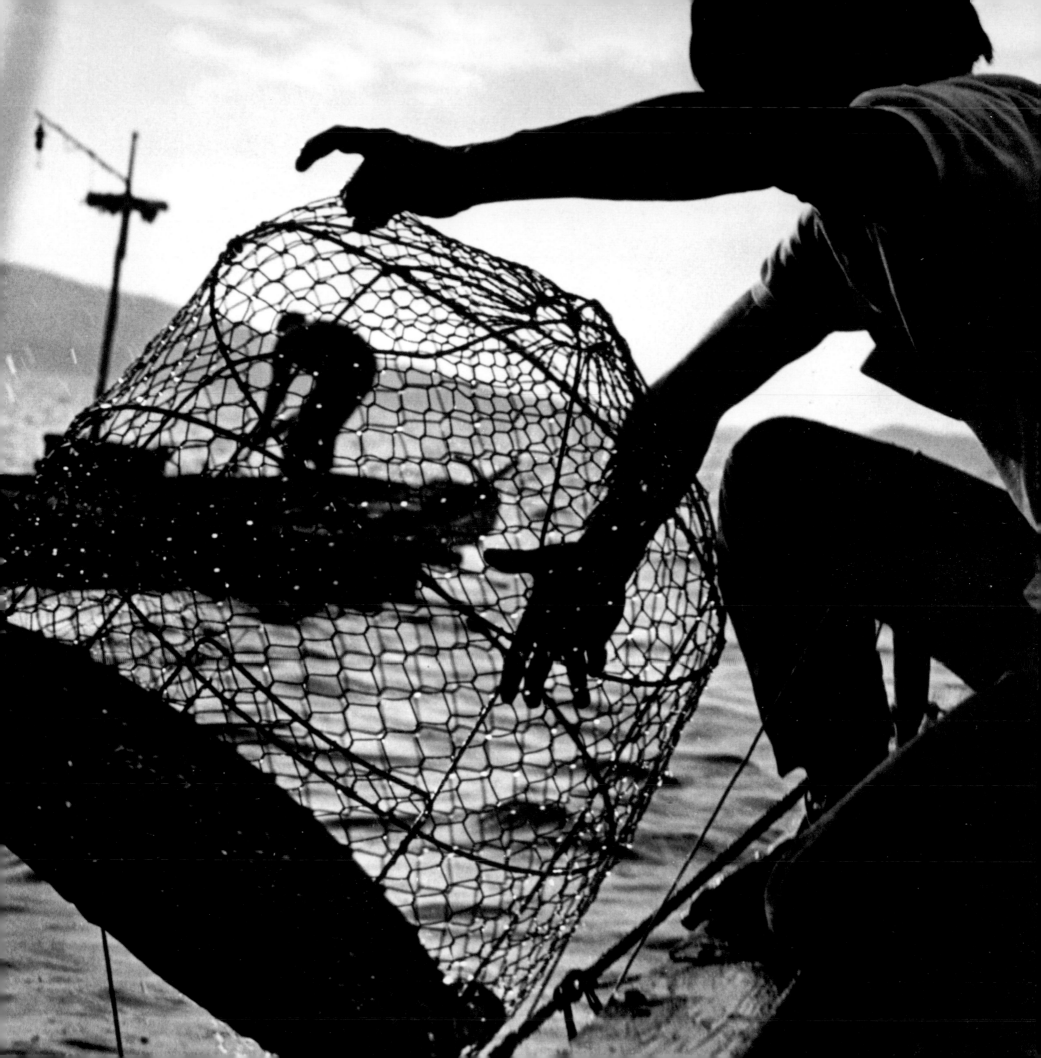

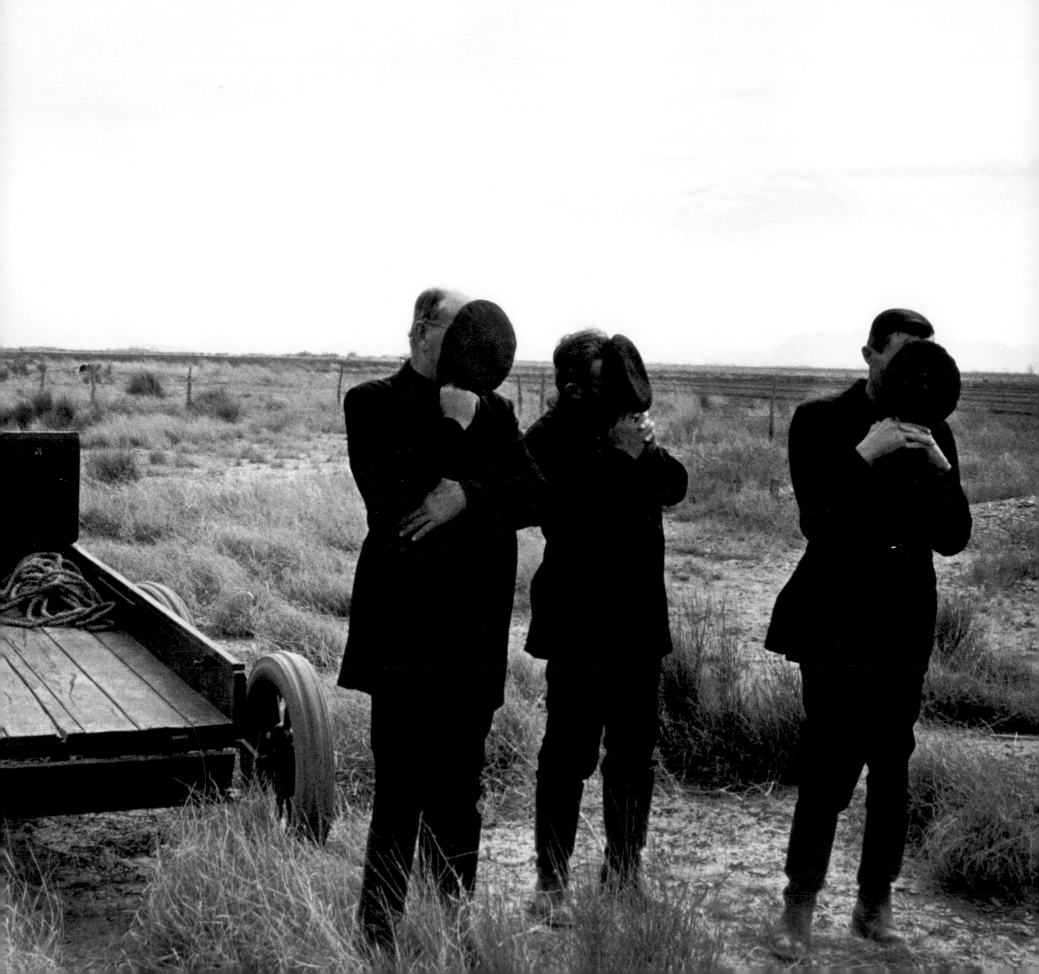

BRETT ABBOTT **ENGAGED OBSERVERS**

IN CONTEXT

In the decades following World War II, a concerned, independently minded, and critically engaged form of photography began to gather momentum. It was not a photojournalism destined for the morning's headlines and meant to be neutral in approach, nor one that would rely exclusively on the picture magazines to convey its message. Instead, it was a self-assigned form of reporting that tackled big-picture problems in a nuanced and evocative fashion, building up arguments through series of images made over long periods of time and from an informed experiential point of view. Books, exhibitions, and, more recently, the Web have become the primary vehicles for its dissemination.

The seeds for this kind of documentary reportage were sowed in the nineteenth century and took root in the early twentieth, but developments during the postwar period provided a platform from which the movement could flourish in its current form. Since that time, a host of independent photographers have combined their skills as reporters and artists, developing extended photographic essays that delve deeply into humanistic topics and present distinct personal visions of the world. While changes over the last fifty years in television and Internet media have increased the pace at which news of the world is produced and consumed, photographers working in this tradition have created bodies of work that require sustained concentration. Embracing the gray area between objectivity and subjectivity, information and interpretation, journalism and art, they create powerful visual reports that transcend the realm of traditional photojournalism.

Through projects advanced over long spans of time, the photographers represented in this publication have all participated in important ways in the development of this documentary approach. Explored in depth on the following pages are Leonard Freed's *Black in White America* (released around 1968), Philip Jones Griffiths's *Vietnam Inc.* (1971), W. Eugene and Aileen M. Smith's *Minamata* (1975), Susan Meiselas's *Nicaragua, June 1978–July 1979* (1981), Mary Ellen Mark's *Streetwise* (1988), Lauren Greenfield's *Fast Forward: Growing Up in the Shadow of Hollywood* (1997) and *Girl Culture* (2002), Larry Towell's *The Mennonites* (2000), Sebastião Salgado's *Migrations: Humanity in Transition* (2000), and James Nachtwey's *The Sacrifice* (2007). But these photographers and projects are certainly not alone in forging the tradition. To their names could and should be added a number of other relevant and innovative photographers working in this mode, including Bruce Davidson, Danny Lyon, Don McCullin, Gilles Peress, and Eugene Richards, to name just a few.

The selection for this publication mirrored that of a 2010 exhibition at the Getty Museum and was therefore tied to a variety of logistical and practical constraints associated with such an endeavor, including the limitations of budgets, the balance of architectural space, relationships to the Getty's existing collection, and the desire to represent the depth of individual projects over that of the field at large. While it is not a selection meant to tell the whole history of documentary photography since the 1960s, nor even to offer a definitive survey of the concerned tradition within it, the project at hand is meant to provide a diverse and representative sampling of socially engaged reportage as pursued by some of its most important practitioners over a period of forty-five years. In looking back over the history of this documentary approach, the present study seeks to be accessible, instructive, and inspiring to novices and specialists alike. While the specific events explored in these projects have passed into history, their larger critical messages can continue to stimulate reflection and dialogue about the state of the world and our responsibilities within it.

The Beginning of *Life*:
Photojournalism and the Documentary Approach before World War II

On November 23, 1936, *Life* magazine published its first issue. The periodical would become the dominant picture magazine of the mid-twentieth century and a major force in shaping the history of photojournalism. Preliminary planning for the magazine had taken place as early as 1934, when Henry Luce, the publisher of *Time* and *Fortune*, assigned a writer, a researcher, and an editor to explore the project. The idea was abandoned after a few months, but then pushed again by Daniel Longwell, a *Time* editor, who persuaded Luce to reconsider the concept and, ultimately, to authorize the venture.[1] Luce's goal was to edit pictures into coherent stories, transforming them from individual fragmentary documents into mosaics that communicated larger meanings. Within a few months of *Life*'s appearance, the publisher wrote an advertisement titled "The Camera as Essayist," in which he explained the magazine's idea of the photo essay:

> When people think of the camera in journalism they think of it as a reporter—the best of reporters: the most accurate of reporters: the most convincing of reporters.
>
> Actually, as *Life* has learned in its first few months, the camera is not merely a reporter. It can also be a commentator. It can comment as it reports. It can interpret as it presents. It can picture the world as a seventeenth-century essayist or a twentieth-century columnist would picture it.
>
> A photographer has his style as an essayist has his. He will select his subjects with equal individuality. He will present them with equal manner. The sum total of what he has to say will be equally his own.[2]

Through series of pictures, then, Luce pushed the idea that a photographer could express a personal visual approach to the world and advance an opinion, or argument, about his subjects. As such, photo essays would become the centerpiece of the new magazine, which would carry as many as ten pages of photographs on a single theme. Sequences were used effectively in combination with captions and other texts to direct the reader's understanding of a topic and thus to communicate news, tell stories, and pursue editorial points of view.

The idea of using pictures in reporting on the world was certainly not a new one when *Life* was founded. Lavishly illustrated newspapers were popularized a few years following the announcement of photography's invention in 1839. In most cases, images were generated not by photographers but by graphic artists, who sketched an event on site and sent the pictures back to a publisher. An engraver then would interpret the drawing, sometimes further dramatizing it in accord with the editor's wishes (fig. 1). The halftone printing process, which became a feasible technology for large-scale newspapers around 1889–90, allowed for the printing of photographs and text together at low cost, leading to the decline of hand-engraved illustrations and prompting the transition to photographic journalism (fig. 2). Improvements in emulsions and camera design were important to this transition. The development of fast gelatin dry plates and roll film during the 1880s, along with smaller hand-held cameras, allowed the press photographer to capture action and movement and thus record a greater range of subjects than was previously possible. Picture agencies, geared toward generating and selling photographs of newsworthy subjects to newspapers and magazines, began to emerge during the mid-1890s, supplementing the coverage of staff photographers and ensuring a steady flow of photographic material for use in the press. Through these developments at the end of the nineteenth century, photographers and mechanical reproduction began to replace sketch artists and engravers, and an institutionalized form of photographic reporting was born. The wide availability of photographic images allowed editors in the early years of the twentieth century the ability to select and arrange pictures, thus providing an opportunity to experiment with shaping meaning through editorial juxtaposition.[3]

Aside from the press, there is a long tradition in the history of photography of using the camera to record issues of social and political consequence for publication. The first extensive record of war can be traced back to Roger Fenton's work in the Crimea. Fenton, who considered himself the leading English artist-photographer of the 1850s, was commissioned by the Queen to photograph the course of the conflict, which pitted the United Kingdom, France, and allies against the Russian Empire. One of Fenton's pictures, *Valley of the Shadow of Death* (1855, fig. 3), depicts a bleak landscape strewn with cannonballs and has become a virtual icon of early war photography. Other photographers worked in the Crimea as well, including Felice Beato, Charles Langlois, and James Robertson. Beato would go on to record the Indian Mutiny in Delhi, Lucknow, and Cawnpore in 1858–59.

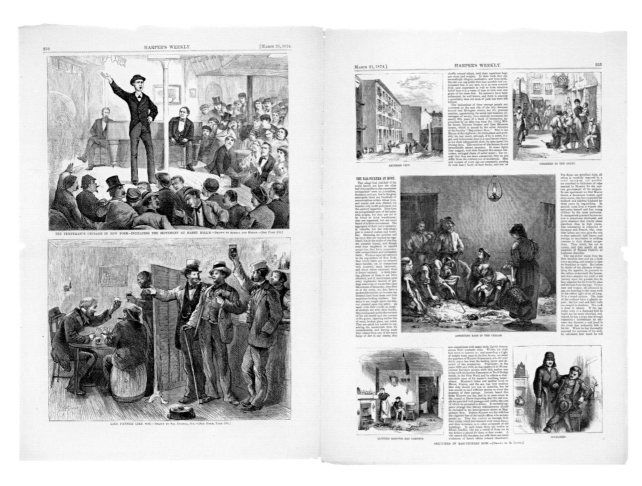

FIGURE 1. *Harper's Weekly* (March 21, 1874): pp. 252–53. Courtesy of the Getty Research Institute.

FIGURE 2. Cover of *Harper's Weekly* (February 26, 1898). Courtesy of HarpWeek., LLC.

FIGURE 3. Roger Fenton (British, 1819–1869), *Valley of the Shadow of Death*, 1855. Salted paper print, 27.6 × 34.9 cm (10⅞ × 13¾ in.). JPGM 84.XM.504.23.

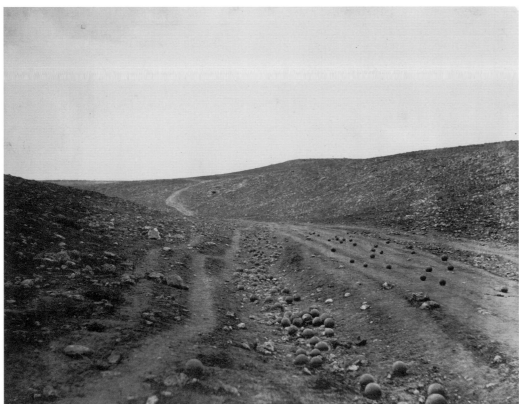

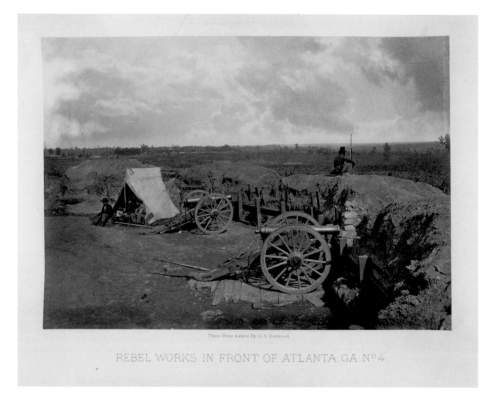

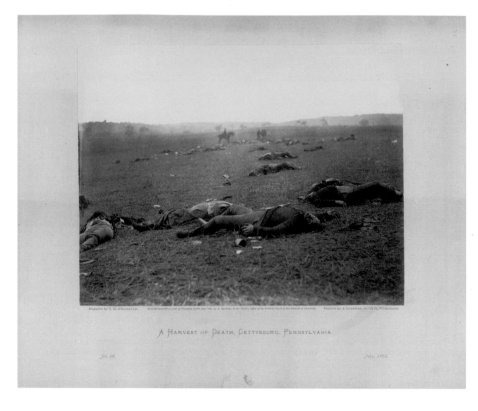

The American Civil War became the first conflict to be covered systematically from beginning to end by commercial and military photographers.[4] George N. Barnard's *Photographic Views of the Sherman Campaign* (fig. 4) and Alexander Gardner's *Gardner's Photographic Sketchbook of the War* (fig. 5), both dating to 1866, are two of the most prominent published records to have emerged from the war. Gardner's account, composed of photographs made by a number of different photographers, is particularly notable for its use of chronological sequencing and text pairings to create a narrative structure.[5] Its depiction of dead soldiers is also among the earliest such portrayals (along with those of Beato in India) known in war reportage. Early conflict studies such as these focus on the periphery of war, or the destruction in the wake of battle, owing to the fact that cameras of the period were cumbersome, photographs required long exposures, and the photographers and the public were accustomed to topographical accounts.[6]

Urban social conditions were also a subject of concern for a number of nineteenth-century photographers. John Thomson, working with journalist Adolphe Smith, published *Street Life in London* (1877–78, fig. 6), which took an anthropological approach to their subject through a presentation of staged street portraits and interviews. It is the earliest significant body of work to deal with street life in a major European city. Jacob Riis's *How the Other Half Lives* (fig. 7), published in 1890, depicts the urban slums of New York in what has been considered the first truly humanistic documentary project that bears witness to a problem with the intention of reversing it. The crusading social reformer used a magnesium flash, a relatively new development, to capture his subjects unposed and in poorly lit places, and his book was the first to make use of extensive halftone photographic illustrations. Lewis W. Hine, working for the National Child Labor Committee in the United States, was heir to this tradition (fig. 8). His photographs and written documentation of children working long hours and in dangerous factory environments during the first decades of the twentieth century were used in the service of reforming labor laws to prevent exploitation of youth.

In Europe, important changes in institutionalized journalism began to take place during the late 1920s, as mass media grew at an astounding pace. The city of Berlin alone had as many as forty-five

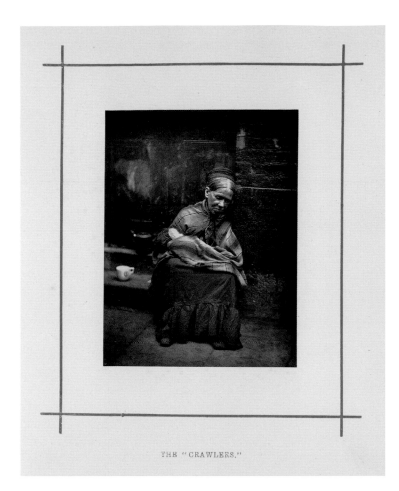

THE "CRAWLERS."

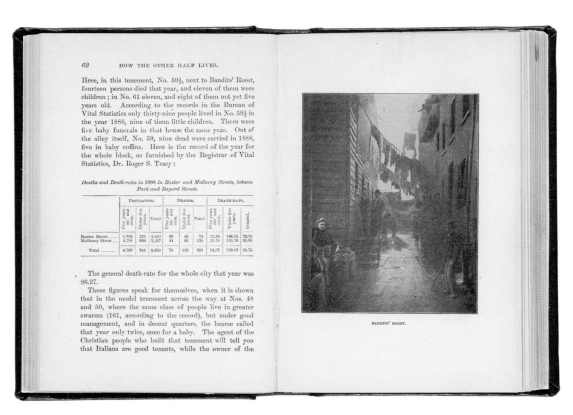

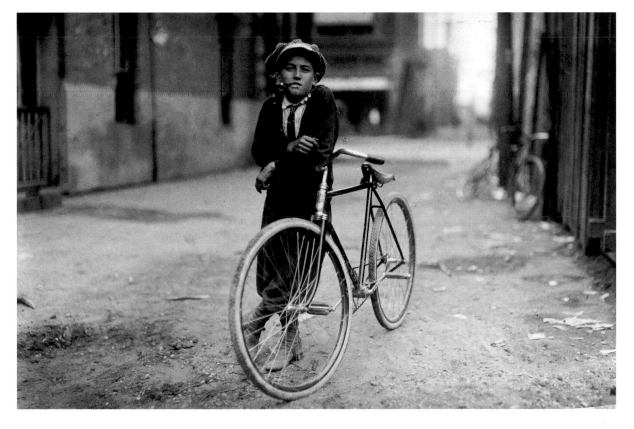

FIGURE 6. John Thomson (Scottish, 1837–1921), *The "Crawlers"*, 1877. From *Street Life in London*, 1877–78. Woodburytype, 11.6 × 8.7 cm (4⁹⁄₁₆ × 3⁷⁄₁₆ in.). JPGM 84.XB.1361.31.

FIGURE 7. Jacob Riis (American, born Denmark, 1849–1914), *How the Other Half Lives* (New York: Charles Scribners' Sons, 1890), pp. 62–63.

FIGURE 8. Lewis W. Hine (American, 1874–1940), *Messenger Boy for Mackay Telegraph Company, Waco, Texas*, 1913. Gelatin silver print, 11 × 16.2 cm (4⁵⁄₁₆ × 6³⁄₈ in.). JPGM 84.XM.132.23.

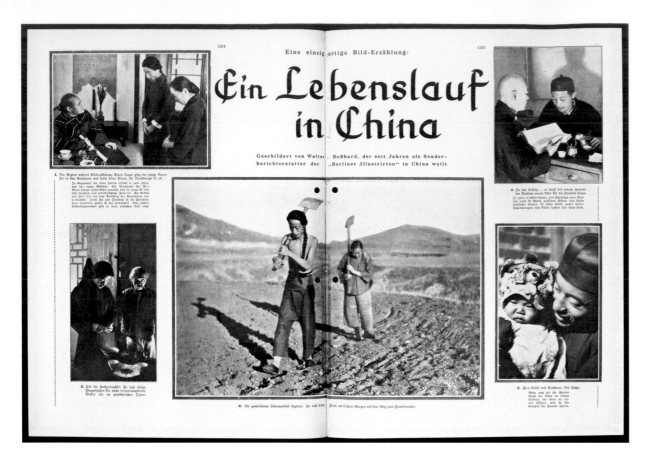

morning and fourteen evening newspapers at the time.[7] Small-format German-made cameras, specifically the Ermanox and the thirty-five-millimeter Leica, were harnessed by the competitive illustrated magazines in their efforts to gain market share of readership. A new language of press photography—one that stressed instantaneous, or candid, capture of informal moments in available light and presented related images in printed sequences—was popularized within this context.[8] Photographers like Erich Salomon and Felix Man, and publications like the *Berliner illustrirte Zeitung* (fig. 9) and *Münchner illustrierte Presse* in Germany and *Vu* in France, pursued this fresh approach to documenting human affairs for purposes of mass communication. Salomon, whose social connections allowed him entrée to bastions of power, including social gatherings of heads of state (fig. 10), contributed to the popularity of pictures made in realms of restricted access.

Editors such as Stefan Lorant, who would later establish *Picture Post* in Britain, were in charge of selecting pictures for presentation. Their compilations, which were normally limited to two- or three-page spreads, typically offered interpretations of themes rather than chronological accounts of events. Topics that were not newsworthy in the traditional sense, such as human-interest subjects, were commonly explored. In America, news and business magazines including *Fortune* (founded in 1930), *Time* (launched in 1923), *Collier's Weekly* (started as *Collier's Once a Week* in 1888), *Harper's Weekly* (introduced in 1857), and others were using photographs to illustrate their articles in the early twentieth century. *Fortune* in particular showed a strong interest in the candid-style reportage popular in Germany.[9] Tabloid newspapers too, like the New York *Daily News*, abounded during the interwar period. It was from this journalistic context that *Life* sprung. In fact, Kurt Korff, a former editor of the *Berliner illustrirte Zeitung*, was brought on as a special consultant in the magazine's formative phase and assisted with the establishment of *Life*'s editorial model.[10] In addition to illustrated layouts of news, *Life*'s focus on issues told primarily through narrative photographic sequences was significant. The magazine's hallmark was its carefully crafted picture story. Photographers were sent around the world to capture images of human activity, and their work was edited and inserted into story layouts for the magazine's pages. Some of the finest photographers of the day worked for the publication, including Esther Bubley, Robert Capa, Alfred Eisenstaedt, Carl Mydans, and W. Eugene Smith. Capa gained fame in the 1930s for his startling images of combat during the Spanish Civil War (fig. 11), including his now-iconic *The Falling Soldier* (1936, fig. 16, image on cover) and his photographs of civilian refugees (fig. 12). He and Smith would go on to bring back powerful and heroic views of World War II, including the D-Day landings and the invasion of Saipan, respectively (figs. 20 and 21). Mydans would

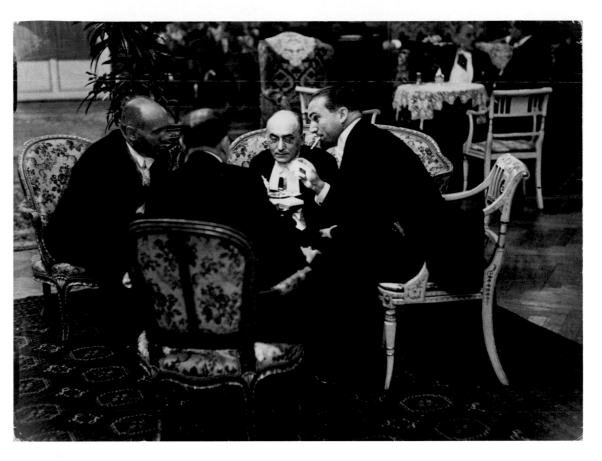

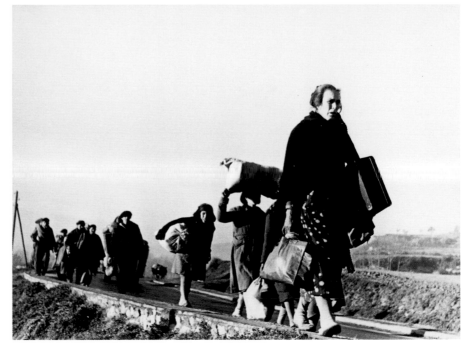

chronicle life in Asia during the 1940s and 50s (fig. 13), while Eisenstaedt and Bubley captured images of the American scene (fig. 14). Within a year of *Life*'s founding, a competitor, *Look*, was established on similar principles. In competition with *Look*, *Picture Post*, and others, *Life*'s approach to the photo essay grew increasingly complex over the course of its history.

From its beginnings, *Life* was not just a news and features magazine that presented facts about the world, but rather a commentator on those events. As early as 1938, Luce explained his desire for the magazine to provide a specific point of view. Overall, he felt *Life* should be positive in its editorial selection of coverage; it should be "for things" rather than in opposition to problems.[11] One of the concerns the magazine pushed for was America's involvement in World War II. A sixteen-page spread in the March 28, 1938, issue told of the rise of the Nazi party in Germany and warned that the country's annexation of Austria was only its first step toward European domination. In the February 17, 1941, issue, Luce wrote an essay called "The American Century," in which he encouraged Americans to accept their duty and opportunity as the most vital nation in the world.[12] In the end, Luce's intention was to harness the photo essay as a moralizing and interpretive medium for public persuasion.

If *Life* didn't invent the photo essay per se, or the desire to record issues of concern around the world in a persuasive manner, it was certainly a major player in popularizing these approaches to a mass audience and in raising photojournalism to new levels of narrative sophistication from the time of the periodical's inception in 1936 into the 1970s and beyond.[13] Its tremendous readership of twenty million people in America and Europe during the late 1940s and 50s was unparalleled.[14]

While using the combination of photographs and words to report on the world was not new in the 1930s, the term "photojournalism" as a description of its modern practice was still fresh. As early as 1938 a book titled *Miniature Camera Work* used the term "photo-journalism" to describe the process.[15] And by 1952,

FIGURE 13. *Life* (November 24, 1941): pp. 88–89, featuring Carl Mydans's photographs of China.

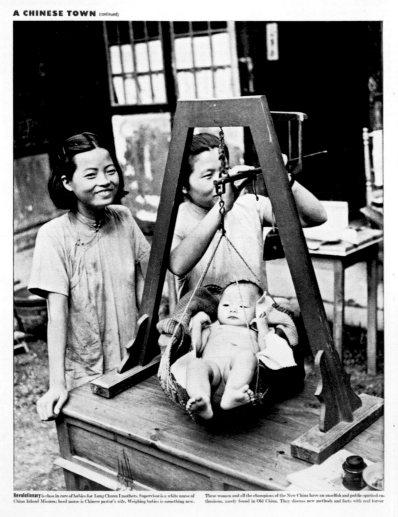

A CHINESE TOWN (continued)

Christian Pastor Hung Hui-yi, shown with his public-spirited wife Helena and baby daughter, has an earnest flock. Churchmen get no automatic respect in China, must make their mark.

Emperor Wu Temple has been taken over as a troop barracks. Though this is not regarded as sacrilege, the old idols are now neglected and Government unity slogans are posted on its front.

MODERNISM REACHES LUNG CHUAN I

A bitter undercover struggle is now going on between the citizens of Lung Chuan I on the preceding pages and those on these pages. The war is between the old doctor of herbs and massage and the modern clinic shown on the opposite page, between the Taoist priest and the educated young Christian pastor above, between the letter writer and the reading room below. The Old China receives its authority from the family system at the bottom. The New China reaches Lung Chuan I from above, usually from the Government at Chungking. It has the disadvantage of being imposed from on top and of seeming to be a slavish imitation of the West.

The educated Chinese shown at right with a basketball is actually a revolutionary apparition in China, where 99 years ago nobody would have dreamed of exerting himself just for the fun of it. What he teaches, even more than physical exercise, is team effort, to a China now engaged in the greatest team effort in its history. The literate people below who are reading about distant things that are, on a Confucian morality, none of their business are utterly new too. For how the New China rules Lung Chuan I, turn the page.

ATHLETIC CLUB DIRECTOR

Reading room in town hall gives citizens of Lung Chuan I a window on the world in Chungking and Chengtu newspapers, Government handouts on the war, politics, farming, hygiene, etc.

Major general from Chungking is Ho Chu-fei, commanding local garrison of Central Government troops. Chiang's honest, able young officers are fast displacing the old, corrupt war lords.

Revolutionary is class in care of babies for Lung Chuan I mothers. Supervisor is a white nurse of China Inland Mission; head nurse is Chinese pastor's wife. Weighing babies is something new.

These women and all the champions of the New China have an unselfish and public-spirited enthusiasm, rarely found in Old China. They discuss new methods and facts with real fervor.

88

CONTINUED ON NEXT PAGE 89

Wilson Hicks, *Life* picture editor from 1937 to 1950, wrote a book titled *Words and Pictures: An Introduction to Photojournalism*, a section of which is devoted to the question: "What is photojournalism?"[16]

The parameters of photojournalism were, and are, difficult to delineate, particularly given the fact that the word itself came into common use well after the institutionalization of photographically illustrated news and nearly one hundred years after the invention of photography itself was announced. At its most basic, it is a kind of journalism that uses pictures, normally in combination with words, to report on the world. Whether it is restricted to reports that are driven primarily by pictures as opposed to those illustrated with pictures, and thus whether it encompasses or is distinct from press photography, is debatable. And whether it should be used to describe visual reporting that did not arise out of the institutionalized press, including nineteenth-century studies like *Gardner's Photographic Sketchbook of the War*, is similarly open to interpretation. It is notable that in the preface to his book, Hicks stated: "I may as well warn the reader at the outset that he will not find in this book the definitive answer to the question, What is photojournalism? I have found even elusive a brief and concise definition."[17]

The same might be said of the term "documentary," which emerged in relation to photography around the same time that *Life* was established. Today, the term is used loosely to refer to a wide variety of practices in which the subject matter of a picture is at least as important as its manner of portrayal. But accounts of what is and is not documentary vary considerably. Sometimes the word is used narrowly to mean pictures aimed at capturing and critiquing social issues (often referred to as Social Documentary), and even more specifically to refer to the Depression-era surveys of the U.S. government's Farm Security Administration (FSA). Other times the term refers in a general way to photographs that record, or document, the world for informational purposes (often in combination with artistic ones). In all, the term has been applied to a remarkably diverse array of pictures, including landscape and architectural documentation of the nineteenth century by European photographers like Beato, Samuel Bourne, Francis Frith, and Henri Le Secq; Western survey photography by Americans William Henry Jackson and Timothy H. O'Sullivan; cityscapes of Eugène Atget and Berenice Abbott; socially engaged work by figures like Hine, Dorothea Lange, Riis, and Thomson; portrait projects by August Sander and Milton Rogovin; ethnographic studies; street photography; war photography of all periods; mug shots and crime-scene pictures; and more.

Indeed, it is often remarked that all photography, by its very nature, is in some way documentary. Since its beginnings, the photographic medium has been understood as a tool for recording or documenting the world. It is perhaps no coincidence that the term "documentary" appeared after the medium went through a symbolist and pictorialist period that presented itself fervently and self-consciously as an art form, thus necessitating some way of distinguishing that vein from the impulse to record for other purposes.[18]

But the breadth of photographs categorized under the word "documentary" also has to do with the dual nature of the term's meaning. William Stott described this dichotomy in his major 1973 study on the topic. On the one hand, documentary has associations with objectivity, fact, and proof, as in historical or legal documents. On the other hand, documents can be humanistic records of emotion and experience. So-called human documents are personal, heartfelt, and emotional. Social documentary work can depict how a situation feels and not just how it looks; it can convey factual information about the world compellingly by delivering it in emotionally charged ways, harnessing compassion and sentimentality for persuasive ends. It can sensitize our intellect and educate our emotions.[19]

Photographers have considerable room to explore this gray territory between proof and expression. Walker Evans—a quintessential American "documentary" photographer—was known to describe his work as being in a documentary style, implying that it harnessed the aesthetic look of the document toward artistic ends.[20] And of course, even the most evidentiary of documents, such as the crime-scene picture, is never entirely free from human interpretation.

The first use of the word "documentary" in relation to visual expression is credited to the Scottish filmmaker John Grierson in a description of Robert Flaherty's nonfiction film *Moana* (1926).[21] He described documentary as "the selective dramatization of facts in terms of their human consequences" and identified it as a means of educating "our generation in the nature of the modern world and its implications in citizenship."[22] In 1938, an American documentarian by the name of Richard Griffiths rephrased Grierson's arguments, saying that documentary was "primarily not a fact-finding instrument, but a means of communicating conclusions about facts."[23] Thus documentary, as it related to film, was understood as an artful means of education and persuasion, rather than a presentation of objective fact.

Beaumont Newhall had this understanding of documentary in mind when he applied the word to the history of photography in 1938, identifying it as an approach rather than an end.[24] In his article "Documentary Approach to Photography," Newhall acknowledged the document-like nature of all straight

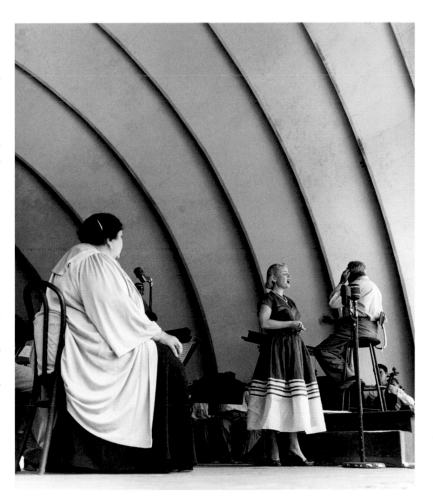

FIGURE 14. Alfred Eisenstaedt (American, born Germany, 1898–1995), *Mama Nina Koshetz coaches daughter Marina at rehearsal in Hollywood Bowl*, 1949. Gelatin silver print, 32.2 × 27.3 cm (12¹¹/₁₆ × 10¾ in.). Gift of Leo Pircher and Nina Pircher. JPGM 2007.62.11.

photography, but also recognized the possibility of using that approach in the service of persuasive statements, much like documentary filmmakers used their medium:

> The documentary photographer is not a mere technician. Nor is he an artist for art's sake. His results are often brilliant technically and highly artistic, but primarily they are pictorial reports.... He puts into pictures what he knows about, and what he thinks of, the subject before his camera.... He will not photograph dispassionately; he will not simply illustrate his library notes. He will put into his camera studies something of the emotion which he feels toward the problem, for he realizes that this is the most effective way to teach the public he is addressing. After all, is not this the root-meaning of the word "document" (*docere*, "to teach")? For this reason his pictures will have a different, and more vital, quality than those of a mere technician.[25]

Newhall went on to explain the importance of presentation in the documentary approach, emphasizing the need for extended captions to give the pictures greater significance and of sequences of images that approach the delivery system of cinema. He even recommends the use of a shooting script. Documentary is, he suggests, a mode in which pictures can be used to engage and report editorially on the world. It is an approach that places emphasis on creating series of images in a straight, emotionally engaged fashion and organizing them into persuasive sequences.

Newhall's article emerged at a time marked not only by the rise of picture magazines and the documentary film genre, but also by a more general impulse toward social realism that flowed through social science, popular literature, radio programs, and art movements of the day.[26] John Steinbeck's *The Grapes of Wrath* appeared in 1939, and a number of early-twentieth-century American painters were collectively dubbed the Ashcan School for their focus on the ordinary aspects of city life. Photographers associated with the Photo League in New York, which retained Hine's negatives after his death, dealt with recording the urban realities of their surroundings as well. Interested in social justice and the dignity of human life, Photo League members sought to depict the rhythms of daily existence in sympathetic ways (fig. 15). Member Aaron Siskind helped to organize a project called "Harlem Document," a collaboration between several photographers and the black writer and social worker Michael Carter. Projects such as this were shown in New York and often reproduced in publications such as *Fortune*, *Look*, and *U.S. Camera*.[27]

The extensive photographic efforts of the FSA to survey the impact of the Great Depression on the agricultural and social fabric of the country were an important part of this environment. Initiated in 1935, the Resettlement Administration, later renamed the Farm Security Administration, was a part of President Roosevelt's efforts to fight the Depression. Roy Stryker supervised and edited the photographic activity of the program, which was aimed at recording and demonstrating the need for the agency's work and transmitting images to the press. Stryker regularly wrote shooting scripts and scheduled assignments for the photographers working for the agency, who included Evans, Lange, Mydans, and Arthur Rothstein, among others.

There has been a tendency to speak of photojournalism and documentary as clearly separate forms of photography. The trend to separate the two became pronounced during the 1960s and 70s as a way of distinguishing what were regarded as more commercial endeavors (dubbed "photojournalism") from those with artistic, or museum, ambitions (dubbed "documentary").[28] Certainly the two are not exactly one in the same, but their divisions are fuzzy and differences not exactly hierarchical in relation to the realm of independently conceived art. Photojournalism need not be considered exclusively an endeavor associated with the commercial media. Instead, it might be better understood as an end (a particular kind of journalistic report composed of pictures and related text), with documentary as a related approach to photography encompassing a much wider range of outcomes.

Moreover, clear hierarchies were not as apparent when the terms came into use. *Life*'s process of photojournalism, which involved the creation of the photo essay as a vehicle for persuasive reporting, was remarkably like Newhall's and Grierson's descriptions of the documentary approach. In fact, Newhall noted in his article that the possibilities for the documentary approach to still photography were already being shown through publications like *Life*, the German illustrated newspapers, and in tabloids.[29] And there was indeed a fluidity between the work of FSA and essay-oriented magazine photographers. *Life* hired FSA photographer Mydans as one of its earliest staff photojournalists and published work by other FSA photographers in its pages. Thus since the late 1930s, documentary, the photo essay, and the practice of photojournalism have been, while not exclusively related to one another, certainly intertwined: that is, many photo essays are photojournalistic reports made from a documentary approach. With the advent

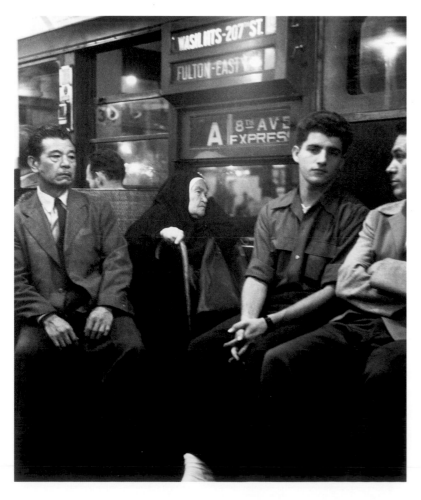

FIGURE 15. Joe Schwartz (American, born 1913), *Elderly Sister on "A" Train, New York City*, 1940s. Gelatin silver print, 31.3 × 26.3 cm (12⁵⁄₁₆ × 10³⁄₈ in.). JPGM 2004.53.4.

FIGURE 16. Cover of Robert Capa (American, born Hungary, 1913–1954), *Death in the Making* (New York: Covici-Friede, 1938). Courtesy of the Getty Research Institute.

FIGURE 17. Margaret Bourke-White (American, 1904–1971) and Erskine Caldwell (American, 1903–1987), *You Have Seen Their Faces* (New York: Modern Age Books, 1937), n.p.

FIGURE 18. Dorothea Lange (American, 1895–1965), *Waiting for Work on Edge of the Pea Field, Holtville, Imperial Valley, California*, 1937. Gelatin silver print, 20.5 × 19.2 cm (8¹⁄₁₆ × 7⁹⁄₁₆ in.). JPGM 84.XP.208.67.

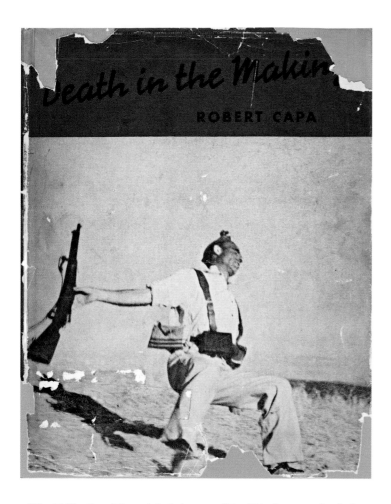

McDANIEL, GEORGIA. "Snuff is an almighty help when your teeth ache."

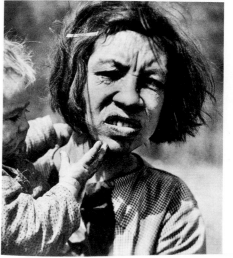
McDANIEL, GEORGIA. "I get paid very well. A dollar a day when I'm working."

of World War II and the related closure of the FSA, the magazine industry would become an important employer of photographers interested in continuing the tradition of humanistic reportage.

Perhaps more significant for this study is the fact that many photographers of the era were not simply drones working for the institutional aims of their employer—be it the government or the magazines. Most were passionately engaged in the process of observing, recording, and communicating what they saw as the critical issues of their time. A number of them actively sought opportunities to independently publish their personal understandings of the situations they witnessed through book-length photo essays. War photographer Capa published a diary-like account of the Spanish Civil War from the anti-fascist perspective in 1938. Titled *Death in the Making* (fig. 16), the book combines his pictures with those of his lover, journalist Gerda Taro, who died during the conflict. Across its cover was the shocking *The Falling Soldier*, one of the pictures for which Capa was named "The Greatest War-Photographer in the World" on the cover of *Picture Post* in December of that same year.[30]

Margaret Bourke-White, a photographer who worked for *Fortune* and *Life*, authored *You Have Seen Their Faces* (fig. 17) together with her future husband Erskine Caldwell in 1937. The book is an emotional and partisan report, with reformist intentions, on the inequities of the Southern tenant-farming system. It was controversial in part because its text includes quotes that were invented by the authors for their subjects. Even though the book makes this clear at its outset, many commentators were uncomfortable with its rhetorical strategy. This did not stop it from being one of the most financially successful documentary books to emerge from the Depression in America.[31]

In a more sober assessment of Americans in transition from farms to factories, Lange and her sociologist husband Paul Taylor published *An American Exodus: A Record of Human Erosion* in 1939. The photo essay is remarkable for its restraint; many of Lange's most memorable pictures, including *Migrant Mother*, were purposefully omitted from the series with the intention of creating a harmonious whole that could better communicate the project's larger messages (fig. 18). Evans and James Agee released *Let Us Now Praise Famous Men*, a project arising out of an unpublished commission by *Fortune* magazine,

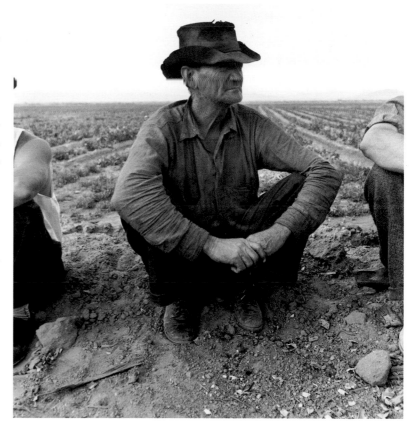

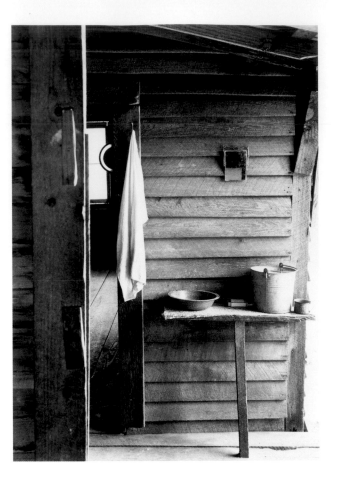

FIGURE 19. Walker Evans (American, 1903–1975), *Washroom in the Dog Run of the Burroughs Home, Hale County, Alabama*, 1936. Gelatin silver print, 23.5 × 16.7 cm (9¾ × 6⁹⁄₁₆ in.). JPGM 84.XM.956.335.

FIGURE 20. Robert Capa (American, born Hungary, 1913–1954), *Omaha Beach, Normandy, France*, 1944 (printed ca. 1964). Gelatin silver print, 22.8 × 34.1 cm (9 × 13⁷⁄₁₆ in.). JPGM 2004.156.2.

FIGURE 21. W. Eugene Smith (American, 1918–1978), *Saipan*, 1944. Gelatin silver print, 22.1 × 17 cm (8¹¹⁄₁₆ × 6¹¹⁄₁₆ in.). JPGM 84.XM.1014.5.

but for which the FSA kept photographic negatives, in 1941. Their book, which documented three impoverished tenant-farming families in Hale County, Alabama, was highly experimental in its organization. Evans's direct and carefully composed photographs (fig. 19) appear at the front of the book, thoughtfully sequenced and uncaptioned. Agee's dense 472-page text follows the pictures, complementing them as a parallel literary approach to recording the environment.[32]

It is instructive to compare the three books made on Depression-era America, for through them three individual philosophies of documentary reporting can be distinguished. Bourke-White's melodramatic study openly embraces creative interpretation, through both its fictional quotes and its dramatic portraiture, as a legitimate means of activist journalism. Lange developed a rigorous non-sensational account, integrating pictures and well-researched texts together as equal building blocks in a project that is "neither a book of photographs nor an illustrated book."[33] Evans's eschewing of a candid style in favor of a clean staid aesthetic, and his separation of image and text to emphasize each as an independent means of communication, set his work in a direction more compatible with museum presentations. (Indeed, the Museum of Modern Art held a major exhibition of Evans's work in 1938 called "Walker Evans: American Photographs."[34]) All three were engaged in a similar process of critical investigation, reporting and commenting on the state of their social environments from personal, rather than corporate or governmental, points of view. In so doing, they pushed the photo essay in new directions and provided diverse models for socially engaged, independent photographers in the second half of the century.

Reframing Life: A Declaration of Independence

America's entrance into World War II marked the end of the FSA's documentary endeavor, but provided a new subject that would occupy many photographers' attention in the coming years. Lange would continue working for the government, documenting the relocation of Japanese Americans into internment camps. Capa (fig. 20), Bourke-White, Mydans, and Smith (fig. 21) would find themselves covering the war for picture magazines in Europe and the Pacific. In addition to generating some of the century's most iconic images, the World War II era engendered a desire on the part of many photojournalists for more control over their work. Projects to cover the war were expensive to carry out and required the support of a news agency or the government, which put a photographer's work and activities under the editorial control of others. Photographs produced over the course of an assignment normally belonged to

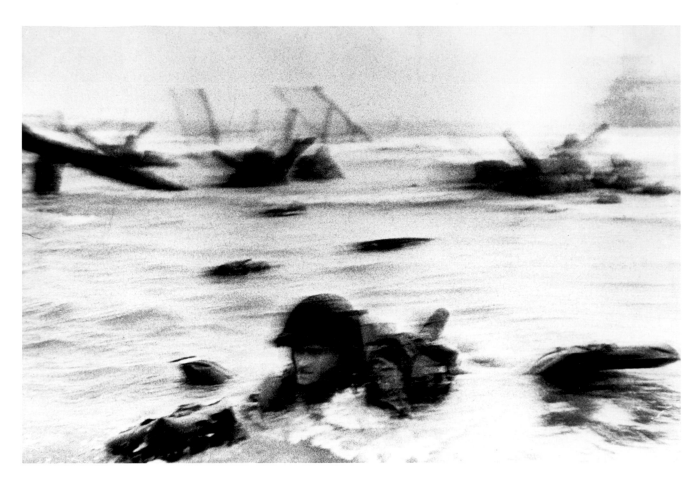

the organization commissioning them, and thus photojournalists were unable to determine how their pictures would be cropped and captioned and in what context they would be shown. Moreover, they were only able to receive income once from each photograph (or never, if a salaried staff photographer).

Seeking to restore his independence and intellectual integrity, Capa conceived of a different kind of relationship between photographer and news organization. He envisioned a photographers' cooperative, which would distribute its members' pictures internationally to publications and assert control over assignments, negatives, photographs, and copyrights. Work could be released in story format as conceived by the photographers themselves, complete with adaptable sequences of pictures, captions, and descriptive context. Because photographers under this model would own their own work, they could license its reproduction to multiple agents at once and continue to make sales from it in the future. In 1947, Capa, together with photographers Henri Cartier-Bresson, George Rodger, David Seymour, and William Vandivert, founded Magnum Photos on those principles. It would provide a new platform for an independent documentary approach to photojournalism and become one of the world's most prestigious photographic organizations.

Magnum was structured to allow its members to pursue stories of their own choosing, spend as much time as they wanted on a particular topic, and be as involved as they desired in the editing, captioning, and publication of their work. Cartier-Bresson would later describe it more lyrically as "a community of thought, a shared human quality, a curiosity and a respect for what is going on in the world, and a desire to transcribe it visually."[35] The organization was meant to harness commercial assignments as a base from which to pursue independent work. The photographers would make all decisions for the cooperative, but the agency's daily operations, which included enforcing copyright and promoting Magnum stories, would be supported by Rita Vandivert in New York and Maria Eisner in Paris. Despite a rough beginning, which was marked by William and Rita Vandivert's resignation in 1948 and the untimely deaths of three of the cooperative's first six members (Capa and Werner Bischof in 1954, and Seymour in 1956), the agency has grown in size and prestige ever since. The Magnum concept has given rise to generations of independent photographers who have sought to combine their skills as reporters and artists, developing extended photo essays that delve deeply into humanistic topics and present distinct personal visions of the world. Magnum now operates offices in London, New York, Paris, and Tokyo and includes a list of constituents that changes yearly, as new photographers are voted by the membership into the organization through a rigorous program of portfolio reviews.

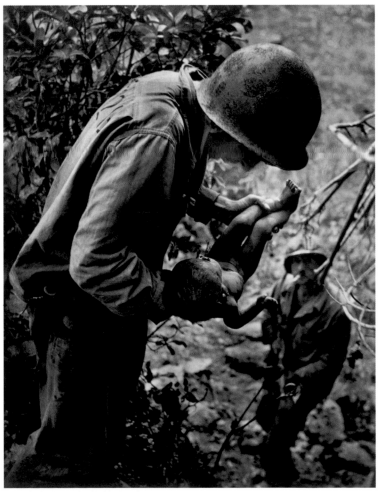

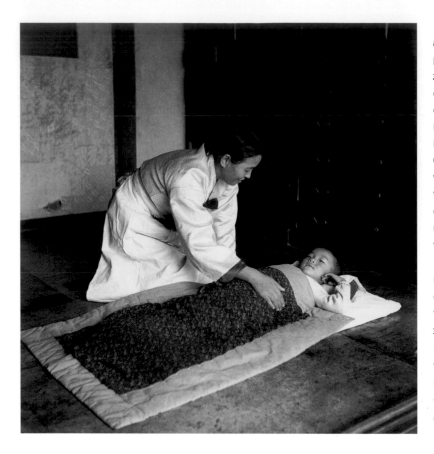

FIGURE 22. Horace Bristol (American, 1908–1997), *Korea*, 1946. Gelatin silver print, 26.4 × 25.4 cm (10⅜ × 10 in.). The Estate of Horace and Masako Bristol.

Magnum's formation was a rebellion from the kind of editorial structure practiced at *Life*.[36] Despite *Life*'s statements implying that photographers could present unique authorial voices in their essays for its pages, the magazine's hierarchy made it very difficult to achieve that in practice. Not only was the magazine geared overall toward a positive outlook on the world, thus making a critical approach to subjects difficult, but its photographers were treated as technicians responsible for providing raw material while editors contributed the intellectual interpretation of a subject. In a photo essay, presentation is exceedingly important in communicating messages. The writing of shooting scripts, selecting and captioning of images, and laying out of essays was all accomplished at *Life* with minimal input from the photographer. Once an assignment was shot, a photographer was required to turn his film over to the *Life* photo lab, where the negatives would be developed, printed, and selected by other staff. From that point forward, the photographer was given very little say over how the pictures were used. While managing editors changed over the course of *Life*'s history, and each took a slightly different approach to the creation of the magazine's essays, *Life* was from its beginnings a picture magazine managed by former writers, not by photographers. The publication's photographers, it has been said, were more like a thesaurus than authors.[37]

The Magnum founders were not the only photojournalists to feel frustrated working within the magazine and government editorial models, where their pursuits were dictated, and results edited, by others. Horace Bristol, who had photographed for *Life*, *Fortune*, and other magazines as a freelance photographer during the 1930s and worked for Edward Steichen's photographic Naval Aviation Unit in the 1940s, set up an agency dedicated to distributing his own work after the war. Establishing himself in Japan, Bristol named his organization the East-West Photo Agency and dedicated his work to documenting postwar Asia (fig. 22). His pictures were sold to Western picture magazines, but he also pursued independent publications that presented his work within an editorial context of his choosing. During the late 1940s and early 50s, he began creating books on subjects like Bali, Formosa (Taiwan), Japan, and Korea. In *Formosa: A Report in Pictures* (1954), he explained his reasoning for such an undertaking:

This volume, sixth in a series of photographic books on Asia by the same author, is frankly a publishing experiment. Dealing as it does with a highly controversial subject, it attempts to integrate photographs and text into a composite picture story presenting the view-point of a photojournalist, unaffected by editorial or other outside influences in a book that is photographed, written, edited, and published by the same person.

Thus it should be obvious that the opinions expressed herein are those of the author, their presentation, in choice of pictures, layout, and text, his sole responsibility.

Most photographic books, unless sponsored or financed by special interests, have wisely avoided offending any large group of potential readers by confining themselves to the purely pictorial, as picture books are expensive to produce.

This is not just a picture book.

It is a photographic report, based on many assignments in Formosa for various magazines of widely divergent political policies. It will surely offend some, please others among its readers, although its purpose is neither to please, nor offend, but to inform.[38]

His book on Korea (fig. 23) is particularly notable for its humanistic concern for the country's people, who found themselves caught between competing Cold War interests. Its introduction notes, "Between two antagonistic ideological enemies, a crushed and impotent Korea fights feebly for its integrity. This book attempts to picture, without emphasis on the political struggle underway, a small part of the quiet, simple life of these little-known people, who want nothing more from the world than to be left alone."[39]

Likewise, John Swope, another of Steichen's Navy photographers during the Second World War and a friend of Bristol's, made efforts to photograph subjects beyond the scope of his military duties while stationed in Japan. Venturing into villages and cities away from the prisoner-of-war camps he was meant to record, Swope built a personal view of postwar Japan that he, too, intended to publish in book form after the war.[40]

W. Eugene Smith's tempestuous relationship with *Life* is similarly well documented. Smith felt strongly that it was a photojournalist's personal responsibility to ensure that his pictures were used appropriately and that their impact on the public was in keeping with the photographer's intentions for the work. He recognized that the stakes were high in mass-media publications, given the large number of people who were influenced by photographic journalism each week through the picture-magazine industry. Rather than abandon *Life* and allow the magazine to follow its own agenda while he pursued another independently, Smith sought to reform the periodical from within. More than any other *Life* magazine

photographer, Smith fought with the magazine's editors to restore his authorship over essay projects. His challenges to *Life*'s editorial control of his pictures were radical at the time.[41] He succeeded in influencing the interpretive strategies of some of his essays and created many of his best photographs for *Life* magazine. By insisting on printing his own work rather than allow *Life* staff to do it, Smith retained a degree of control over the editing of his photographs. His selection tended toward the melodramatic, a characteristic that could be emphasized through adjusting the contrast between shadow and light in printing.[42] Ultimately, however, Smith was rarely satisfied with the compromises required as a *Life* photographer, and he eventually resigned in protest in 1954.[43] He joined Magnum for a short period and then began representing himself, an arrangement that eventually resulted in *Minamata*, developed collaboratively with Aileen M. Smith and arguably the most cohesive long-term project of his career (pp. 98–119).

This drive toward photojournalistic independence continued during the 1960s. Magnum photographer Cornell Capa, Robert Capa's brother, started a fund for socially committed photography in 1966. The next year, he curated the exhibition "The Concerned Photographer," which was followed by a corresponding publication of the same title in 1968. Both included selections from Leonard Freed's Black in White America project along with work by five other photographers (several of them Magnum members). Capa's intentions were explained in the introduction to the catalogue:

> It is my personal conviction … that the production demands and controls exercised by the mass communications media on the photographer today are endangering our artistic, ethical, and professional standards and tend to obliterate the individuality of the witness-artist. … The Fund is dedicated to the recognition of photography as a very personal means of communication, to the recognition of the photographer as an individual with his very own, recognizable graphic style and human content who translates what he sees into frozen reality. The resulting images bear the photographer's own respect for truth. They also reveal his appreciation of the aesthetic values for light and form, and his artistic concepts of composition.[44]

Through the fund, which would lead to the establishment of the International Center of Photography in 1974, Capa sought to keep independent humanitarian photography relevant and visible.

The Janus Face of Documentary Expression

The trend toward independence as seen in the formation of Magnum; in the resistance of photographers like Bristol, Smith, and Swope to the strictures of their employers; and in the development of institutional support for concerned photography took place in a postwar environment marked by two very different concepts of how the documentary approach should be used. Steichen, who had gone from being an acclaimed pictorialist photographer to a successful fashion photographer before heading up the Navy's Photographic Aviation Unit, was hired as the director of the Department of Photography at the Museum of Modern Art in New York following the war. In 1955, to great acclaim, he opened "The Family of Man," a monumental exhibition dedicated to the exploration of universal humanity. The exhibition included 503 photographs, organized into broad thematic categories (love, motherhood, family, work, play, hunger, grief, etc.). The photographs were printed not to the specifications of the photographers themselves but according to the systematic design needs of the presentation. They were used much more as objective didactic tools than as representations made by a particular person with a particular point of view. That is, the exhibition was driven more by subject matter than by the photographers' independent visions, and the thesis of the show was given precedence over the original context in which the images were made. According to Steichen, the exhibition was meant to reveal "the relationship of man to man; to demonstrate what a wonderfully effective language photography is in explaining man to man; and to express my own very firm belief that we are all alike on this earth, regardless of race or creed or color."[45] A message of universal kinship was conveyed through a careful utilization of images, texts, and architectural space. Steichen, in effect, organized the exhibition as a picture-magazine editor would have organized a photo essay. And, like a magazine, the exhibition harnessed photography as a tool of mass communication; by 1962, the show had traveled to thirty-eight countries and been seen by more than nine million people.[46]

If Steichen's endeavor represented one important understanding of what constituted a good end to the documentary approach, another quite different result would be expressed by a young Swiss photographer named Robert Frank. In 1958 Frank said, "I have a genuine distrust [of] all group activities. Mass production of uninspired photo journalism and photography without thought becomes anonymous merchandise … I feel that only the integrity of the individual photographer can raise its level."[47] The same year that "The

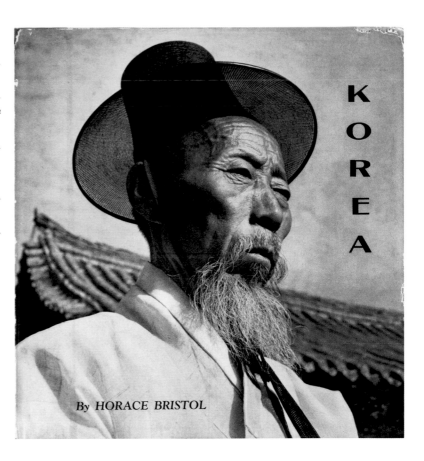

FIGURE 23. Cover of Horace Bristol (American, 1908–1997), *Korea* (Tokyo: East-West at Toppan Press, 1953). Originally published in 1948.

Family of Man" opened, Frank embarked on a cross-country photographic trip to explore American culture. His project, funded by a Guggenheim grant, resulted in one of the most important photo books of the period: *The Americans* (1958). The work betrays a disinterested, even skeptical, view of the need for objectivity, social agency, and universal meaning in photography. Instead, it champions an intimate, evocative, personal, and subjective purpose in documenting the world. Its less-than-flattering portrayal of America's contradictory and uninspiring facets of life offered a distinct point of view. Frank's documentary was not a universal objective language but a means of personal expression, built up through a series of seemingly disconnected moments.

Laid out in a carefully constructed sequence, *The Americans* was a photo essay in book form, but without words or the intention to report in a traditional way. It has been compared to jazz improvisation and Beat poetry, both forms of individualistic expression popular at the time, and could also be measured against the Abstract Expressionism of the period, which renounced long-established approaches to the craft of painting in favor of fragmentary splashes of paint.[48] This kind of personal documentary work with little or no journalistic pretext had been practiced by Evans in the late 1930s and 40s and street photographers of the 1950s. It would become a popular mode during the 1960s in the hands of Diane Arbus, Lee Friedlander, and Garry Winogrand (fig. 24), all of whom were included in the Museum of Modern Art's influential 1967 exhibition "New Documents."[49] "[A] new generation of photographers has directed the documentary approach toward more personal ends," wrote John Szarkowski, curator, of this anti-narrative trend. "Their aim has been not to reform life, but to know it."[50]

These two approaches to documenting the world—one stressing photography as an objective medium for editorial communication or social agency and the other privileging personal experience and discovery—were both harnessed by the founding photojournalists of Magnum. Robert Capa, on the one hand, spearheaded an early group project among the members to participate in "People Are People the World Over," a series of essays published in *Ladies' Home Journal* focused on showing farming families from countries around the world. Organized as part of a strategy to raise money for the cooperative, the endeavor's larger thematic and editorial structure has been compared to the direction Steichen would take with "The Family of Man," albeit with a more sensitive approach to the integrity of its participants' individual points of view.[51] Henri Cartier-Bresson, on the other hand, championed the vein that Frank would take; he considered himself a photojournalist insofar as it meant he kept a journal with photographs.[52] He once explained, "I believe that, through the act of living, the discovery of oneself is made concurrently with the discovery of the world around us which can mold us, but which can also be affected by us. A balance must be established between these two worlds—the one inside us and the one outside us. As the result of a constant reciprocal process, both these worlds come to form a single one. And it is this world that we must communicate."[53]

The photographer had, in fact, crossed America during the early 1950s on assignments (figs. 25–27), interpreting America as an outsider much like Frank would do in *The Americans*. And like Frank,

FIGURE 24. Garry Winogrand (American, 1928–1984), *Los Angeles*, 1964. Gelatin silver print, 22.9 × 34.1 cm (9 × 13⁷/₁₆ in.). JPGM 99.XM.35.1.

FIGURE 25. Henri Cartier-Bresson (French, 1908–2004), *Trinket-buying in Miami's Lincoln County*, 1957. Gelatin silver print, 24.8 × 17.1 cm (9³/₄ × 6³/₄ in.). JPGM 2004.74.7.

FIGURE 26. Henri Cartier-Bresson (French, 1908–2004), *Baseball Fever*, 1957. Gelatin silver print, 25.3 × 16.9 cm (9¹⁵/₁₆ × 6⁵/₈ in.). JPGM 2004.74.9.

FIGURE 27. Henri Cartier-Bresson (French, 1908–2004), *Listening to Billy Graham in New York's Madison Square Garden*, 1957. Gelatin silver print, 17.2 × 24.7 cm (6³/₄ × 9³/₄ in.). JPGM 2004.74.10.

Cartier-Bresson was suspect of photojournalism's capability for comprehensive or objective reporting. In the introduction to his 1968 *The World of Henri Cartier-Bresson*, he wrote cleverly: "The pictures...that follow are not intended to give a general idea of any particular country, but I am quite unable to assert that the subjects depicted are imaginary and that any resemblance to any individual is coincidental."[54] The photographer's famous 1952 book *The Decisive Moment*, which stressed his creed of endowing fleeting moments with intellectual significance through their aesthetic organization on film, demonstrated his early interest in artistic rendering as an integral part of the documentary endeavor.

Engaging the Big Picture: The New Photojournalism

Leonard Freed, not yet a Magnum photographer in the 1960s but friends with members of the cooperative, would forge a path somewhere in between these two poles, creating documentary reports that were both persuasive and expressive, analytical and evocative. A mounting concern for individual rights and social justice marked much of this era's politics and its photographic projects, and Freed's work was no exception. Embracing a visually powerful and experiential approach to photojournalism, he spent the better part of three years traveling the country to better understand and report on the lives of African Americans living in a segregated nation. *Black in White America* (initiated 1962, published ca. 1968, pp. 38–67), the book that emerged, is a kind of visual diary with a moralizing purpose. It is highly personal and socially engaged, with the implicit goal of effecting change through communication. While Freed made pictures of important events in the civil rights struggle, including the 1963 March on Washington, he more often sought to record quiet aspects of life in black communities. The photographer's approach to photojournalism sacrificed immediacy to emphasize a deeper and more contemplative engagement with his subject. His project was aimed not so much at telling the details of a particular day or week, but at relating the contours of a bigger, more conceptual narrative about America. It was an approach to the news that Cartier-Bresson had characterized in 1957 as "the poetry of life's reality."[55] As such, Freed's work provided a balance to the era's familiar press images of intense strife. Complementing iconic series of pictures, like those by Bob Adelman (fig. 28) and Charles Moore of fire hoses and attack dogs being used to control protesters in Alabama, Freed's pictures provide a reflective context to the era's defining moments.

Immediacy was, and still is, considered key in much of journalism. In the pre-digital age, newspapers and magazines regularly used couriers to move pictures quickly around the world and harnessed the technology of wirephoto systems, developed in the 1930s, that allowed for the fast transmission of black-and-white images over telephone lines. The 1950s through 70s saw the rise of another medium well suited to telling the news, doing so with a speed and immediacy that was unparalleled: television, which had been in existence since well before the war, became increasingly dominant. By 1970, 95 percent of U.S. homes had one or more television set.[56] Leading picture magazines found it more and more difficult to secure advertising revenue, and many of them folded or reduced their operations. *Collier's* ceased publication in 1957, and *Look* in 1971. *Life* reduced its staff of photographers overseas, opening up a market during the 1960s and 70s for non-collective–based press agencies like Gamma and Sygma, which were built to be highly competitive businesses in reporting quickly on the world.[57] Likewise, more specialized periodicals from all sides of the political spectrum began to appear in this environment, targeting smaller, more focused audiences. *Life* closed its weekly operations in 1972 and eventually transformed itself into a monthly later in the decade.

Freed's book project ran counter to the speed that characterized much photojournalistic practice of the 1960s. His publication marked an alternate approach to reporting on the world—one that is characterized by its focus on large, more deeply rooted issues and timely, rather than immediate, dissemination. His single images work well on their own, but the big-picture message that emerges from their grouping into a book transcends the sum of its parts. Moreover, his work reflects an increasing interest in visually expressive modes of reporting. Meant to be more than factual records of newsworthy subjects, Freed's work communicates in evocative ways. As television began to replace still images as the primary conveyor of information about the world, photography was increasingly subsumed into the world of art and approached as a creative medium for personal expression.[58] Amid the transformations in the news industry, many independent photojournalists found a niche for themselves as the authors of more nuanced accounts of the world that demonstrated a higher degree of visual creativity, complexity, and depth than could be achieved through television. From the 1960s onward, variations on this kind of reporting would become increasingly popular in the hands of independent photojournalists interested in engaging the world from a personal point of view.

The Vietnam War, also raging during this period, would prove to be a battleground for more than just the forces of communism and capitalism. In addition to the competition between television and print

media for market share of news consumption related to the war, debates among journalists themselves over how best to approach reporting on such an event were percolating. Whether journalism should present news in as neutral and objective terms as possible or whether it should seek to more actively interpret and comment on situations it depicted was in question.[59] Vietnam was a difficult conflict to make sense of as a reporter. Readers and editors wanted to grasp who was winning, which side was in the right, what the war was about.[60] But how was one to make sense of the way in which poorly equipped communist guerillas were able to defy the advanced American military machine; how was one to explain the rationale behind the forcible relocation of civilians and the burning of their homes, or of destroying villages in order to save them?

As Malcolm Browne, the writer-journalist well remembered for his iconic picture of a Buddhist monk's self-immolation to protest religious repression by the Vietnamese government (fig. 29), explained in 1964, "Viet Nam does not lend itself well to numerical reporting, or even to the kind of simple, narrative statement required of the average newspaper lead. There are too many uncertainties, too many shades of gray, too many dangers of applying English-language clichés to a situation that cannot be described by clichés."[61] Michael Herr, a reporter for *Esquire*, concurred: "Conventional journalism could no more reveal this war than conventional firepower could win it, all it could do was view the most profound event of the American decade and turn it into a communications pudding."[62] Herr is well known for *Dispatches* (1977), his evocative book on Vietnam gathered from notes made over several years as a front-line reporter. David Halberstam, a journalist for the *New York Times*, turned to fiction as a medium for communicating the Vietnam experience with his 1967 novel *One Very Hot Day*. As one literary historian has explained, the book showed that "despite the fragmented, layered nature of the conflict in regard to its political, social, and military aspects, a small book of carefully chosen details, self-conscious arrangement, and sufficient associative power could do in a reduced frame what many panoramic attempts would fail to achieve."[63]

It was not just word-based journalists who felt incapable of dealing with the Vietnam War in the usual "objective" fashion. Many photographers felt similarly. David Douglas Duncan, a famous war photographer for *Life* magazine had, in 1951, produced an experiential, but relatively neutral, account of the

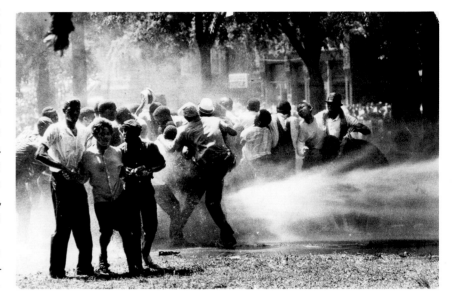

FIGURE 28. Bob Adelman (American, 1930–2005), *Birmingham, Alabama*, 1963. Gelatin silver print, 17.8 × 26.7 cm (7 × 10½ in.). JPGM 2005.34.5.

FIGURE 29. Malcolm Browne (American, born 1931), *Self-Immolation of Thich Quang Duc, Saigon, South Vietnam*, 1963. Gelatin silver print, 19.6 × 24.3 cm (7¹¹⁄₁₆ × 9⁹⁄₁₆ in.). JPGM 2003.124.

Korean conflict in a book titled *This Is War!* Seventeen years later, Duncan would find himself covering the Vietnam conflict in a much more critical way. Unwilling to simply record the war, he felt compelled to create a book with a damning political message. *I Protest!*, published in 1968, derides the senseless human carnage that he witnessed in an attack on the 26th Marine Regiment entrenched at Khe Sanh. Photographer Don McCullin embraced a bitter approach to the war as well in his powerful book *The Destruction Business* (1971), a section of which deals with the cruel and gruesome effects of the conflict in Southeast Asia.

Perhaps the broadest critical investigation of Vietnam by a photojournalist was Philip Jones Griffiths's book *Vietnam Inc.* (initiated 1966, published 1971, pp. 68–97). Griffiths's account, devoted to unraveling what he saw as the misguided policies of the American endeavor, falls squarely within the camp of journalists who advocated for critical and interpretive analysis in their reports. "I put together what are, in my case, truthful objective pictures, and write the captions, and then produce a subjective book which tells the story as I experienced it," the photographer explained.[64] Griffiths's image of a Vietnamese boy being washed by an American soldier (pl. 34), coupled with a caption that explains the Vietnamese dumfounded reaction to the scenario, is a perfect example of the photographer's approach. Griffiths did not simply present the facts of the situation (Americans sharing the benefits of their modern way of life with the Vietnamese), nor did he stop at an analysis that explains the real motive at hand (that convincing the Vietnamese of the benefits of an urban consumerist society was in America's interests, because it could encourage them to support capitalist ideals over those of the communists, thus fulfilling a military objective). Instead, Griffiths took his analysis a step further, describing how and why that tactic was misguided and ineffective: the Vietnamese already valued cleanliness and had trouble understanding why one would want to dirty a vegetable bowl by bathing in it. The implications of Griffiths's approach were clear—the American way of life as presented by the soldiers was not particularly enticing. Set within the context of a book that relates other, at times more grim, interactions between the military and civilians, the episode comes to represent the deep misunderstandings that made it difficult for American forces to win the hearts and minds of the Vietnamese people. Griffiths's project is more than a record of the war and its traditionally newsworthy moments. It attempts to answer the why of the conflict's failures in an unabashedly subjective and analytical way, using details of his experience in the country to build up a larger argument about the war.

The 1960s and 70s saw the development of what would be termed "the New Journalism." In his 1973 book on the subject, self-identified New Journalist Tom Wolfe described an artistic excitement in written journalism of the period and outlined what he saw to be among the movement's defining characteristics.[65] New Journalism took a variety of forms, but at its heart was a literary approach to writing nonfiction reports. Its practitioners placed importance on creative and compelling forms of delivering the news, seeing journalism as a means of expression and not simply of conveying information. New Journalists immersed themselves in subjects, gathering together unusual descriptive details in order to conjure an image of a given situation in a reader's mind. Artistic expression became a legitimate approach to dealing with the news. Through narrative and descriptive format, the significance of events could be evoked and interpreted rather than catalogued.

Writer Truman Capote investigated the murder of a wealthy farming family in Kansas, publishing the work serially in the *New Yorker* in 1965 before releasing it in the form of a nonfiction novel, *In Cold Blood*. Capote spent five years researching his story and interviewing the killers in prison. In 1968, Norman Mailer wrote *The Armies of the Night*, a journalistic book on his experience at an antiwar demonstration in front of the Pentagon. The subtitle was *History as a Novel/The Novel as History*. Herr, too, was identified by Wolfe as a New Journalist for the work he did in Vietnam. Wolfe's own writing stretched the conventions of journalism with a characteristic style, which included unusual typography marked by the free use of dots, dashes, and italics and the interjection of shouts, onomatopoeia, and nonsense words to create atmosphere. Coupled with a related growth of advocacy journalism, which featured a subjective and partisan approach to reporting on issues, New Journalism expanded on the documentary movement of the prewar era and opened up fresh approaches to dealing with current events. With their embrace of interpretive and experiential reporting over long periods of time, and their use of powerfully emotive pictures in book-length studies, Freed's *Black in White America* and Griffiths's *Vietnam Inc.* might be considered a part of this larger movement to rethink journalistic practice.[66]

W. Eugene and Aileen M. Smith's study *Minamata* (initiated 1971, published 1975, pp. 98–119), on methyl-mercury poisoning in Japan, could be grouped into this larger framework as well. Emerging during a period marked by increasing concern for the environment, the Smiths' project was a crusading endeavor to seek justice for the families afflicted by the Chisso Corporation's toxic waste, which was dumped into

Minamata Bay. "The first word I would remove from the folklore of journalism is the word objective," he wrote in his introduction to the book. Elsewhere he noted, "The journalistic photographer can have no other than a personal approach, and it is impossible for him to be completely objective. Honest—yes! Objective no!"[67] Honesty, for Smith, was a more important goal than neutral objectivity, and honesty as he understood it was often partisan. Smith believed that good truthful reporting could be achieved through engaging with a situation, getting to know it, and portraying it from a personal perspective. Experience, evocation, and opinion could be powerful and legitimate forms of journalistic communication, providing greater dimension than straight factual reporting. Smith even felt it was appropriate to heighten the pictorial effects of his images if that process helped to more accurately convey his understanding of a situation.

Socially engaged photojournalism of the 1960s and 70s might also be compared to similar endeavors by documentary filmmakers of the time. Frederick Wiseman, for example, began making films out of a desire for social reform. His first film, *Titicut Follies* (1967), was dedicated to exposing the appalling conditions at an institution for the criminally insane in Bridgewater, Massachusetts. Like Griffiths's approach to *Vietnam Inc.*, Wiseman's style was to shoot in a direct observational mode and then create larger subjective meaning for the film through careful editing and presentation of content, putting forward a rhetorical argument through the film's essay-like construction. Wiseman's process was one of discovery that resulted in a report on what was found. And like Smith's study on Minamata, which aimed at addressing larger issues surrounding industrial pollution, Wiseman's film uses its literal subject as a metaphor for exploring larger social and ethical issues.[68]

Susan Meiselas served as an assistant editor on Wiseman's 1971 film *Basic Training* before dedicating herself to still photography and creating her well-known historical account of the Nicaraguan revolution (initiated 1978, published 1981, pp. 120–35). Recognizing the way in which film and photography can complement one another, Meiselas has involved herself in film projects (*Voyages* [1985] and *Pictures from a Revolution* [1991]) since that time that contextualize and further develop themes explored in her Nicaragua book. Other photojournalists have similarly explored the dialogue between filmic and photographic representations of their subjects. Mary Ellen Mark's Streetwise project (initiated 1983, published 1988, pp. 136–51) on homeless runaways living in Seattle was developed in stages as a documentary film and a photographic project with Mark's husband Martin Bell and reporter Cheryl McCall. The book that resulted uses quotations from the subjects as they were recorded in the film. Lauren Greenfield's approach to observing contemporary American culture is similar. The idea for Greenfield's film *Thin* (2006) arose out of her earlier photographic project Girl Culture (initiated 1998, published 2002, pp. 155–58, 161–62, 164–67). *Thin* subsequently gave rise to a book of the same name that reproduces still photographs and related ephemeral materials gathered during and following the making of the film. The dialectic between film and photographs explored by these three documentarians has allowed each to add degrees of depth, context, interpretive direction, and nuance to her study that could not have been achieved exclusively through one medium or the other.

The book, even more than film, has been central to the pursuit of socially engaged photo-reportage. Books offer an ideal medium for disseminating projects in this tradition for a number of reasons. First, because much work of this kind depicts unpleasant subject matter, gaining exposure through commercial galleries whose survival depends on sales can be difficult. The art museum, too, has historically given more attention to work in which personal expression and self-conscious creativity trumps social agenda.[69] Moreover, projects that are critical of, or out of sync with, the mainstream media are not always well matched to exposure through magazines. Greenfield's Fast Forward project (initiated 1992, published 1997, pp. 159, 163, 168–73) was supported in part by a grant from *National Geographic*, but the story was deemed unsuited to the magazine's editorial objectives and never ran in its pages. Likewise, Larry Towell's decade-long study of Mennonite communities (initiated 1989, published 2000, pp. 174–93) persevering in challenging circumstances was difficult to expose through a media that is hungry for more sensational subjects. As Towell explained, "Violence sells newsprint by the ton and TV time by the split second. Positive stories, or stories of how families manage to survive, are seldom rewarded; so the countless acts of goodness, love, and courage we encounter in everyday life seldom make it into the media."[70] Thus, the book offers photographers a medium of mass communication that circumvents other traditional outlets. And because communication is the ultimate goal for this kind of work, exposure is key.

Beyond issues of dissemination, the book format is also particularly well suited to the structure of work in this tradition. Books allow for greater depth of reporting than magazine articles, their lengths can be tailored to the needs of a particular project, and they exist as physical objects long after a related exhibition of prints comes down or a magazine is recycled. As such, they are appropriate for preserving

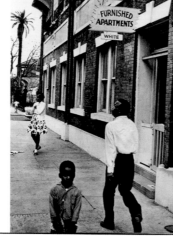

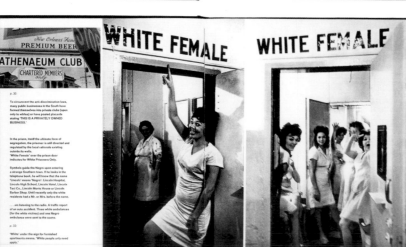

history. And because they can be read in private, books are conducive to extended contemplation and the slow absorption of ideas, both of which are important to understanding projects that are broad in scope and have layers of meaning developed, in many cases, over the course of years. Sebastião Salgado's epic Migrations project (initiated 1994, published 2000, pp. 194–211) surveys people in forty-three countries forced to abandon their homes and is laid out over 432 pages in the publication. A project of that magnitude simply could not be fully communicated without the book (or today, perhaps, the Internet) format.

Storytelling is an important component of work in this tradition. Books provide independent-minded photojournalists with complete authorial control over the presentations of their work. Each photographer has the ability to decide how pictures will be captioned and with what kinds of information they will be paired. Rhetorical structures like narrative and contextual sequencing that direct interpretation of images can be employed. Towell in The Mennonites and Freed in Black in White America (fig. 30) paired their pictures with parallel text adapted from their own diary entries. Salgado provided as back matter paragraph-length captions for each of his pictures in Migrations. Meiselas, Greenfield, and Mark provided ample space for the inclusion of words spoken by their subjects. Griffiths and Smith used systems of captions and longer running texts to build up arguments around pictures. Many of these photographers also included statistics, maps, and other kinds of documentation in their books to buttress their pictorial observations.

A number of photographers have used the book format as a way of recontextualizing and reasserting control over pictures lost in the mainstream media. Meiselas gathered together her Nicaragua images, which had been disseminated to the public in ones and twos through newspapers and magazines during the war, and sequenced them into a book that tells a more cohesive history of the conflict. Greenfield has taken pictures made on assignments for the media and then appropriated them into a context that subverts their original use. Her picture of Amy Smart (2000, pl. 116), for example, resulted from a fashion shoot for Harper's Bazaar. In the magazine's pages, it might have been read as a revelation of current fashion by Versace, or perhaps by a more discerning reader as a commentary on consumerist culture and class relations (note the progression of protagonists, from actress to maid to live mannequin modeling lingerie in a glass box). Placed in context with pictures from Greenfield's book Girl Culture (such as pls. 111, 115, 118–19, 121), one begins to understand it as a document critical of American cultural values. It speaks to the way in which success is linked to notions of exclusivity and consumerism, how display of the body becomes equated with self-expression and celebrity is built through the exaltation of beauty, and the way these obsessions impact aspirations and activate insecurities. As Greenfield wrote in Girl Culture, "While I often can't control the picture editing, writing, and design in my work for magazines, the selection and presentation of photographs in this book are my own."[71]

Books, though vitally important to the genre, are only one of many avenues these photographers have selected for communicating their messages. Despite limitations in authorship and contextual control, many of them use the mainstream media as a platform for financing their independent projects and popularizing them to a mass audience, and as such their work is sometimes distributed in smaller portions through magazine articles. In some cases, projects are initiated independently and released in pieces to the media, while in other situations they are originally commissioned by the press and subsequently developed more fully by the photographer. The Smiths developed and sold a reduced Minamata story to Life magazine before publishing it as a book. Their work also appeared in Japanese periodicals, and was shown through numerous exhibitions.[72] Mark's Streetwise project was first commissioned as a Life magazine story (fig. 31) and appeared there before being developed into a film and book project. Salgado, following a well-tested Magnum strategy, submitted numerous short stories from his Migrations series to Paris Match, Stern, Rolling Stone, and El País Semanal, among other international periodicals, over the course of the project's development (fig. 32). Publishing the work in segments over many years helped to financially support the larger endeavor, which eventually resulted in two publications[73] and a traveling exhibition, accompanied by speaking engagements. Greenfield harnesses traveling exhibition programs as well, developing educational curricula, lectures, and Internet discussions as a way of furthering dialogue on the topics she addresses in book format. Multimedia Web presentations are also becoming a popular way of sharing work.

Exhibitions of documentary work have a long tradition. Fenton's Crimean photographs were exhibited, as was much of the FSA work of the 1930s. But many mid-century photojournalists saw the majority of their negatives printed for practical purposes related to reproduction, not exhibition. The Freed and Griffiths prints in the Getty's collection were originally made as a step in the process of reproducing the images in journals, books, and films (fig. 33). As exhibitions of photojournalism, and photography in general, have proliferated in the art world since the 1980s, fine prints made specifically for exhibition purposes

FIGURE 30. Leonard Freed (American, 1929–2006), *Black in White America* (New York: Grossman Publishers, ca. 1968), pp. 30–35.

FIGURE 31. "Streets of the Lost: Runaway Kids Eke Out a Mean Life in Seattle," *Life* (July 1983): pp. 34–35, featuring photographs by Mary Ellen Mark.

FIGURE 32. "Rwandans in Tanzania," *Paris Match* (May 26, 1994): pp. 50–51, featuring photographs by Sebastião Salgado. Courtesy the University of Southern California.

FIGURE 33. Leonard Freed (American, 1929–2006), verso of *Jazz Funeral, New Orleans, Louisiana*, 1965. Gelatin silver print, 24.5 × 36 cm (9⅝ × 14³⁄₁₆ in.). JPGM 2008.62.40.

have become more common. The Getty's prints by Greenfield, Mark, Meiselas, and Towell, for example, were made not for utilitarian reasons but to be shown as objects unto themselves. As such, the more contemporary prints tend to be physically larger, their visual power geared as much toward holding a wall as engaging a page.

James Nachtwey (pp. 212–25) has approached exhibition projects in particularly innovative ways. The work he makes for shows is sometimes very different in character from the images he disseminates through books and magazines. In each format he tailors his work to the context in which it will be seen. As a self-described antiwar photographer, Nachtwey wants to make the consequences of conflict both unavoidable and uncomfortable. In addition to framing and dramatic use of light and shadow, scale is something that he employs to achieve his desired effect. For his *Inferno* book project (1999), which gathered together images of some of humanity's grimmest moments of the 1990s, Nachtwey deliberately chose an awkwardly large size and heavy paper stock to give the final publication a serious and weighty presence. He wanted a publication incapable of being lost within a bookshelf.

He applied a similar principle to his exhibition project The Sacrifice (initiated 2006, completed 2007), reproduced on pages 214–25. The pictures in the project were originally made on assignment for *National Geographic* (fig. 34) to survey the work of doctors and nurses treating casualties of the Iraq War; a group of pictures were shown as a series of single images in that context. In preparing the project for independent exhibition, however, Nachtwey created one print of enormous proportions. Collating sixty gruesome trauma-center images together into a single photographic print measuring approximately thirty-three-feet long, the photojournalist constructed an object that is impossible to avoid in a gallery setting. It has a powerful visceral effect on those in its presence, thus communicating in an experiential and architectural way that complements, but is different from, his work as presented in book and magazine format. In the case of both the *Inferno* book and *The Sacrifice* print, the presentation of Nachtwey's photographs is aimed at achieving a forceful delivery of his antiwar message.

FIGURE 34. *National Geographic* 210, no. 6 (December 2006): pp. 92–93, featuring James Nachtwey's series The Sacrifice.

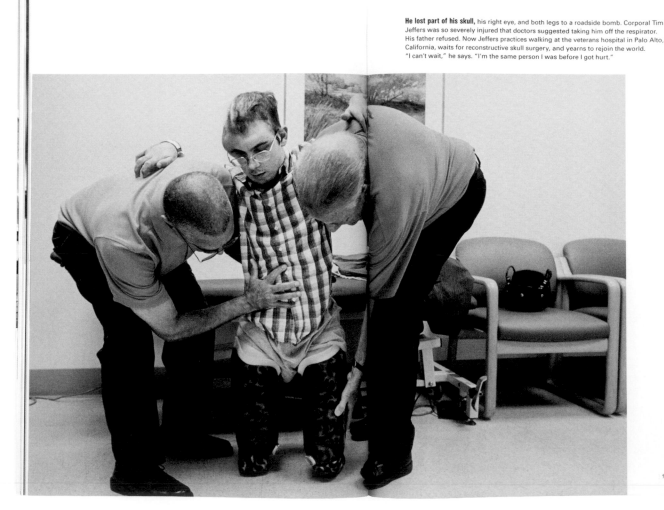

He lost part of his skull, his right eye, and both legs to a roadside bomb. Corporal Tim Jeffers was so severely injured that doctors suggested taking him off the respirator. His father refused. Now Jeffers practices walking at the veterans hospital in Palo Alto, California, waits for reconstructive skull surgery, and yearns to rejoin the world. "I can't wait," he says. "I'm the same person I was before I got hurt."

93

One does not always associate style with photojournalism, where ideas of objectivity and neutrality are traditionally valued. But as in the New Journalism, which stressed artistic modes of reporting through words, aesthetics have been an important consideration for all of the independent photographers represented in this book. One of the strengths of this tradition has been its ability to harness creative artistic decisions toward reportorial ends. Many of these photographers have what might be called a signature style, or a recognizable look. In the unlikely event that Towell, Salgado, and Greenfield all photographed the same subject, the resulting pictures presumably would be very different in character and could be identified fairly easily by their authors' approach. Simply reviewing the sections of this book, with representative samples of work by the photographers, one is struck by the degree to which each individual brings a particular vision to bear on the world. Some images are more mannered than others, but all reveal certain choices that inflect the way their subjects are presented and understood.

Stylistic choices are made not as meaningless garnishes to enliven the presentation of subjects but as an integral part of the photographer's interpretive program, helping to endow stories with experiential significance and editorial points of view. Meiselas chose color film for her Nicaragua project not simply to make the images electrifying, but because she felt it better captured and conveyed the spirit of the revolution as she experienced it. Salgado noted that the solemn beauty so characteristic of his approach is important in conjuring a persistent grace among his distressed subjects, allowing him to present them in a dignified way while calling attention to their plight. Towell's lyrical photographs place more emphasis on evoking than cataloguing life in migrant Mennonite communities. He suggested that photography's strength lies in its communication of spirit and feeling rather than fact: "I believe that photojournalists should remain both astounded at the beauty of the world and repulsed by its cruelty. The inherent lie of 'professionalism,' often a guise for indifference, is that it can shut and bolt the door of feeling. This is antithetical to the truth within us and to the real world outside. If we cannot feel it, how can we see it?"[74] Nachtwey used tight framing of messy conglomerations of tubes, instruments, and arms in *The Sacrifice* as a way of conjuring the atmosphere of controlled chaos that he experienced there. Nachtwey said of his work, "The images I create are a confluence of what is in front of me and what is inside of me. They are objective and subjective at the same time, and they must be seen that way by the viewer in order to be convincing."[75] In this kind of work, subject and style, message and its delivery, are deliberately wrapped up together in inextricable ways. These are documents not just of events that happened but of events as experienced by an observer.

In embracing ambiguous ideas of intuition, point of view, interpretation, and creative expression as important elements in reporting, these photographers question the basic assumption that the world's events are best delivered in ways that strive toward neutrality and negate mediation. According to Towell, objectivity appropriates "the language of honesty while ignoring fairness and impartiality."[76] Mark, too, put it categorically: "I think no one can be objective. I think you're always subjective. You have opinions about things and you shoot them. You try and be fair, but it's basically your opinion…it's your truth and you believe it's true. Someone else may think you're a liar."[77]

This is, of course, a fine line to walk. Reporting on topics of concern and communicating effectively and truthfully about them is ultimately the point of this kind of work. Compositional strategies are a tool, not an end, in that process. Despite the sophisticated aesthetic organization of her pictures, Meiselas explained that it is of critical importance that her photographs be understood and derive value from their status as documents of an event, and not simply as pictures by a well-known photographer. She is "always looking for that thin line…between form and content."[78] In another context, Meiselas elaborated: "When I see repression on the scale that I do, I respond humanly, but I try to document how the people respond, not how I respond. As a photographer you witness and document what happens. If people end up thinking simply that these are my pictures, I've failed in terms of what was important."[79]

If harnessing style to enhance the communicative power of journalistic photography is inevitably a subjective endeavor, so are the choices photographers make when constructing narratives through sequences of photographs. All of the photographers represented in this study use series of images to engage in a process of addressing larger conceptual issues that transcend the literal circumstances of their depicted subjects. Individual photographs in each project are parts of a bigger picture, built up around a framework and chiseled down through editing. They are used by the photographer as an historian uses facts to make sense of the past and its relationship to the present. The pictures that make up these projects ground one another contextually, giving direction to the interpretive program. As Griffiths explained, "I don't want to diminish the accomplishments of anyone taking a single, beautiful, informative image—that's what I try to do when I look through the viewfinder. If I was a poet I would certainly

want each word in the poem to be a beautiful and evocative and meaningful word, but still it's only a word. Stringing words together is what makes a poem. I want to write poetry, not come up with evocative words."[80] Many of these photographers are ultimately documenting invisible topics, photographing people and events as symptoms of abstract social phenomena. Sometimes what is not shown is as instructive as what is in revealing the subjective nature of these projects.

As we peruse one of these studies forward and backward—reading, looking, pausing, and think-ing—relationships develop between the images and the texts that allow for more sophisticated under-standings to emerge. Freed was concerned with bridging cultural understanding to engender support of basic civil rights and Griffiths with denouncing the violent commercialization of the world; Salgado pointed to the effects of globalization, while the Smiths addressed the related issue of industrial pollu-tion; Meiselas engaged and countered the fragmented process by which we receive news and understand history, while Towell challenged the meaning of "newsworthy" and explored, together with Greenfield, the way in which cultural values impact life; Nachtwey found unacceptable the human toll of war and Mark the idea of homeless street kids in one of the wealthiest nations in the world. None of these meanings are explicit or overly didactic; nor are they entirely fixed, for the reader will interpret them within the context of personal experience. But as narrative series they evoke meanings that surpass factual information, and they channel understandings in ways that single images do not.

Assumptions and Challenges

The history of concerned photojournalism, and social documentary practice in general, is not without its share of controversy. In addition to the contentious nature of some of the subjects themselves, debates have centered on how such topics should and should not be represented. The 1970s and 80s saw significant challenges to the practice, and debates since that time have been useful in clarifying and articulating con-cerns that many people feel when looking at this kind of work. Artist Martha Rosler was one of the most strident critics of the tradition. Among Rosler's concerns was that social documentary practice was rooted more in moralism than in revolutionary politics; in transferring information from one powerless group (the subjects) to another powerful group (the viewers), it inspired charity more than reform. A central part of documentary's impotence, she felt, was its relationship to art. Documentary photographers seeking accep-tance into museums put self-expression, style, and ego ahead of social mission. Likewise, focusing on the genius of a photographer and the artistic form of a particular photograph relegated political messages to a secondary position. Rosler called for a social documentary practice that would go beyond compassion, becoming an integral part of activism and not a substitute for it.[81]

Artist Allan Sekula echoed her sentiments for a more political documentary form: "Documentary photography has amassed mountains of evidence. And yet…the genre has simultaneously contributed much to spectacle, to retinal excitation, to voyeurism, to terror, envy, and nostalgia, and only a little to the critical understanding of the social world."[82] He suggested cinematic sequences of pictures to coun-ter their incorporation into museums, which were more focused on singular objects, and he proposed surrounding them with text to anchor or subvert meanings associated with them. He wanted pictures to reveal problems as systemic to the capitalist system and not as isolated incidents, and he wanted to make pictures that would be useful to the subjects they depicted.[83]

In many ways, the engaged photographers represented in this book have done much of what Rosler and Sekula proposed, although perhaps not as radically (or self-consciously) as the two critics desired. By the time the critical essays emerged in the late 1970s/early 80s, Freed, Griffiths, Smith, and Meiselas were all working in series of images, surrounding their pictures with narrative texts, and engaging in critical appraisals of society in ways that surpassed simple compassion. Even while they each employed what might be considered a characteristic style, social considerations were primary to their endeavors. Moreover, each used exhibitions as only one of several ways to disseminate their messages. Sekula and Rosler were particularly concerned with the personal documentaries of photogra-phers like Arbus and Winogrand, whose work largely eschewed social agency and was well established in the art world. Still, a number of Rosler's concerns were articulated in direct response to Meiselas's *Nicaragua* book.

In her review of *Nicaragua*, Rosler spoke of the dangers of conflating art and journalism. She saw Meiselas's use of color as incompatible with depictions of atrocity and as catering to sensation, exoticism, and commercial interests, and she disliked the element of mystery evoked by the photojournalist's pic-tures of masked revolutionaries (see pls. 86–87). She found the book's textual content lacking in detail and scope. And she thought Meiselas's approach overly romantic. Meiselas's separation of images and captions

into different parts of the book, too, was disturbing to Rosler for its implication that the photographer's pictures might be appreciated for their dynamic form.[84]

Rosler did not address the practical intentions for Meiselas's organization of the book, which was geared toward making the work accessible and experiential rather than artistically emancipated (see page 121). And nearly thirty years later, in a world where color photography is considered a standard in journalism, Rosler's fixation on Meiselas's use of the medium comes across as somewhat dated. Still, the larger concerns related to artistic intentions in the documentary approach have a long history in America. Stryker, as head of the FSA efforts, was wary that a focus on aesthetic considerations could trump his social agenda, and thus he emphasized the importance of subject matter over the merits of its visual presentation.[85] The idea that documentary photographers should assume a staid, apparently style-less style (which is not the same as giving primacy to subject matter over its presentation) was put forward by supporters of Evans in direct opposition to the more dramatic and emotional approach practiced by Bourke-White. Evans's documentary aesthetic—which appears to be devoid of subjectivity, free from exaggeration of angle and perspective, and detached from concerns of sentimentality and melodrama—was praised by the Museum of Modern Art as exemplary when that institution prepared a retrospective of his work in 1938.[86]

The idea that a disengaged aesthetic and dispassionate approach produces pictures that are more truthful, because they pretend to be unmediated by a person, has persisted among many critics and historians, despite the fact that Evans's style is just that—a style. On the other hand, dynamism, candid-capture, emotional appeal, and especially aspects of beauty in the depiction of suffering or atrocity has often been equated with exploitation.[87] Work that presents tragedy in visually compelling ways does make many viewers uneasy. This is in part because formal concerns seem, at first, so insignificant in relation to the problems depicted that one wonders whether the photographer is more interested in beauty or in subject, in form or in message.

In 1991, Ingrid Sischy writing for the *New Yorker* berated Salgado's penchant for self-consciously emotive and well-structured compositions. She said, "Salgado is far too busy with the compositional aspects of his pictures—with finding the 'grace' and 'beauty' in the twisted forms of his anguished subjects. And this beautification of tragedy results in pictures that ultimately reinforce our passivity toward the experience they reveal. To aestheticize tragedy is the fastest way to anesthetize the feelings of those who are witnessing it. Beauty is a call to admiration, not to action."[88] Sischy's remarks echo the ethical dilemmas of representing tragedy that were posed by Susan Sontag during the 1970s. In her *On Photography* (1977), Sontag noted, "The vast photographic catalogue of misery and injustice throughout the world has given everyone a certain familiarity with atrocity, making the horrible seem more ordinary—making it appear familiar, remote ('it's only a photograph'), inevitable.... In these last decades, 'concerned' photography has done at least as much to deaden conscience as to arouse it."[89] Indeed, the implications of such criticism on the documentary tradition are grave: if both striking compositions[90] and the representation of problems in the world serve to deaden social conscience rather than to raise it, then the ethics of depicting suffering become difficult to defend.

Other critics and historians have disagreed with these concerns. Quite the opposite of Sontag, John Taylor has argued for the importance of seeing pictures of horror in order to combat the indifference that can be bred by censorship and sanitization of news.[91] Nachtwey would likely agree. His monumental antiwar photo essay *The Sacrifice* is shocking in part because of the relative lack of images related to American casualties that have circulated from the Iraq War. Beyond the well-known ban on depicting the flag-draped coffins of deceased service members, the *Los Angeles Times* reported that not a single image of a dead American soldier had been reproduced in its pages, nor those of the *New York Times*, the *Washington Post*, *Time*, and *Newsweek* between September 11, 2004, and February 28, 2005.[92] Sontag, too, reversed course to some extent on her 1970s statements, concluding in her 2003 publication *Regarding the Pain of Others* that one should not dismiss the power of horrific images: "Let the atrocious images haunt us. Even if they are only tokens, and cannot possibly encompass most of the reality to which they refer, they still perform a vital function. The images say: This is what human beings are capable of doing—may volunteer to do, enthusiastically, self-righteously. Don't forget.'"[93]

David Levi Strauss has taken issue with Rosler's and Sischy's suggestion that artistic and journalistic intentions are incompatible. Strauss not only asks, "Why can't beauty be a call to action?" but he notes that all representation is inevitably aesthetic; the simple act of portraying a three-dimensional subject in a two-dimensional print transforms it. News content and critical engagement are not necessarily pushed to the margins simply by the introduction of beauty or other compelling aesthetics.[94] Indeed, one would be hard pressed to find a viewer so enthralled by the forms of Salgado's pictures as to want to be a subject in one. Moreover, engaging delivery of content can be beneficial. We have seen how Nachtwey's

political messages are emphasized through the visual strategies of his presentations. In a more general way, images with strong visual power find their way into publications and exhibitions, allowing for the subject matter depicted to be seen, interpreted, and reacted to, which is the ultimate point of the work. A photographer's name recognition, too, plays a part in his or her work's exposure. If spurring dialogue and thought about critical issues in the world is a central part of this kind of photography, then artistic renown can be effective in achieving that end. There is no point, after all, in journalism that is not made public or otherwise useful.

Lyricism, mystery, and storytelling—expressive aspects of documentary practice that Rosler wanted to eliminate in favor of more concrete factual data—can function as important elements in the process of communication. Strauss noted, in defense of Meiselas's *Nicaragua*, "More information does not necessarily increase realism. Information can be indigestible in its raw form, and must be prepared differently in order to be effective, to be of use. Masses of data are not memorable. Images are memorable. Stories are memorable. As we move headlong into a world in which the delivery of information, in images and words, becomes more fluent and more rapid every day, the task of the storyteller is becoming more necessary, and more endangered."[95] Referencing Walter Benjamin, he elaborated that evocative storytelling "achieves an amplitude that information lacks."[96]

Certainly the portrayal of difficult subjects for purely aesthetic pleasure would constitute a breach of ethics for many people, but that is counter to the aims of most concerned photography. The photographers represented in this book have used style not to its own ends but as a tool in their interpretive and communicative process. While the effectiveness of a particular project might be debated, their endeavors are not without precedent in the history of art. Expressive forms have been used by Western culture and religion for millenia as a means of communicating points of view, building consensus, and grappling with troubling circumstances: one need only think of Greek tragedy and painted vases (fig. 35, depicting a story from Homer's *Iliad*: Odysseus slitting the throat of a Thracian warrior), Christian art of nearly two millennia, or the elegy in poetry.[97] Francisco de Goya depicted people in dire circumstances in his early-nineteenth-century drawings (fig. 36) and portrayed the brutality of conflict in his Disasters of War (1810–20) etchings. Pablo Picasso would follow in that tradition with his 1937 *Guernica* painting, with its twisted and distorted forms inspired by the chaos of aerial bombardment.

FIGURE 35. Attributed to the Inscription Painter (Greek, active 570–530 B.C.), *Chalkidian Black-Figure Neck Amphora*, ca. 540 B.C. Terracotta; height 39.6 cm (15⁹/₁₆ in.), body diameter 24.9 cm (9¹³/₁₆ in.). JPGM 96.AE.1.

FIGURE 36. Francisco José de Goya y Lucientes (Francisco de Goya, Spanish, 1746–1828), *They Are Dying*, ca. 1825–28. Black chalk with lithographic crayon and/or stumping, 18.9 × 14.4 cm (7⁷/₁₆ × 5¹¹/₁₆ in.). JPGM 96.GB.9.

As in all photography, there are sensitivities associated with the depiction of people, and these sentiments can be amplified in situations where subjects are vulnerable or do not want their likeness used in the service of reporting. The press has negotiated the line between the sometimes conflicting desires to inform the public and defend privacy throughout the twentieth century.[98] Avoiding conflict and building a sense of collaboration with subjects has been important to many of the photojournalists represented here. Greenfield's approach is to "hang out" with her subjects, nearly all of whom (or whose parents) sign model releases and are complicit in the documentary endeavor. Likewise, Mark could not have made her work without the cooperation of the street kids she photographed. Mark noted of the film *Streetwise* that "The street children of Seattle embraced the film as their own. They felt it was truly their story."[99] Smith, too, could not have proceeded without the willingness of those afflicted by Minamata disease, nor Towell without his acceptance into communities normally opposed to being photographed. Getting to know subjects was a critical part of their working process. Even Salgado and Nachtwey, whose work crosses the globe more than it follows specific individuals for prolonged periods, both like to spend time with their subjects. In watching footage of Nachtwey's working method in the film *War Photographer* (2001), one is struck by the degree to which the photographer's subjects perform for his camera. There is a definite sense that, at least in certain circumstances, his subjects want their plight to be transcribed and communicated through him.

There has also been an attempt on the part of many of these photographers to make their work useful to the subjects depicted. Meiselas has made a concerted effort to bring her pictures back to Nicaragua, installing them in public spaces as markers of the country's past in a project called *Reframing History* (2004). Her original book was published in Spanish and English and was meant as much for a Nicaraguan audience as for an international one. Griffiths's project was released in the United States when the war's support was quickly dwindling, and as such was intended to fan the flames of the antiwar movement. It seems the South Vietnamese officials perceived the book as an effective counter to their goals, because they banned him from returning to the country after its publication.[100] Greenfield's Thin project has a related online forum where the photographer's pictures act as a vehicle for discussions within the community. At least one young woman has credited her participation in the photographer's Girl Culture project as an important part of her recovery from an eating disorder.[101]

This is not to suggest that people are always appreciative of their involvement in such projects. A number of Greenfield's subjects claimed exploitation when an article reproducing her photographs of them appeared in the *Los Angeles Times Magazine* in 1992.[102] Greenfield's book *Fast Forward*, which subsequently presented the pictures in a more nuanced and respectful context, was better received by the community.[103] The experience demonstrates the tenuous strings by which collaboration sometimes hangs and the fine line that photographers like Greenfield must walk in achieving both cooperation and credibility as discerning observers of culture.

Smith's work, too, has disturbed some of its subjects. One of the photographer's most famous images, *Tomoko and Mother in the Bath* (1972), is no longer licensed for publication due to these concerns. The picture, which depicts a young victim of mercury poisoning being held by her mother in the bath of their home, was made with the full cooperation of the mother. Its visual power as a sort of modern pietà made it into a symbol for the plight of the Minamata victims, and it has been published extensively in articles and materials supporting their cause. Aileen M. Smith, who was a collaborator on the Minamata project and has controlled its copyright since W. Eugene Smith's death, released a statement in July of 2001 explaining her decision to no longer license the image for reproduction. She described this as an act of exercising copyright, not relinquishing it:

> Gene said that as photographer he had two responsibilities. One was to his subjects and the other was to his viewers. . . .
>
> Tomoko's parents to this very day remain firm in their desire to rid the world of pollution. "Extermination" is the word Tomoko's father uses. And so they care that this photograph be not erased from this earth. And so be it. (The work in publications that already exist, in museums and with collectors, will do that.) . . .
>
> To be honest, over the years it became a greater and greater burden for me to continue to answer to the publication of this photograph. Tomoko's parents remained silent, but I knew how they felt because I know how I feel. I kept telling myself, "I know people have been moved, even their lives changed by this image. I must continue to release it to the world. It is my duty." But gradually, this was turning to profanity. I knew that Tomoko's parents, now nearly a quarter century since her death, wanted Tomoko to rest. "*Yasumasete agetai*" (we want to let her rest) were their words. And I felt the same. I literally felt Tomoko's efforts over these two and a half decades, each time going out to the world, naked, showing everything of her polluted body.
>
> This photograph would mean nothing if it did not honor Tomoko. This photograph would be a profanity if it continued to be issued against the will of Tomoko and her family. Because this was a statement about Tomoko's life, it must honor that life and by it her death.[104]

The action has been the source of much debate in the photographic community, some seeing it as a dangerous precedent and others applauding it as an ethical triumph.[105] The image is not reproduced in the pages of this book but can still be found widely on the Internet and in pre-2001 publications.

For many people, the answer to whether it is ethical to make and distribute (through magazines, books, museums, and the Web) pictures of people in distress hinges on whether the work has social agency. In the case of *Tomoko and Mother in the Bath*, Aileen M. Smith evidently believes that the picture's relevance as a political and historical image no longer outweighs the discomfort it brings, particularly given the fact that in this case, a large body of other pictures related to Minamata is still available to represent the cause. Her feelings have to do with the larger question of how photojournalism engages the public in productive ways. There is good reason to doubt the ability of a single photograph to dramatically change public policy on its own. But photographs are an ingredient in the complex systems through which people understand the world and confirm their opinions about it, and they have been used effectively in political contexts.[106]

Nachtwey is well aware of the perceived power of photography in the eyes of policy makers and the public:

> Why photograph war? Is it possible to put an end to a form of human behavior which has existed throughout history, by means of photography? The proportions of that notion seem ridiculously out of balance. Yet that very idea has motivated me. For me, the strength of photography lies in its ability to evoke a sense of humanity. If war is an attempt to negate humanity then photography can be perceived as the opposite of war. And if it is used well it can be a powerful ingredient in the

antidote to war. In a way, if an individual assumes the risk of placing himself in the middle of a war in order to communicate to the rest of the world what is happening, he is trying to negotiate for peace. Perhaps that's the reason that those in charge of perpetuating war do not like to have photographers around.[107]

Strauss has asserted that Nachtwey's work, in its capacity to remind us of the problems of the present and past, is important in countering social and political amnesia.[108]

The majority of socially engaged photographers are not naïve enough to believe their photographs will have an immediate, direct, and quantifiable impact on remaking social structures. But many of them have a positivist core, accepting the importance of bearing critical witness to society, for both immediate and historical purposes, and trusting that the communication of experience can lead to greater understanding. Smith, for example, dedicated his Minamata book to "those who do not take the past as proof against the future."

Independent studies by documentary photographers are a part of the greater dialogue about the state of society, penetrating issues in ways that the mainstream media is unwilling or unable to accomplish on its own. While none of the projects should be considered comprehensive accounts of their topics, each provides insightful and alternative ways of engaging the world and thinking about the past, complementing rather than replacing other forms of critical inquiry. Whether understanding then leads to change depends on what viewers do with the information they gather. Those who would lay this responsibility at the feet of the photographers place an undue faith in the agency of the medium, and those who would suggest that photography disengage the world for lack of quantifiable results miss its point.

Each of the photographers represented here has taken a slightly different tack on addressing what they have deemed to be critical issues of their time. The strengths and weaknesses of each approach can be weighed, as can the ethics of each endeavor. In the end, the question is perhaps not whether to depict problems in the world, but how to do so in ways that are both sensitive and productive.[109] On that question, dialogue will certainly persist as photographers continue to rethink the boundaries and traditions of art, journalism, and documentary practice.

NOTES

1. For a discussion of *Life*'s beginnings and its editorial structure, see Glenn G. Willumson, *W. Eugene Smith and the Photographic Essay* (Cambridge University Press, 1992), pp. 14–24.

2. "The Camera as Essayist," *Life* 2, no. 17 (April 26, 1937): pp. 60–61.

3. This discussion is indebted to Willumson, *W. Eugene Smith and the Photographic Essay* (note 1), pp. 7–14; and Ulrich Keller, "Photojournalism Around 1900: The Institutionalization of a Mass Medium," in *Shadow and Substance: Essays on the History of Photography*, ed. Kathleen Collins (Bloomfield Hills, Michigan: The Amorphous Institute Press, 1990), pp. 283–303.

4. Martin Parr and Gerry Badger, *The Photobook: A History*, vol. 1 (London: Phaidon Press, 2004), p. 37.

5. Keith F. Davis, "'A Terrible Distinctness': Photography of the Civil War Era," in *Photography in Nineteenth-Century America*, ed. Martha A. Sandweiss (Fort Worth, Texas: Amon Carter Museum; and New York: Harry N. Abrams, 1991), p. 168.

6. Parr and Badger, *The Photobook* (note 4), p. 44.

7. Mary Warner Marien, *Photography: A Cultural History* (London: Laurence King, 2002), p. 239.

8. Chris Boot, ed., *Magnum Stories* (London: Phaidon Press, 2004), p. 4.

9. John Stomberg, "A Genealogy of Orthodox Documentary," in *Beautiful Suffering: Photography and the Traffic in Pain*, eds. Mark Reinhardt, Holly Edwards, and Erina Duganne (Williamstown, Massachusetts: Williams College Museum of Art; and University of Chicago Press, 2007), p. 40.

10. Willumson, *W. Eugene Smith and the Photographic Essay* (note 1), pp. 13–15. See also Estelle Jussim, "'The Tyranny of the Pictorial': American Photojournalism from 1880 to 1920," and Colin Osman and Sandra Phillips, "European Visions: Magazine Photography in Europe between the Wars," both in Marianne Fulton, *Eyes of Time: Photojournalism in America* (New York: New York Graphic Society, 1988), pp. 36–73 and 75–103, respectively.

11. Willumson, *W. Eugene Smith and the Photographic Essay* (note 1), p. 17.

12. See *Life*, March 28, 1938, and February 17, 1941, issues, or refer to Stomberg, "*Life* Magazine," in *Encyclopedia of Twentieth-Century Photography*, vol. 2, ed. Lynne Warren (New York: Routledge, 2006), pp. 952–55.

13. Unable to secure adequate advertising revenue in the age of television, *Life* ceased publication as a weekly in 1972 but continued as a monthly from October 1978 to May 2000. It was then issued as a newspaper supplement from October 2004 to April 2007.

14. Willumson, *W. Eugene Smith and the Photographic Essay* (note 1), p. 1.

15. This is the earliest noted use of the word listed in the *Oxford English Dictionary*. Although the word may have appeared in print prior to this, the editors' attempt to answer the question "What is this new photo-journalism?" implies that the dimensions of the term, particularly as it exceeded press photography of earlier decades, were in need of some elaboration at the time. See Willard D. Morgan and Henry M. Lester, eds., *Miniature Camera Work: Emphasizing the Entire Field of Photography with Modern Miniature Cameras* (New York: Morgan and Lester Publishers, 1938), p. 36.

16. Wilson Hicks, *Words and Pictures: An Introduction to Photojournalism* (New York: Harper and Brothers Publishers, 1952).

17. Hicks, preface to *Words and Pictures* (note 16), xiii.

18. Abigail Solomon-Godeau, *Photography at the Dock: Essays on Photographic History, Institutions, and Practices* (Minneapolis: University of Minnesota Press, 1991), p. 170.

19. William Stott, *Documentary Expression and Thirties America* (Oxford University Press, 1973), pp. 5–63.

20. Leslie Katz, "Interview with Walker Evans," *Art in America* (March–April 1971): p. 85.

21. See Anne Wilkes Tucker, "Photographic Facts and Thirties America," and Beaumont Newhall, "A Backward Glance at Documentary," both in *Observations: Essays on Documentary Photography*, ed. David Featherstone (Carmel, California: Friends of Photography, 1984), pp. 41–55 and 1–6, respectively; see also Parr and Badger, *The Photobook* (note 4), p. 118; and Newhall, "Documentary Approach to Photography," *Parnassus* 10, no. 3 (March 1938): pp. 2–6.

22. John Grierson, quoted in introduction to Forsyth Hardy, ed., *Grierson on Documentary* (New York: Harcourt Brace and Company, 1947), p. 4, as cited in Parr and Badger, *The Photobook* (note 4), p. 118.

23. Richard Griffiths, "The Film Faces Facts," in *Survey Graphics* 27, no. 12 (December 1938): p. 25, as cited in Parr and Badger, *The Photobook* (note 4), p. 118; see also Tucker in "Photographic Facts and Thirties America" (note 21).

24. Newhall, "Documentary Approach to Photography" (note 21). Note also that the term is described that same year in *Miniature Camera Work* (note 15) and is there defined quite broadly: "to record the daily social and economic activities of our society in all its aspects" (p. 4).

25. Newhall, "Documentary Approach to Photography" (note 21), p. 5.

26. Marien, *Photography: A Cultural History* (note 7), p. 281; see also Keith F. Davis, *An American Century of Photography: From Dry-Plate to Digital* (Kansas City: Hallmark Cards, Inc., 1999), p. 160; and Stott's study on the era, *Documentary Expression and Thirties America* (note 19).

27. Davis, *An American Century of Photography* (note 26), p. 163.

28. Parr and Badger, *The Photobook* (note 4), p. 119.

29. Newhall, "Documentary Approach to Photography" (note 21), p. 6.

30. *Picture Post* 1, no. 10 (December 1938): cover.

31. Parr and Badger, *The Photobook* (note 4), p. 140. See also Stott's chapter on the documentary book in *Documentary Expression and Thirties America* (note 19), pp. 211–37.

32. Other photojournalists were producing books, albeit with less overtly important social messages, on their interpretations of urban culture, like Weegee in New York (*Naked City*, 1945), Bill Brandt in London (*The English at Home*, 1936, and *A Night in London*, 1938), and Brassaï in Paris (*Paris de nuit*, 1933). For more on the photobooks of this period, see Parr and Badger, *The Photobook* (note 4), pp. 116–45.

33. Dorothea Lange and Paul S. Taylor, *An American Exodus: A Record of Human Erosion* (New York: Reynal and Hitchcock, 1939), p. 5.

34. For an account of the competition between Evans and Bourke-White over what would become the dominant documentary mode, see Stomberg, *Beautiful Suffering* (note 9).

35. Henri Cartier-Bresson, typeset statement in the archive at the Fondation Henri Cartier-Bresson, Paris, n.d.

36. From the time of its inception, George Rodger nicknamed Magnum the "Time Life Stink Club." Boot, *Magnum Stories* (note 8), p. 5.

37. Willumson, *W. Eugene Smith and the Photographic Essay* (note 1), pp. 21–23.

38. Horace Bristol, preface to *Formosa: A Report in Pictures* (Tokyo: East-West at Toppan Press, 1954).

39. Bristol, introduction to *Korea*, 4th ed. (Tokyo: East-West at Toppan Press, 1953). Originally published in 1948.

40. See Carolyn Peter's study on John Swope in *A Letter from Japan: The Photographs of John Swope* (Los Angeles: Hammer Museum; and Göttingen, Germany: Steidl, 2006), pp. 19–29.

41. Willumson, *W. Eugene Smith and the Photographic Essay* (note 1), pp. 235–37.

42. Willumson, *W. Eugene Smith and the Photographic Essay* (note 1), pp. 249–50.

43. For an account of Smith's difficulties and successes at *Life*, see Willumson, *W. Eugene Smith and the Photographic Essay* (note 1).

44. Cornell Capa, ed., introduction to *The Concerned Photographer* (New York: Grossman, 1968).

45. Edward Steichen, "Photography: Witness and Recorder of Humanity" (1958), reprinted in Peninah R. Petruck, ed., *The Camera Viewed: Writings on Twentieth-Century Photography*, vol. 2 (New York: E. P. Dutton, 1979), pp. 3–10. See also Gretchen Garner, *Disappearing Witness: Change in Twentieth-Century American Photography* (Baltimore: The Johns Hopkins University Press, 2003), p. 62.

46. Davis, *An American Century of Photography* (note 26), p. 293.

47. Frank, quoted in Davis, *An American Century of Photography* (note 26), p. 224.

48. Davis, *An American Century of Photography* (note 26), pp. 262 and 295.

49. For a survey of street photography, see Colin Westerbeck and Joel Meyerowitz, *Bystander: A History of Street Photography* (Boston: Little, Brown and Company, 1994).

50. John Szarkowski, wall text for "New Documents" exhibition, Department of Photographs archive, The Museum of Modern Art, New York.

51. Boot, *Magnum Stories* (note 8), p. 6.

52. Boot, *Magnum Stories* (note 8), p. 4.

53. Cartier-Bresson, *The Decisive Moment* (New York: Simon and Schuster, 1952), p. xvi.

54. Cartier-Bresson, preface to *The World of Henri Cartier-Bresson* (New York: Viking Press, 1968), n.p.

55. Cartier-Bresson, "A Conversation with Henri Cartier-Bresson," *Popular Photography* (September 1957), reprinted in Byron Dobell, *Magnum: The First Ten Years* (New York: Magnum Photos, n.d.).

56. Davis, *An American Century of Photography* (note 26), p. 388.

57. Fulton, "Changing Focus: The 1950s to the 1960s," in *Eyes of Time* (note 10), pp. 173–275.

58. See Davis, *An American Century of Photography* (note 26), p. 389. Also see Garner's book on the topic, *Disappearing Witness* (note 45).

59. Susan D. Moeller, *Shooting War: Photography and the American Experience of Combat* (New York: Basic Books, 1989), p. 378.

60. Murray Sayle, introduction to Philip Jones Griffiths, *Dark Odyssey* (New York: Aperture, 1996), n.p.

61. Malcolm Browne, quoted in Moeller, *Shooting War* (note 59), p. 327.

62. Michael Herr, quoted in Moeller, *Shooting War* (note 59), p. 327.

63. Thomas Myers, *Walking Point: American Narratives of Vietnam* (Oxford University Press, 1988), p. 43.

64. Philip Jones Griffiths, in Simon James, "Vietnam: The Truth As We See It," *RPS Journal* 141, no. 8 (October 2001), pp. 344–47.

65. Tom Wolfe, *The New Journalism*, with an anthology edited by Wolfe and E. W. Johnson (London: Picador, 1996). First published in 1973. It has been suggested that "the New Journalism" is a misnomer, in that some of its characteristics have antecedents in earlier writing, just as the photographers explored in this book grow out of a complex tradition. Nonetheless, Wolfe's anthology demonstrates the movement's shape and vitality during the second half of the century. It is worth noting that Stott refers to New Journalism as a form of "documentary reportage" prevalent during the 1930s, thus relating its prehistory to the same documentary forces that shaped the direction of photojournalism; see preface to *Documentary Expression and Thirties America* (note 19), p. x.

66. The relationship between several photojournalists and the New Journalism movement was also described in Adam Weinberg, *On the Line: The New Color Photojournalism* (Minneapolis: Walker Art Center, 1986), pp. 26–28.

67. W. Eugene Smith, prologue to his and Aileen M. Smith's *Minimata* (New York: Holt, Rinehart, and Winston, 1975), p. 7; and quoted in Davis, *An American Century of Photography* (note 26), p. 290.

68. For a discussion of Frederick Wiseman's approach, see Barry Keith Grant, "'Ethnography in the First Person': Frederick Wiseman's *Titicut Follies*," in Grant and Jeannette Sloniowski, eds., *Documenting the Documentary: Close Readings of Documentary Film and Video* (Detroit: Wayne State University Press, 1998), pp. 238–53.

69. Parr and Badger, *The Photobook: A History*, vol. 2 (London: Phaidon Press, 2006), p. 13.

70. Larry Towell, *The World from My Front Porch* (London: Chris Boot, 2008), p. 151.

71. Lauren Greenfield, *Girl Culture* (San Francisco: Chronicle Books, 2002), p. 152.

72. Jim Hughes, *W. Eugene Smith, Shadow and Substance: The Life and Work of an American Photographer* (New York: McGraw-Hill, 1989), pp. 491–507.

73. Along with *Migrations*, Salgado also published *The Children: Refugees and Migrants* (New York: Aperture, 2000), drawn from the same body of work.

74. Towell, *The World from My Front Porch* (note 70), p. 150.

75. James Nachtwey, afterword to *Inferno* (London: Phaidon, 1999), p. 469.

76. Towell, *The World from My Front Porch* (note 70), p. 149.

77. Mark, quoted in Weinberg, *On the Line* (note 66), p. 27.

78. Susan Meiselas, "Central America and Human Rights," in Ken Light, *Witness in Our Time: Working Lives of Documentary Photographers* (Washington, D.C.: Smithsonian Institution Press, 2000), p. 105.

79. Meiselas, quoted in *Soho News*, May 20, 1981, as cited in Edmundo Desnoes, "The Death System," reprinted in *Susan Meiselas: In History*, ed. Kristen Lubben (New York: International Center of Photography; and Göttingen, Germany: Steidl, 2008), p. 222.

80. Griffiths, statement in Boot, *Magnum Stories* (note 8), p. 202.

81. Martha Rosler, "In, Around, and Afterthoughts (On Documentary Photography)," originally published in *Martha Rosler: 3 Works* (Halifax, Canada: Press of the Nova Scotia College of Art and Design, 1981) and reprinted in Rosler, *Decoys and Disruptions: Selected Writings, 1975–2001* (Cambridge, Massachusetts: The MIT Press, 2004).

82. Allan Sekula, "Dismantling Modernism, Reinventing Documentary" (1976), reprinted in *Photography Against the Grain: Essays and Photo Works, 1973–1983* (Halifax, Canada: Press of the Nova Scotia College of Art and Design, 1984), p. 57.

83. Sekula, *Photography Against the Grain* (note 82). See also Grant Kester, "Toward a New Social Documentary," *Afterimage* (March 1987): pp. 10–14.

84. Rosler, originally published as "A Revolution in Living Color: The Photojournalism of Susan Meiselas," *In These Times* (Chicago), June 17–30, 1981. A reprinted version of the original article is called "Wars and Metaphors," in Rosler, *Decoys and Disruptions* (note 81), pp. 245–58. Rosler noted in the reprinted version her admiration for Meiselas's commitment, skill, and resourcefulness, despite the criticisms elaborated.

85. Tucker, "Photographic Facts and Thirties America" (note 21), pp. 43–44.

86. For an account of the history of these associations, see Stomberg, "A Geneology of Orthodox Documentary" (note 9), pp. 37–56. See also Stott's discussion of Evans's rivalry with Bourke-White in his chapter on the documentary book in *Documentary Expression and Thirties America* (note 19), pp. 211–37.

87. Stomberg, "A Geneology of Orthodox Documentary" (note 9); and Stott, *Documentary Expression and Thirties America* (note 19).

88. Ingrid Sischy, "Good Intentions," *The New Yorker* (September 9, 1991): pp. 89–95.

89. Susan Sontag, *On Photography* (New York: Farrar, Straus and Giroux, 1973), pp. 20–21.

90. I use the word "striking" here deliberately, as it seems a more appropriate descriptor of Salgado's work. Sischy used notions of "beauty" and "aesthetics" interchangeably, but the conflation of these concepts is inaccurate and can be confusing, as Reinhardt has noted. See Reinhardt, "Picturing Violence: Aesthetics and the Anxiety of Critique," in *Beautiful Suffering* (note 9), p. 28.

91. John Taylor, *Body Horror: Photojournalism, Catastrophe and War* (Manchester University Press, 1998).

92. James Rainey, "Portraits of War: Unseen Pictures, Untold Stories," *Los Angeles Times*, May 21, 2005. Cited in Reinhardt, "Picturing Violence" (note 90), p. 18.

93. Sontag, *Regarding the Pain of Others* (New York: Farrar, Straus and Giroux, 2003), p. 115.

94. David Levi Strauss, *Between the Eyes: Essays on Photography and Politics* (New York: Aperture, 2003), p. 9. See also Reinhardt, "Picturing Violence" (note 90), for how aesthetic strategies can invite critical engagement.

95. Strauss, "'An Amplitude that Information Lacks'," reprinted in *Susan Meiselas* (note 79), p. 112.

96. Strauss, "'An Amplitude that Information Lacks'" (note 95), p. 112.

97. Reinhardt and Edwards, "Traffic in Pain," in *Beautiful Suffering* (note 9), p. 8.

98. Keller, "Photojournalism Around 1900" (note 3), p. 293.

99. Mary Ellen Mark, preface to *Streetwise* (Philadelphia: University of Pennsylvania Press, 1988), p. xi.

100. Griffiths, interview with William Messer, "Presence of Mind: The Photographs of Philip Jones Griffiths," *Aperture*, no. 190 (spring 2008): p. 64. See also Russell Miller, *Magnum, Fifty Years at the Front Line of History: The Story of the Legendary Photo Agency* (New York: Grove Press, 1998), p. 212.

101. Greenfield, conversation with the author, June 2009.

102. D. James Romero, "Life on 'Fast Forward,'" *Los Angeles Times*, May 4, 1997, Life & Style, p. 1. See also the original article, Greenfield, "Lifestyles of the Young and Privileged," *Los Angeles Times Magazine* (December 13, 1992): pp. 41–46.

103. Greenfield, conversation with the author, October 7, 2008.

104. Aileen Mioko Smith, "The Photograph *Tomoko and Mother in the Bath*," Photo Fetes press conference, Arles/Perpignan, France, July 5, 2001, available online at http://aileenarchive.or.jp/aileenarchive_en/aboutphoto.html. A form of the letter was published in Michael L. Sand, "Latent Image: W. Eugene Smith's Controversial Minamata Photograph," *Aperture*, no. 160 (summer 2000): pp. 14–19.

105. Sand, "Latent Image" (note 104).

106. For case studies on the agency of photographs in foreign policy, see David D. Perlmutter, *Photojournalism and Foreign Policy: Icons of Outrage in International Crises* (Westport, Connecticut: Praeger, 1998).

107. Nachtwey, quoted from *War Photographer* (2001), directed by Christian Frei.

108. Strauss, "James Nachtwey: International Center of Photography, New York," *Artforum* 39, no. 1 (September 2000): p. 180.

109. For a larger discussion of ethical approaches to the depiction of suffering, see Reinhardt, "Picturing Violence" (note 90).

Author's note

Sections devoted to the photographers follow. Each is preceded by a short essay that sets the work in a biographical and historical context. These sections are necessarily summations of the photographers' larger projects, and as such the curatorial endeavor is inevitably an editorial one. The underlying principle, however, has been to retain the spirit of the projects (going so far as to preserve the spelling and formatting of the original texts) in reduced form while exploring their greater aims. For more information on each, it is recommended that readers seek out the photographers' own publications.

THE PHOTOGRAPHERS

LEONARD **FREED**
BLACK IN WHITE AMERICA

Born in Brooklyn, New York, to working-class parents of Eastern European descent, Leonard Freed (1929–2006) grew up wanting to be a painter. On a trek through Europe in his early twenties, Freed decided to take up photography as a means of supporting his travels, and by 1954 he made his first sale of a photograph to a newspaper in Amsterdam. Later that year, having returned to New York and resolved to pursue photography instead of painting, he visited Magnum in search of career advice; the manager of the office invited him to use their facilities for his work, and thus began his relationship with the cooperative of photojournalists (he would become a full member in 1972). The first topic the young photographer took up was an exploration of New York's Hasidic Jews, in 1954. Over his long career, which spanned five decades, Freed's pictures regularly appeared in prominent magazines and newspapers around the world, including the *Sunday Times* of London, *Stern* of Germany, and the *New York Times Magazine*. The photographer's true passion, however, was for the extended essays he spent years developing and publishing as books.

Freed's only formal professional training came through a short period spent with Alexey Brodovitch, the famed art director of *Harper's Bazaar* and teacher of a good number of successful photographers, who in 1955 allowed the young photojournalist to attend his "design laboratory" without paying the customary fee. Early the next year, Freed returned to Europe, yearning to travel further and enjoy his youth. In Rome he met a young German woman by the name of Brigitte Klück, and in 1958 the couple married, first settling in the Netherlands, and later in the United States. Brigitte quickly became the photographer's collaborator on projects, responsible for printing most of his work in the darkroom and assisting him with the design of books.

Freed's long-term projects always revolved around subjects to which he felt personally connected; his work was as much about coming to terms with a given situation for himself as it was about sharing his findings with others. Though not religious, Freed was raised in a Jewish family and maintained a curiosity about his cultural heritage throughout his career. In Amsterdam he embarked on a project that focused on the area's postwar Jewish community, publishing his first important book on the subject, *Joden von Amsterdam*, the year he and Brigitte married. In 1961, he broadened his project, this time focusing on the postwar Jewish communities of Germany, and the following year he spent two months photographing in Israel. In 1963 he worked on a film, produced by Dutch television as *Dansende Vromen* (Dance of the pious), about his work with the Hasidic Jews of New York and Jerusalem. Shortly thereafter his photographs from Germany resulted in his second major publication, *Deutsche Juden heute* (German Jews today), which came out in 1965.

While working in Germany in 1962, Freed photographed a black American soldier guarding the divide between East and West as the Berlin Wall was being erected (pl. 1). The idea of a man standing in defense of a country where his own rights were in question haunted Freed. Focused as the photographer was at the time on German Jewish communities, which had suffered irreparable ethnic abuse at the hands of their own fatherland during World War II, the experience ignited the photographer's interest in the American civil rights movement. The divide between blacks and whites became something that he felt compelled to address with his camera, and in June of 1963 Freed headed back to the United States to embark on a project that would become the signature work of his career, published as *Black in White America* around 1968.[3]

Among the first events related to the topic that Freed photographed was the March on Washington. While he created volumes of remarkable pictures from this historic event, Freed found that his interests lay not in recording the progress of the movement per se but in exploring the diverse everyday lives of a people that had been marginalized for so long. He returned to his childhood home in Brooklyn and began photographing the African-American neighborhoods around New York City, connecting with the community by visiting churches and outdoor religious gatherings (pls. 4–6), recording life on the streets (pls. 7–10), photographing people at work and play (pls. 2, 9), and capturing the way in which protests and other forms of activism had become a regular part of existence in the urban environment (pls. 11–13). The following year, he bought a car and traveled through the southern United States, conducting a similar survey. He photographed jails and jazz funerals in New Orleans (pls. 20, 25–27), an abundance of segregated businesses (pl. 21), religious gatherings (pls. 28–29), and former plantations on which the descendants of black slaves still lived (pls. 22–24). Freed's photographs in *Black in White America* avoid depictions of intense strife in favor of a more subtle approach to the struggles of the period. Penetrating the fabric of daily existence, they portray the humanity of a people living in unjust circumstances. Freed's message is built up in a sophisticated way over the course of the published corpus. His sensitive and empathetic approach seeks not to stimulate outrage, but to foster understanding and bridge cultural divides as a means of transcending racial antipathy.

Freed was particularly adept at making individual photographs that encapsulated the crux of his greater subject, taking a cue from Henri Cartier-Bresson's creed as expressed in his landmark book *The Decisive Moment* (1952): "To me, photography is the simultaneous recognition, in a fraction of a second, of the significance of an event as well as of a precise organization of forms which give[s] that event its proper expression."[2] Freed's photograph (pl. 15) of two men passing on the street in Washington, D.C., is a perfect illustration of his interpretation of Cartier-Bresson's influential concept. In Freed's picture, the two protagonists face off, their noses nearly touching on the two-dimensional surface of the print. The older white gentleman occupies a commanding presence in the center of the photograph, but it is the African American on the right who is in focus. Within the context of the larger project, they can be seen as representing the basic and opposing forces of the civil rights movement: white and black, old and new, prominently centered and marginalized, present and future. Indeed, the two play out this dialectic beneath a balcony clearly marked as belonging to the house where Lincoln died.

In North Carolina (pl. 18), Freed framed an interracial couple smiling as one hands their baby to the other. Centered in the picture, the child's body literally and figuratively bridges racial divides. The caption, quoting the man pictured, describes the difficulty of such a union: "A few years ago the whites would have lynched me for sure, today they're afraid, afraid of stirring up a hornet's nest. Afraid the Supreme Court might nullify their laws.

FIGURE 37. Cover of Leonard Freed, *Black in White America* (New York: Grossman Publishers, ca. 1968).

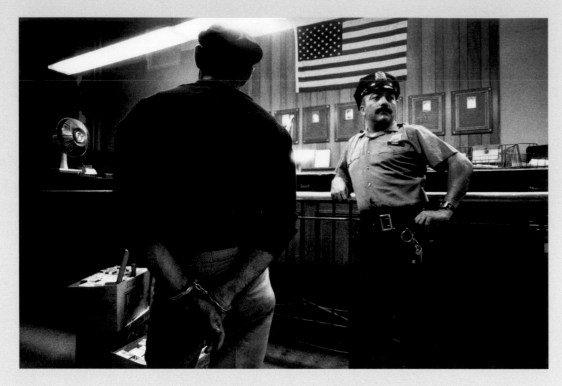

FIGURE 38. Leonard Freed (American, 1929–2006), *New York City*, 1978. From the series Police Work. Gelatin silver print, 22.6 × 34.3 cm (8⅞ × 13½ in.). JPGM 2006.8.12.

Afraid of the race riots that might result. Afraid to touch us for fear that others may do as we did. They know I can fight them, so they're afraid to prosecute or draw up a case against us; what they would like best is just forget we ever existed. They're afraid to say we're living in sin and afraid not to, for in this state it's criminal to have inter-racial marriages and we're criminals in their eyes. But the real crime is our having had to marry in Ohio, while my own state would like to lynch me." Other pictures in the book (like pl. 19) go uncaptioned, allowing their meanings to remain unfixed. We are invited to contemplate the two figures as they appear to contemplate one another—to participate, in an intuitive way, in the subject of the picture itself.

While Freed's highly poetic photographs are strong enough to stand alone, individual pictures from his Black in White America project are meant to function as parts of a whole. In his extended essays, Freed wanted to "show atmosphere" and be "inside and outside and see different points of view," building a story from multiple angles in order to facilitate an understanding of his subject.[3] Through series of images, made in different communities and diverse situations around the country, he explored his topics with greater nuance than could be achieved through a single image. Freed's use of words in the publication adds further dimension to this interpretive approach. The bulk of *Black in White America*'s running text is drawn from notes that were made by the photographer over the course of his travels. They detailed, as a diary would, his experiences and conversations with the people he encountered.

In most cases, these sections of text do not relate directly to specific photographs and instead exist alongside the pictures as a parallel evocative medium. The texts work as a part of Freed's larger rhetorical strategy, complicating and adding depth to the circumstances portrayed and grounding any romanticism that might be read into the pictures. Freed reported on the dangers faced by activists in the South and their techniques for testing desegregation laws; he related stories of wrongful imprisonment and acts of great injustice; he portrayed white civil rights supporters whose comments revealed them to be both critically important to the movement and deeply paternalistic; he told of a young African-American woman who relished making history by enacting her newly established rights; and he detailed the story of another who turned her back on the movement, preferring segregation to the seemingly insurmountable difficulties inherent to the struggle for integration and equality. Indeed, there is a considerable amount of gray area explored in Black in White America.

In the end, we are left with a book that describes—visually and textually, and in a remarkably fluid and effective way—Freed's perception of life in African-American communities during the challenging decade of the 1960s. His pictures and words relate his story in an experiential way without fixing narrative. It is a deeply personal study, and one in which Freed acknowledges his position as an outsider. Ultimately, Freed was interested in understanding the world through his photography. And his pursuit to come to terms with his

surroundings is shared with us so that we, and future audiences, might take part in his journey of reflection.

In the nearly forty years between his completion of the Black in White America project and his death in 2006, the photographer published more than twenty books on his photographs, most notably *Police Work* (1980, fig. 38), which explored the critical and difficult job of law enforcement in New York City, and *La Danse des fidèles* (Dance of the faithful, 1984), a project on deeply religious Jews around the world.

NOTES

1. Leonard Freed, *Black in White America* (New York: Grossman Publishers, ca. 1968).

2. Henri Cartier-Bresson, *The Decisive Moment: Photography by Henri Cartier-Bresson* (New York: Simon and Schuster, 1952), xvi.

3. William A. Ewing, Nathalie Herschdorfer, and Wim van Sinderen, *Worldview: Leonard Freed* (Lausanne, Switzerland: Musée de l'Elysée; and Göttingen, Germany: Steidl, 2007), pp. 206 and 203.

The photographs reproduced on the following pages all emerged from the Black in White America project, although not all of them were published in Freed's book of the same name. They are accompanied here by place-name titles and any captions that appeared with them in the original publication.

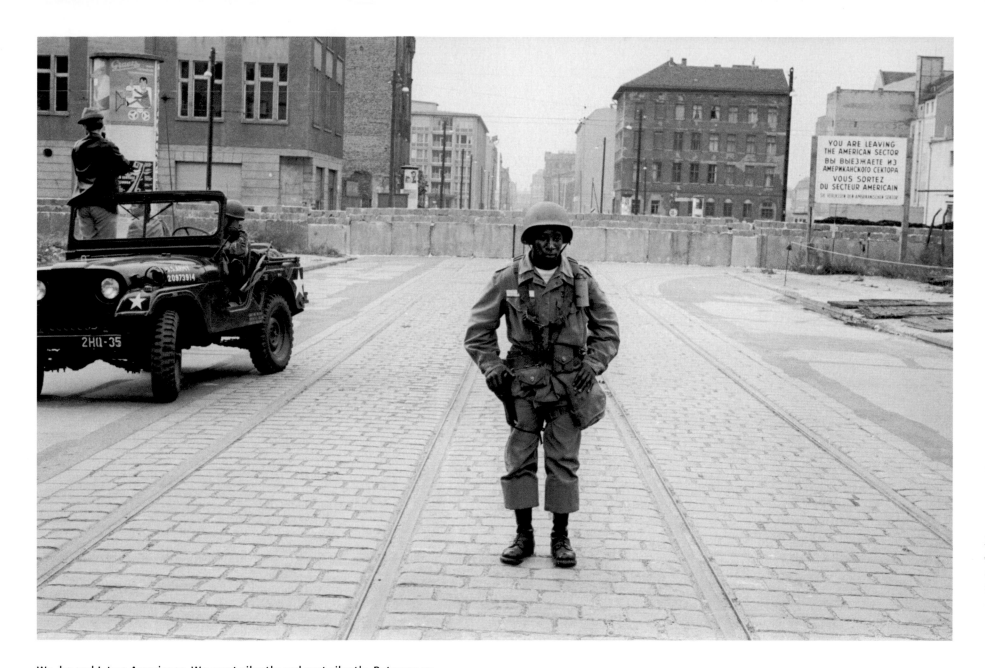

We, he and I, two Americans. We meet silently and part silently. Between us, impregnable and as deadly as the wall behind him, is another wall. It is there on the trolley tracks, it crawls along the cobble stones, across frontiers and oceans, reaching back home, back into our lives and deep into our hearts: dividing us, wherever we meet. I am White and he is Black.

1. *Berlin, West Germany,* 1962
In defense of Western Civilization, an American soldier's hand rests on his gun.

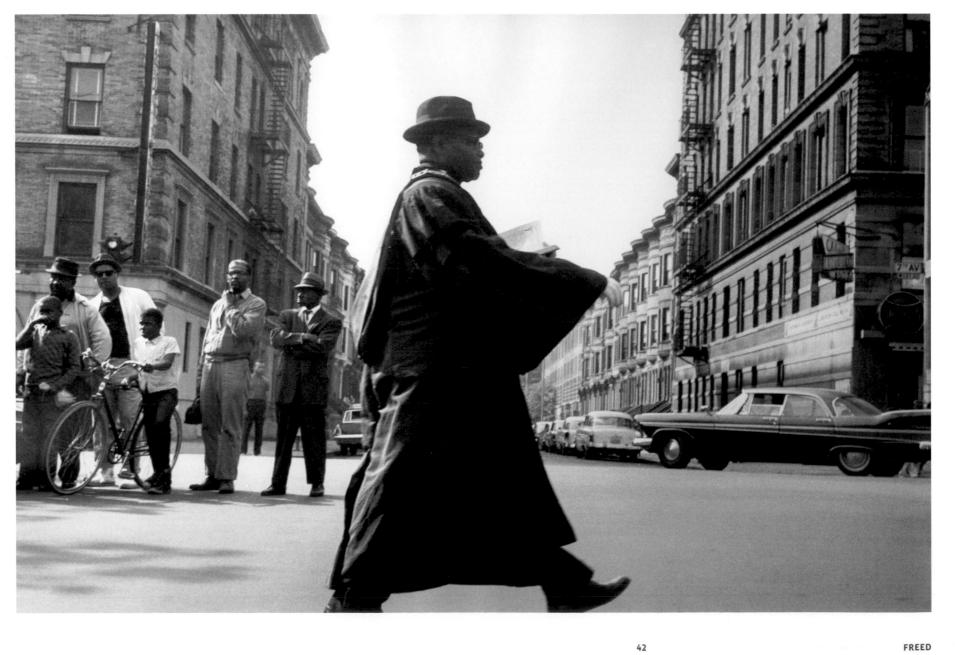

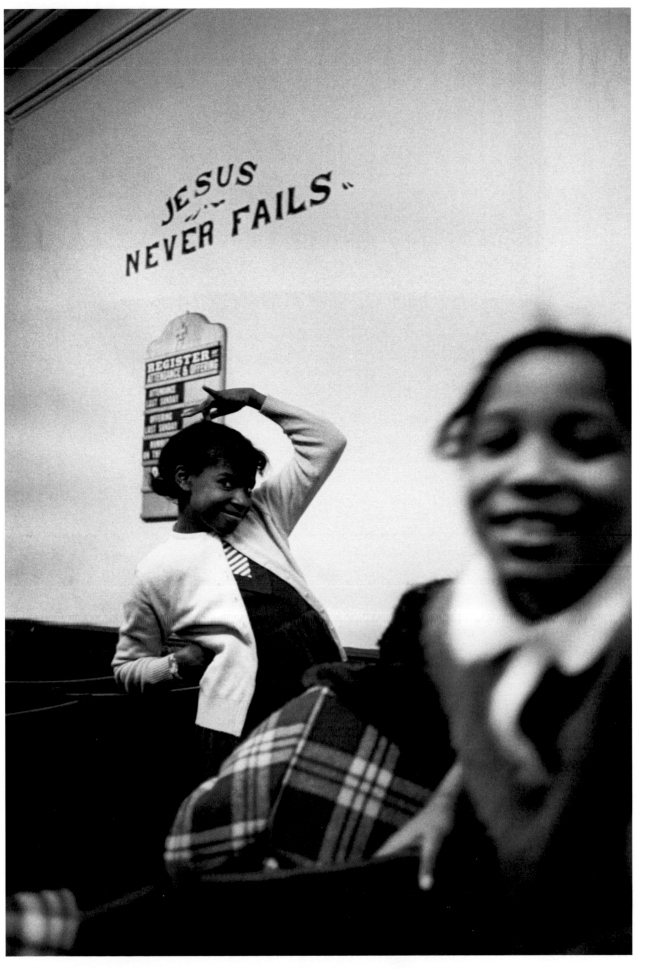

2–3. *New York City,* 1963

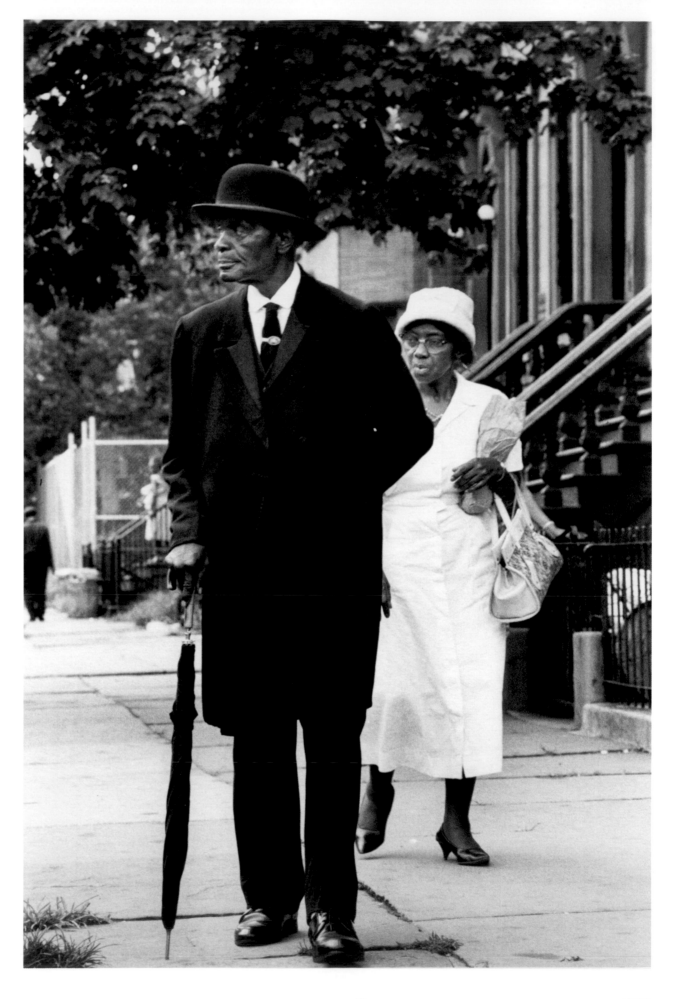

4-6. *Brooklyn, New York*, 1963

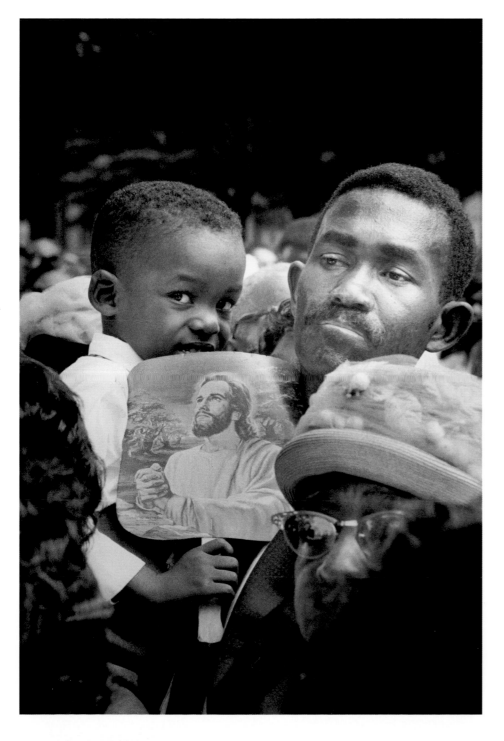

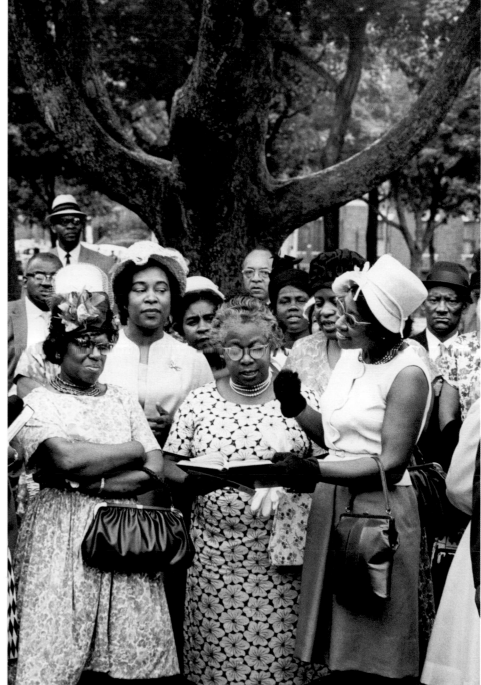

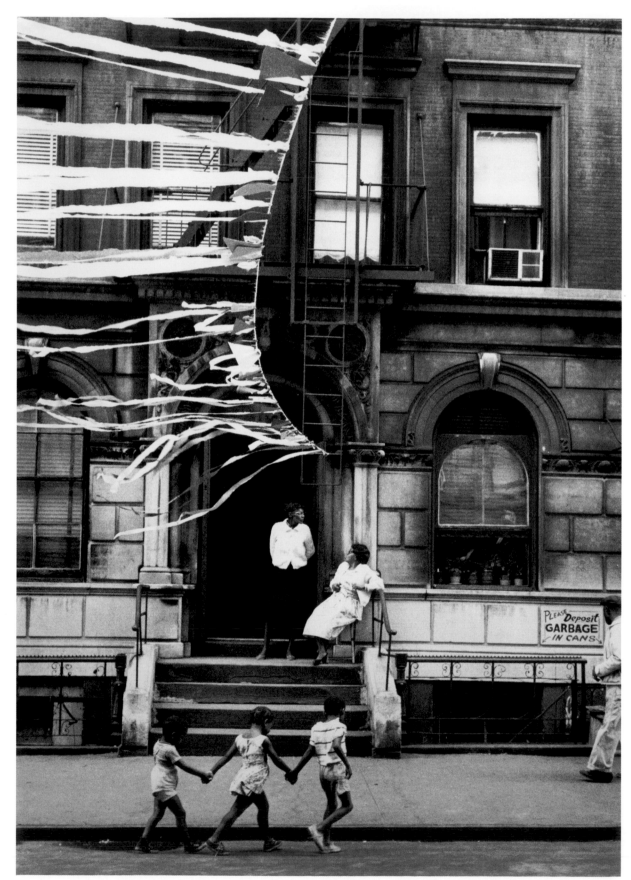

7. *Harlem, New York,* 1963

8. *Brooklyn, New York,* ca. 1963

"Every wire has its function," he said, opening the door and getting in. "I like things to run perfectly. Look at this, without my turning I can get any view I want. These antennas are set up for HiFi; the wife thinks it's loud but I like it that way when I'm driving. I'm an amateur Ham operator, got the license and all. Picked up all these little tricks in the army. Even got a telephone in here but keep it disconnected; all my friends used to call their girl-friends. Unbelievable, ain't it? Did it all myself. Had a portable T.V. set in it but the police made me take it out, got me while I stopped for a red light, saw me watching it."

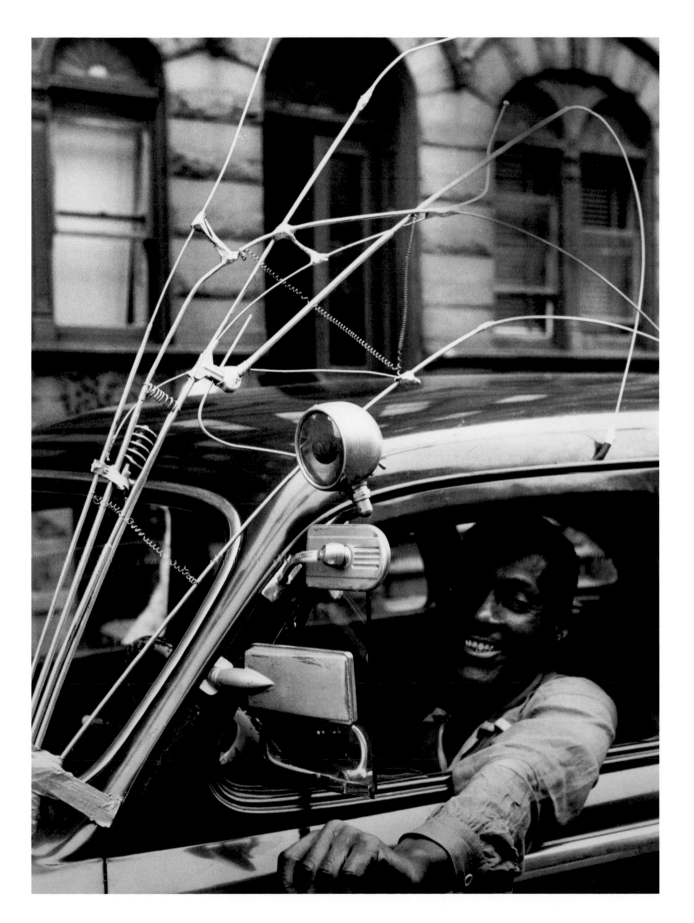

9. *New York City,* 1963

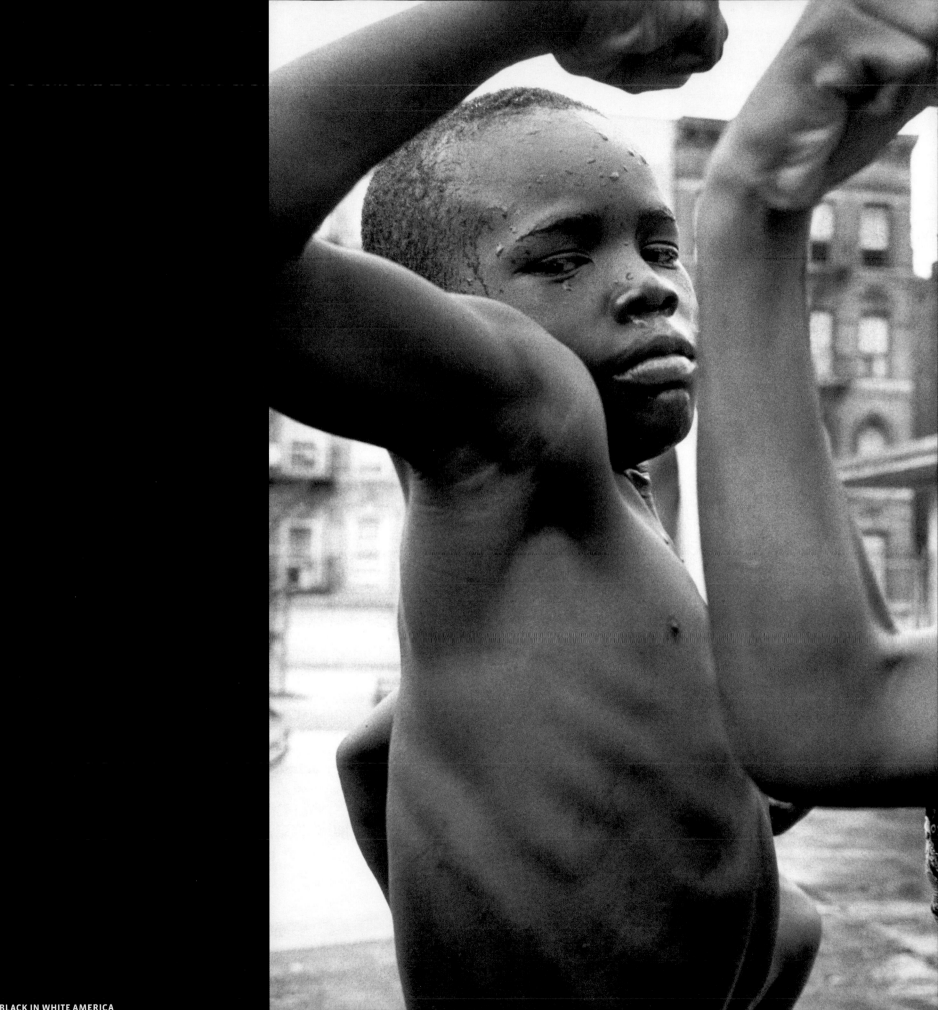

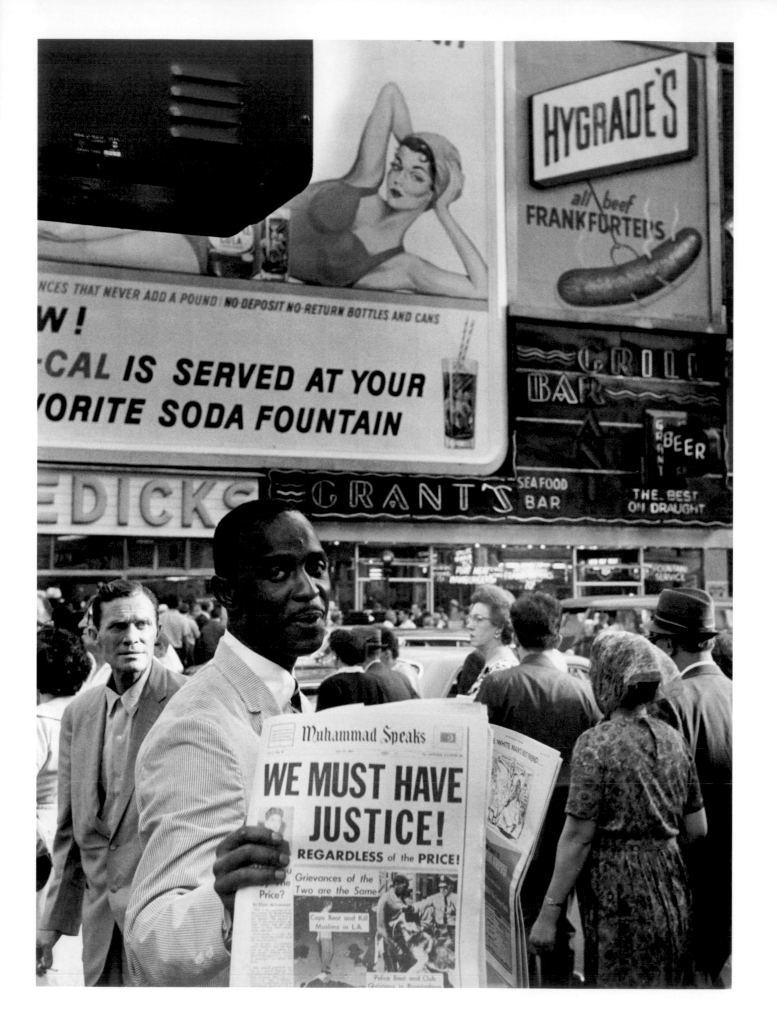

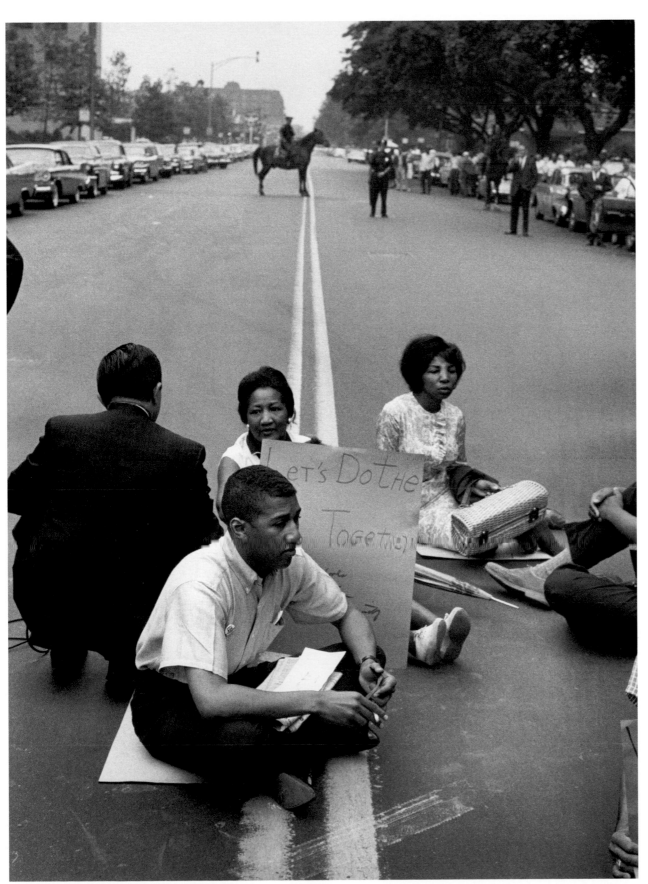

10. *New York City,* 1963
A member of the Black Muslim sect, one of many black nationalist
organizations, selling the sect's newspaper on a street corner.

11. *Brooklyn, New York,* 1963

12. *New York City*, 1963

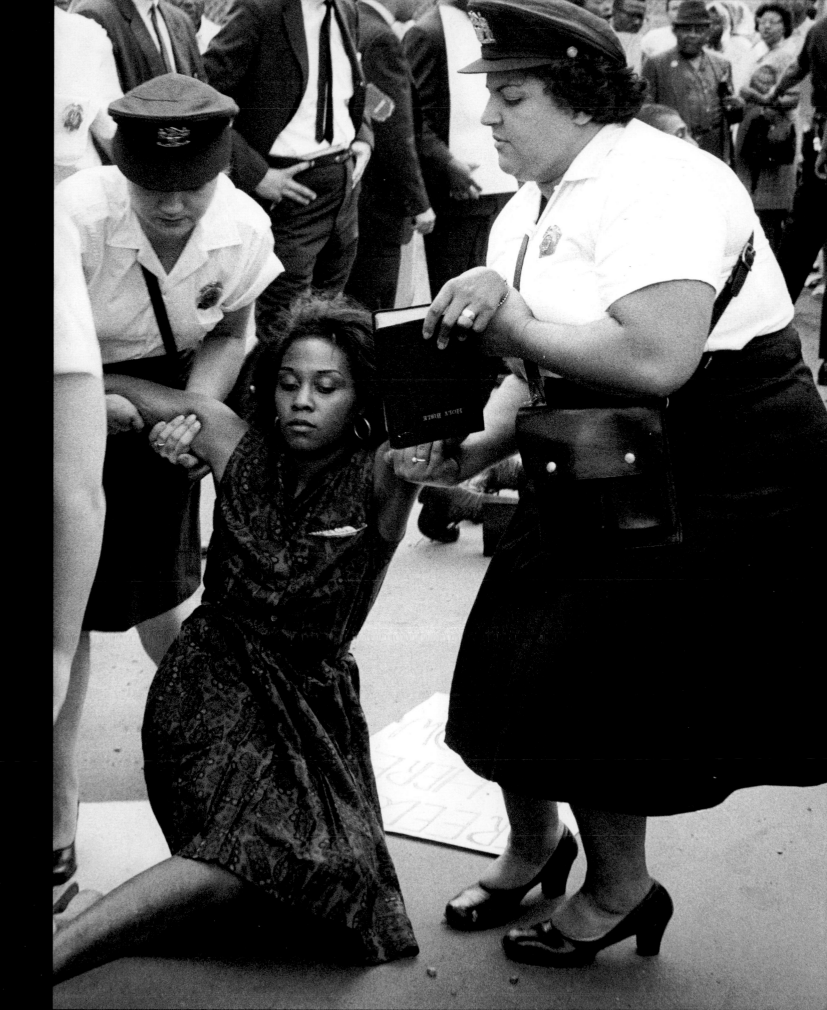

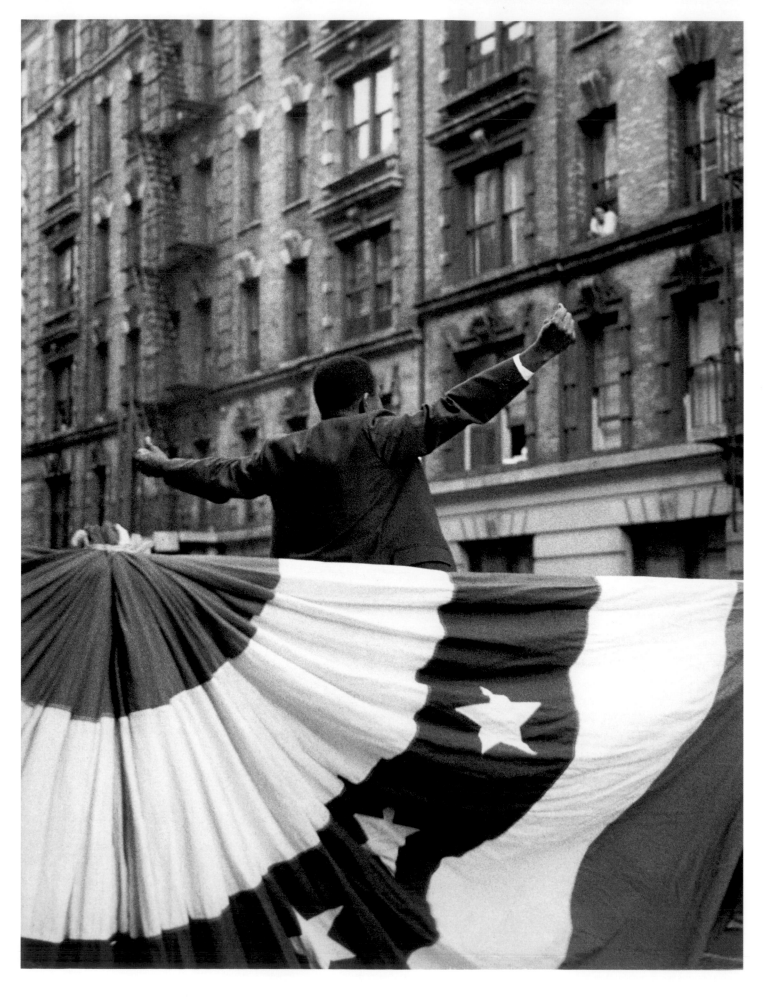

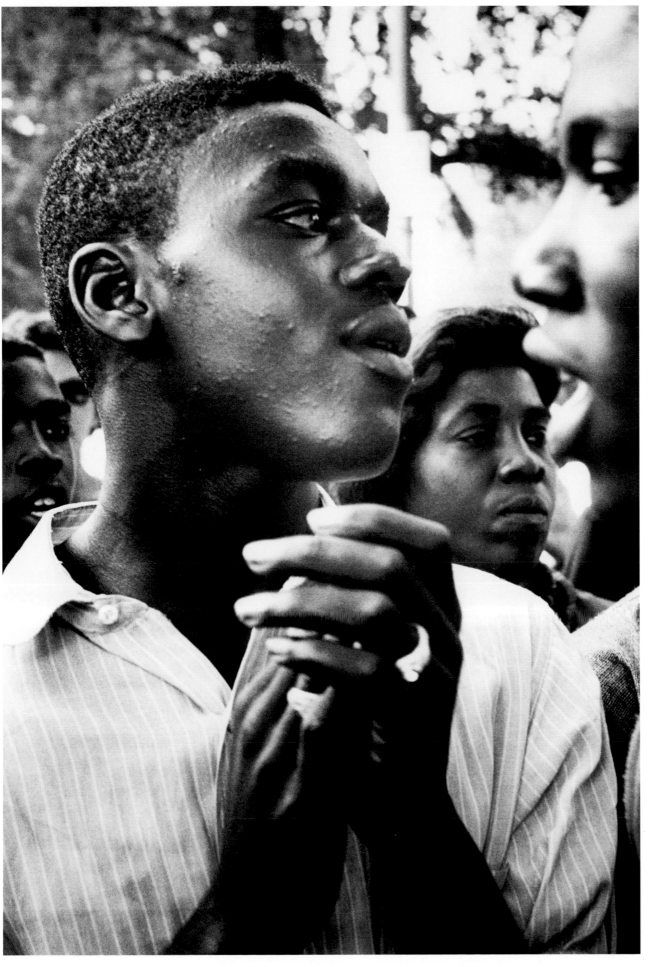

13. *Harlem, New York,* 1963
Political meeting in Harlem.

14. *March on Washington, Washington, D.C.,* 1963

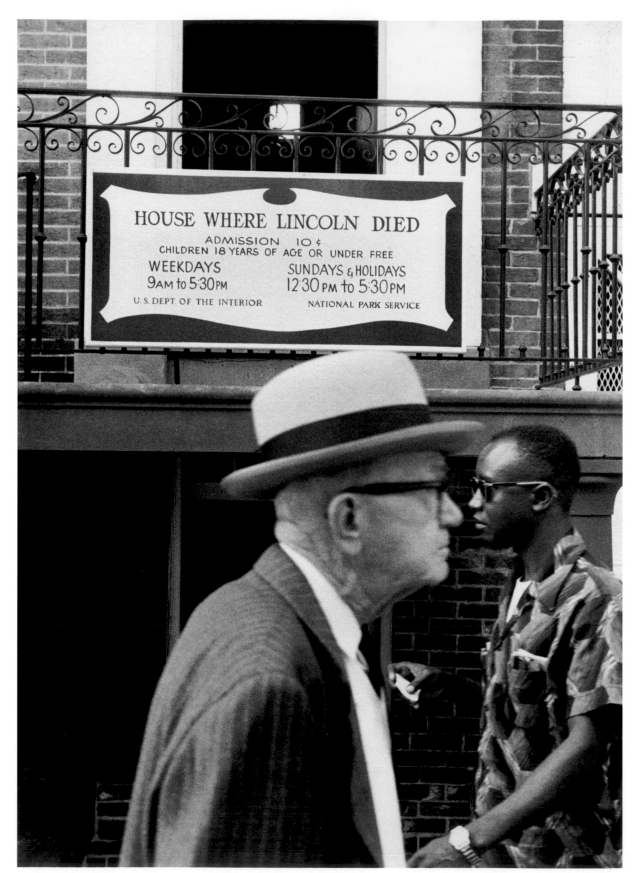

15. *Washington, D.C.*, 1963

16. *South Carolina*, 1965
In a poor cotton picker's cabin, far from the towns and cities where the civil rights agitation is taking place, a new force has entered the lives of the isolated Negro youths. Television, with its instant communication, direct to the living rooms of the poorest, has created a revolution the likes of which the world has not seen before. Television confronts today's Negro youth with a way of life completely at odds with his own experience. The richness advertised makes him acutely aware of the gulf separating his physical and moral condition from that of the whites. The faces he sees are those of whites speaking to whites and now white society has reached him in the depths of his innermost being. For the Negro youth there is now no flight; he is being forced to acknowledge his condition, to take note that he lives as a black in a white America. And he is in revolt.

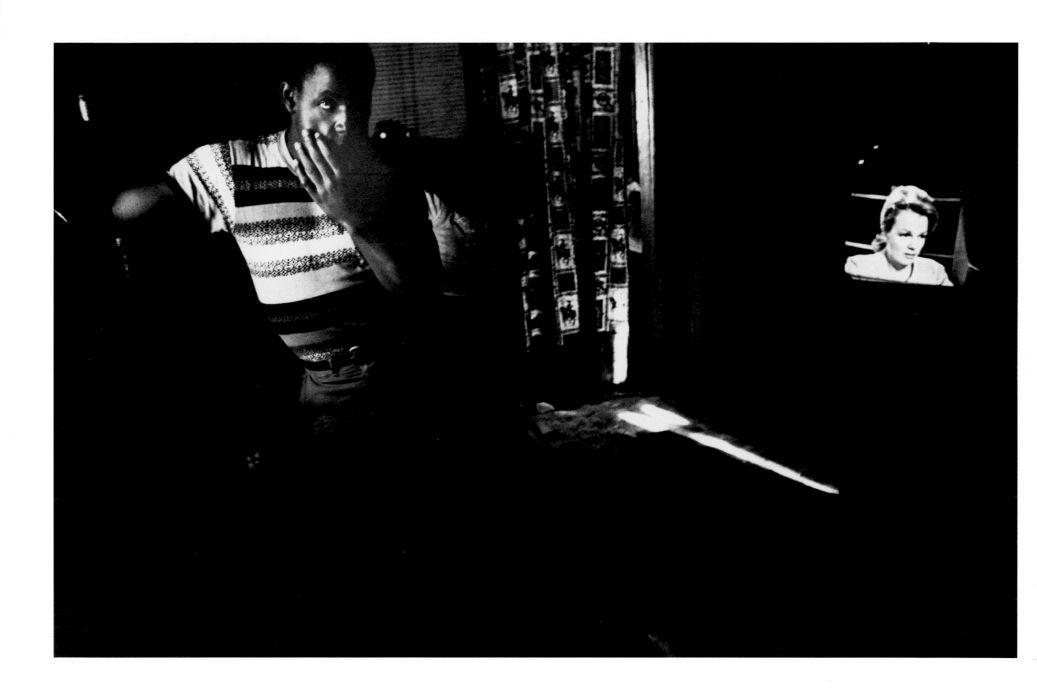

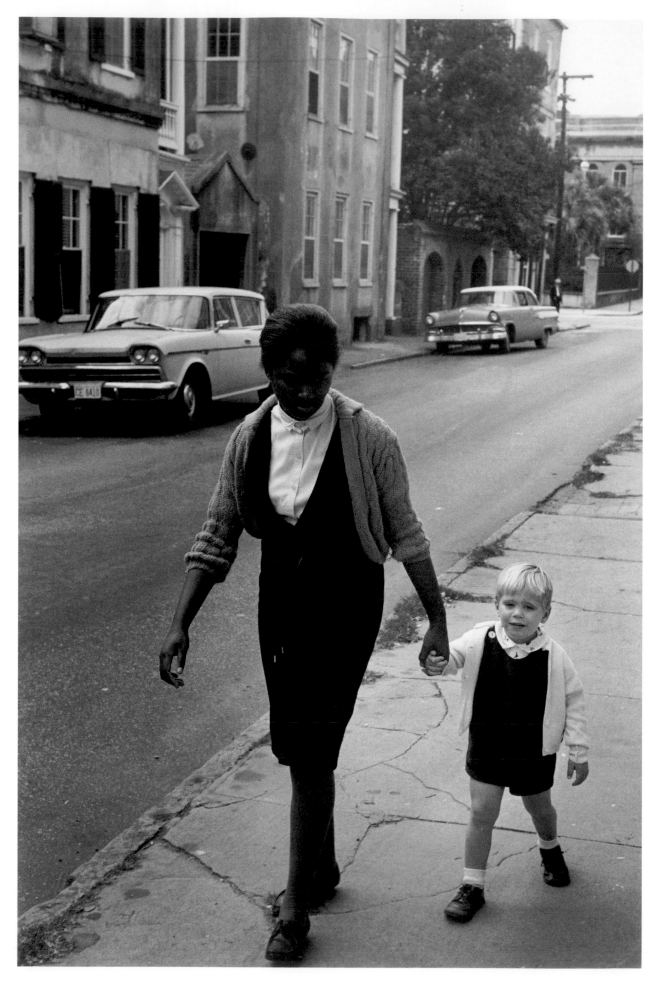

17. *Charleston, South Carolina,* 1964

18. *North Carolina,* 1965
"A few years ago the whites would have lynched me for sure, today they're afraid, afraid of stirring up a hornet's nest. Afraid the Supreme Court might nullify their laws. Afraid of the race riots that might result. Afraid to touch us for fear that others may do as we did. They know I can fight them, so they're afraid to prosecute or draw up a case against us; what they would like best is just forget we ever existed. They're afraid to say we're living in sin and afraid not to, for in this state it's criminal to have inter-racial marriages and we're criminals in their eyes. But the real crime is our having had to marry in Ohio, while my own state would like to lynch me."—age 23

19. *New Orleans, Louisiana,* 1965

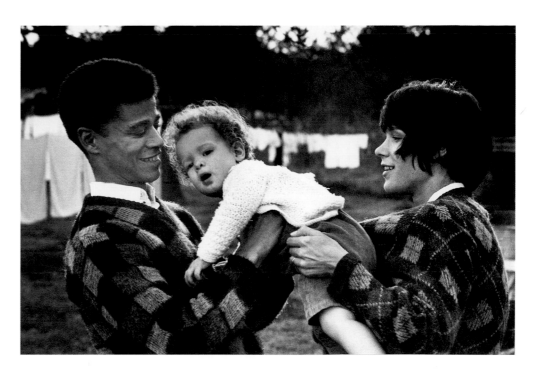

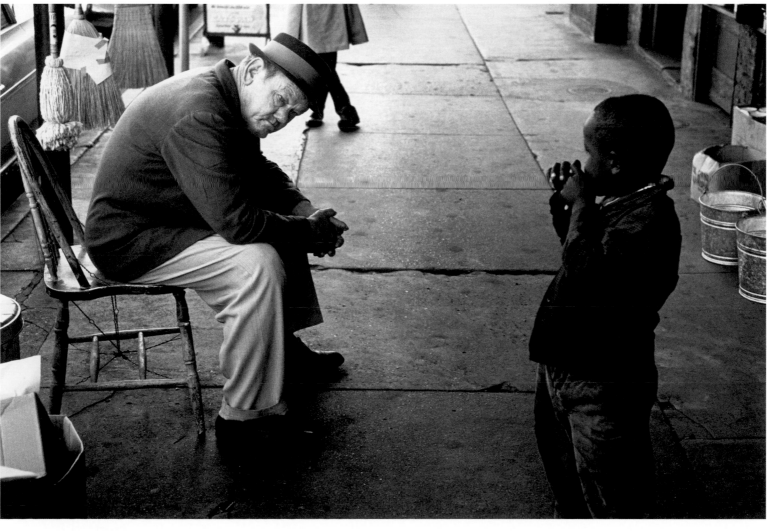

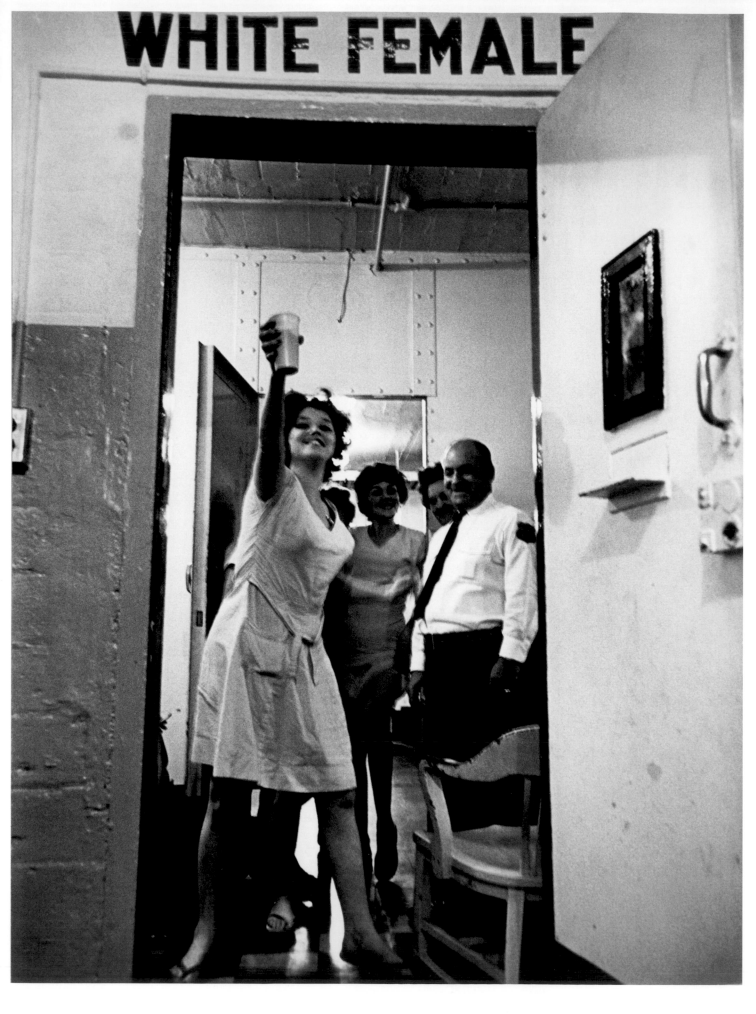

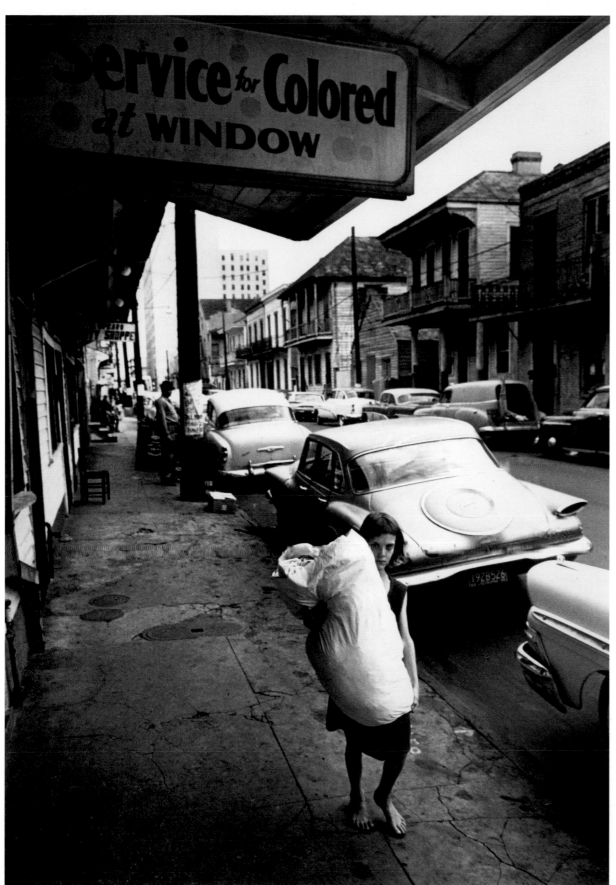

20. *New Orleans, Louisiana,* 1965

21. *New Orleans, Louisiana,* 1965
"Service for Colored at Window" is a sign on a local white bar. Negroes may buy bottled beer only through the window, they may not enter through the door. It is against the law to drink on the street.

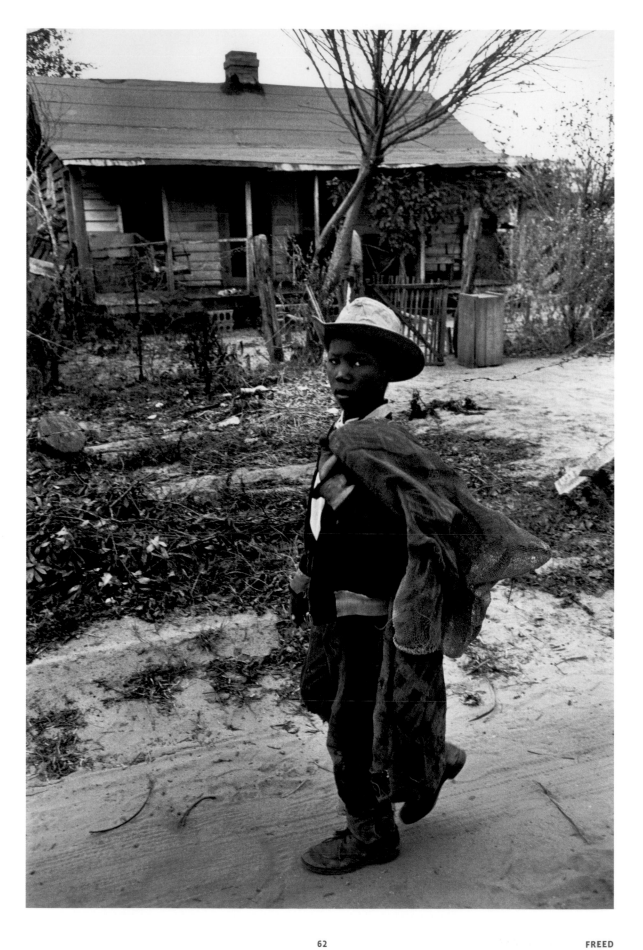

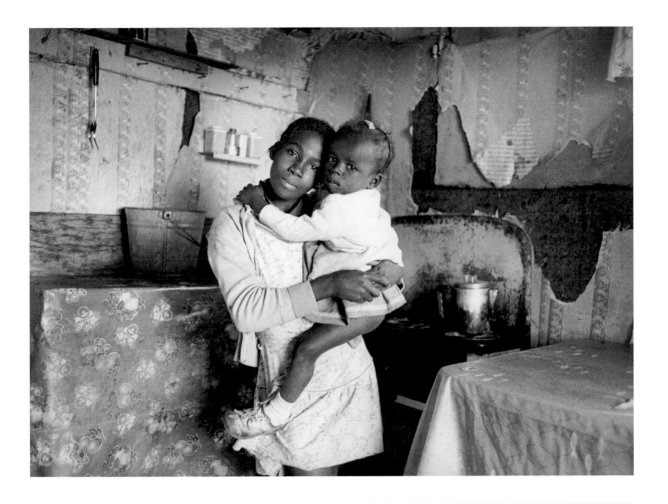

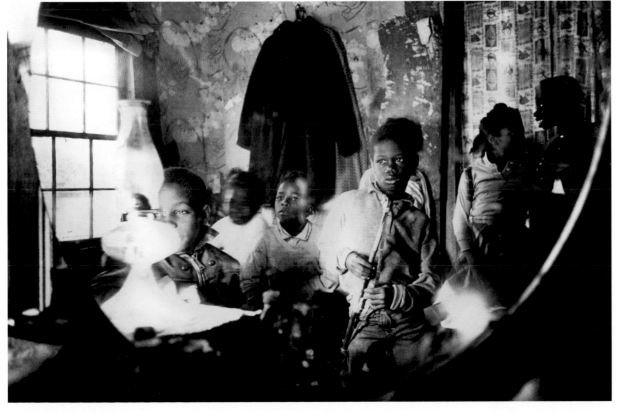

22. *South Carolina, 1964–65*

23–24. *Johns Island, South Carolina, 1964*

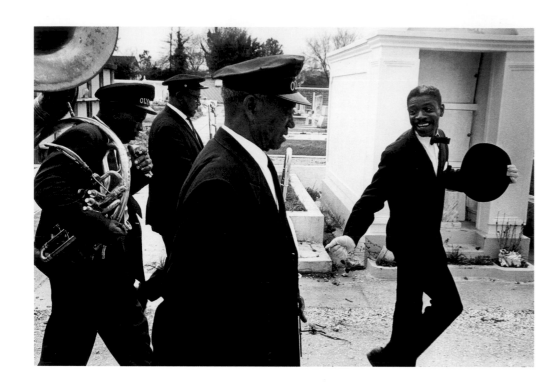

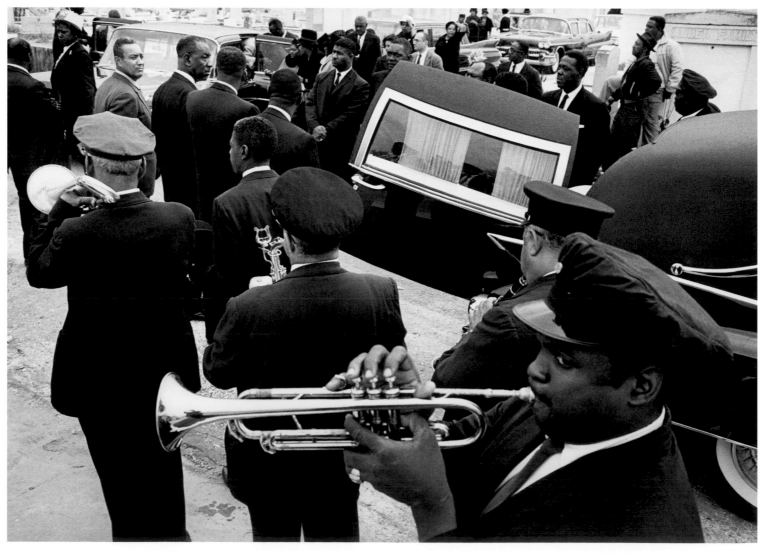

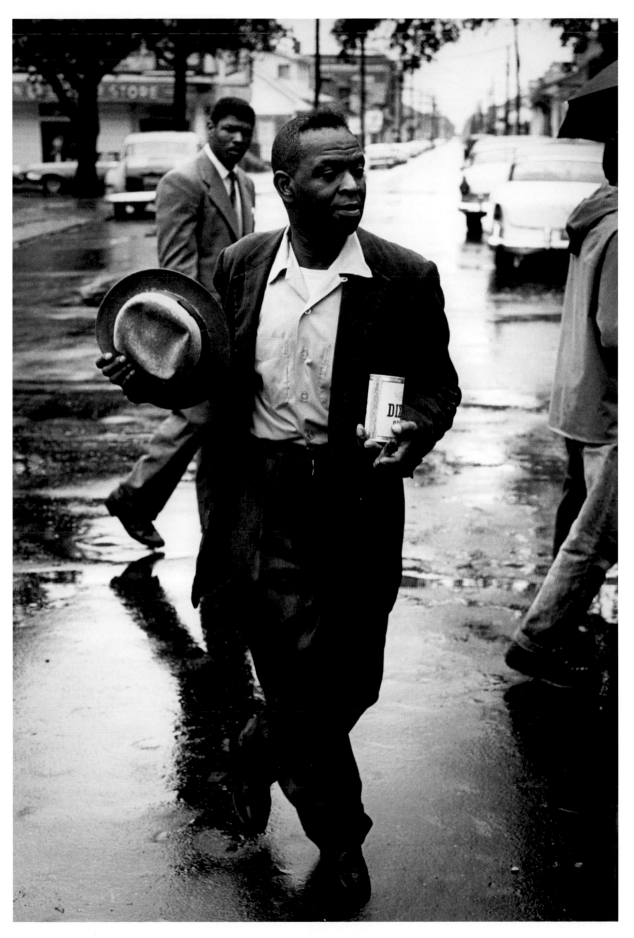

25–27. *Jazz Funeral, New Orleans, Louisiana, 1965*

28. *Florida, 1965*

29. *Johns Island, South Carolina, 1964*

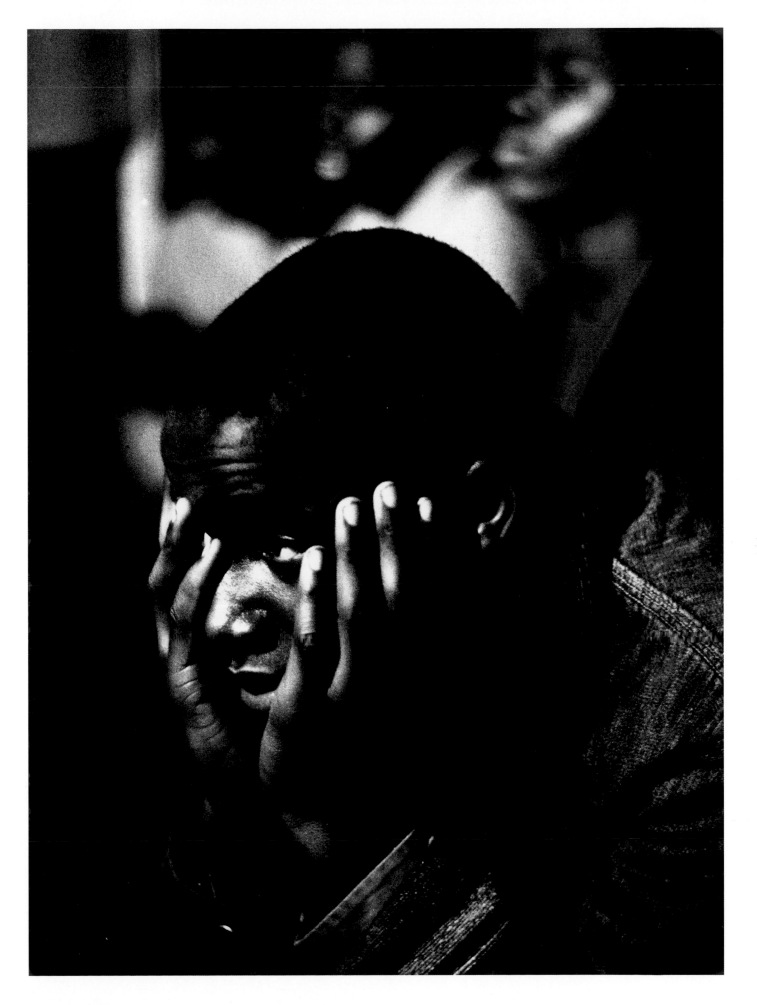

PHILIP JONES **GRIFFITHS**
VIETNAM INC.

A lifelong desire to leave the world a better place drove Philip Jones Griffiths (1936–2008),[1] whose work is marked by a fiercely independent approach, deep engagement with his subjects, and a skeptical view of authority. While he photographed around the world, his career has become indelibly associated with a single place, Vietnam, for his nearly forty years of coverage of its people. *Vietnam Inc.*, the photographer's critical 1971 account of America's armed intervention in that country, is one of the most detailed photographic stories of a war published by a single photographer.[2] The book made an impression when it was released, selling forty thousand copies in approximately three weeks.[3] High praise from noteworthy sources followed: Griffiths's Magnum colleague Henri Cartier-Bresson referred to it as "the best description of war since Goya," and *Time* magazine called it "the best work of photo-reportage ever published."[4] The project's exploration of the *why*, and not just the *what*, behind the war's failures made it a particularly engaging and ambitious work of advocacy journalism and a model to which many photojournalists still aspire today.

Born in Wales, Griffiths grew up in the small town of Rhuddlan, speaking Welsh until age five, when he learned English at school. *Picture Post*, one of the dominant news magazines of the era, was a staple in his home, and he recalled reading it religiously. In his teens, he began earning money by photographing weddings and printing his film in the family bathroom. Griffiths went on to study pharmaceuticals in Liverpool and subsequently took a job in London as the night manager of a pharmacy in Piccadilly Circus, working part time as a photographer during the day and selling pictures to the *Guardian*. In 1961, he was offered a contract by the editor of the *Observer* newspaper, which he accepted as a full-time occupation at the start of 1962. By the next year he was covering the Algerian War and accomplished his

first major scoop on the treatment of Algerian nationalists by the French military. In 1966 he joined Magnum as an entry-level nominee, becoming a full member in 1970 and later the organization's president from 1980 to 1985. With experience in war photography, he was well positioned to cover the Vietnam conflict. He arrived in the country in 1966 and spent the better part of the following five years working on a project to document the situation. It was his dedication during those years that resulted in the landmark publication, *Vietnam Inc.*

The Vietnam War was unusual for the freedoms allowed its reporters. Correspondents of allied and neutral countries could gain accreditation and receive free military transportation in the country without being subject to government censorship.[5] While writers could choose to remain in Saigon and investigate their stories through military briefings and word of mouth, photojournalists, by simple virtue of their craft, could only produce their reports by venturing into the field of action. Griffiths went out regularly, hitching rides with American helicopters en route to operation sites.

In *Vietnam Inc.* there is a relative paucity of photographs documenting the travails of American troops and the might of their military prowess. Certainly there were many stories to tell in Vietnam that related the horrors of war as experienced by the soldiers involved. Griffiths's English colleague Larry Burrows produced remarkable pictures of America's seemingly endless supply of helicopters and artillery, as well as tragic essays for *Life* magazine on soldiers who were wounded or killed in action, including his well-known coverage of the crew of Yankee Papa 13[6] and his color pictures of battle zones in the demilitarized zone (fig. 40). And certainly Griffths was in a position to tell the same kind of stories through his many airlifts around the country. But he had a different narrative in mind. In his viewfinder, America's advanced technological tools of warfare and

soldiers engaged in combat were less emphasized than Vietnamese civilians and a culture in crisis. In his retrospective book *Dark Odyssey* (1996), Griffiths explained: "The task, of course, was to see beyond the obvious. All wars produce the familiar iconic images of horror, which do little to further anyone's understanding of a particular conflict."[7] He later elaborated in an interview, "The 'bang-bang' aspect of any war is the least likely to offer any explanation of the underlying causes. My task is to discover the *why*, so it's the actions surrounding the battlefields that present the best clues."[8]

Griffiths's independent approach is remarkable because of its sensitivity to the people of Vietnam and its eschewing of a Western point of view. His book put the conflict in the context of the country's history and culture, showing the ways in which the capitalist values that America promoted in its efforts to contain the spread of communism were out of sync with Vietnam's predominantly communal and agrarian way of life. Vietnam, for Griffiths, became a "goldfish bowl where the values of Americans and Vietnamese can be observed, studied, and, because of their contrasting nature, more easily appraised." And in Griffiths's appraisal, it was America's "misplaced confidence in the universal goodness"[9] of its own values that would ultimately lead to an imperialist failure and, more importantly, the unjust devastation of a people.

In order to make his argument, Griffiths employed what he described as the peeling-onion principle. His book was constructed to elicit first an emotional response from the pictures, then to draw the reader in with layers of short and long captions, and then finally to reveal deeper conceptual issues through extended section texts. Its structure is that of a long-form photo essay, laid out in such a way that the rhythm of texts and images shifts on each page spread, delivering content in a fresh and varied way across its 224 pages and building upon itself with a clear sense of purpose. "I'm a journalist who produces stories. I'm a storyteller in the sense that I present the truth in an engaging way, rather like the way a lawyer would present evidence to a jury. There's a logic to it, I try to explain what's happening, using a narrative that leads to a convincing conclusion."[10]

The publication begins by describing the nature of Vietnamese village life, its values, and the logic of its hamlet structure, portraying it as a system worth emulating rather than annihilating (pls. 31–33). It moves on to discuss the military strategy of obliterating the village as a social unit, a tactic aimed at denying cover to the guerillas and at reconstructing Vietnamese society to be more like that of the United States, consolidating populations into urban environments and transforming them into a consumer-based society (pls. 36–43). Pictures depicting the rounding up of civilians (pl. 40), the attempts to distinguish and separate the supporters from the communists (pls. 41–43), the killing of

suspected Viet Cong (pl. 39), and the burning of villages (pl. 37) make up a significant portion of the publication. The way in which these relocation efforts resulted in an overpopulated urban environment in Saigon constitutes another major theme, with pictures documenting the sense of alienation brought on by city life, the proliferation of prostitution, and families living in cemeteries and makeshift shelters constructed from discarded military-supply boxes (pls. 44–48). If the one benefit of the new urban environment was the promise of safety, that too would be stripped away in 1968 with the beginning of the Tet Offensive, which brought the war from the jungle into the streets and led to the U.S. bombing of its own occupied cities in the south (pls. 49–52). The final, and perhaps most chilling, section of the book deals with the so-called automated war, in which troops were pulled back and an air campaign took center stage. In this section, Griffiths effectively juxtaposed pictures of the aircraft-carrier personnel responsible for the bombing with depictions of the civilian casualties, from whom they were far removed (pls. 56–60).

One way that Griffiths built his argument was by pointing out cultural slippages between occupier and occupied as a recurring theme, thereby demonstrating the way in which American policies of pacification—its attempt to manage and restructure the country's perspective on life—were culturally misguided and

ineffectual. The image of a soldier attempting to "teach" a meticulously clean people how to properly wash with soap and water (pl. 34) is indicative of the deep misunderstandings that Griffiths elaborated. He reported through his caption that, rather than being impressed by the superior American form of hygiene, the Vietnamese "could never understand why Americans restricted themselves to only daily washing." Moreover, one mother present at the demonstration realized that her vegetable bowl was being used as the wash basin and strode off with it, cursing "such disregard for the basics of cleanliness."[11]

Other relationships are depicted as similarly corrupted. Attempts of soldiers to endear themselves to the locals, handing out candy or, in the case of another photograph (pl. 35), cigarettes to children are revealed to be part of the Winning Hearts and Minds (WHAM!) program. In his captions, Griffiths described the manner in which the Vietnamese came to take advantage of the opportunities afforded by such interactions, "A pretty daughter can feed a family for days, producing a stockpile of gifts which a parent guards while she returns empty-handed for more."[12] Thus, what might at first seem to be spontaneous and sincere cultural encounters between soldiers and civilians are shown through Griffiths's lens to be both engineered as part of America's larger program of cultural hegemony

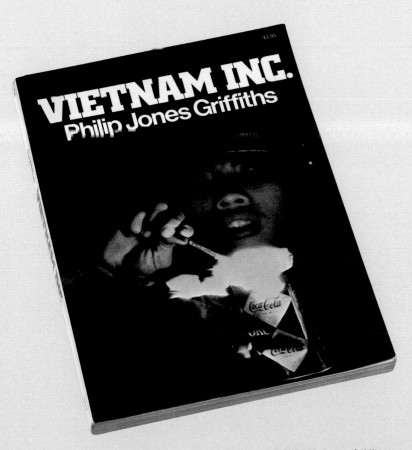

FIGURE 39. Cover of Philip Jones Griffiths, *Vietnam Inc.* (New York: Collier Books; and London: Collier-Macmillan, 1971).

and manipulated by Vietnamese adapting to their difficult situations. However, Griffiths did acknowledge a heartfelt search for friendship on the part of many American soldiers. One image (pl. 62) shows a GI sitting in a fatherly role with a young Vietnamese girl in his lap. They appear tired and bedraggled, huddled together for strength in a moment where cross-cultural humanity trumped the brutality of war, both the victims of a hopeless situation beyond their control. But Griffiths noted that the relationships developed were most often ones of convenience and necessity, quipping elsewhere in the book, in his characteristically skeptical tone, "It is estimated that more dogs than wives have been taken back to the United States by returning GIs."[13] Griffiths was careful, nonetheless, not to paint an ugly picture of the American soldier. In one photograph from the book, he showed a GI giving water from his canteen to a wounded Viet Cong, the soldier's sense of human dignity overriding the desire to exact punishment on his enemy. In the end, Griffiths's critical sights are not set on the soldiers so much as the policies they were expected to carry out.

While Griffiths's fault-finding approach to the conflict's problematic nature was in step with the general disapproval in America for the war, the pictures he made did not receive widespread publication in the press prior to their appearance in his book. This made his job all the more difficult, for financing the project was a serious obstacle. He was so low on money early on in his coverage that he considered leaving Vietnam, but in 1967 he managed to photograph Jacqueline Kennedy

in Cambodia with a British aristocrat rumored to be her romantic liaison, and the proceeds from that paparazzi venture allowed him to continue covering the war. In the end, his completed book demonstrated that war photojournalism did not need to be driven by the agendas of the magazine industry. A large-scale project like *Vietnam Inc.* could be independently approached and thoughtfully compiled into book form while its topic was still relevant, allowing it to both participate in the dialogue about current events and document them in an enduring fashion for the historical record. It was not a journalism aimed at competing for the morning headlines; instead, it was a timely editorial investigation, led by pictures, of a problem that was far from over. Along with Freed's *Black in White America* and the Smiths' *Minamata*, it is among the earliest books of a classic journalistic nature with the photographer in complete authorial control over its direction.

While Griffiths went on to photograph other events around the world, including the 1973 Arab-Israeli conflict, Vietnam was the country to which he would return multiple times over the course of his career. As a coda to *Vietnam Inc.*, Griffiths published the disturbing book *Agent Orange: Collateral Damage in Vietnam* (2004), which explores the deformative effects of Agent Orange, the defoliant herbicide used by the military to deprive its enemies of jungle cover, on the children and grandchildren of those exposed to it. The following year, he published the book *Vietnam at Peace* (2005, fig. 41), a summation of his thirty years of engagement with the country's postwar reconstruction.

NOTES

1. Philip Jones Griffiths, *Recollections* (London: Trolley, 2008).

2. Griffiths, *Vietnam Inc.* (New York: Collier Books; and London: Collier-Macmillan, 1971).

3. Simon James, "Vietnam: The Truth as We See It," *RPS Journal* 141, no. 8 (October 2001): pp. 344–47; and "Phillip Jones Griffiths, 1936–2008: Photojournalist showed the face of modern warfare to the world," *Los Angeles Times*, March 25, 2008, p. B8.

4. "Philip Jones Griffiths, 1936–2008" (note 3), p. B8.

5. Murray Sayle, introduction to *Dark Odyssey* (New York: Aperture, 1996), n.p.

6. *Life* (April 16, 1965).

7. Griffiths, Maelstrom section of *Dark Odyssey* (note 5), n.p.

8. Griffiths, in William Messer, "Presence of Mind: The Photographs of Philip Jones Griffiths," *Aperture*, no. 190 (spring 2008): p. 60.

9. Griffiths, *Vietnam Inc.* (note 2), p. 4.

10. Griffiths, in Chris Boot, ed., *Magnum Stories* (London: Phaidon Press, 2004), p. 202.

11. Griffiths, *Vietnam Inc.* (note 2), p. 162.

12. Griffiths, *Vietnam Inc.* (note 2), p. 28.

13. Griffiths, *Vietnam Inc.* (note 2), p. 33.

The following pages reproduce a selection of photographs from Griffiths's Vietnam Inc. project, along with excerpts of related captions and texts from the original publication and Magnum's archive.

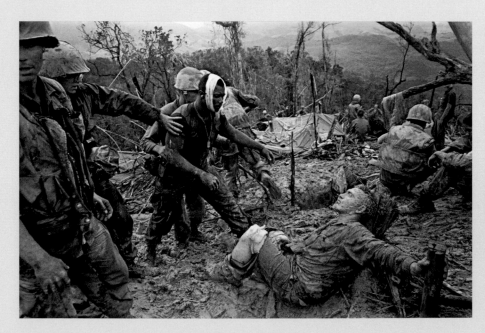

FIGURE 40. Larry Burrows (British, 1926–1971), *Mutter Ridge, Nui Cay Tri, South Vietnam*, 1966 (printed 1987). Dye transfer print, 45.9 × 70 cm (18³⁄₁₆ × 27⁹⁄₁₆ in.). JPGM 2004.154.

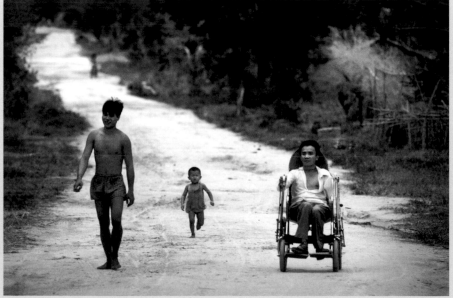

FIGURE 41. Philip Jones Griffiths (Welsh, 1936–2008), *VIETNAM. A soldier who worked on the Ho Chi Minh Trail and was wounded in the spine by fragments from an anti-personnel bomb in his wheelchair near the village of A Loei*, 1980. From the series Vietnam at Peace. Courtesy of The Philip Jones Griffiths Foundation/Magnum Photos, Inc., NYC47869.

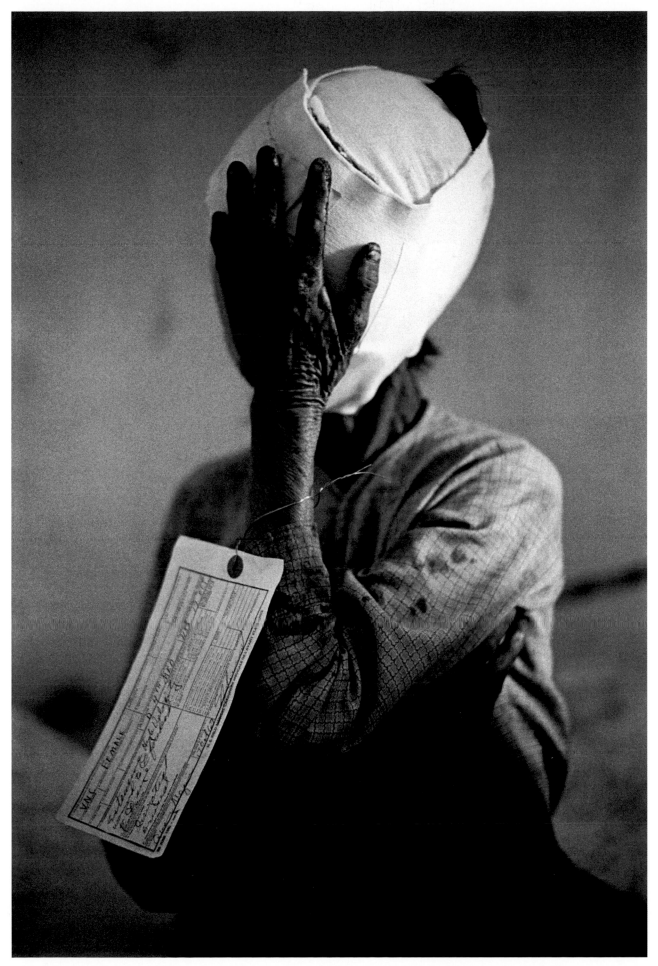

30. *Quang Ngai, Vietnam,* 1967
Quaker amputee center. This woman was tagged, probably by a
sympathetic corpsman, with the designation VNC (Vietnamese civil-
ian). This was unusual. Wounded civilians were normally tagged
VCS (Vietcong suspect) and all dead peasants were posthumously
elevated to the rank of VCC (Vietcong confirmed).

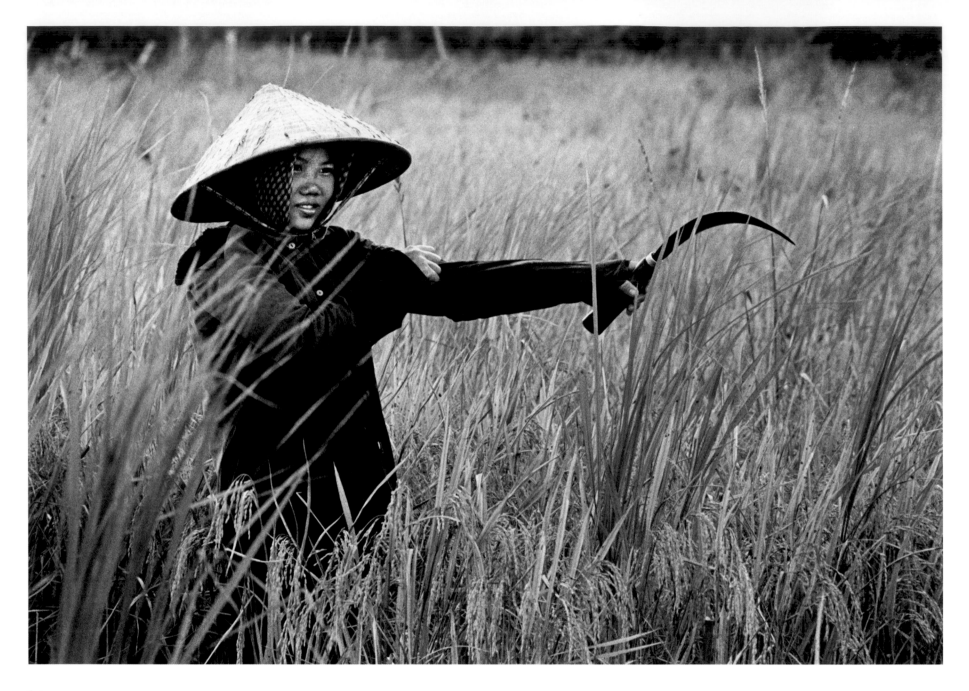

31. *Vietnam,* 1970
Rural Life

Rice is the staple diet. But it is more than food to the Vietnamese—it is their purpose for existing. A symbiosis exists between the society's religious beliefs (its moral values) and its task of growing rice. To a Vietnamese, each meal has some of the significance that eating Communion bread has for a Catholic. Nowadays, American rice has to be sent to Vietnam to feed those driven from the land. The people hate it; they try to sell it for pig food to get money to buy what Vietnamese rice is available. (It is, of course, perfectly wholesome—but so is canned dog food, which no American would eat however many vitamins it contained.) With as much as half (according to one report) of the arable land rendered barren by U.S. defoliation, plus the destruction of dikes and also the "free-fire" zone designation which prevents the people from working it, Americans now place great importance on the introduction of new "miracle" rice strains to increase production on the remaining land. In this way it is hoped that the people will have less need to return to the land from which they were forcibly removed.

32. *Vietnam,* 1970
The peasants spend most of their lives in their rice fields and when they die they are buried there. Thus, they believe their spirits will pass through the soil into the rice when they die, so that their souls will be inherited by their descendants when the rice is eaten.

33. *Vietnam,* 1970
The oldest and the most venerated man in the village with his great-grandchildren. Torn posters describing the life of Buddha adorn the wall. The childrens' mother left the village to "work" for the Americans. Being just as beautiful as their mother, her daughters are destined to follow.

34. *Danang, Vietnam,* **1967**
Personal hygiene—particularly that of the Vietnamese—was always
a matter of great concern to Americans. Every American seemed quite
convinced the people were somehow "unhygienic." On the other
hand, the Vietnamese, who found it necessary to bathe three times a
day, could never understand why Americans restricted themselves to
only daily washing. The Marine was demonstrating to bored mothers
how to bathe a child. One mother realized the Marine was using her
vegetable dish to stand the boy in and, to the embarrassment of the
other Marines, grabbed the dish and strode off, cursing such disregard
for the basics of cleanliness.

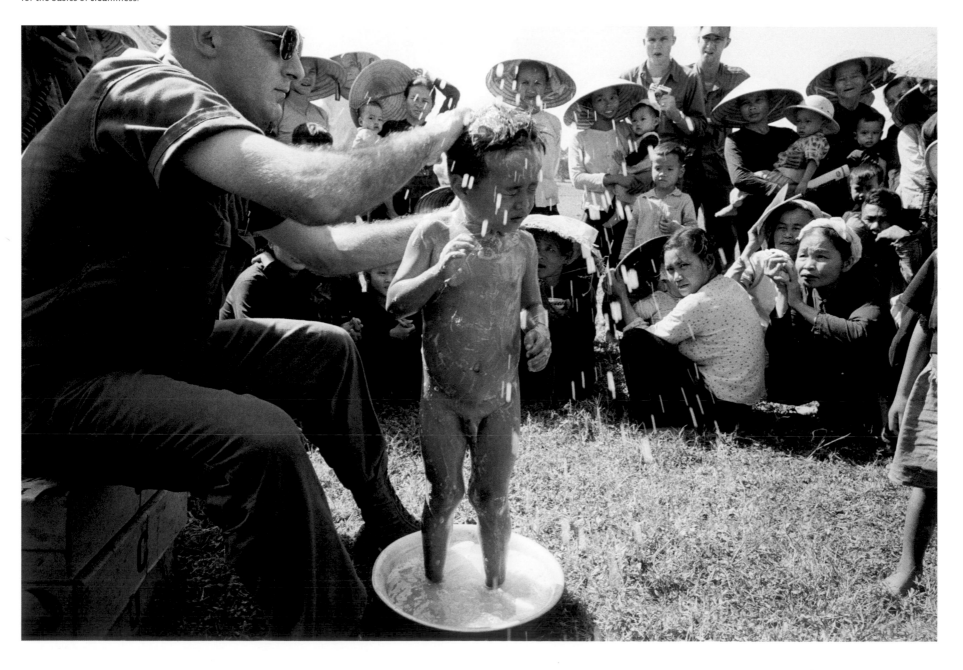

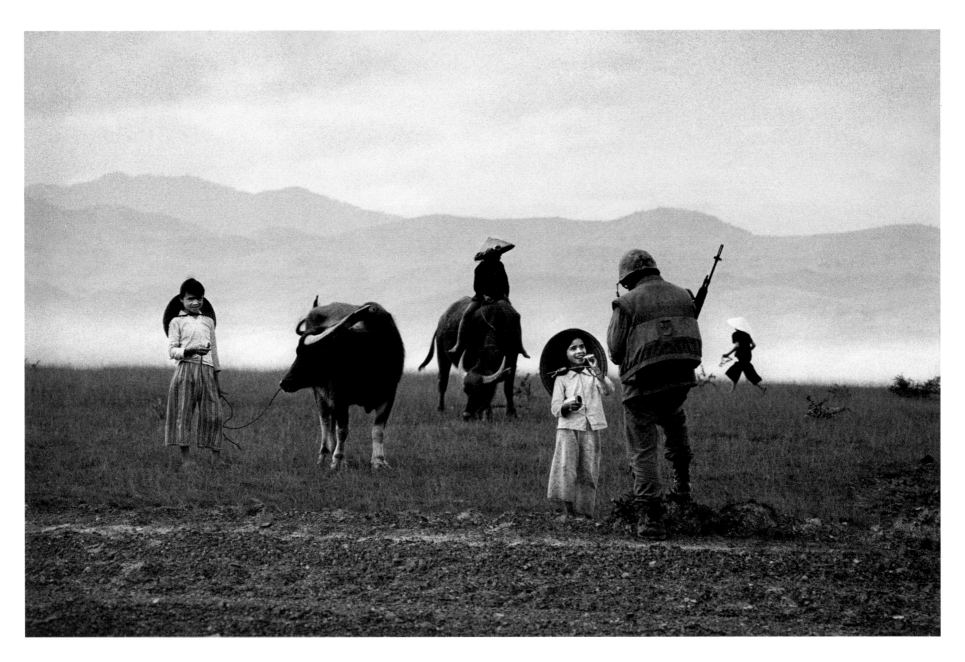

35. *Vietnam,* 1967

Limits of friendship. A Marine introduces a peasant girl to king-sized filter-tips. Of all the U.S. forces in Vietnam, it was the Marines that approached "Civic Action" with gusto. From their barrage of handouts, one discovers that, in the month of January 1967 alone, they gave away to the Vietnamese 101,535 pounds of food, 4,810 pounds of soap, 14,662 books and magazines, 106 pounds of candy, 1,215 toys, and 1 midwifery kit. In the same month they gave the Vietnamese 530 free haircuts.

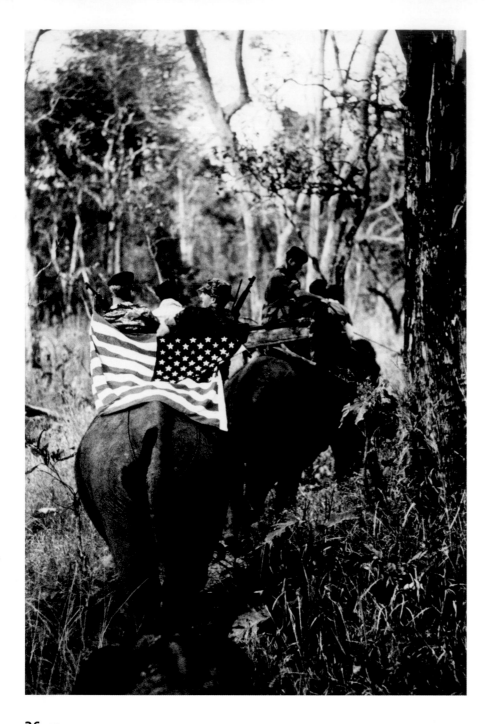

36. *Vietnam,* 1970
Soldiers never marched, they hunted "Cong" by helicopter or even
on elephants (beflagged, for U.S. pilots shoot all elephants as VC).

37. *Song Tra, South Vietnam,* 1967
The "Zippo" Squad, named after the cigarette lighter used to ignite homes.

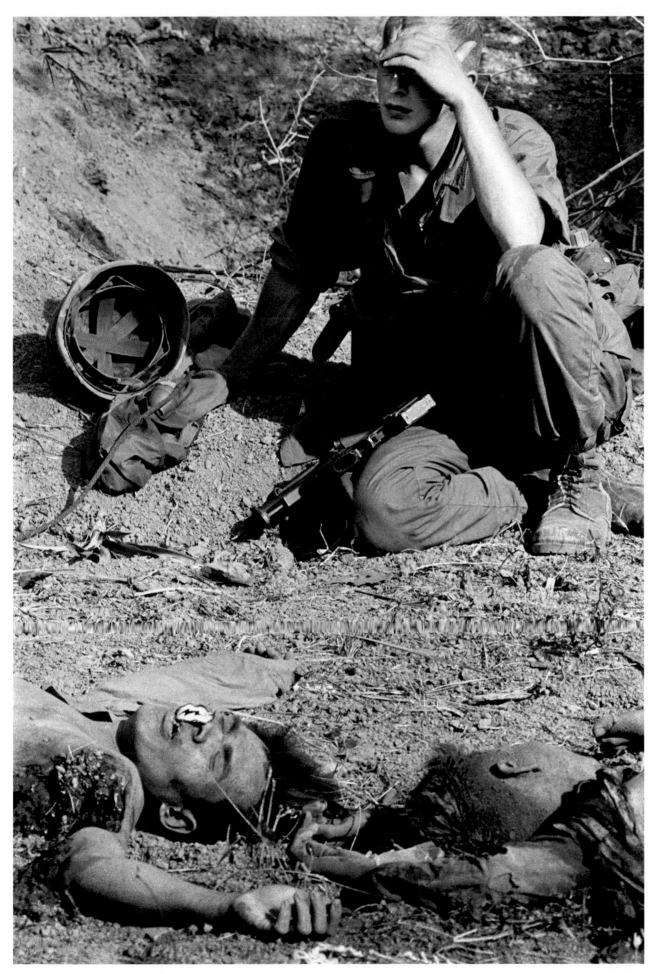

38. *Quang Ngai, Vietnam,* 1967
Men of the "Tropic Lightning," the 25th Infantry Division, leave their "visiting cards"—torn-off shoulder patches depicting the division's emblem, a bolt of lightning—stuffed in the mouths of people they kill

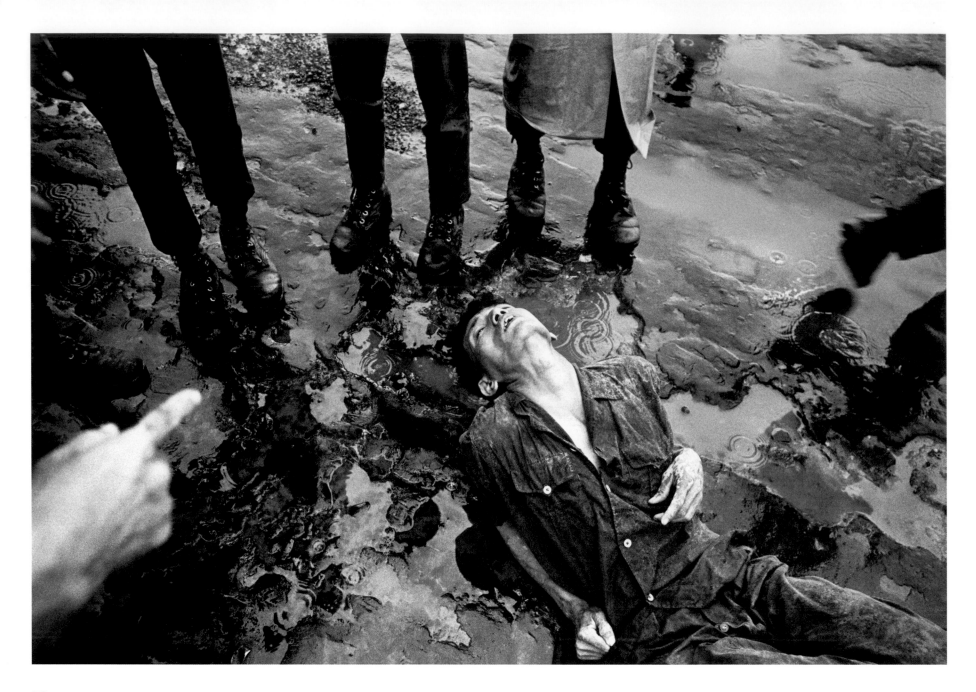

39. *Cambodia*, 1970

Captured Vietcong. It is difficult to avoid the conclusion that the effect of American involvement in Vietnam has been to differentiate the most admirable Vietnamese from the most deplorable. The values that the Vietnamese regard highly are possessed almost exclusively by the Vietcong. These values are nowhere better set down in writing than in the national poem *Kim Van Kieu,* which is a veritable handbook on the Vietnamese psyche, yet is virtually unread by Americans. In it is chronicled the life of the heroine, Thuy Kieu, with whom the Vietnamese, as a nation, identify. In her adventures, mostly sad, can be seen the moral blueprint which all Vietnamese live by. These values are either unknown to or trampled over by Americans, who are anxious to replace them with those for a new society built up of individuals "motivated" by personal greed. The ARVN are earmarked to be part of this new society. These soldiers, unable or unwilling to resist the easy life afforded by the ARVN (compared with fighting

for the Vietcong), harbor a deep resentment toward their "masters," the Americans, as foreigners who are trying to divide Vietnam.

For the captured Vietcong shown here there is no equivocation. They are firmly set in the honorable tradition of sacrificing one's life for one's country....

As Thuy Kieu declared in the poem:

It is better that I should sacrifice myself alone,
It matters little if a flower falls if the tree can keep its leaves green.

40. *Quang Ngai, Vietnam,* 1967

Mother and child, shortly before being killed. A unit of the American Division operating in Quang Ngai Province six months before My Lai. The resentment was already there: this woman's husband, together with the other men left in the village, had been killed a few moments earlier because he was hiding in a tunnel. After blowing up all tunnels and bunkers where people could take refuge, GI's withdrew and called in artillery fire on the defenseless inhabitants.

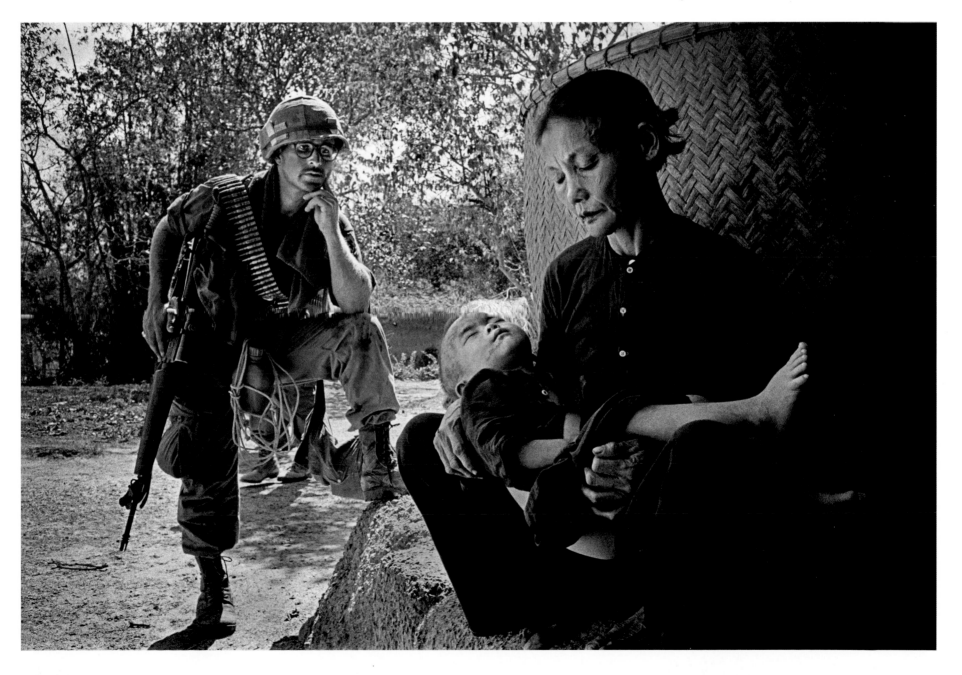

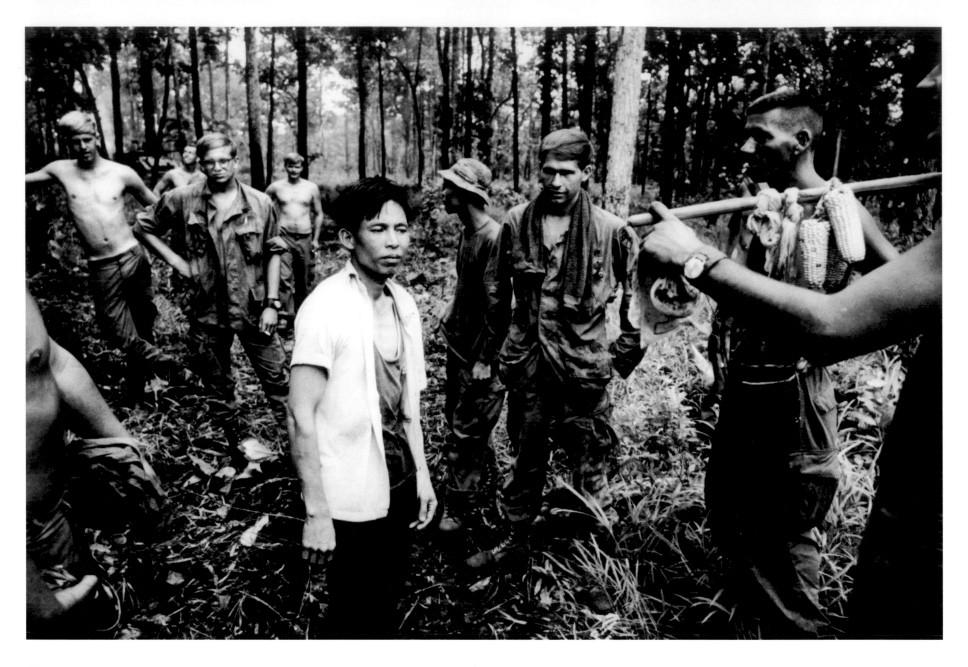

41. *Cambodia,* **1970**
The enemy. His lack of equipment is a constant source of wonder to
the GI's. Surrounded, this Vietcong "defected," in the best Maoist
tradition. Caught in the wires of an "automatic ambush," he produced
a Chieu Hoi (safe conduct) pass to classify himself as a "rallier" to the
GVN side.

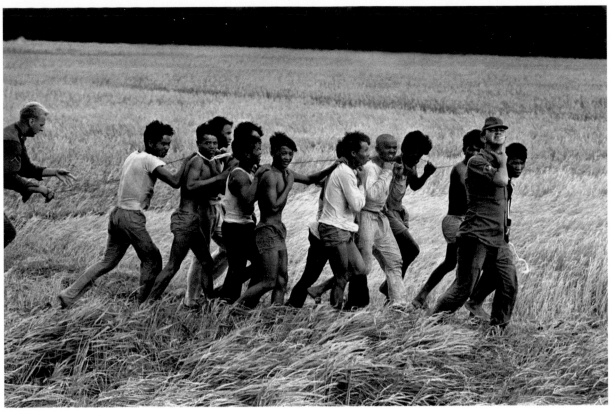

42. *Quin Hon, Vietnam,* 1967
Captured suspects. Anyone who was male and between 15 and 50 was automatically assumed to be Vietcong and treated as such. After the traumatic experience of being arrested and then "interrogated," any person released would quickly want to join the Vietcong.

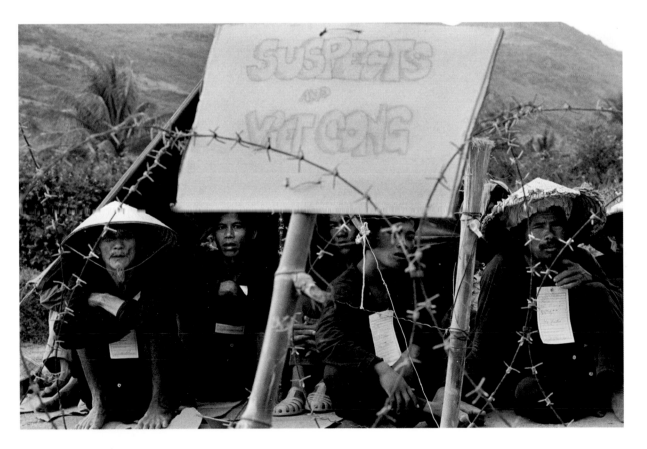

43. *Quin Hon, Vietnam,* 1967
Villagers were rounded up, often taking with them only what they could carry.... Any male villagers were usually held for days for interrogation. The sign was incorrect, for the only VC [had already] escaped during the night.

44. *Saigon, Vietnam,* 1970
Graveyards were taken over by newly arrived residents in the congested towns and cities. (Saigon is said to have the highest population density of any city in the world.) Despite living conditions in the urban centers, the inhabitants could constantly console themselves that at least they were safe from the death being rained down on those who remained in the countryside. Somehow, amid the overcrowding, the rats, and the disease, they survived, even with a certain poise....

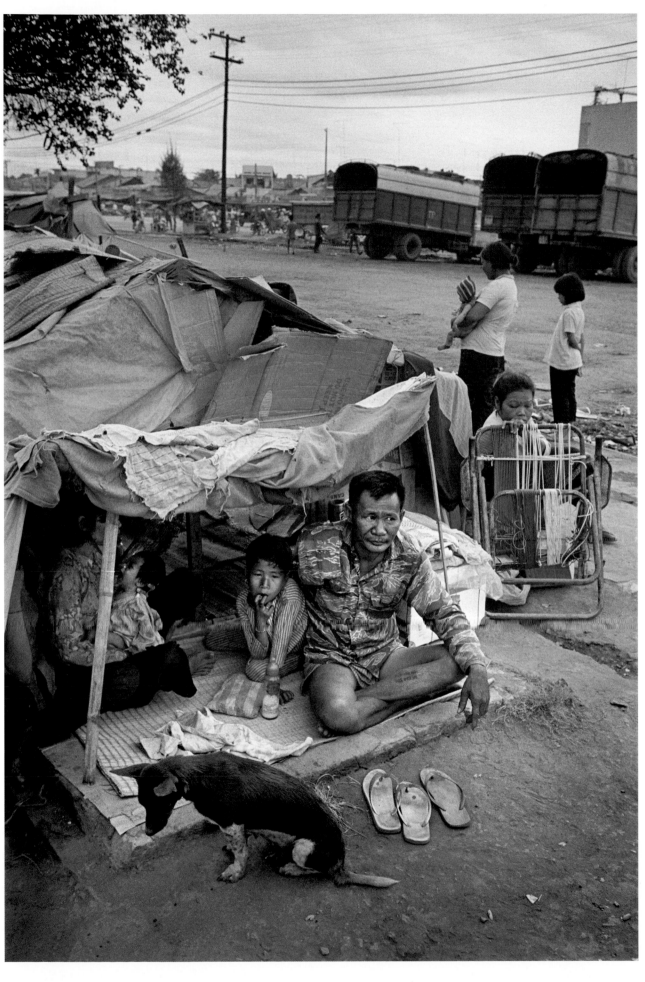

45. *Can Tho, Vietnam,* 1970
The main square in the center of Cantho where families live in shacks
made from old C-ration boxes.

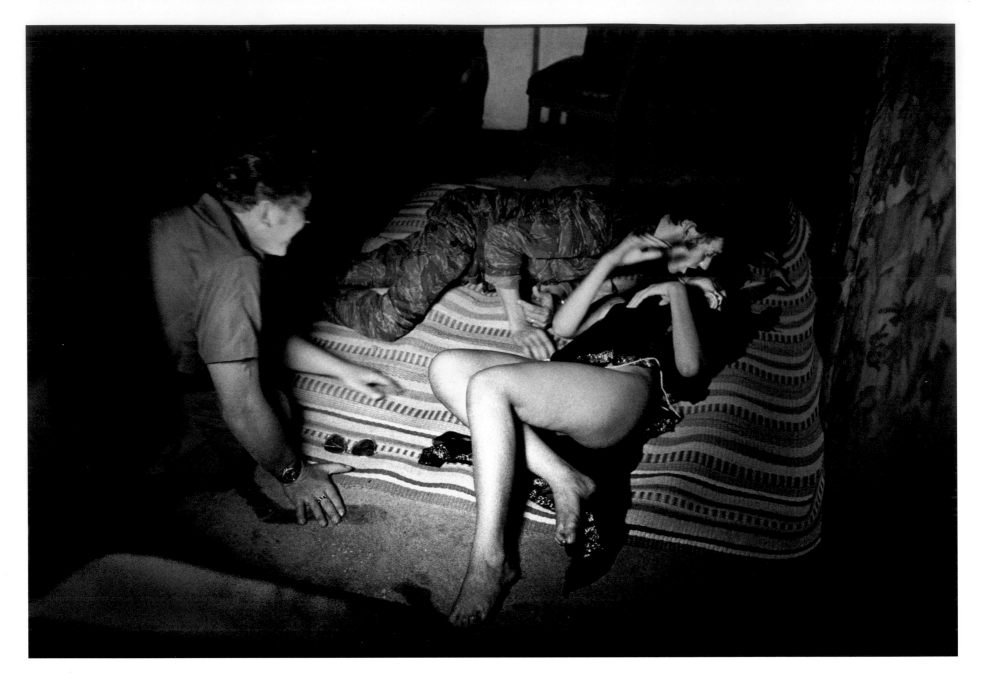

46. *Nha Be, Vietnam,* **1970**
In a society where women are traditionally revered for their poise and purity, the wartime conditions effectively dehumanized them. This girl was dancing for a group of U.S. Navy personnel on a makeshift stage (the officer's reviewing stand) when she was joined by two unwelcomed spectators.

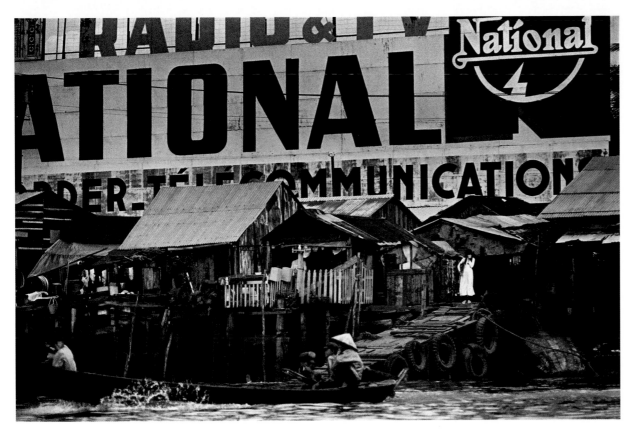

47. *Salvades Bar, Saigon, Vietnam,* 1970
Saigon waterfront. In keeping with its position as the fountainhead of consumerism in Vietnam, its homes are dominated by advertisements. The drive is to replace the traditional status values of the village—such as writing great poetry—with new ones like owning a TV set.

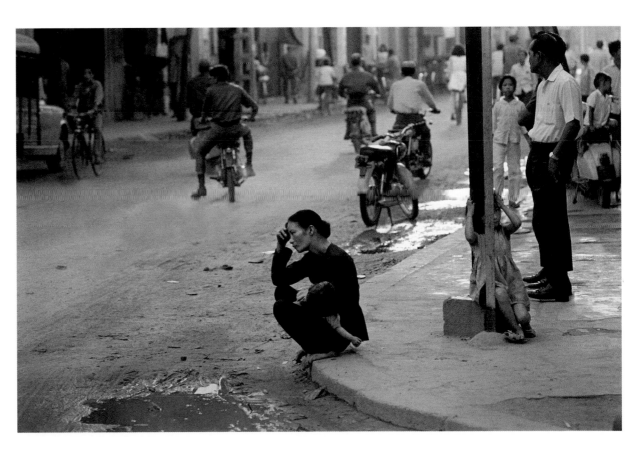

48. *Vietnam,* 1967
The main street in Nhatrang.

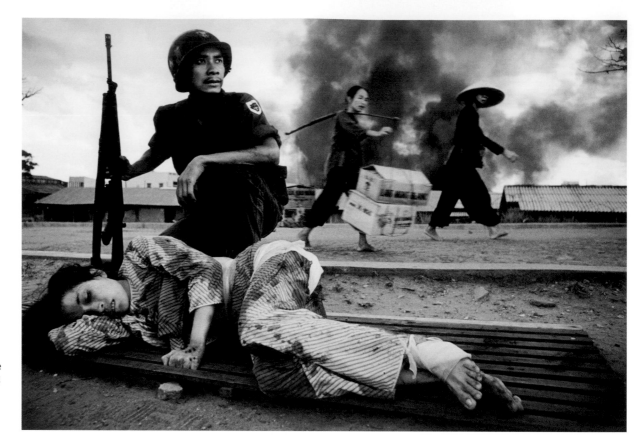

49. *Saigon, Vietnam,* **1968**
The battle for Saigon. U.S. policy in Vietnam was based on the premise that peasants driven into the towns and cities by the carpet-bombing of the countryside would be safe. Furthermore, removed from their traditional value systems, they could be prepared for the imposition of consumerism. This "restructuring" of society suffered a setback when, in 1968, death rained down on the urban enclaves.

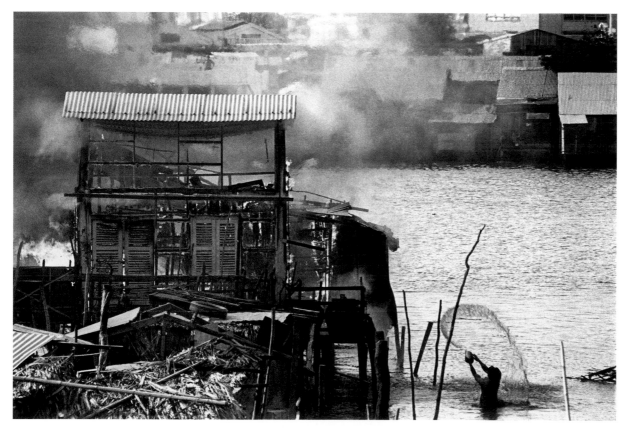

50. *Saigon, Vietnam,* **1968**
Fires were started deliberately to drive out the VC, occasionally with napalm, but usually one helicopter tracer bullet was enough. The United States has given the Saigon government a fleet of fire engines, but they are too wide to enter the narrow streets where most people live.

U.S. troops were used to retake Saigon, but only after ARVN soldiers had first tried and failed.... The U.S. troops were from the 9th Division and had spent the whole of their tour wading through the mud of the delta. Some GI's were amazed to see multi-story buildings, and many were sobered by the realization that they were destroying the homes of people who, in some cases, enjoyed a higher standard of material comfort than they themselves did in America. The looting was staggering. The ARVN, who had entered the areas first, had taken everything that could be carried by hand. The GI's, with their APC's, were able to take away refrigerators, TV sets, and other heavy items. Each evening they could be seen unloading their vehicles for sleeping. This procedure had been made a rule after two GI's were killed by an enemy mortar round on the first night because their APC was so full they had had to sleep outside.

51. *Saigon, Vietnam,* 1968
The battle for Saigon.

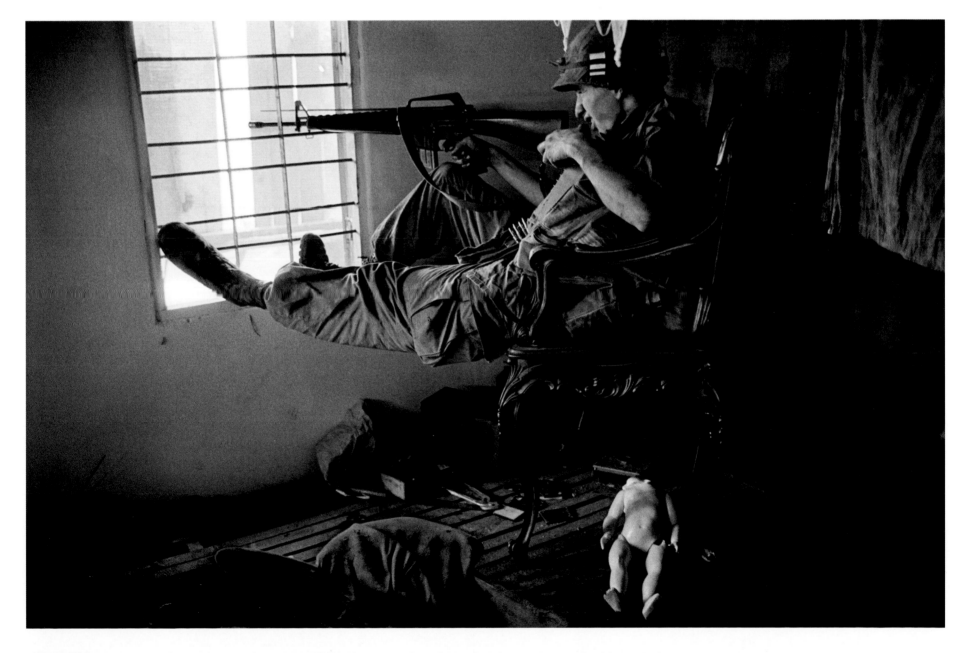

After the fighting was over, the people were allowed to return to their former homes—or rather what was left of them. The government paid each owner twenty dollars compensation, that is if the owner was still alive. The high number of civilian casualties was in part due to the fact that Vietnamese homes offer little protection from the large-caliber bullets which are fired by helicopters. Most houses have thin tin roofs and the walls are made of the fragile hollow bricks favored by the Vietnamese because they keep the houses cool. Unlike the peasants in the countryside, the people of Saigon felt no need to build bunkers under their homes for they never anticipated being bombed and strafed.

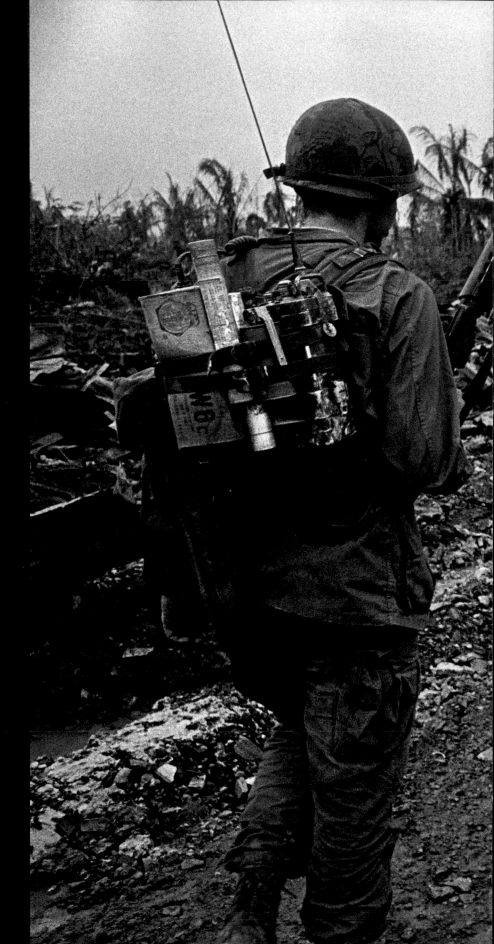

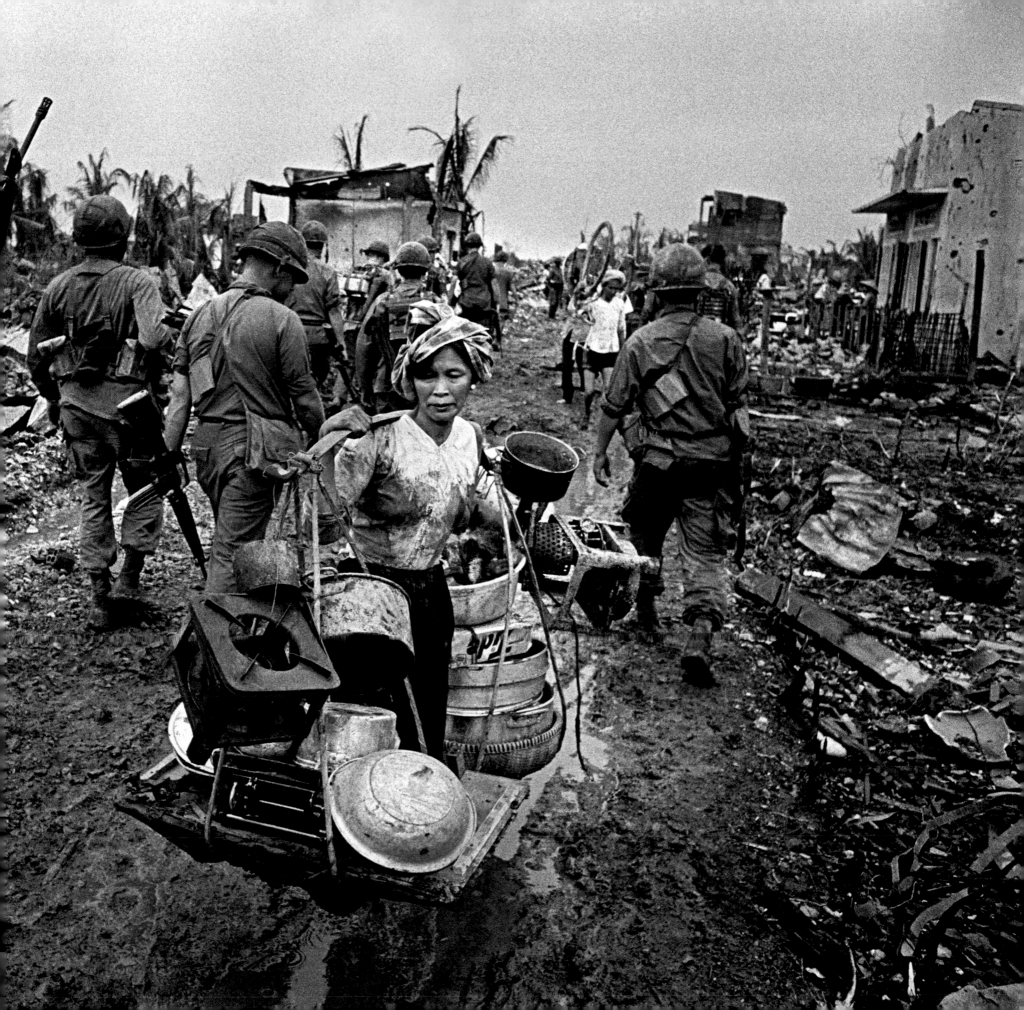

53. *Vietnam,* **1970**
The computer that "proves" the war is being won. Data collected for the "Hamlet Evaluation System" is analysed by it to "see who loves us." Optimistic results on the "my-wife-is-not-trying-to-poison-me-therefore-she-loves-me" pattern are reliably produced each and every month.

54. *Vietnam,* **1970**
H.E.S. Program, MACV headquarters, Tan Son Nhut Airport. These are MACV (Military Assistance Command, Vietnam) personnel who were lectured monthly on the progress of pacification.

55. *Vietnam*, 1971

The Automated War. Back in the United States, dead GI's gave the war a bad name, so that by 1968 Nixon's electioneering pledge had to include a promise "to bring the boys home." The efficacy of air power in depopulating the countryside was indeed so great that this promise was easy to keep. But not until the Cambodian invasion of 1970 did the military leaders finally grasp the futility of employing American ground troops. GI's were never needed—a company of Girl Scouts would have sufficed, provided they could use a radio and a map to inform the pilots when fired at by the enemy. By today, even this function is obsolete, for there now exist electronic sensing devices whose information is passed through computers that automatically launch artillery or air-strikes.

The shape of things to come was predicted by General Westmoreland in 1969: "...enemy forces will be located, tracked and targeted almost instantaneously through the use of data links, computer-assisted intelligence evaluation, and automatic fire control. With first round kill probabilities approaching certainty, and with surveillance devices that can continually track the enemy, the need for large forces to fix the opposition physically will be less important."

Aircraft carriers are an integral part of the new warfare—they are the United States' invulnerable sanctuaries on the sea. They have never been attacked by the enemy but still have many casualties through accidents. This man walks through flames in his asbestos suit to rescue pilots.

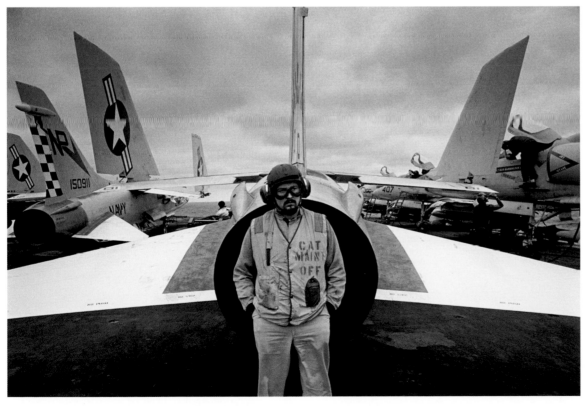

56. *Vietnam*, 1971

"Yankee station" is the area in the South China Sea where the United States carriers position themselves for bombing runs on Vietnam. The sailors and the pilots on board have never been to Vietnam. They have never seen the faces of their victims, the Vietnamese people.

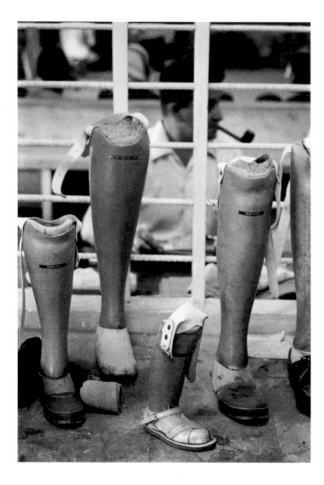

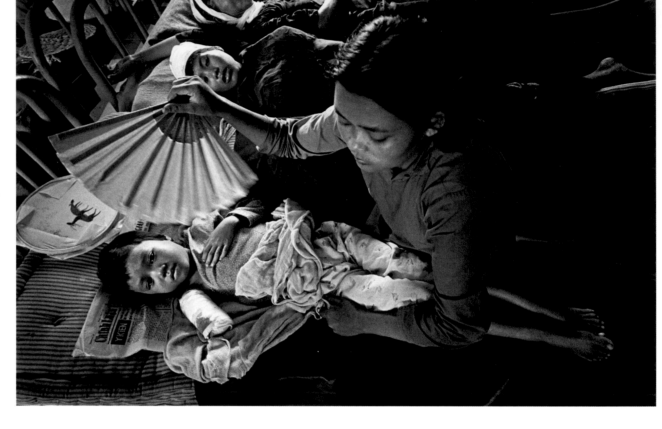

57. *Vietnam,* **1967**
Amputees are fortunate if they can get fitted with artificial limbs. There are only three centers in all of South Vietnam, and only one of these, the one run by the Quakers, is situated where it is most needed—in this case, in battle-scarred Quang Ngai Province where casualties abound.

58. *Vietnam,* **1967**
The wounded. Perhaps nothing more clearly reveals the extent of American indifference toward the suffering of the Vietnamese people than the enormous disparity between the money and effort expended to kill the Vietcong and that used to treat and care for civilians wounded—in theory accidentally—by U.S. forces while being protected from the VC. Wounded GI's had the best medical care possible lavished upon them, but the Vietnamese were allowed to lie dying in desperately overcrowded hospitals. Patients died simply for want of intravenous fluids or just someone to administer them.

At Quang Ngai Province Hospital in 1967, the only available surgeon, a European, turned up each morning after curfew and had to decide which of the newly arrived casualties (victims of the night's artillery fire) had a chance. Every morning he played God, deciding who would live and who would die. He hated the role but he knew that he could not possibly operate on them all and that it was better to spend time on those who might pull through.

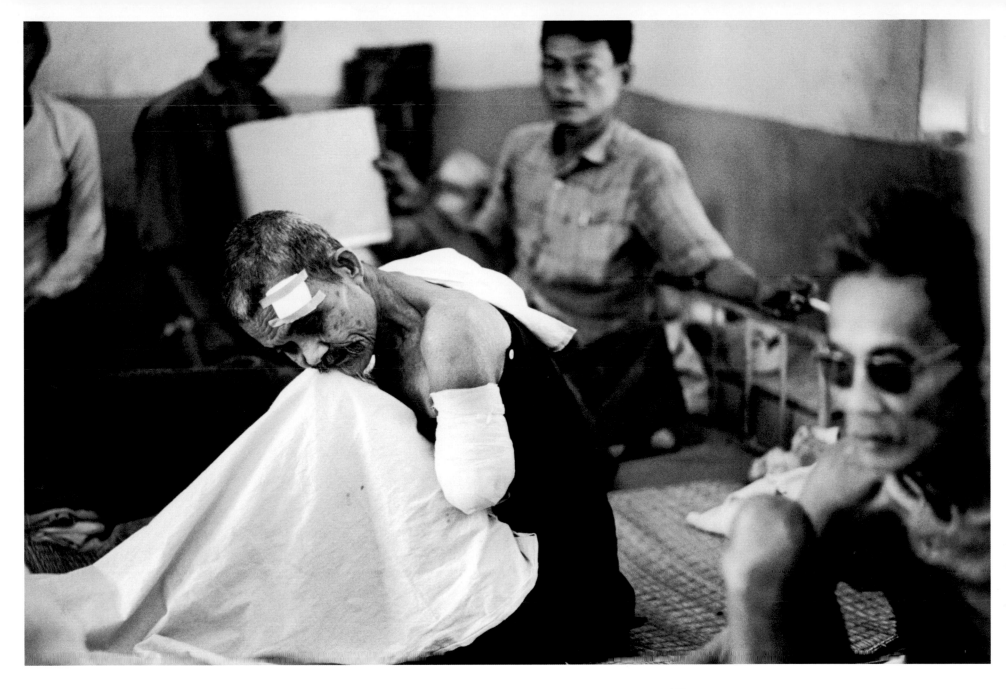

59. *Vietnam*, 1968
Maimed civilians, the result of the indiscriminate use of American firepower, will be a notable feature of the Vietnamese population for years to come. The lack of doctors and specialized surgical techniques has caused the adoption of amputation as a time-saving measure. On the GVN side, there is no "public medicine"—doctors treat only the wealthy. The peasants are cared for by foreigners working for the various relief agencies. However, as most of them work with Vietnamese interpreters, peasants still have to be able to raise money to bribe the interpreters before they can get past them for treatment.

60. *Phu Me Hospital, Vietnam,* 1970

Madness. At the age of two, this boy was in the arms of his fleeing
mother when she was killed by a helicopter gunship outside their
home. He survived but went insane. Now he spends his life chained
up. When helicopters pass overhead he goes berserk trying to shut
out their sound.

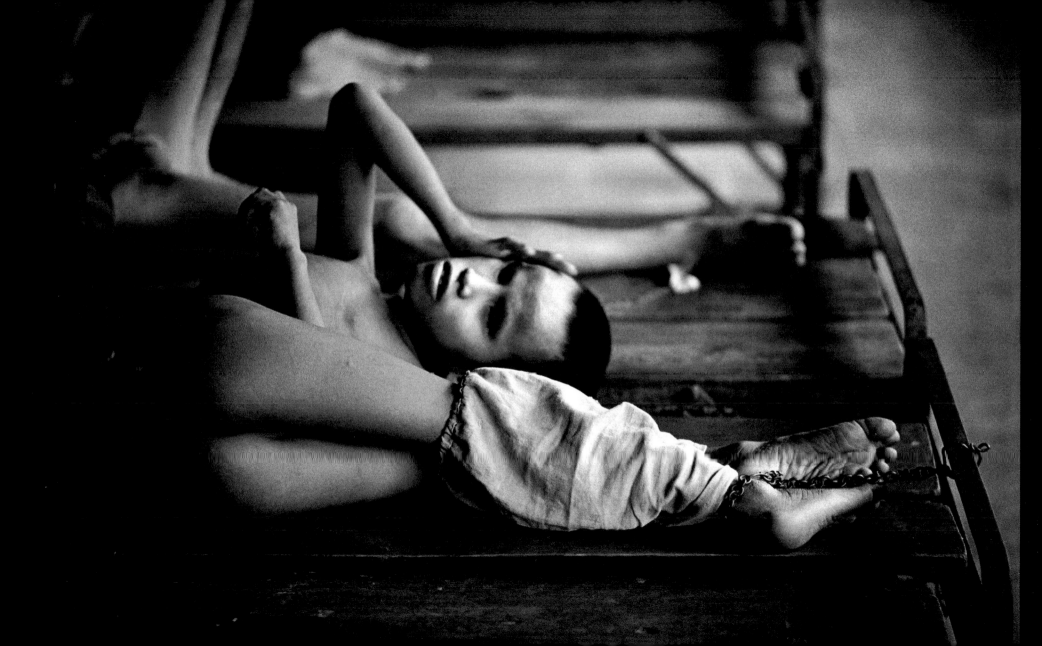

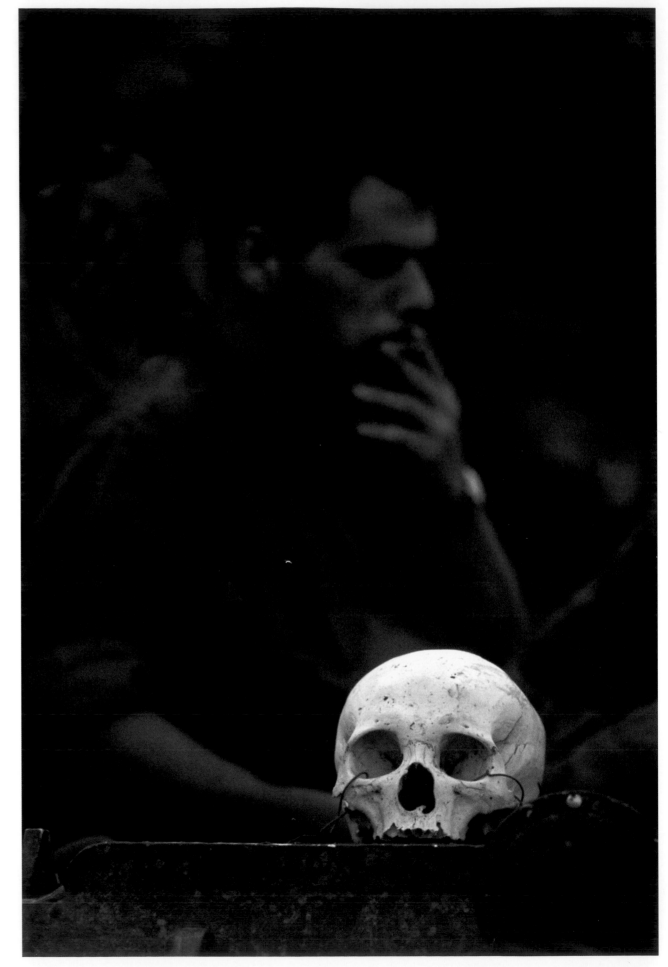

61. *Vietnam,* 1967
Human skulls were a favorite souvenir among the soldiers and their officers. The commander of this unit, Colonel (now Brigadier General) George S. Patton III, carried around a skull at his farewell party.

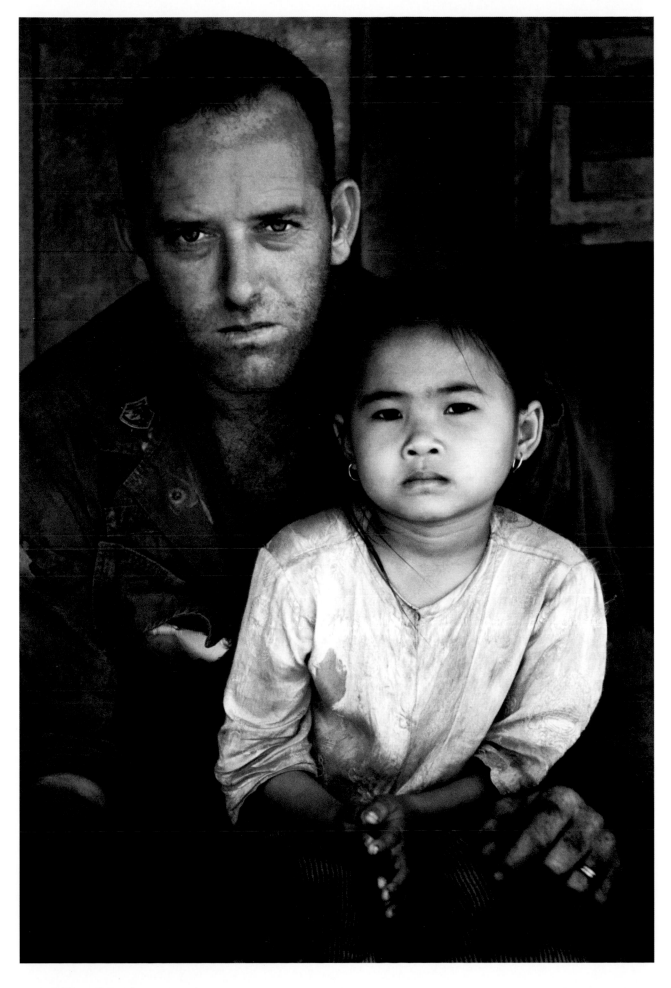

62. *Vietnam*, 1967

W. EUGENE AND AILEEN M. SMITH

MINAMATA

A significant figure in the history of photojournalism and socially concerned photography, W. Eugene Smith (1918–1978) is generally recognized as the leading practitioner of magazine-based photo essays during the genre's heyday around the mid-twentieth century, and he is credited with pushing its narrative and expressive potentials to new levels of sophistication. His drive to immerse himself physically, emotionally, and intellectually with his subjects in his quest for complex and morally responsible portrayals is a practice that is still valued by many photojournalists today, and his commitment to emotionally charged and aesthetically compelling compositions continues to inspire contemporary practice. Smith's early drive toward independence as a journalist, his embrace of activism over neutrality of coverage, and his experimentations with the book-length photojournalistic project helped lead the genre in new directions and established a model for practitioners of socially engaged photojournalism in the second half of the century.

Born in Wichita, Kansas, Smith was exposed to the craft of photography at an early age. His mother was a serious amateur photographer who maintained her own darkroom in the family residence and submitted her work to salon exhibitions. Smith's own interest in photography developed during high school, when his pictures of sports events began appearing in the *Wichita Eagle* and one of his photographs depicting the Midwestern drought was published by the *New York Times*. Smith was awarded a scholarship to attend the University of Notre Dame in 1936, but he left after only one semester in order to pursue his first formal training in photography at the New York Institute of Photography. Establishing himself as a freelance photojournalist with the Black Star agency, he obtained a retainer from *Life* magazine and regularly contributed to Crowell-Collier, the publisher of *American Magazine*,

Collier's Weekly, and *Women's Home Companion*. At the outbreak of World War II, Smith began making pictures for *Parade*, where he developed his narrative approach to stories in support of the nation's war efforts.

In 1943, Smith began covering the war from aircraft carriers in the Pacific, and the following year he accepted a commission from *Life* to cover Marine invasions. Among his first ground assignments was the offensive on Saipan, where he experienced up close the human costs of the conflict. He had left for the Pacific on an upbeat note, but witnessing the loss of human life, especially that of civilians, deeply affected him and sparked a humanitarian commitment that would guide his approach to photography for the rest of his career (fig. 21). He wrote to his wife at the time, Carmen Martinez, that each time he made a photograph of the war it was "a shouted condemnation hurled with the hopes that it might survive through the years."[1] Not all of Smith's photographed "condemnation," however, was approved by the Pentagon censors, who were keen on managing critical news of the front. In May of 1945, Smith was seriously wounded by a mortar explosion, which sent him into a long period of convalescence from which he didn't resume full-time work until 1948.

The postwar period constituted a remarkably productive time for Smith. He worked actively for *Life* during these years, producing some of his best-known photo essays, including "Country Doctor" in 1948 and "Spanish Village" (fig. 43) and "Nurse Midwife" in 1951. It was also a time of great frustration for the photographer, whose working methods and ideology increasingly came into conflict with those of his editors at *Life*, and with the magazine industry at large. Historically, the production of the photo essay was a collaborative process, involving the work of a photographer, a writer, and an editorial committee.[2] At *Life*, a topic would be selected by the editors, a script would be written, and

a photographer would be assigned to illustrate it. The resulting photographs would be reduced and laid out for publication, often with little or no input from the photographer. Projects were expected to move swiftly to meet production and publication demands.

Smith came to see his role not as an illustrator but as an active interpreter of content. He felt strongly that it was a photographer's duty to respond to what he learns from experiencing a situation directly, and not to act as an illustrator of preconceived ideas.[3] Spending time with subjects and immersing oneself in their lives was something he considered an important part of capturing and communicating essential truths about them, and this process did not always fit *Life*'s desired timetables. Moreover, Smith saw his camera as a weapon for social justice, and only through control over the interpretive presentation of his photographs could he ensure they would be used as he intended.

Smith's arguments for the photographer's authorial control over the development, layout, and captioning of images pushed a radical departure from photojournalistic tradition.[4] His attempts to maintain the authorial integrity of his work met with some degree of success. In several instances, he forced his editors to compromise and managed to imbed picture narratives with his own editorial subtexts.[5] But an argument over an essay on Albert Schweitzer—"Man of Mercy," which *Life* published against his adamant objections in 1954—led to his ultimate resignation from the magazine.

Smith joined Magnum in 1955 and began work on a project with Stefan Lorant, the former editor of such important publications as the *Münchner illustrierte Zeitung*, *Picture Post*, and *Lilliput*. Lorant was preparing a publication on the city of Pittsburgh to celebrate its bicentennial, and one chapter was to include pictures documenting the city's renaissance. It was an assignment that Lorant expected to take a matter of weeks. Smith, however, obsessively transformed it into the most ambitious project of his career, thoroughly researching the city's past and present, shooting an estimated seventeen thousand negatives, and taking several years to print them.[6] Magnum had to decline other assignments for Smith while the Pittsburgh project dragged on, causing serious financial distress for the agency and Smith's family. While Smith eventually fulfilled his obligations to Lorant after much turbulence in their relationship, he never finished the epic multilayered essay of Pittsburgh to his satisfaction. His attempt to do so pushed his relationships to the point of exhaustion, and he suffered physical and emotional breakdowns exacerbated by the abuse of benzedrine and alcohol. He ultimately resigned from Magnum in 1958. The project, nonetheless, was a bold experiment in redrawing the limits of the photo essay into a long-form study.

While Pittsburgh proved too big and unfocused a topic to be successfully summarized in a narrative fashion, Smith did find a subject that lent itself perfectly to a book-length investigation in 1971. That year, Smith and his second wife, Aileen M. Smith (born 1950), traveled to Minamata, Japan. The couple met when Aileen, who is of Japanese-American descent, served as the photographer's translator during arrangements to travel his retrospective exhibition to Japan. Over the course of preparing for that show, they were told of a controversy over industrial pollution taking place in the small fishing village of Minamata. Beginning in the 1950s, thousands of people in the area were severely affected by mercury poisoning, brought about through eating fish contaminated by chemical waste dumped in the bay by the Chisso Corporation. Those affected were afflicted with brain damage, paralysis, and convulsions. Many of the victims were children born with deformities from exposure to the compounds while in their mothers' wombs. The ailment, which came to be known as Minamata Disease, is not reversible. In addition to suffering the effects of the poisoning, early victims were ostracized by parts of the community due to confusion over the causes of the disease.

In 1959, a Chisso scientist had determined that the company's reckless waste was responsible for the problems, but the corporation did not formally acknowledge mercury as the cause of the poisoning until 1968. When the Smiths arrived in Minamata, lawsuits had already begun, and the couple set out to document the progress of the claims. What was originally intended to be a three-month project developed into a three-year crusade to call attention to the cause and to bring pressure on the company to compensate victims. Aileen facilitated their integration into the community. She acted as an equal collaborator in the project as a whole, making pictures and writing texts together with W. Eugene Smith. The work resulted in numerous magazine publications during the course of events,[7] exhibitions held around Japan and in the United States, and a coauthored book, published in 1975 after the completion of the trial.[8]

The Smiths' study records the course of the trial through the court's ruling in favor of the plaintiffs in 1973. It tells the complicated story of disagreements among the afflicted and the negotiations between them and the company, building context around the situation by describing the cause-and-effect relationship of mercury poisoning in the area. The essay relates the importance of the sea and fishing in the town's culture (pls. 63–66), reports on the company's drainage pipes into the sea (pl. 69), chronicles the lives of those affected by the disease (pls. 70–76, 84–85), and depicts the demonstrations that took place in opposition to Chisso (pls. 77–81).

The Verdict
An Excerpt

"…It must be said that a chemical plant, in discharging the waste water out of the plant, incurs an obligation to be highly diligent; to confirm safety through researches and studies regarding the presence of dangerous substances mixed in the waste water as well as their possible effects upon the animal, the plant, and the human body, always availing itself of the highest skill and knowledge; to provide necessary and maximum preventive measures such as immediate suspension of operation if a case should arise where there be some doubts as to safety…in the final analysis…no plant can be permitted to infringe on and run at the sacrifice of the lives and health of the regional residents….

"The defendant's plant discharged acetaldehyde waste water with negligence at all times, and even though the quality and content of the waste water of the defendant's plant satisfied statutory limitations and administrative standards, and even if the treatment methods it employed were superior to those taken at the work yards of other companies in the same industry, these are not enough to upset the said assumption…the defendant cannot escape from the liability of negligence."

Kumamoto District Court
March 20, 1973

FIGURE 42. W. Eugene and Aileen M. Smith, *Minimata* (New York: Holt, Rinehart, and Winston, 1975), pp. 128–29.

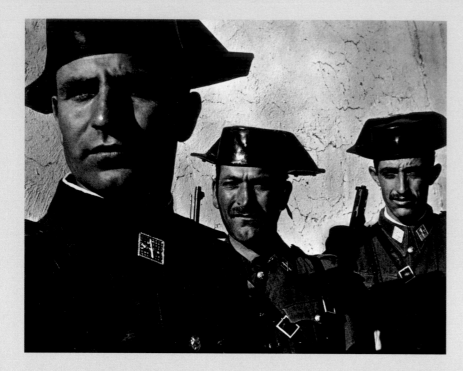

FIGURE 43. W. Eugene Smith (American, 1918–1978), *Spanish Civil Guards*, 1951. Gelatin silver print, 18.1 × 22.7 cm (7⅛ × 8¹⁵⁄₁₆ in.). JPGM 84.XM.1014.12.

The publication that resulted includes 175 photographs accompanied by extensive narrative texts by the Smiths. The book is structured in such a way as to tell a story representative of their experiences rather than adhere to a strict linear unfolding of their activities. The pictures and texts are complemented at the end of the book by a traditional chronology of events and a thirteen-page medical report on Minamata Disease. As a tale of the dangers of industrial pollution, the project gained traction within the political atmosphere of the 1970s, when the environmental movement was taking off.[9]

The publication was written from a first-person perspective, detailing the Smiths' experience of living within the community and participating in its efforts to seek retribution, including an episode in which W. Eugene was severely beaten by Chisso employees during the course of a demonstration that turned violent. While clearly partisan in its support of the victims and its condemnation of Chisso's behavior, their report is nonetheless thoroughly researched and diligently investigated. The Smiths were careful not to end the book with the resolution of the court case; instead, the last section of pictures depict life after the verdict. In this way, the Smiths moderated the heroic trajectory of justice with a reminder that those affected by the disease must continue to bear the burden of its effects for the rest of their lives. This was a device that Smith used with other essays he worked on: "I have personally always fought very hard against ever packaging a story so that all things seem to come to an end at the end of a story. I always want to leave it so there is a tomorrow. I suggest what might happen tomorrow—at least to say all things are not resolved, that this is life, and it is continuing."[10]

In leaving the story devoid of a tightly packaged, happy ending, the Smiths suggested the need for continued attentiveness to the problems of industrial pollution. Indeed, they saw the book's relevance as extending beyond the community of Minamata. They wrote that pollution, whether it be the result of mercury, asbestos, food additives, or radiation, "is closing more tightly upon us each day. Pollution growth is still running far ahead of any anti-pollution conscience. But what we also found in Minamata was the kind of courage and stubbornness that can encourage other threatened people not only to refuse to give in, but also to work at righting their own situations. After reflecting on the rights and wrongs of the situation in Minamata, we hope through this book to raise our small voices of words and photographs in a warning to the world. To cause awareness is our only strength."[11]

In the Minamata project—the last major essay of W. Eugene Smith's career—the photographer finally achieved the results he envisioned could be possible working independently from the magazine industry. It represents the culmination of a life's struggle to select, research, and develop a story; to maintain complete authorial control over its length, layout, and accompanying text; to see it result in the form of a book and traveling exhibition; and to do all of this in the service of a humanistic cause with global implications.

NOTES

1. W. Eugene Smith, letter to Carmen Martinez, quoted in Glenn G. Willumson, *W. Eugene Smith and the Photographic Essay* (Cambridge University Press, 1992), p. 28.

2. Willumson, *W. Eugene Smith and the Photographic Essay* (note 1), p. 7.

3. Smith, "Photographic Journalism," typed manuscript, W. Eugene Smith Archive, Center for Creative Photography, The University of Arizona, Tucson, AG 33:7, file #27.

4. Willumson, *W. Eugene Smith and the Photographic Essay* (note 1), p. 7.

5. See Willumson's study (note 1) for examples related to Smith's most important *Life* photo essays.

6. Sam Stephenson, ed., *Dream Street: W. Eugene Smith's Pittsburgh Project* (Durham, North Carolina: Center for Documentary Studies; and New York: W. W. Norton, 2001), p. 20.

7. An article appeared in *Life* magazine on June 2, 1972.

8. W. Eugene Smith and Aileen M. Smith, *Minamata* (New York: Holt, Rinehart, and Winston, 1975).

9. For example, DDT pesticides were revealed to be jeopardizing several bird species during the 1960s; the first Earth Day took place in 1970, the same year that President Nixon founded the Environmental Protection Agency and signed the Clean Air Act, Clean Water Act, and Endangered Species Act; and the National Resources Defense Council was formed in 1970, followed in 1971 by Greenpeace.

10. W. Eugene Smith, quoted in Chris Boot, ed., *Magnum Stories* (London: Phaidon Press, 2004), p. 435.

11. Smith, prologue to *Minamata* (note 8), p. 8.

The following pages include a selection of pictures from the Minamata project, along with text excerpts from the original publication.

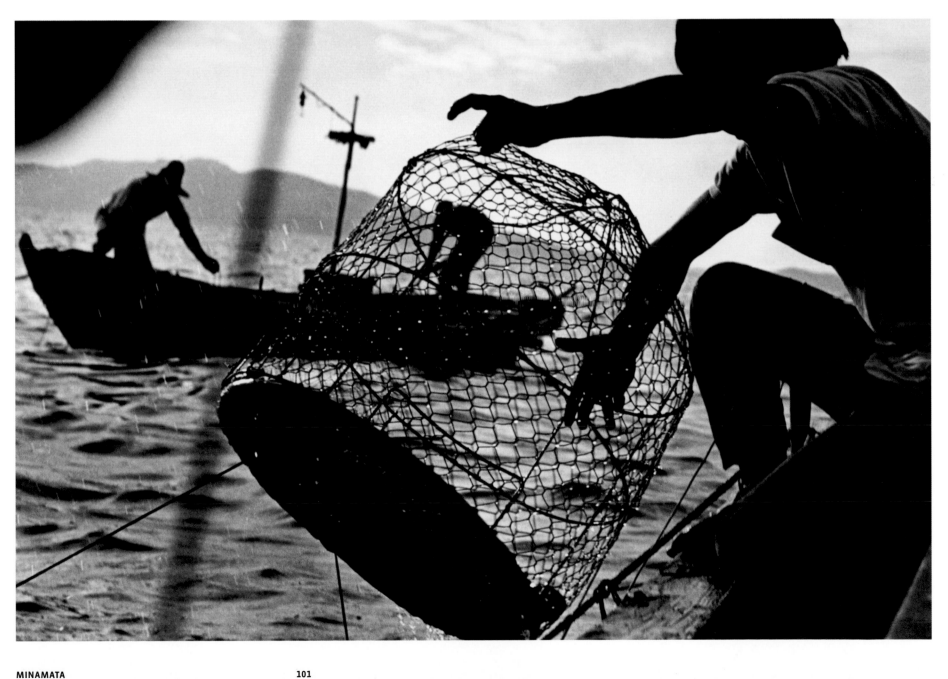

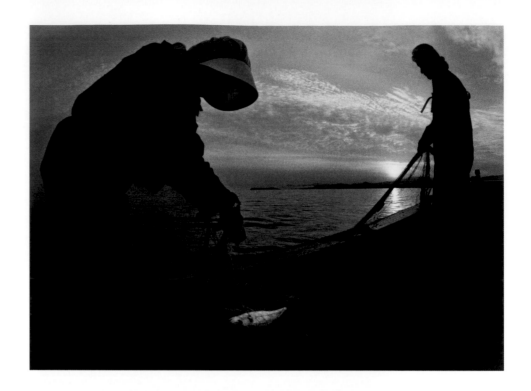

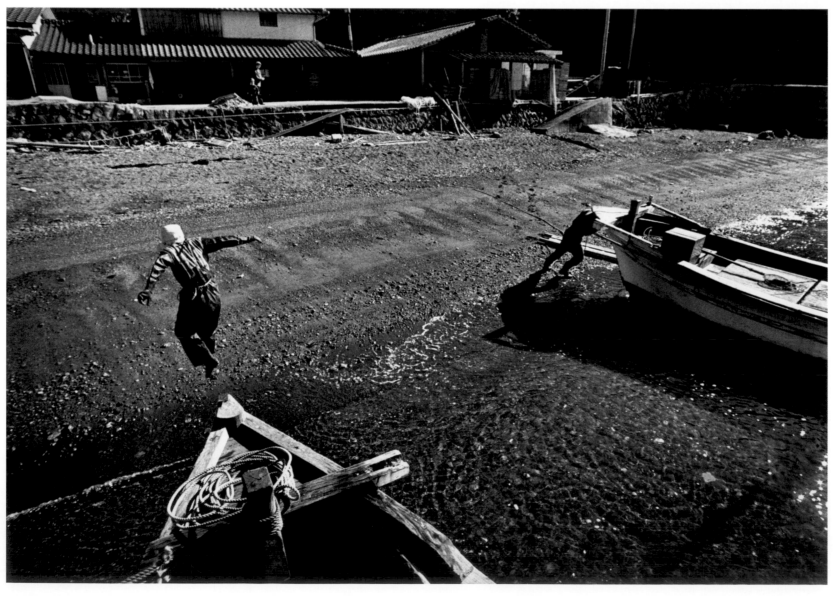

64. *Fishing in Minamata Bay, 1972*

65. *Mrs. Kama Jumping off Boat, 1972*

66. *The Sugimotos' last day of sardine fishing, ca. 1972*

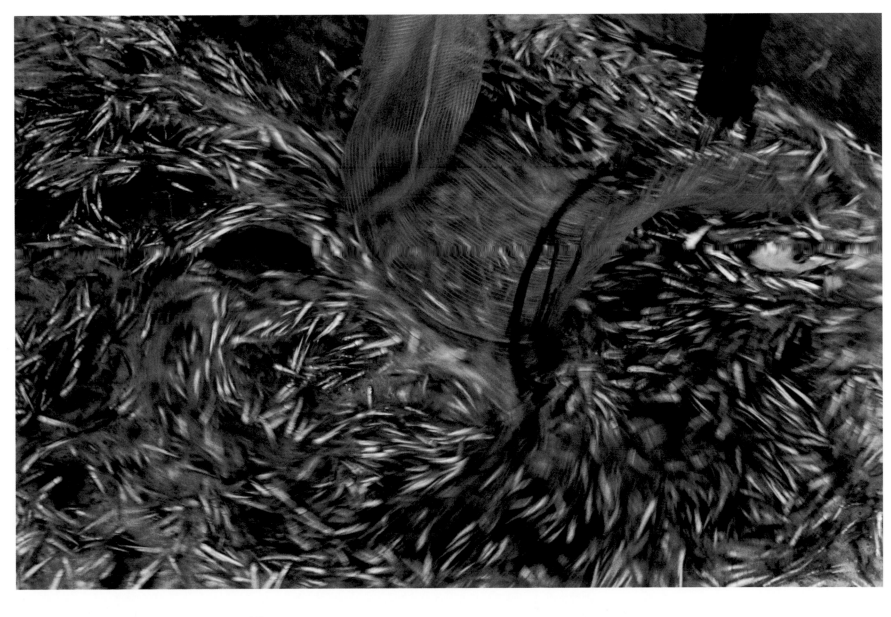

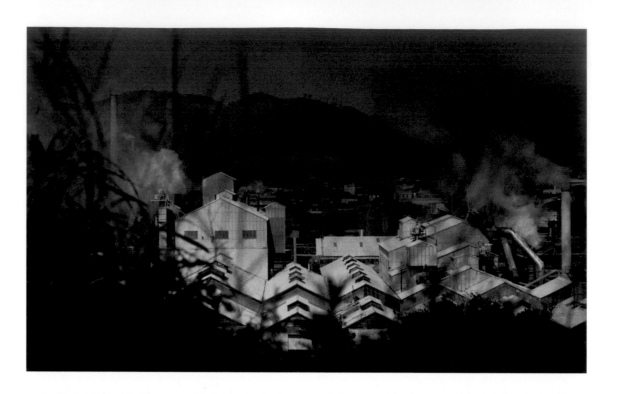

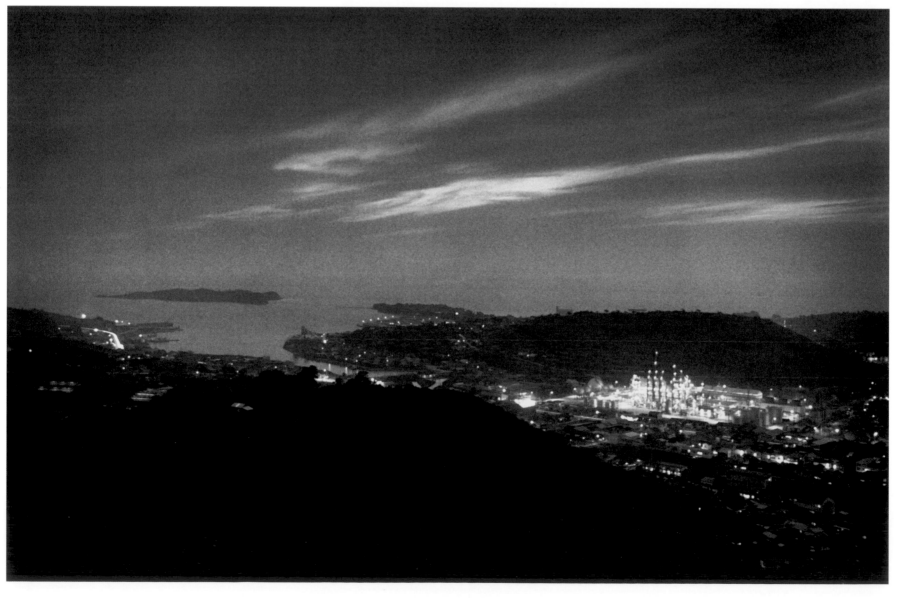

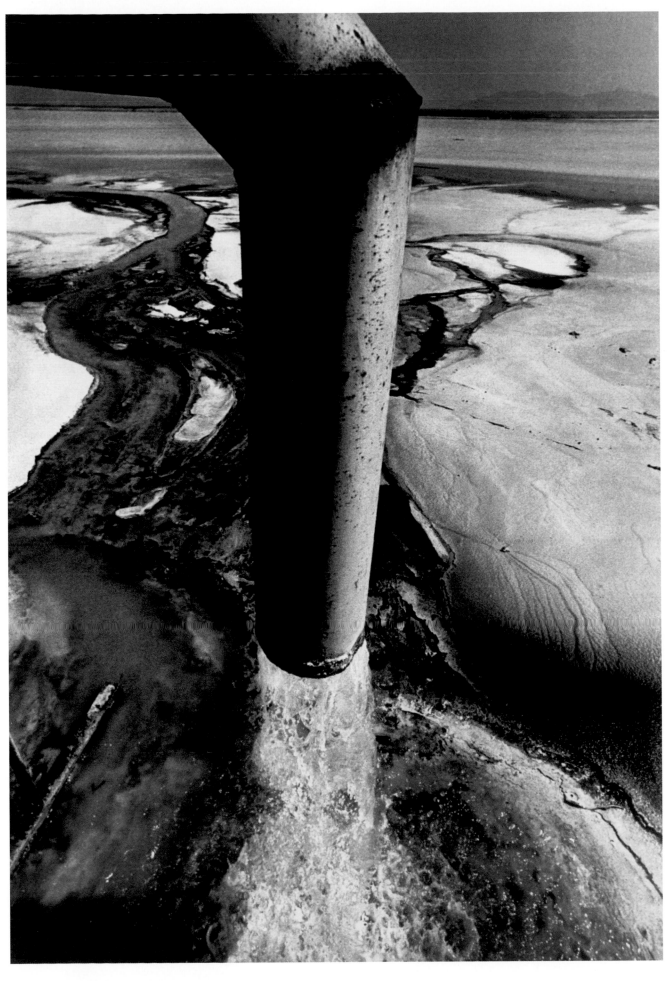

67. *The Chisso factory in Minamata, ca. 1972*

68. *Minamata: The edge of the factory, the dump-way, the bay, and on to the sea, ca. 1972*

69. *Industrial Waste from the Chisso Chemical Company, 1972*

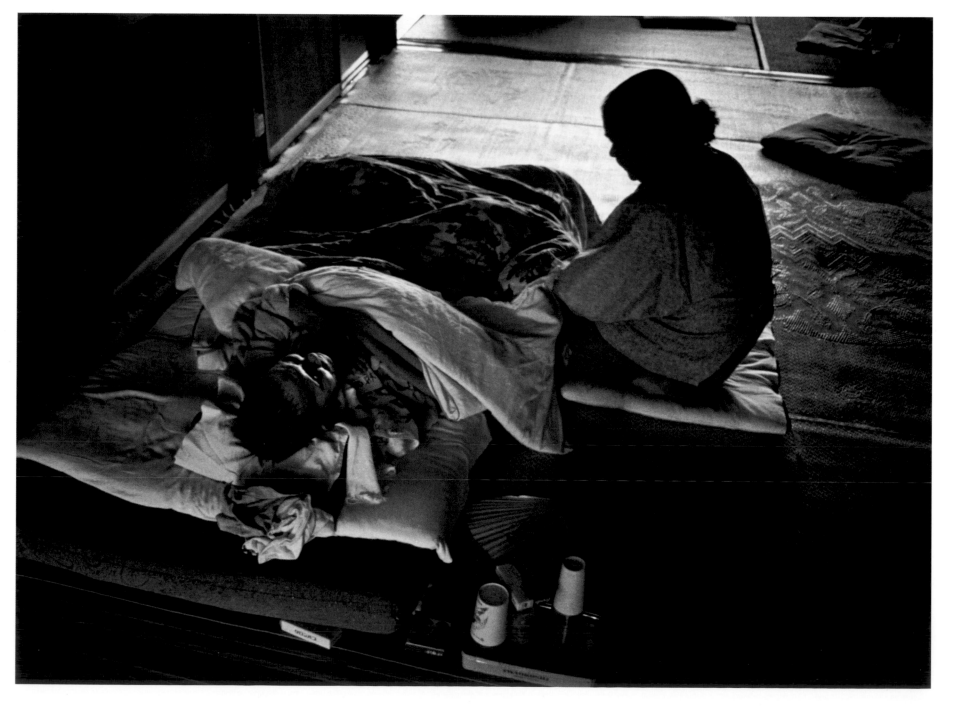

70. *Bunzo Hayashida,* ca. 1972
For years, Bunzo Hayashida's wife kept vigil at his sickbed. He died
two weeks after these photographs were made. An autopsy proved
he was a Minamata Disease victim.

71. *Mrs. Ikeda lifting her husband up,* ca. 1972

72. *Bunzo Hayashida,* ca. 1972

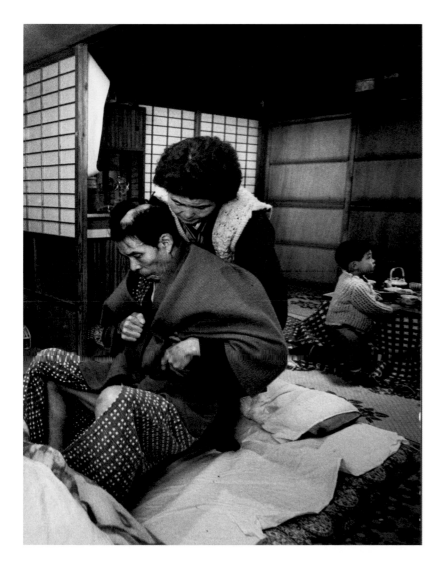

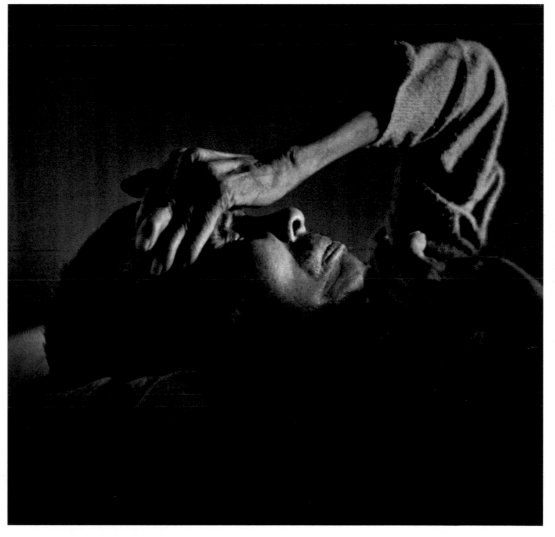

73. *Cremation pyre of young disease victim, Toyoko Mizoguchi, ca. 1973*

74. *Takako Isayama and her mother, ca. 1972*

75. *Mr. Hamamoto with Stick, ca. 1971*

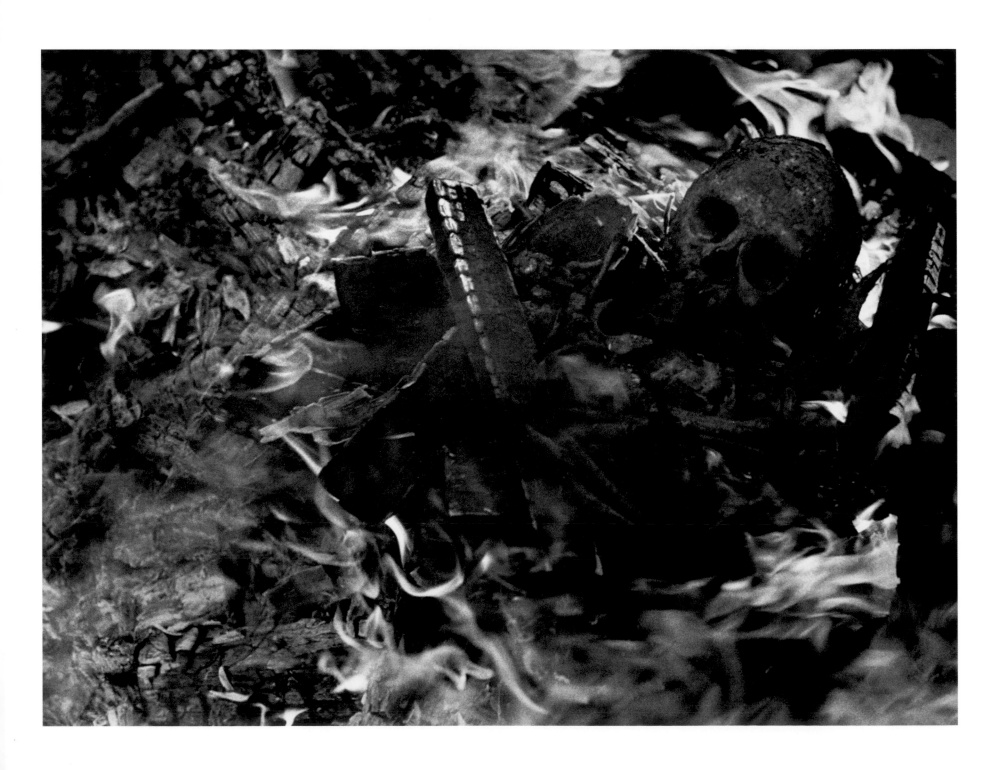

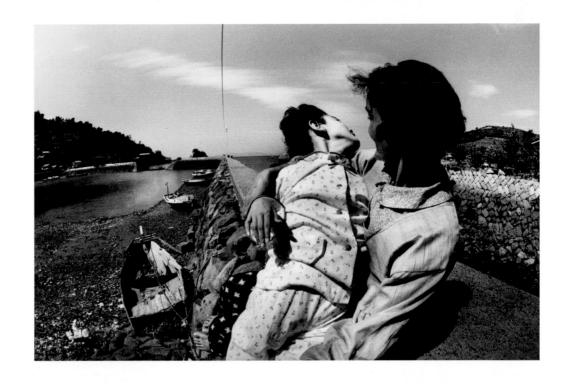

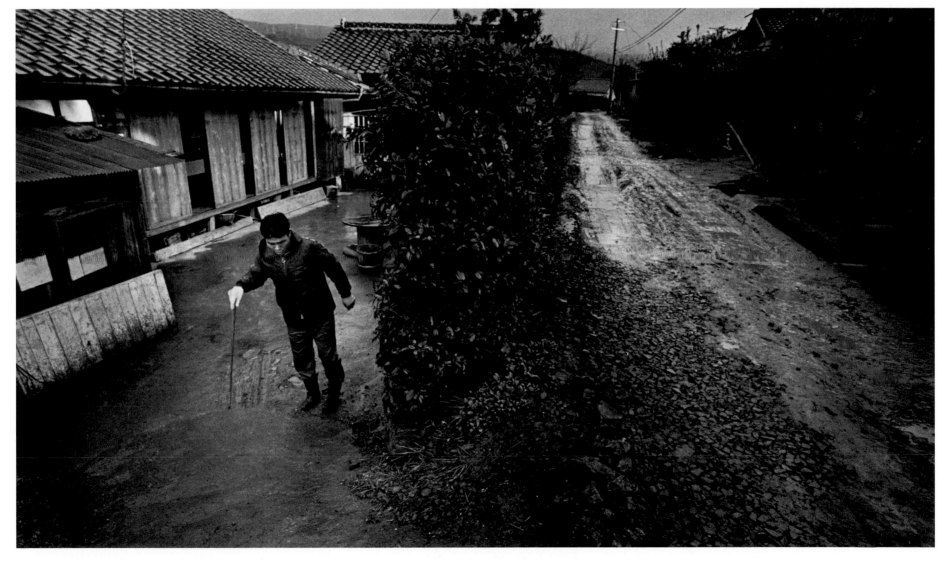

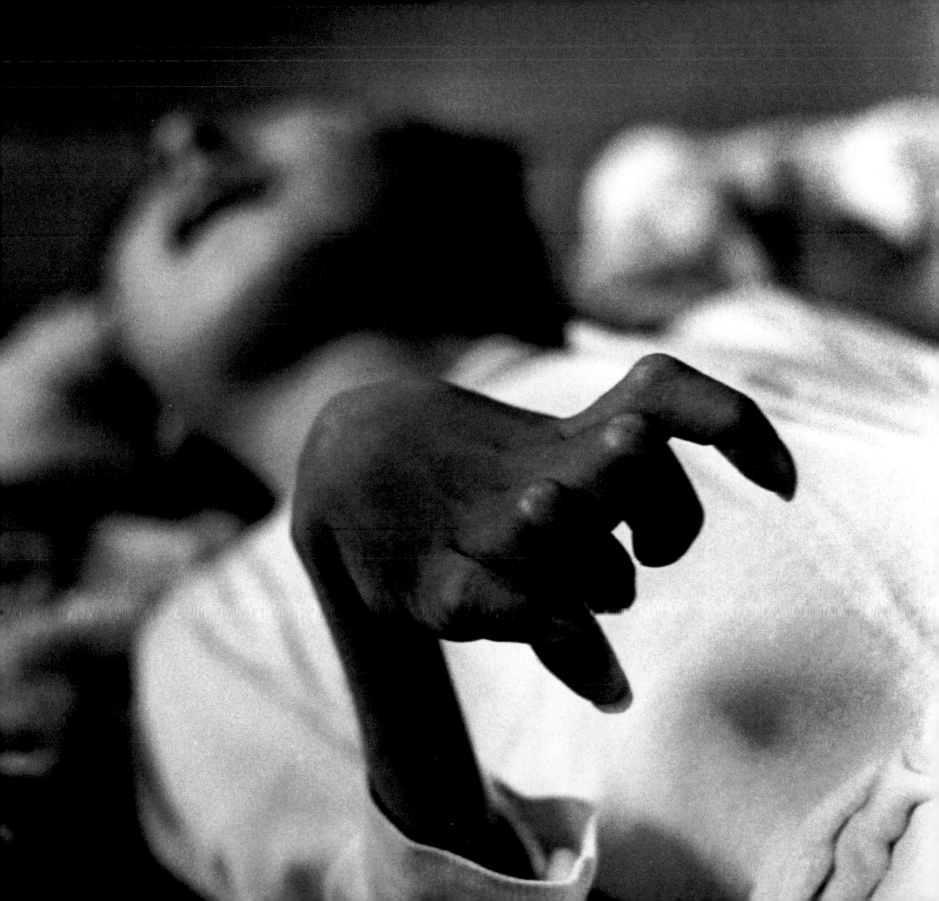

"Vengeance," the closest translation of the Japanese character on
these flags, does not mean revenge. It means something more intense,
almost mystical: that we shall pursue you to justice, and even then we
shall not forget.

78. *Protesters in Front of Chisso Factory, Goi, Japan,*
1972–73

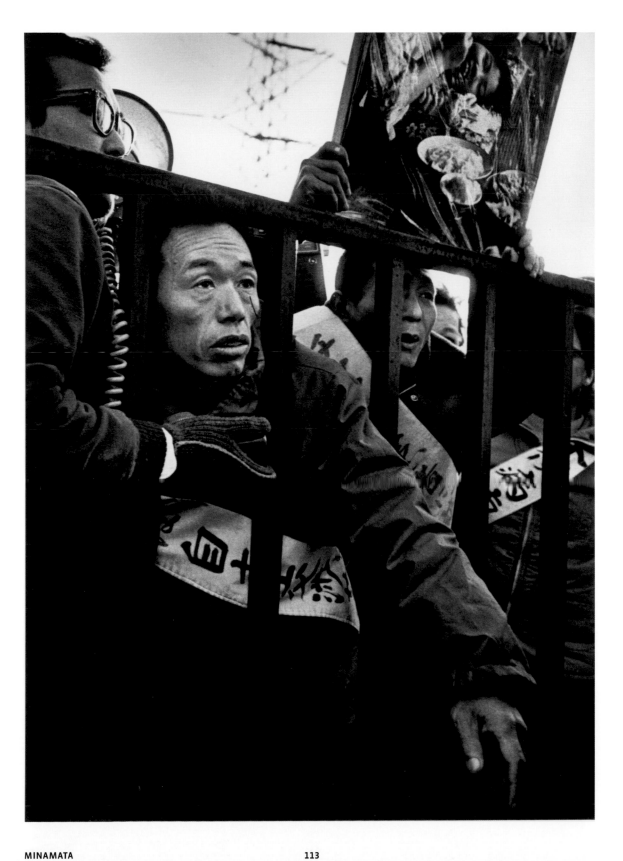

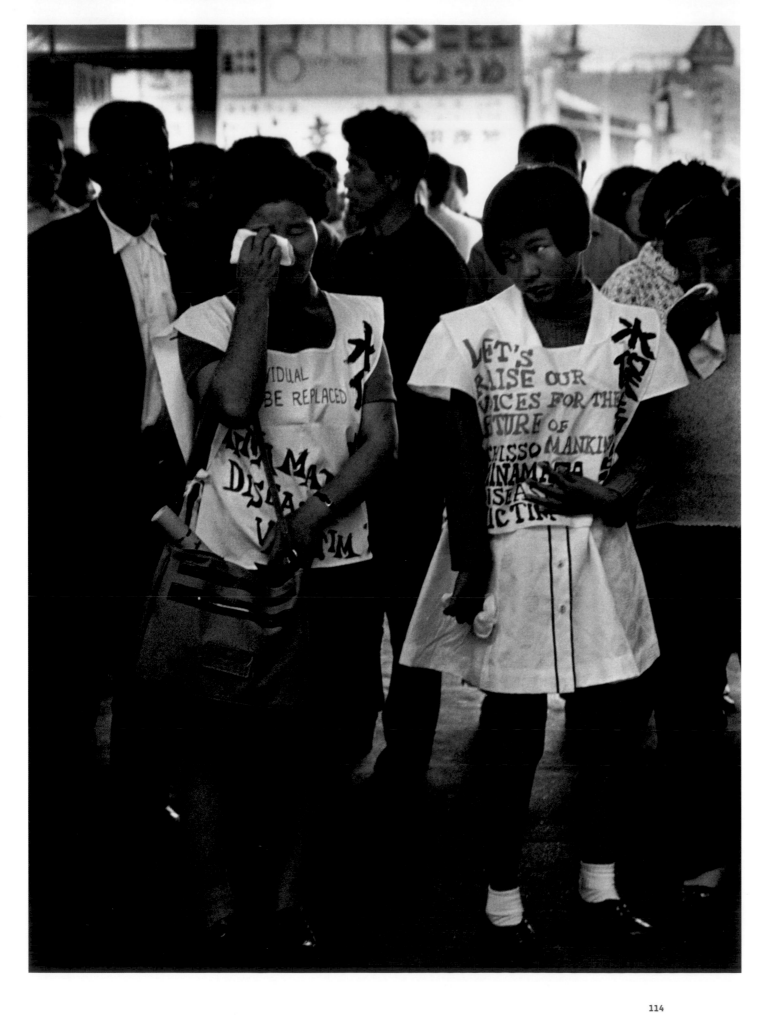

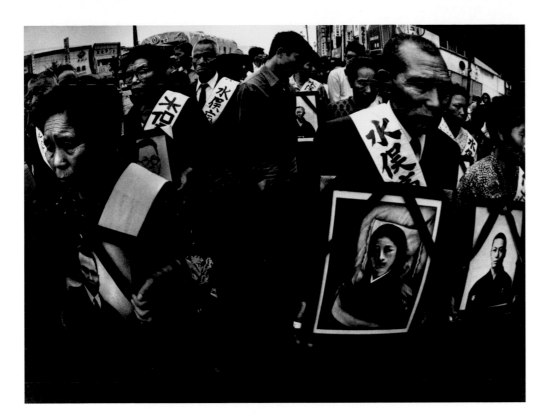

79. *Shinobu and her mother preparing to leave the Minamata train station for the United Nations Environmental Conference in Stockholm, Sweden,* 1972

80. *Patients and Relatives Carry Photographs of the "Verified" Dead on the Last Day of the Minamata Trial,* 1972

81. *Tomoko Uemura at Central Pollution Board Meeting,* **ca. 1973**
Tomoko Uemura was taken to the Central Pollution Board for the benefit of others. The patients demanded that the board members look, touch, hold this child, and remember the experience as they evaluated human beings in dollars and cents.

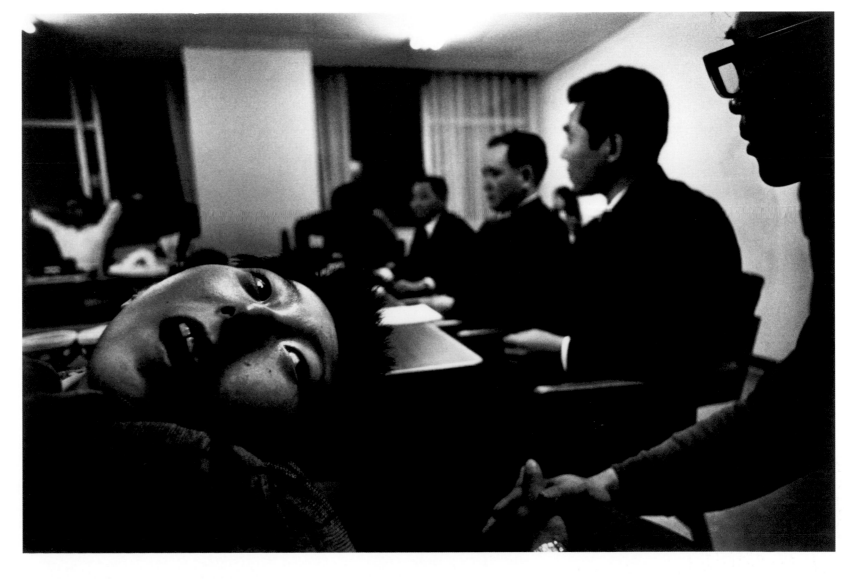

82. *Verdict Day, March 20,* 1973

83. *Judge Jiro Saito,* ca. 1973

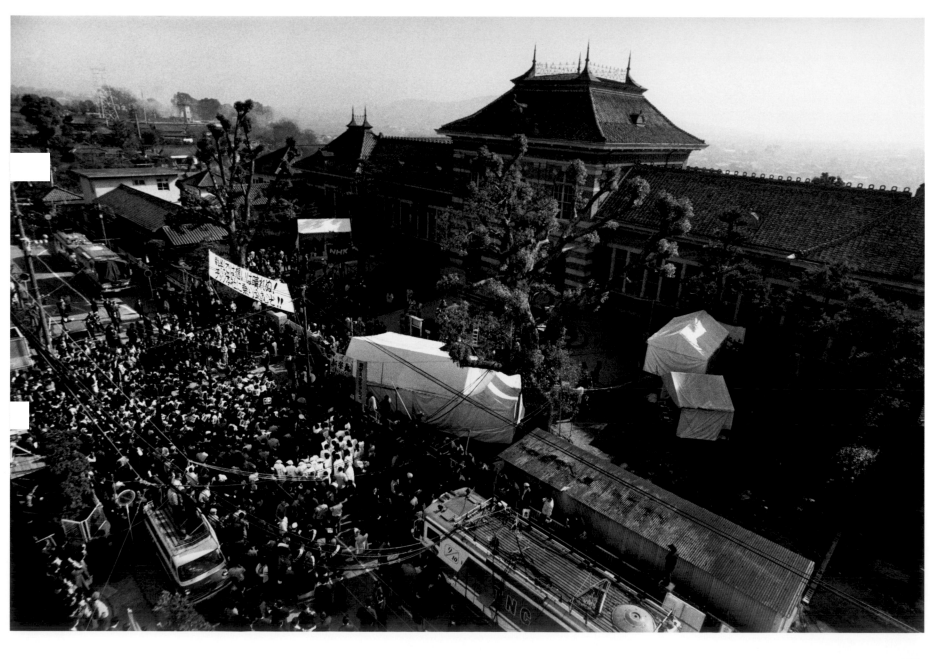

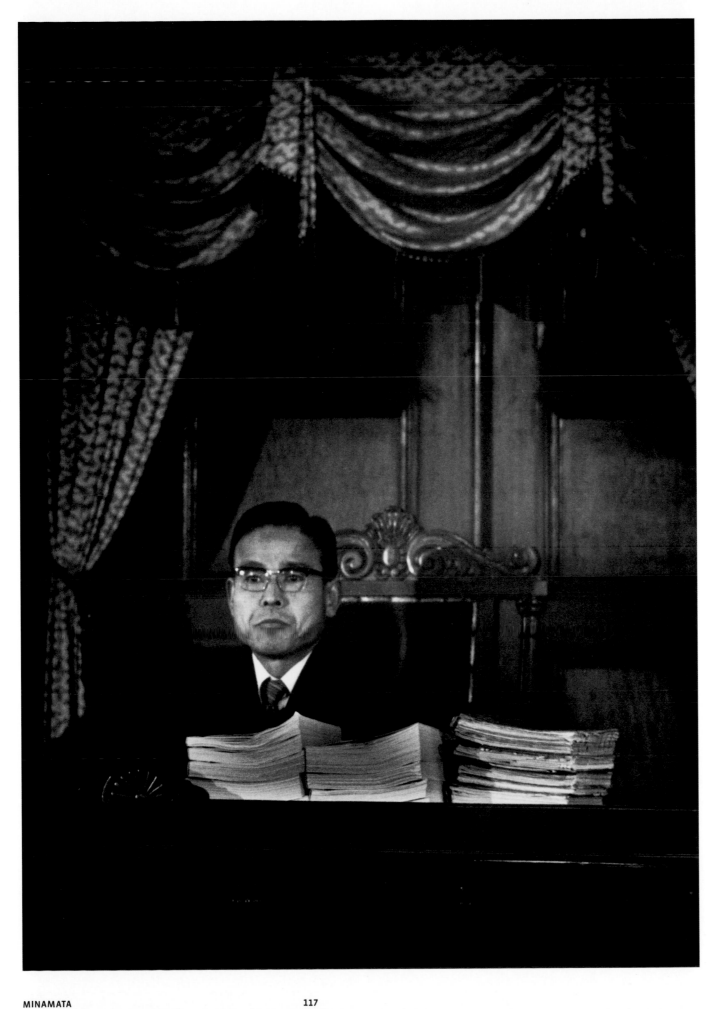

84. *Shinobu at the entrance of her house, 1972*

85. *Shinobu used to clean her tray with the other students after lunch at school, ca. 1972*

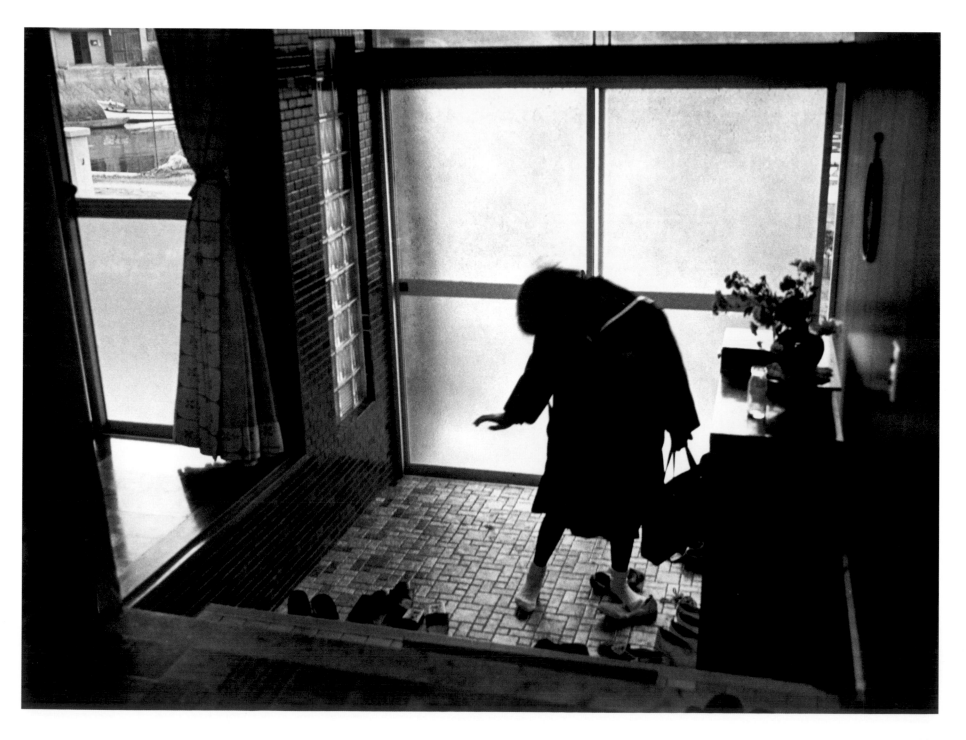

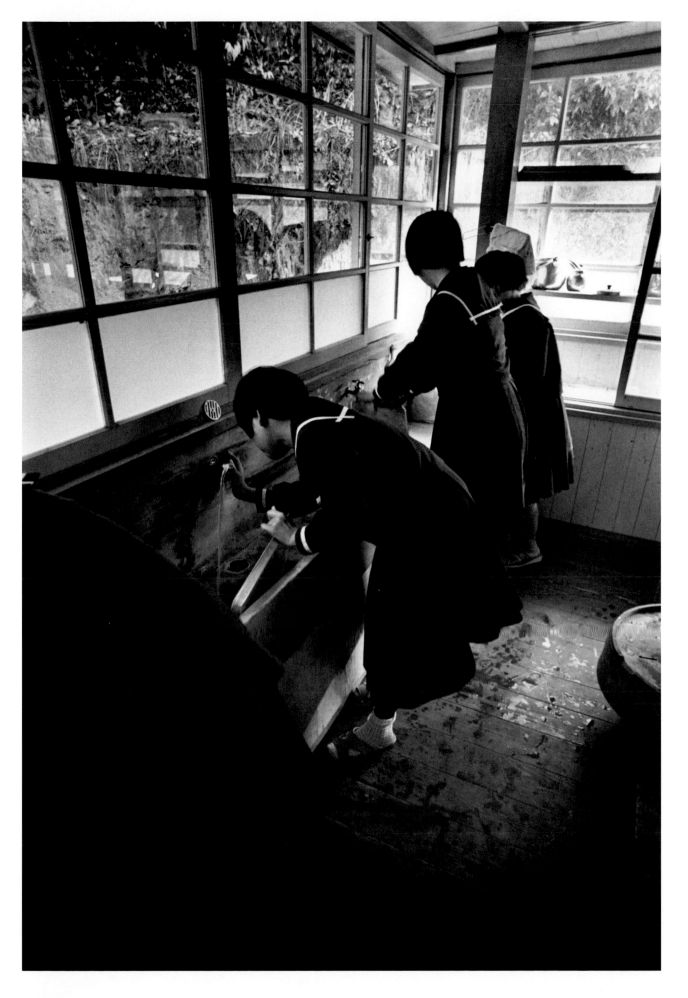

SUSAN MEISELAS

NICARAGUA, JUNE 1978–JULY 1979

For Susan Meiselas (born 1948), making pictures is just the beginning of a long meditative process of creative and intellectual engagement with a given topic. Through her rich and varied career, she has repeatedly harnessed her own photographs and those made by others in an effort to document events and communities around the world. Her careful approach, which employs photography, film, and dialogue, functions more outside of the press than within it and as much in record as in visual expression, conscientiously marrying realms of journalism and art in the complex process of constructing historical narratives. An important characteristic of her documentary method is the way in which she encourages her subjects to tell their own stories through her projects.

Born in Baltimore, Maryland, Meiselas received a bachelor's degree from Sarah Lawrence College in Bronxville, New York, in 1970 and went on to complete a master's in visual education the following year at Harvard University. It was during her time there that Meiselas began her first photography project, making portraits of her fellow boarding-house residents in Cambridge and asking each of them to write something about themselves in relation to their likenesses. It was the beginning of Meiselas's career-long meditation on how the process of photographic representation could be, as she puts it, "collaborative rather than confrontational."[1] During this time she also gained experience in film, working as an assistant editor under influential documentary filmmaker Frederick Wiseman on his film *Basic Training* (1971). Following graduation, Meiselas took up work as a teacher and consultant for the Community Resources Institute, developing curricula using visual materials for New York City public schools. During the summers, Meiselas began following small carnivals and state fairs in New England and the South. Becoming fascinated by the itinerant strip shows that accompanied them, Meiselas embarked on a three-year project to document the working lives of a group of showgirls she befriended. Over the course of the project, she conducted extensive interviews with the women, their clients, and their managers. Her pictures and audio recordings were edited and exhibited in a multimedia presentation at the CEPA Gallery in Buffalo in 1975 and compiled the following year into her first major publication, *Carnival Strippers* (fig. 45). Although she was already established in the field of visual education, Meiselas decided to give up teaching and pursue photography full time; she was accepted to Magnum the same year that her publication appeared on the strength of her carnival work.

In 1978, Meiselas traveled to Nicaragua for the first time. She spoke no Spanish, had no specific assignment to be there, and did not know what exactly she would photograph upon arrival. "The camera is an excuse to be someplace you otherwise don't belong," she later said.[2] Tensions were high in the country following the assassination of Pedro Joaquín Chamorro, the editor of an opposition newspaper critical of the repressive, hard-line government of president Anastasio Somoza Debayle, and popular uprisings had begun. Having matured as a young adult within the countercultural trends of 1960s–70s America, Meiselas was drawn to Nicaragua by her curiosity for the recent revolts against authority there. Unaware of the extreme form those protests would take, she began familiarizing herself with the place and investigating the roots of the coming rebellion. Her purpose gradually became clearer as she learned that the United States was providing military aid in support of the Somoza regime. As an American, she felt a responsibility to know, and to make known, the United States's involvement in other countries.[3] The first story reproducing her work on the topic was printed in the *New York Times Magazine* at

the end of July. After a trip back to the United States, Meiselas returned to Nicaragua to witness the eruption of full-scale revolution in August of 1978. Fighters associated with the Sandinista National Liberation Front (Frente Sandinista de liberación nacional, or FSLN) had stormed the national palace that month, taking one thousand government officials hostage. By September the group had taken control over a number of towns with the assistance of popular insurrections. Meiselas was aware that a momentous process was taking place, and she stayed on to record its unfolding, including the celebration of FSLN victory in the central Plaza of Managua in July of 1979. "I started to see pictures in the present as they would be perceived in the future as the past. That was an incredibly powerful and important recognition for me. People were making history."[4]

Meiselas was taken by the bravery of those who were willing to risk their lives against the dictatorship for the promise of a better future. The record of her movements around the country formed a narrative about the progress of their insurrection. Following Robert Capa's famous dictum "if your pictures aren't good enough, you're not close enough," Meiselas took great pains, and great risk, to photograph the action from the point of view of those involved in it, largely rejecting telephoto lenses that could have provided the safety of distance. Early on, she captured evidence of growing tensions between Somoza supporters and the opposition in pictures such as one in which the car of a Somoza supporter burns in Managua (pl. 90). In another, several boys wear traditional Indian masks to protect their identities and practice throwing contact bombs in anticipation of the coming revolution (pl. 87).[5] Meiselas went on to photograph the coalition of opposition leaders (known as Los Doce, or The Twelve) on their return to Nicaragua from self-exile followed by a crowd of one hundred thousand supporters (pl. 89); the early days of the popular insurrection in the town of Matagalpa and the makeshift barricades erected in anticipation of the national guard's counterattack (pls. 91, 96–97); the disruption and destruction of human lives lost in the conflict (pls. 92–94); and the final assaults by FSLN forces that led to the government's fall. Many of her pictures depict the surreal unexpected moments between skirmishes that constituted much of the war. For example, one shows two FSLN fighters crouching below a barricade, alert to potential attack, while a third stands alongside playing a clarinet acquired from the ranks of a defeated government battalion (pl. 97).

Meiselas made a decision, which at the time was still considered somewhat unusual in serious war reportage, to record the revolution on color film. While she carried a second camera loaded with black-and-white film, she came to see color as the more appropriate medium for communicating the spirit of her subject. It "did a better job of capturing what I was seeing. The

vibrancy and optimism of the resistance, as well as the physical feel of the place."[6] Meiselas proved herself to be remarkably good at structuring effective compositions in this mode. In one image, she balanced a gunman's bright red mask in the right foreground with the pink dress of a woman emerging from a doorway in the background (pl. 91). Likewise, in another photograph, a group of young men barricade themselves behind a wall of white sandbags (pl. 96). The intense blues, reds, and yellows of their clothes, a functional mishmash of articles layered so that they could be removed quickly for an impromptu identity change, are emphasized against the rich red-brown wall.

Meiselas's compelling pictures of the revolution were picked up by major newspapers and magazines around the world, giving individual images a public life, but one that was beyond her immediate control with regard to captioning and that was ephemerally fragmented from the context of her larger body of pictures. In collecting seventy-one of her photographs into a book, published in 1981 as *Nicaragua, June 1978–July 1979*,[7] Meiselas reasserted the narrative of the revolution as she had witnessed it and gave greater permanence and coherence to her documentary endeavor. "This book was made so that we remember," she stated on the table-of-contents page for the book. Indeed, her ultimate goal was to provide a kind of bicultural history of the event for both the Nicaraguans and the international audience.[8] In order to ground the narrative of the pictures in an historical and social context, Meiselas added information about the country to the back matter of her book, including demographics, a timeline

of the nation's development and of critical moments in the revolution, and a series of quotes, letters, and poems gathered to represent the perspectives of the people of Nicaragua. In its time, the publication was significant, being, as one critic described, "a high-budget, high-profile photo book, put out by the important publisher Pantheon Books, about a leftist revolution in the Third World—just the area of the world that we in the United States considered our fiefdom—at the start of the 'Reagan revolution' and the historic swing to the right in the United States."[9] Today it is still considered a major contribution to the history of documentary photo books, both for its employment of color and for its innovative use and placement of text. All of the captions for the pictures are consolidated in the back matter of the book, along with the contextual information she compiled. This allows the pictures to stand on their own merits in the body of the book, while still being complemented by the critical dimension that words bring to a documentary essay.[10] The idea to structure the book this way was proposed more for practical than artistic reasons: having text consolidated in the back matter meant that the publication could be printed in multiple languages at lower cost, fulfilling the photographer's desire for the work to be accessible. Still, she felt the organization represented the content appropriately, for it allowed the reader to experience a visual narrative before understanding its significance through captions, simulating the process of her own encounter with the revolution.[11]

Publishing a book on the Nicaraguan revolution would not be the end of Meiselas's engagement with

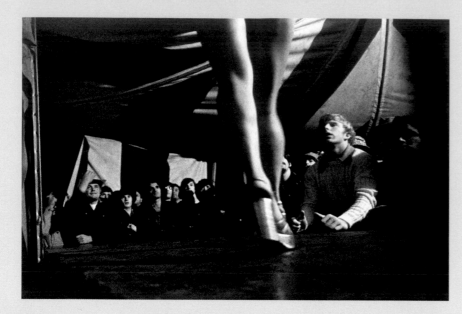

FIGURE 45. Susan Meiselas (American, born 1948), *USA. Tunbridge, Vermont. Tentful of marks*, 1974. From the series Carnival Strippers. Courtesy of Susan Meiselas/Magnum Photos, Inc., NYC15710.

the topic, nor her only attempt to give it shape, engage its history, and recontextualize her work on it. She returned to photograph the destruction of infrastructure by the Contras during the United States–backed, and Cold War–fueled, counterrevolution in 1983. She went on to co-direct and co-produce the film *Living at Risk: The Story of a Nicaraguan Family* in 1985 with Alfred Guzzetti and Richard Rogers, and that same year co-wrote a narration reflecting on her work for the documentary film *Voyages* with Mark Karlin. In 1987, she continued coverage of the Contra war and the beginnings of the peace process and two years later began locating the subjects depicted in her book as part of the documentary film *Pictures from a Revolution* (1991), which gave the subjects the opportunity to tell their own stories about the conflict. The film somberly reflects on the aftermath of the revolt, which failed to live up to the expectations of many of its participants. On the twenty-fifth anniversary of the overthrow of the Somoza regime, Meiselas returned to Nicaragua yet again, this time bringing with her mural-size banners of pictures she took of the revolution. She installed these large-scale reproductions in the landscapes where they were originally made and co-produced a video documentary, *Reframing History* (2004), with Guzzetti on the public response to the project.

The process of creating visual histories, and of returning pictures to a place from which they were taken, has become a central quest for Meiselas. Making pictures that are useful to the subjects depicted in them is of great importance to her. Concurrent with her documentation of the end of the revolution in Nicaragua, she began photographing the developing civil war in nearby El Salvador, moving back and forth between the two countries until the end of the Nicaraguan insurrection, remaining in El Salvador until 1983. As with Nicaragua, Meiselas looked to create a book project

following the civil war. But instead of focusing solely on her own work, she compiled the pictures of thirty photographers, consolidating their collective visual testimony of the conflict with her own into a single volume. This strategy, in which Meiselas harnesses images made by others in the construction of visual history, is something that continues to preoccupy her. Over the course of six years in the 1990s, she conducted a major project aimed at giving form to the collective memory of the Kurds, using pictures of her own in combination with historical photographs, texts, and other documents that she gathered. The project resulted in the publication *Kurdistan: In the Shadow of History* (1997), which acts as a repository of memory for the Kurdish people. The book evolved into a Web site that continues to act as a living archive for the project, perpetuating the dialogue of history.

NOTES

1. Susan Meiselas, quoted in Chris Boot, ed., *Magnum Stories* (London: Phaidon Press, 2004), p. 322.

2. Meiselas, quoted in Boot, *Magnum Stories* (note 1), p. 322.

3. Meiselas, in interview with Kristen Lubben, *Susan Meiselas: In History*, ed. Lubben (New York: International Center of Photography; and Göttingen, Germany: Steidl, 2008), p. 116.

4. Meiselas, quoted in Caroline Brothers, "Well-Traveled Photographer, Recording and Then Returning," *The New York Times*, 11 August 2007.

5. This was reproduced on the cover of the *New York Times Magazine*, becoming the first photograph of the Nicaraguan revolution to be published in an American newspaper. See the transcript of Meiselas's experimental documentary *Voyages* (1985), included in *Susan Meiselas* (note 3), p. 226.

6. Meiselas, interview with Lubben (note 3), p. 116.

7. Meiselas, edited with Claire Rosenberg, *Nicaragua, June 1978–July 1979* (New York: Pantheon, 1981). Spanish and French editions were also published.

8. Meiselas, interview with Lubben (note 3), p. 116.

9. Martha Rosler, introductory remarks to "Wars and Metaphors," reprinted in Rosler, *Decoys and Disruptions: Selected Writings, 1975–2001* (Cambridge, Massachusetts: The MIT Press, 2004), p. 245.

10. This was a structure that was not always viewed in a favorable light; Rosler argued that it detracted from the journalistic endeavor. See Rosler, "Wars and Metaphors" (note 9).

11. Meiselas, conversation with the author, December 15, 2009.

Reproduced on the following pages is a selection of photographs from Meiselas's project documenting the Nicaraguan revolution.

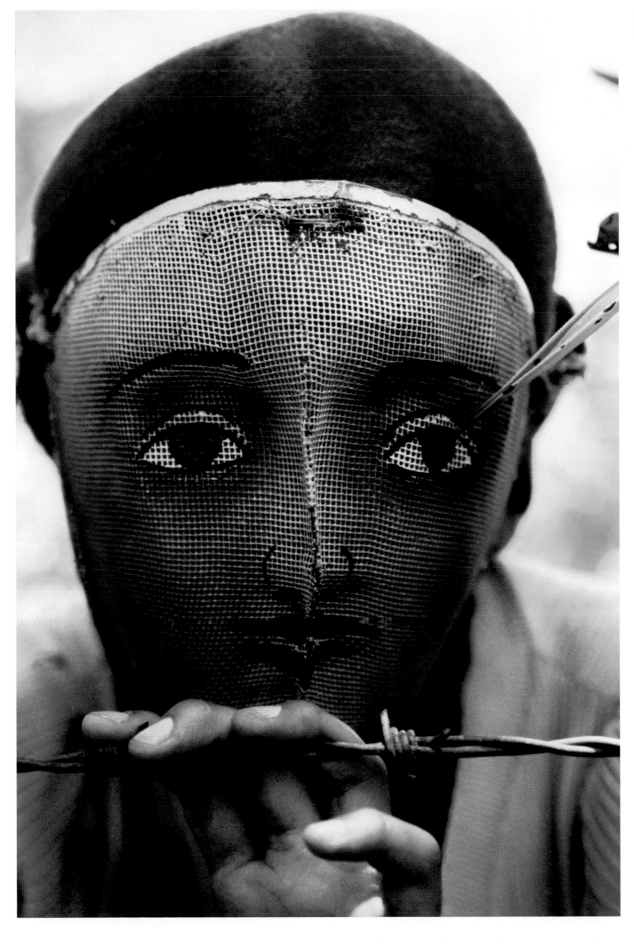

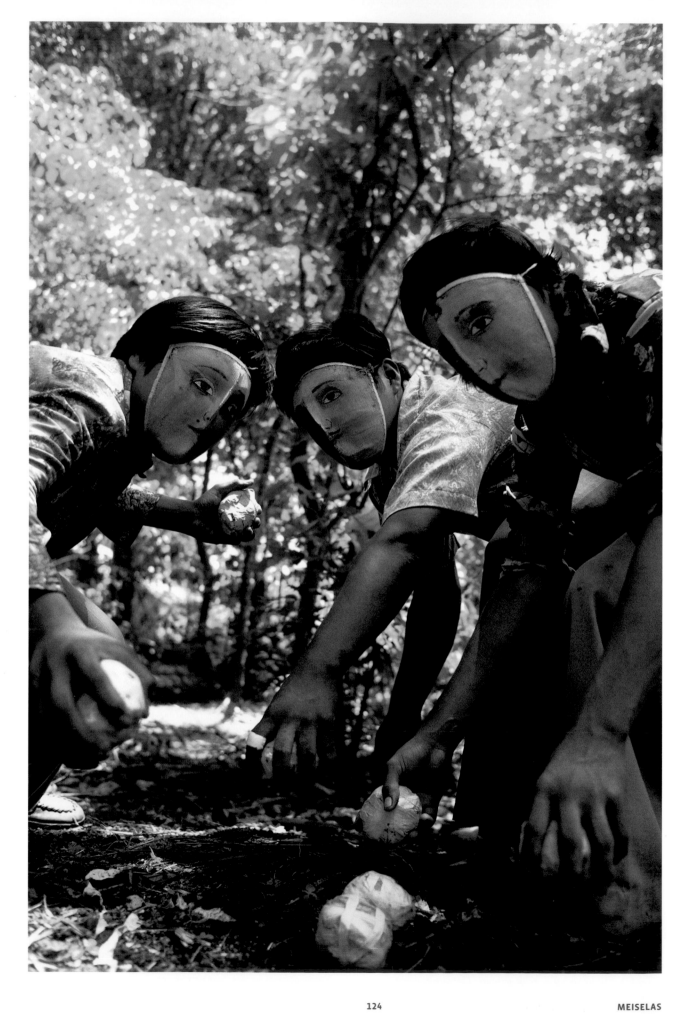

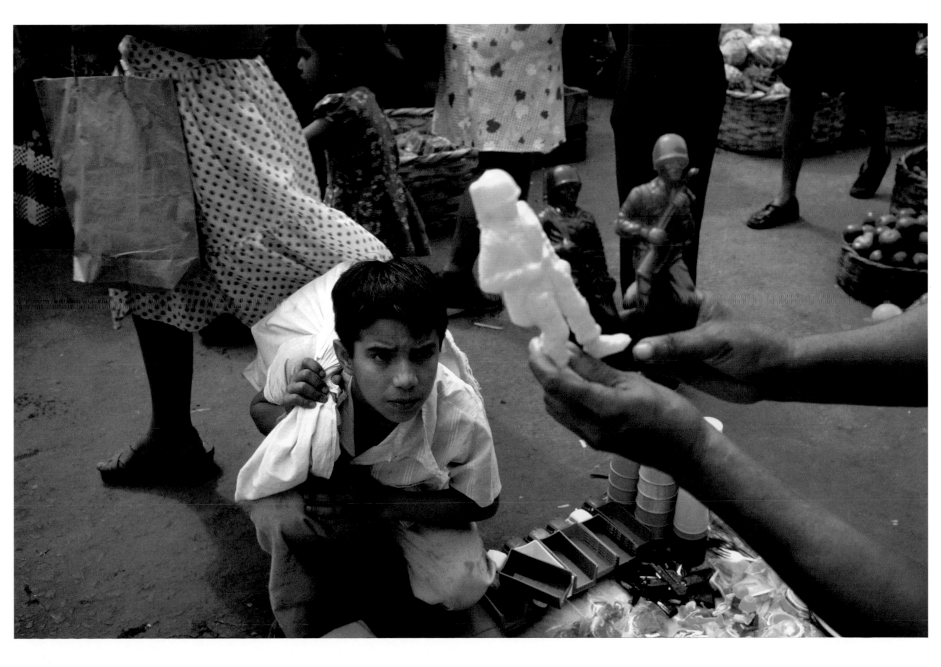

89. *Leading Los Doce (The Twelve) into Monimbo, July 5, 1978, Nicaragua, 1978*

90. *Car of a Somoza informer burning in Managua, Nicaragua, 1978*

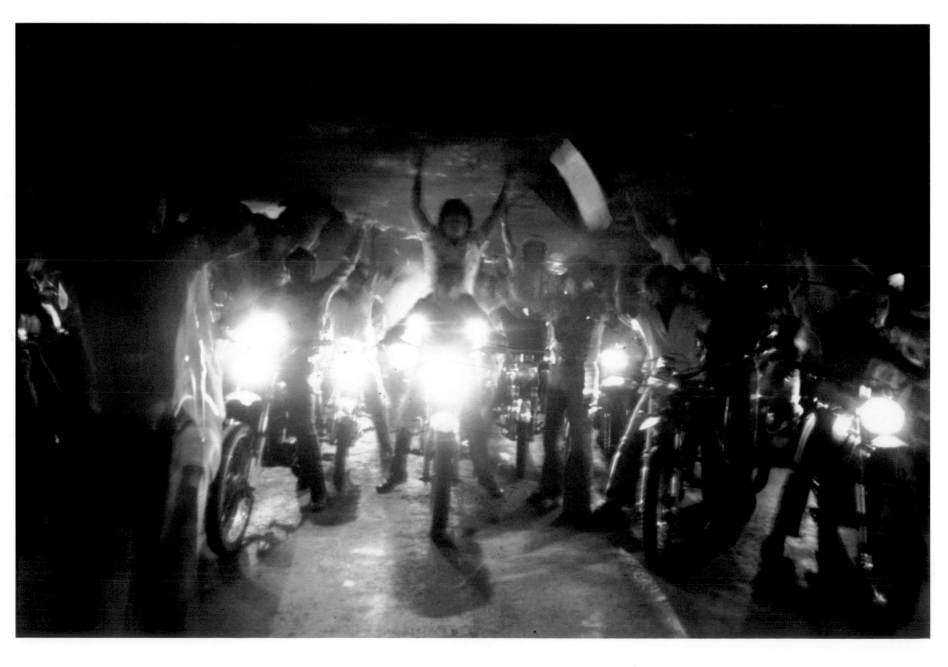

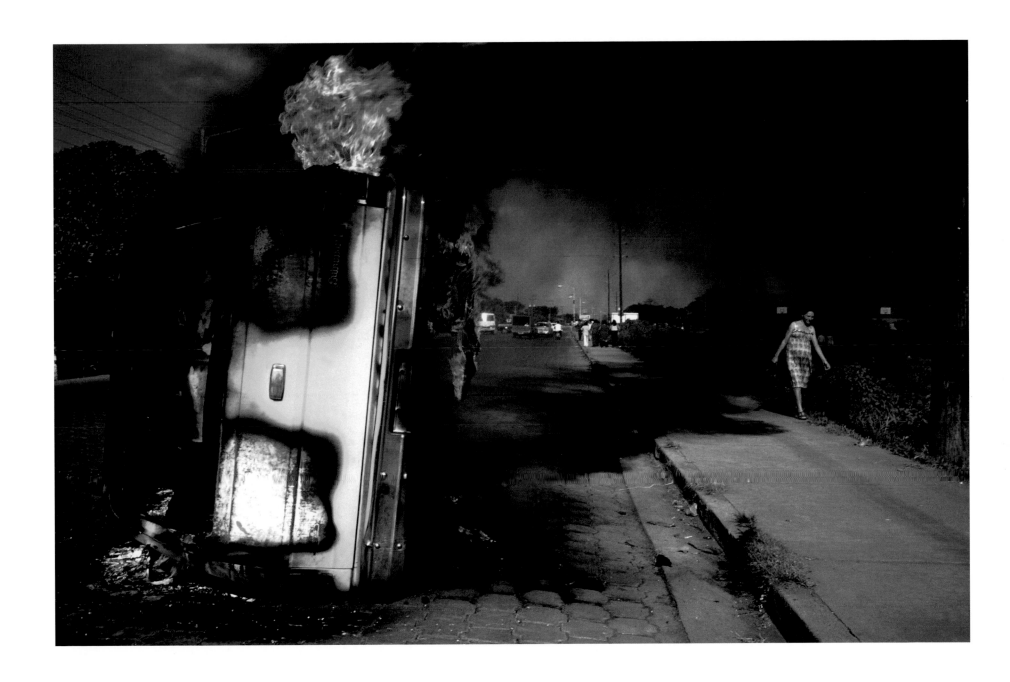

91. *First day of popular insurrection, August 26, 1978,*
Matagalpa, Nicaragua, 1978

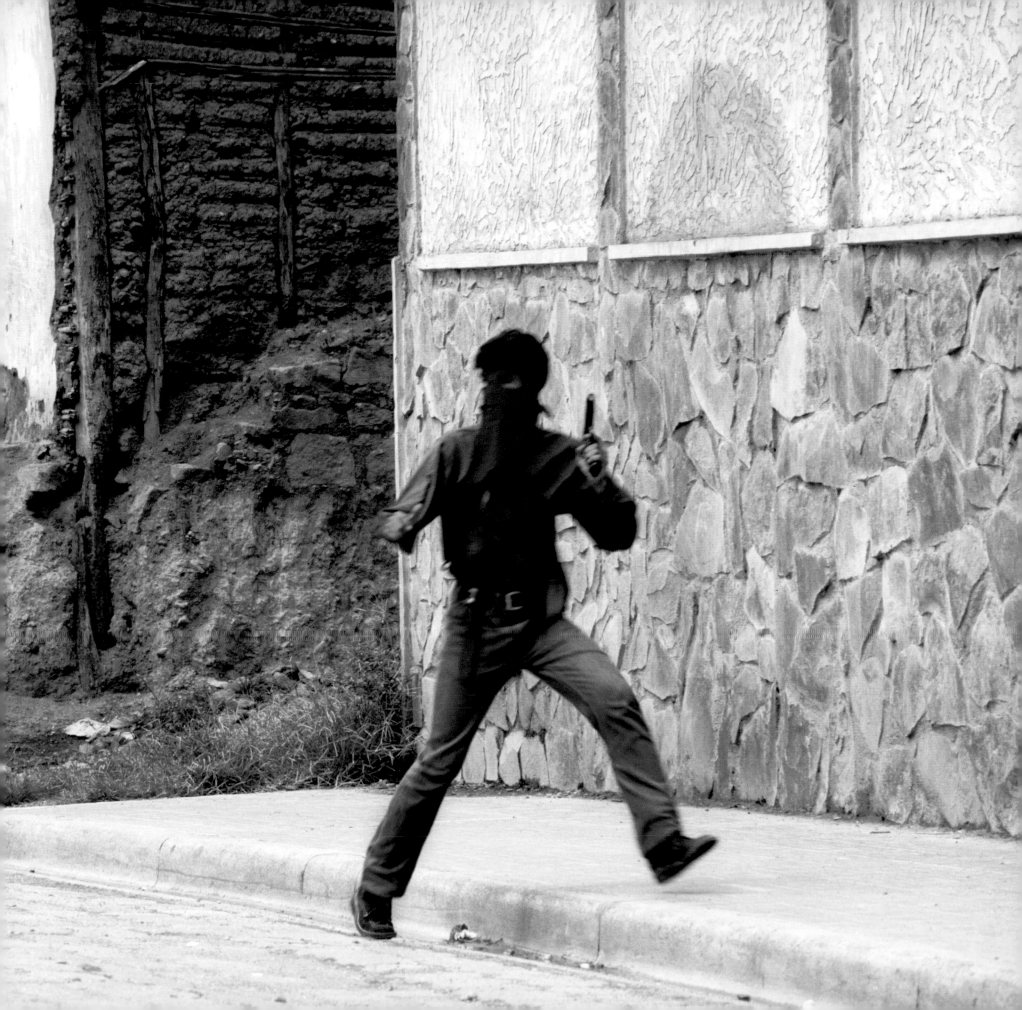

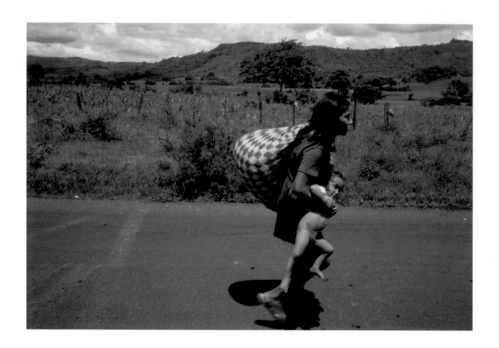

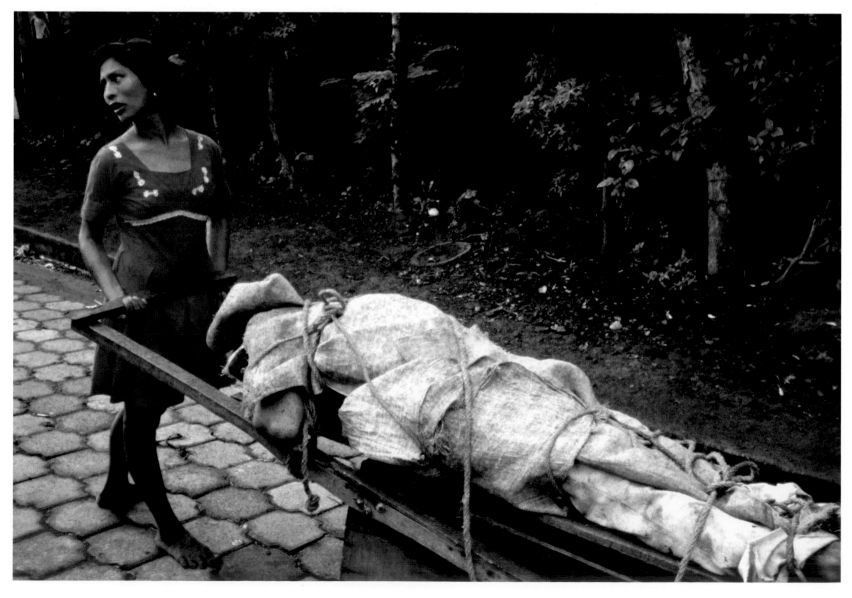

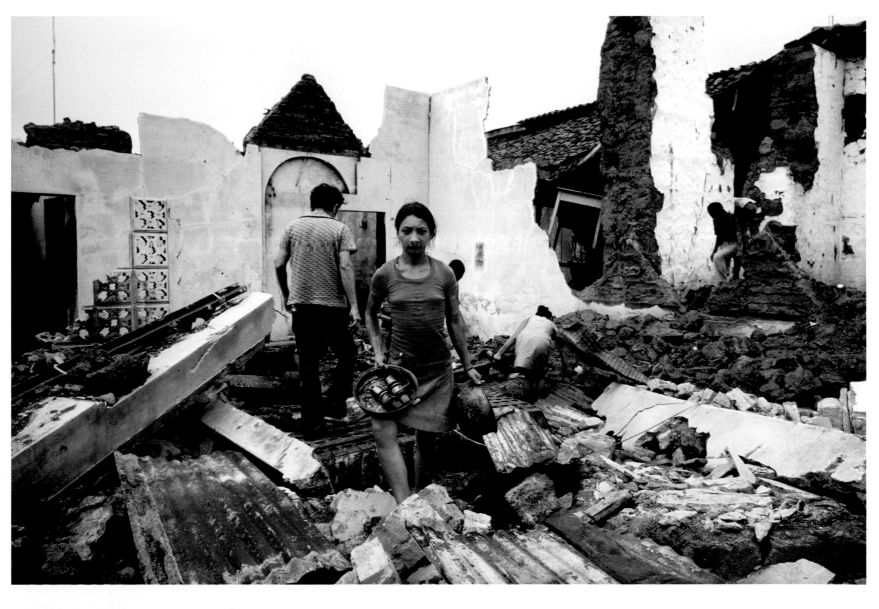

95. *National Guard patrol in Masaya beginning house-to-house search for Sandinistas, Nicaragua, 1979*

96. *Awaiting counterattack by the Guard in Matagalpa, Nicaragua, 1978*

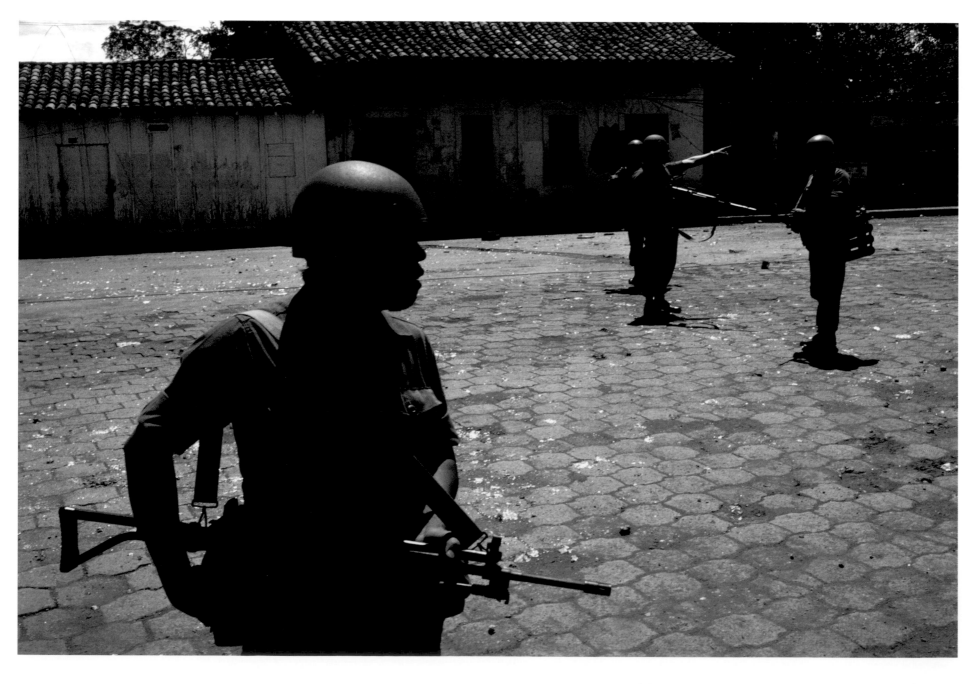

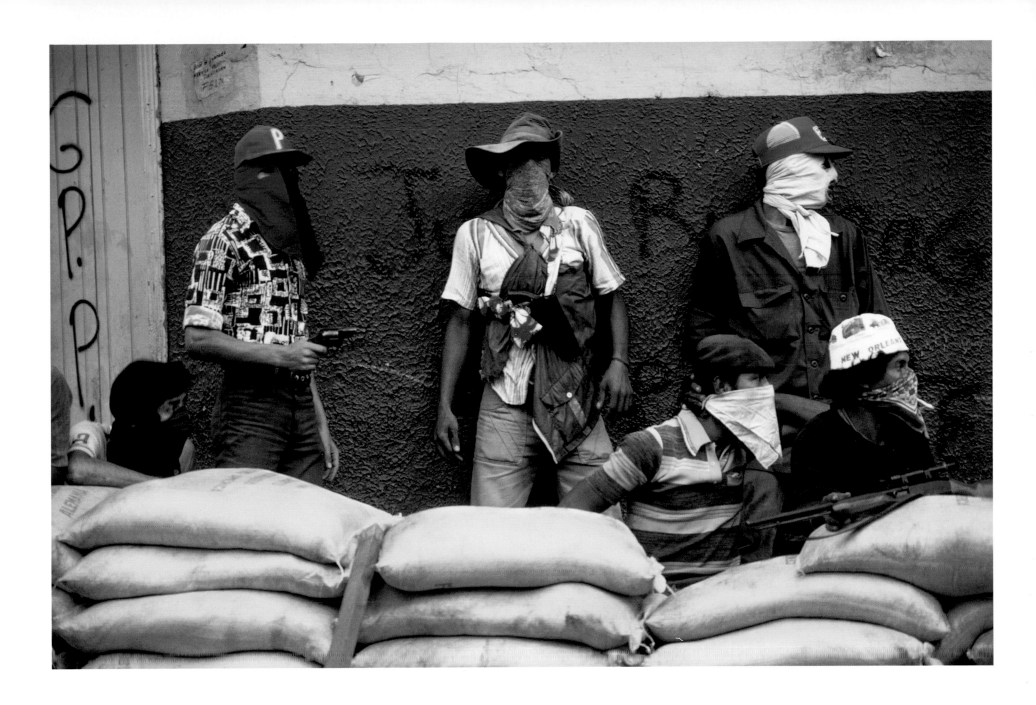

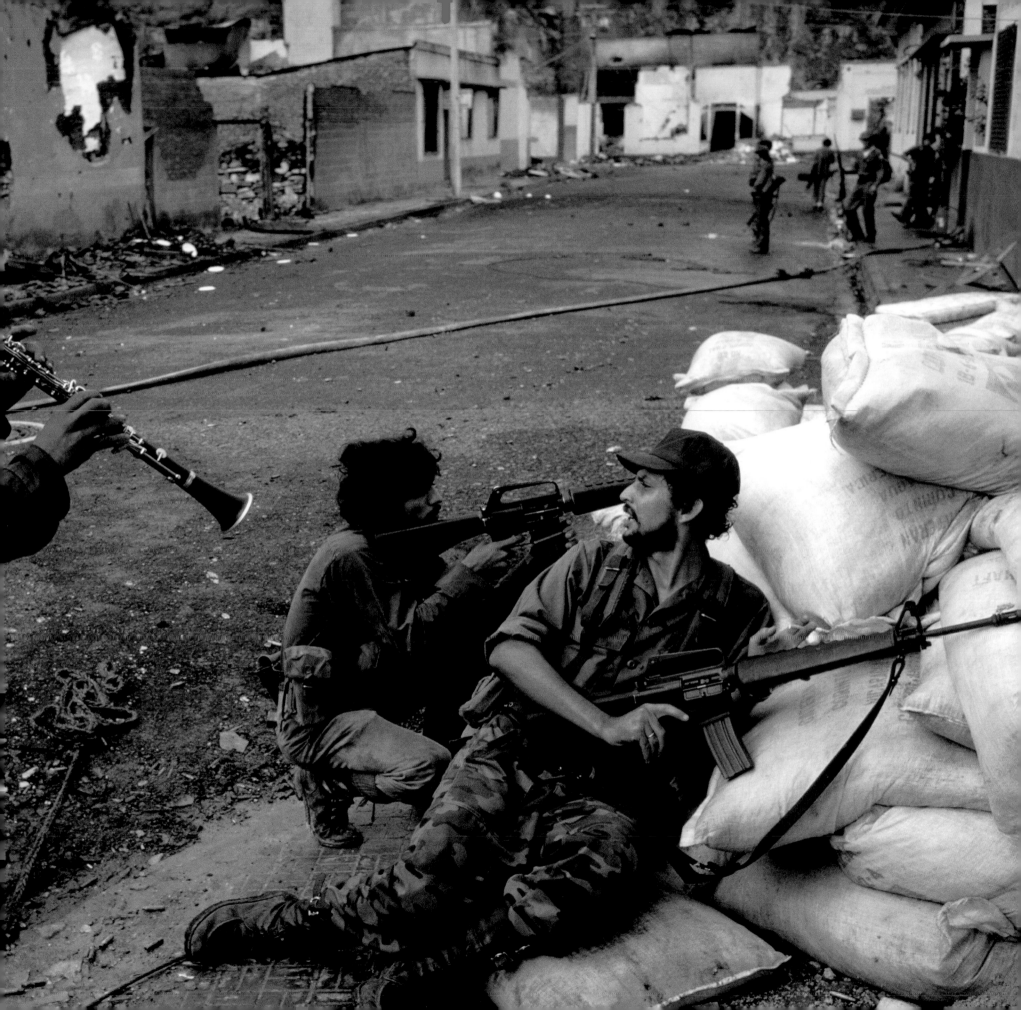

MARY ELLEN MARK
STREETWISE

Mary Ellen Mark (born 1940) has reported on the state of our social environment, both domestically and internationally, for more than four decades. Of particular concern to her are people on the fringes of mainstream culture. Her patient, sensitive, and persevering approach has resulted in extraordinarily intimate access to the lives of ordinary individuals. Far removed from the immediacy of war and conflict, her work eschews issues of crisis and exoticism in favor of plumbing the basic commonality of human experience.

Raised in the suburbs of Philadelphia, Mark studied painting and art history as an undergraduate at the University of Pennsylvania and then completed graduate work in communications and photography at the university's Annenberg School for Communication. Following graduation, she was granted a Fulbright scholarship in 1965 to photograph in Turkey, where she remained for about a year. She subsequently traveled through other parts of Europe and Mexico before setting herself up as a professional photojournalist in New York. The trip proved to be important in developing her portfolio and her independence as a photographer. Some of the work she made on her voyage was later published in her first book, *Passport* (1974).

Her curious and intrepid spirit would be an important ingredient to her success in New York. As a young photographer without significant name recognition, she found it difficult to gain assignments from editors, and thus she began assigning herself stories, selling finished groups of photographs to magazines that were interested in avoiding the risks associated with commissioning unseen work. Through this method, her photographs gained exposure in publications like *New York* magazine and *Evergreen* during the late 1960s. Among Mark's earliest picture stories was an article on a controversial law in England that allowed clinics to dispense heroin to registered addicts. In 1970, it was

published in collaboration with writer Mary Simons in *Look* magazine as "What the English Are Doing About Heroin."

In 1967, Mark took on a freelance job as a movie production-still photographer with United Artists, which provided a suitable environment to develop her skills in portraiture and reportage. She would photograph on a number of sets, including *Fellini Satyricon* (1969), *Catch-22* (1970), and *One Flew Over the Cuckoo's Nest* (1975). For the latter she volunteered to work for expenses only because the production was on a tight budget and she wanted the opportunity to work in a mental institution.

It was a worthwhile investment, for the experience was instrumental in providing both inspiration and access for her first major independent project. While working on set, she was able to tour the Oregon State Mental Hospital, where much of the movie was filmed. She became intrigued by Ward 81, a maximum-security unit for women. After completion of the film, she developed a proposal to photograph there and kept in touch with the warden, who eventually allowed her the opportunity to return. She lived in Ward 81 with writer and social scientist Karen Folger Jacobs for thirty-six days, photographing and interviewing the women in 1976. The work resulted in the publication *Ward 81* (1979). Mark and Jacobs were particularly interested in depicting the women they encountered as people with distinct personalities, feelings, and thoughts of their own, and not simply as examples of psychological disorders. In humanizing their subjects and depicting the difficulties of their circumstances, the two reporters emphasized the ordinary over the sensational and called for compassion in dealing with people afflicted by mental illness.

Ward 81 was Mark's first independent project of significant proportions, and in it she broke from the formulaic structure of the traditional magazine photo

essay, with its beginning, middle, and end and its reliance on didactic factual texts. She explored the topic in a more personal and free-form narrative than she was accustomed to doing, embracing an evocative mode of reporting that gave visual expression to her experience with the patients. Having spent a significant period of time with her subjects in the ward, Mark realized the value of extended coverage as a means of achieving thoughtful documentation. She would continue to use this process in her approach to future projects.[1]

In 1977 the photographer became associated with Magnum, which provided her with a platform for pursuing other long-term projects. The following year she would embark on an investigation of prostitution in Bombay (now Mumbai). She focused her documentation on a lower-class area along Falkland Road that was lined with brothels. She had been interested in the subject since the 1960s, but her attempts to photograph there on various occasions had been met with hostility by the area's inhabitants. Making a concerted effort in 1978 to get to know the people living there, she cultivated relationships that allowed her unusually intimate access to the brothels and their activities. Her photographs (fig. 47), made over the course of several months, were published in *Stern* and other magazines and resulted in her third major publication, *Falkland Road*, in 1981. As with *Ward 81*, Mark's *Falkland Road* study tells the story of those in the margins of society who go about their daily lives, forging an ordinary existence amid difficult circumstances.

In 1981, Mark left Magnum to form Archive Pictures with four other photographers. That same year she went to India to pursue a second project in the country, this time focusing on Mother Teresa's Missions of Charity. The year prior she had completed a story for *Life* magazine titled "Teresa of the Slums: A Saintly Nun Embraces India's Poor," and her 1981 trip was aimed at pursuing the topic more fully. Mother Teresa began including Mark on visits to hospitals, where the photographer documented abandoned children, the homeless, those afflicted by leprosy and tuberculosis, and the nuns devoted to attending to them. In 1985, the project was published in book form by the Friends of Photography in Carmel.[2]

Mark began what is perhaps her best-known project two years before her publication on Mother Teresa. She and reporter Cheryl McCall traveled to Seattle in 1983 to do an article for *Life* magazine on runaway children. At the time, more than one million children between the ages eleven and seventeen ran away from home each year.[3] As Mark described, "One of the reasons we chose Seattle was because it is known as 'America's most livable city.' Los Angeles, San Francisco, and New York were well known for their street kids. By choosing America's ideal city we were making the point 'If street kids exist in a city like Seattle then they can be found

everywhere in America, and we are therefore facing a major social problem of runaways in this country.'"[4]

Mark and McCall began by driving around Seattle for a few days, discovering places where street kids hung out. They eventually focused on an area between First and Second avenues along Pike Street in Seattle's downtown area. The kids were suspicious of the reporters at first, believing them to be undercover cops. But over time, Mark and McCall built a sense of trust with the community of runaways, meeting more and more kids and learning about their methods of survival. Their work resulted in the *Life* story "Streets of the Lost: Runaway Kids Eke Out a Mean Life in Seattle," which appeared in July of 1983.

While developing the *Life* story, Mark spoke with her husband, filmmaker Martin Bell, and the two decided together with McCall that they should all develop the topic further as both a documentary film and still-photography project after the *Life* assignment. McCall raised a significant portion of their film budget from her friend Willie Nelson, and the remaining expenses for the project were covered by the three documentarians, who began working again in August of that year. Over the course of several months, teenagers by the names of Tiny, Lulu, Rat, Dewayne, Patti, Laurie, Shadow, and others became central characters in the two projects. The film, titled *Streetwise*, was released the following year and was nominated for an Academy

Award. Its first showing took place in Seattle, with the children present. According to Mark, the kids embraced the documentary, even while some were disturbed by seeing their lives from a new perspective. "By the end of the film many of the children were in tears. One boy approached Martin. 'Are our lives really like this?' he asked."[5] In 1988, Mark published her still photographs from the project in a book of the same title. The publication includes an edited transcript of the soundtrack from the film, allowing the kids' own words about their lives to punctuate the images.

Through the book's combination of words and pictures, Mark depicted an intimate portrait of teenagers who managed to survive on the tough streets through petty crime, prostitution, dumpster diving, and panhandling. She showed the abandoned buildings and underpasses they inhabited and the bonds they built with one another in the absence of family. Quotes excerpted from the film provide a glimpse into the kids' desire for a more ordinary existence off the streets. Before committing suicide, Dewayne elaborated his modest aspirations: "Get a girl friend, have a house or a car or somethin', have a little money in the bank. Get a job. That's what I expect out of life. Not much."

Mark's compositions are striking and uncomfortable, emphasizing her subjects' youth while capturing them engaged in activities beyond their years. A young Laurie, shown indulging in bubble gum and ice cream

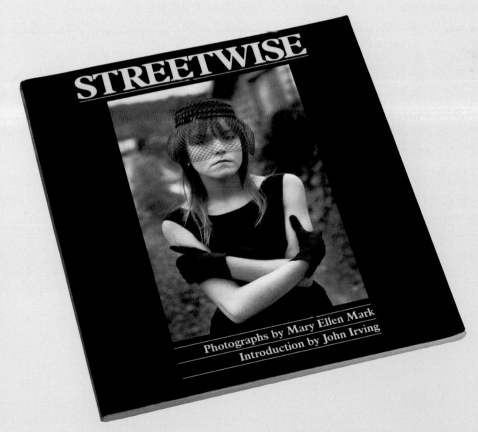

FIGURE 46. Cover of Mary Ellen Mark, *Streetwise* (1988; New York: Aperture, 1992).

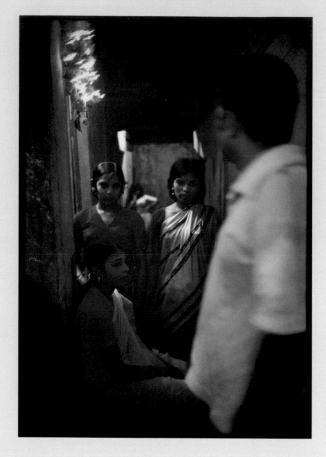

FIGURE 47. Mary Ellen Mark (American, born 1940), *The brothel hallway at night*, ca. 1978–79. From the series Falkland Road. Courtesy of the photographer.

with the much older "Ferret Man" in one picture, is seen sitting on his lap in another (pl. 106). A third picture of Laurie (pl. 104) is accompanied in Mark's book by a quote from her friend Tiny, who noted, "I think it is very strange that older men like little girls. They're perverts is what they is." Tiny's own mother says of her daughter, "She has grown up quite a bit since she's been on these streets. She's fourteen going on twenty-one." And indeed Tiny embodied this contradiction of maturity and youth, surviving on the streets (pl. 108) but still taking pleasure in dressing up for Halloween (pl. 109). Likewise, in another photo, a simultaneously tough and vulnerable Lillie (pl. 107) stands smoking against a graffiti-strewn wall. She clutches a rag doll that betrays her age and appears so incompatible with the harsh concrete environment around her. Similarly, Rat and Mike (pl. 98) seem much too young to be packing a .45 handgun. Mark captured the gun in close proximity to the boys' youthful faces, further emphasizing the incongruity of elements by framing them against an inhospitably deserted street receding dramatically into the background.

Mark's Streetwise project with Bell and McCall provided dimension to an important issue of their day. In giving specific shape, individuality, and visibility to the problem of homeless children, they called for greater social and political commitment to addressing America's epidemic of broken families. John Irving's

introduction to Mark's book framed the project in an even more specific political context, suggesting that President Reagan's social agenda might be better spent on improving the lives of those already in dire circumstances than on crusades for the unborn.

> I wish the president could see *Streetwise*, for there is little acknowledgment of the existence of Pike Street's children in his plans for America.... Mary Ellen Mark and Martin Bell have been paying attention to the children of Pike Street, who are very much born—and unloved, poor, unwanted, abused. Like all good stories, *Streetwise* is timely. I wish that the national (and presidentially approved) fervor for fetuses could be slightly redirected. Dewayne and Tiny and their friends Rat and Shadow and Munchkin—they all managed to be born. But who is taking care of them?[6]

After *Streetwise*, Mark left Archive Pictures and initiated a photographic library dedicated solely to her own work. She continues to pursue independent projects and books and maintains relationships with some of her past subjects, like Tiny from Streetwise. Her more recent projects include an exploration of circus life in India (*Indian Circus*, 1993), an investigation of homelessness in America (*A Cry for Help: Stories of Homelessness and Hope*, 1996), a twenty-by-twenty-four-inch Polaroid

portrait series on twins (*Twins*, 2003), and a report on disabled children (*Extraordinary Child*, 2007). Due out in 2011 is a second large-format Polaroid project on high-school proms. Since the 1990s, Mark has also turned her attention to broader monographs and exhibitions of her rich and varied career.

NOTES

1. Marianne Fulton, *Mary Ellen Mark: 25 Years* (Boston: Bulfinch Press/Little, Brown and Company, 1991), p. 12.

2. Mark, *Photographs of Mother Teresa's Missions of Charity in Calcutta, India* (Carmel, California: The Friends of Photography, 1985).

3. Fulton, *Mary Ellen Mark* (note 1), p. 23.

4. Mark, preface to her *Streetwise* (Philadelphia: University of Pennsylvania Press, 1988), p. xi.

5. Mark, *Streetwise* (note 4), p. xi.

6. John Irving, introduction to *Streetwise* (note 4), p. xiii.

The following pages reproduce a selection of prints drawn from Mark's publication.

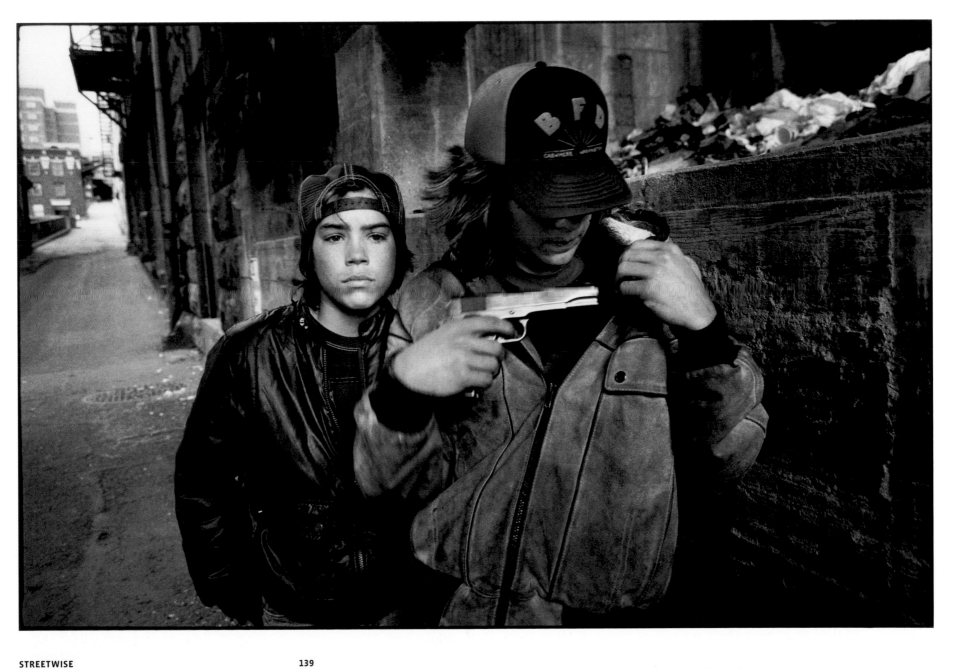

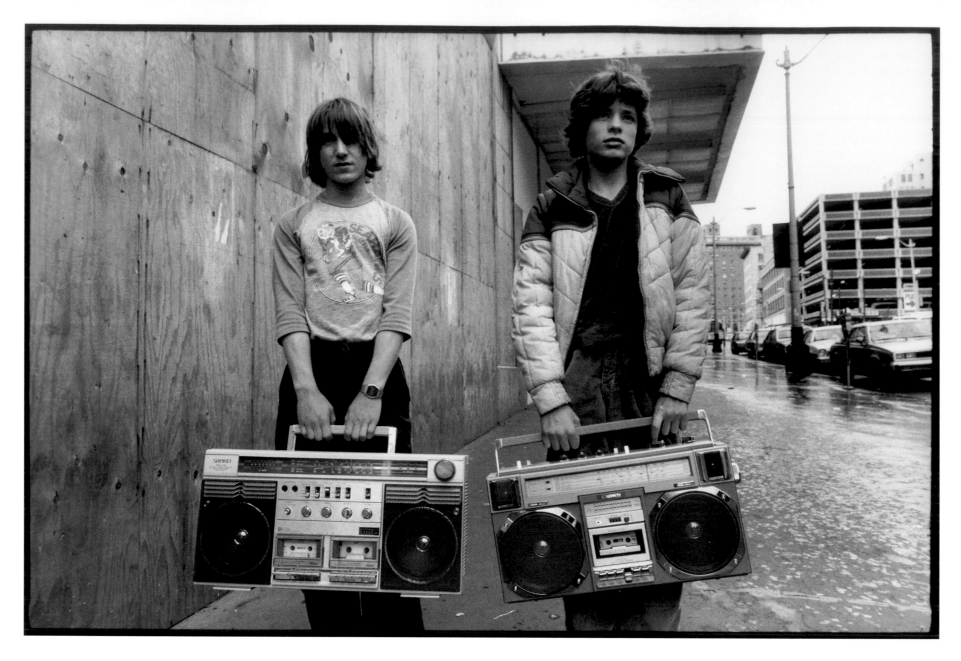

99. *Seattle*, 1983

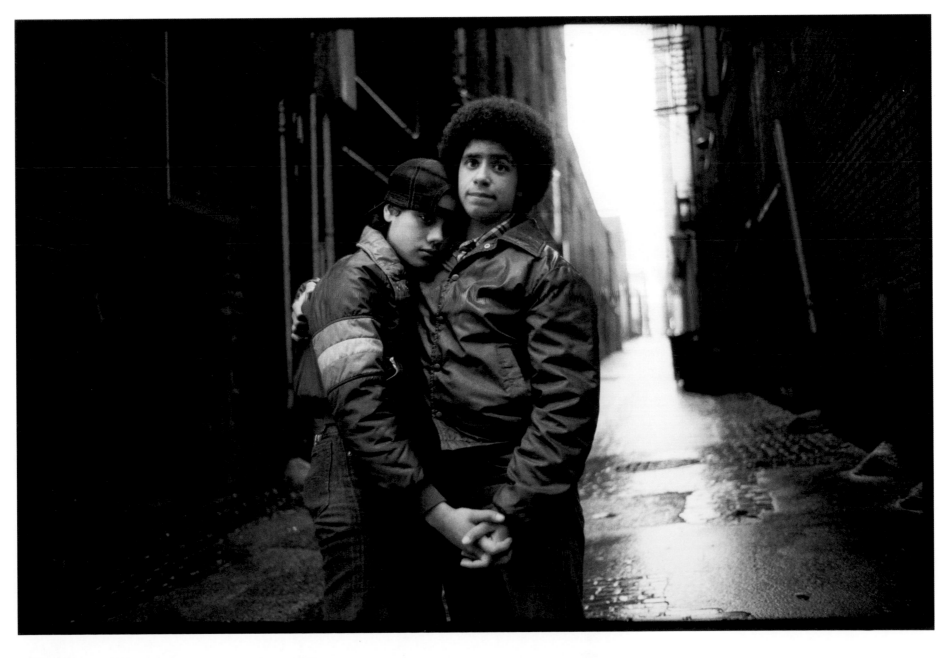

101. *"Patti and Munchkin," Seattle,* 1983

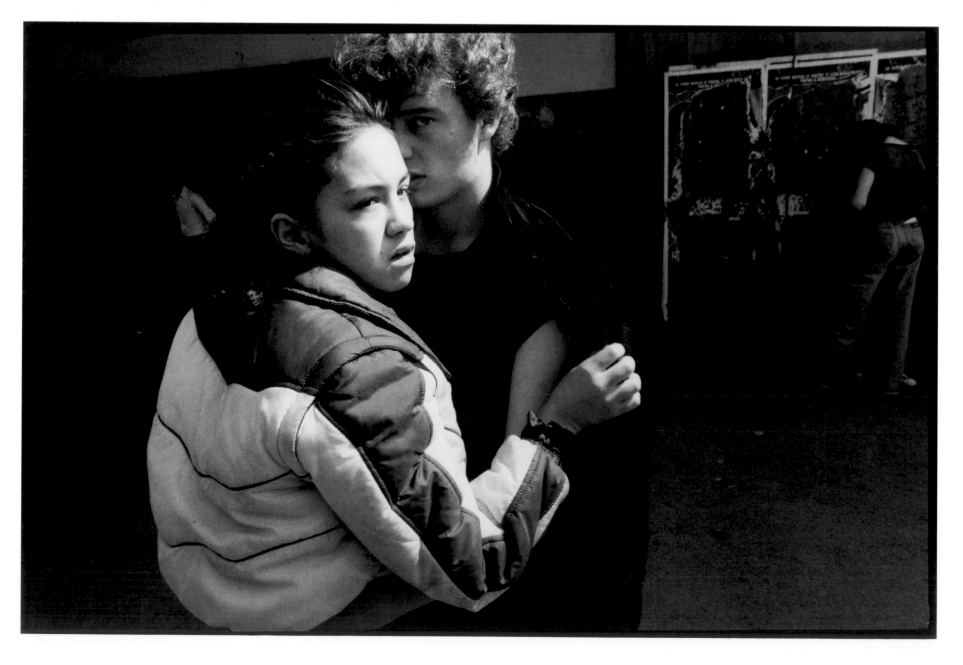

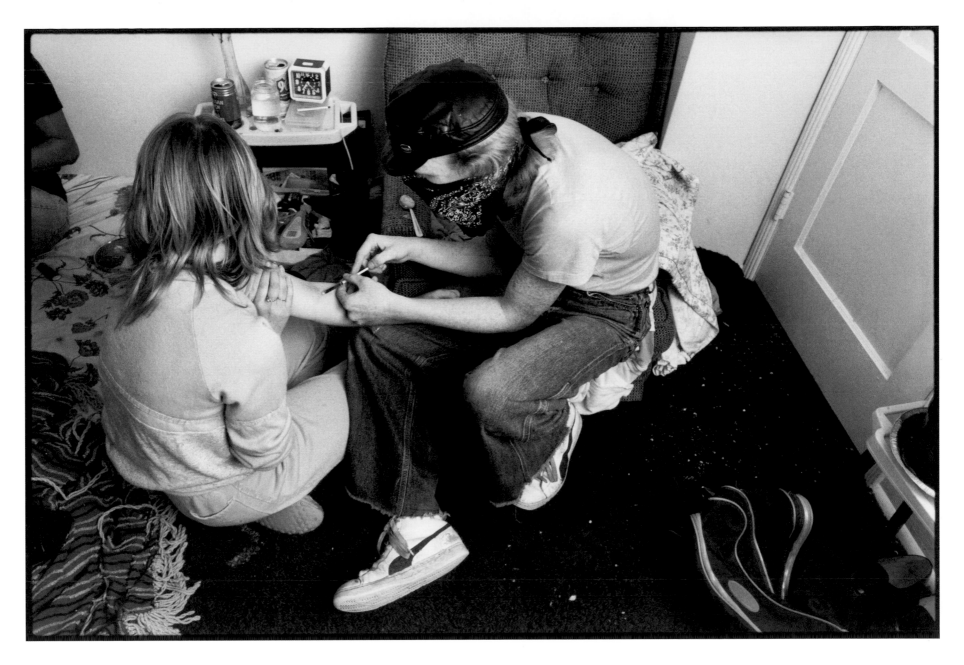

102. *Dealer Injecting Fourteen-year-old Customer in Crash Pad for Runaways, 1983*

103. *Laurie and Companions at a Table, Pike Street Area, Seattle*, 1983

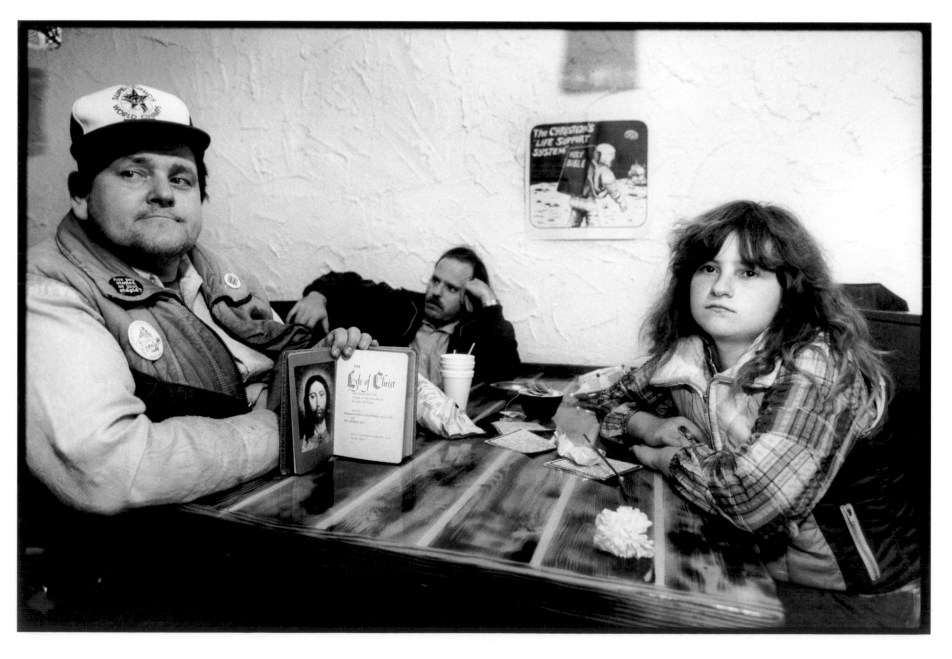

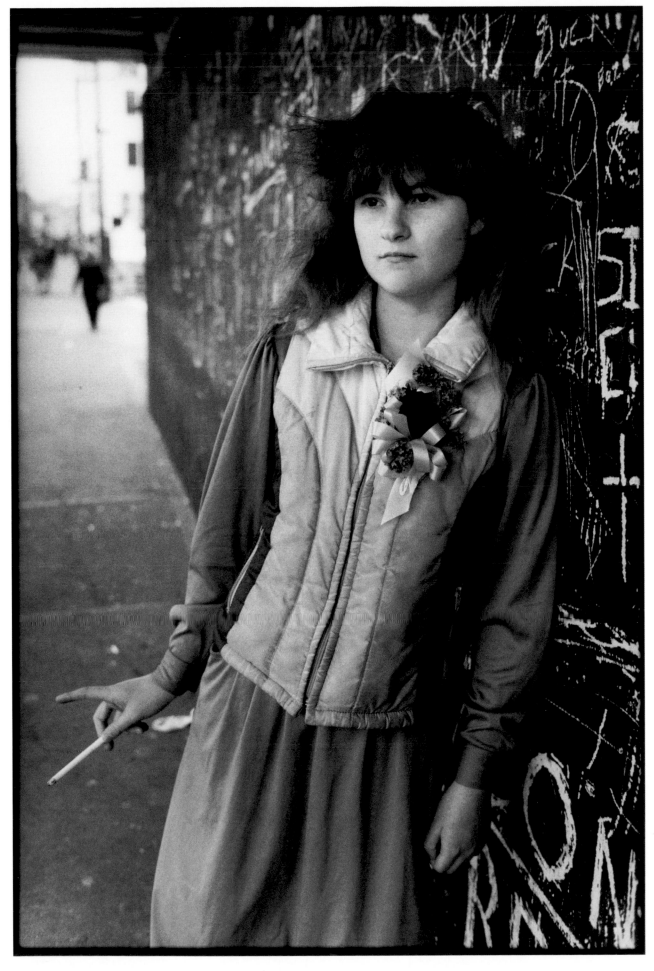

105. *Laurie and the Ferret Man, Seattle,* 1983

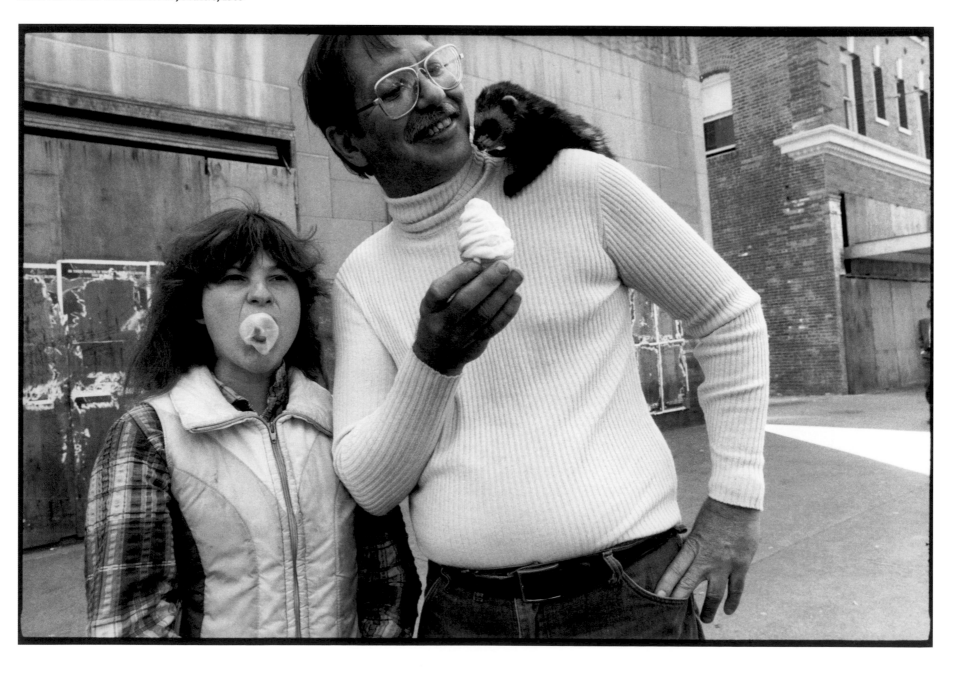

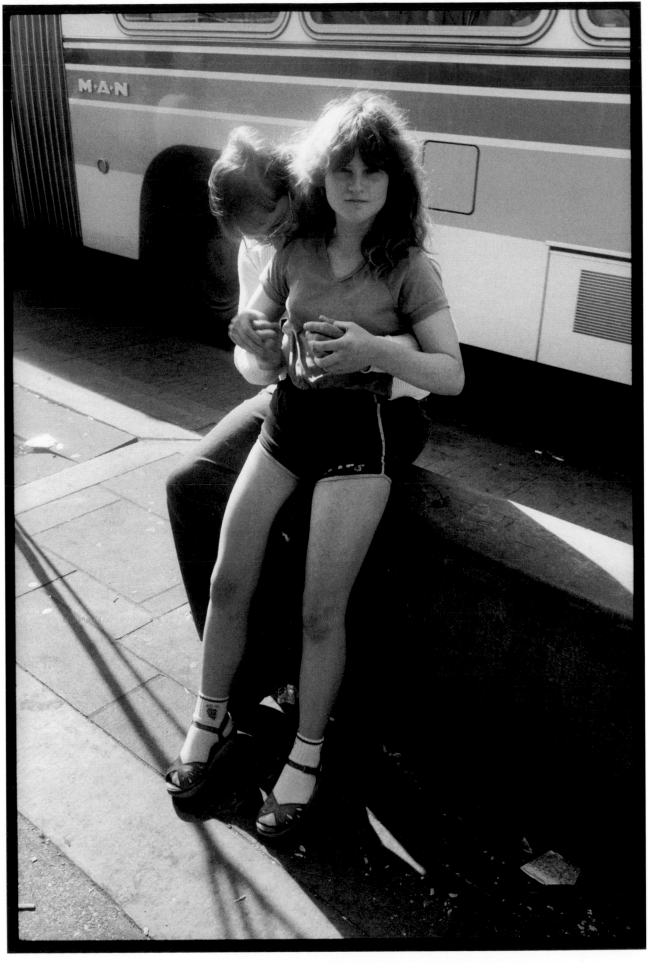

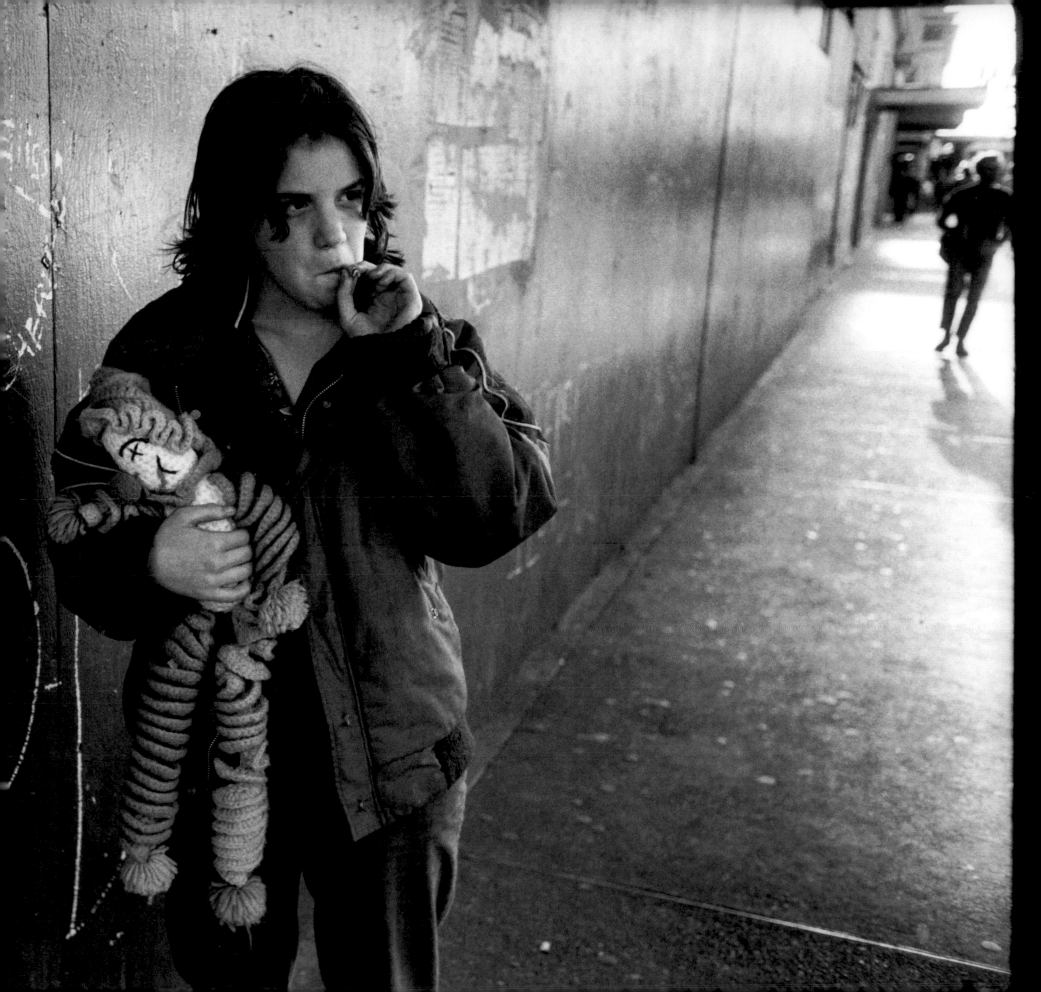

108. *Tiny in the Park, Seattle,* 1983

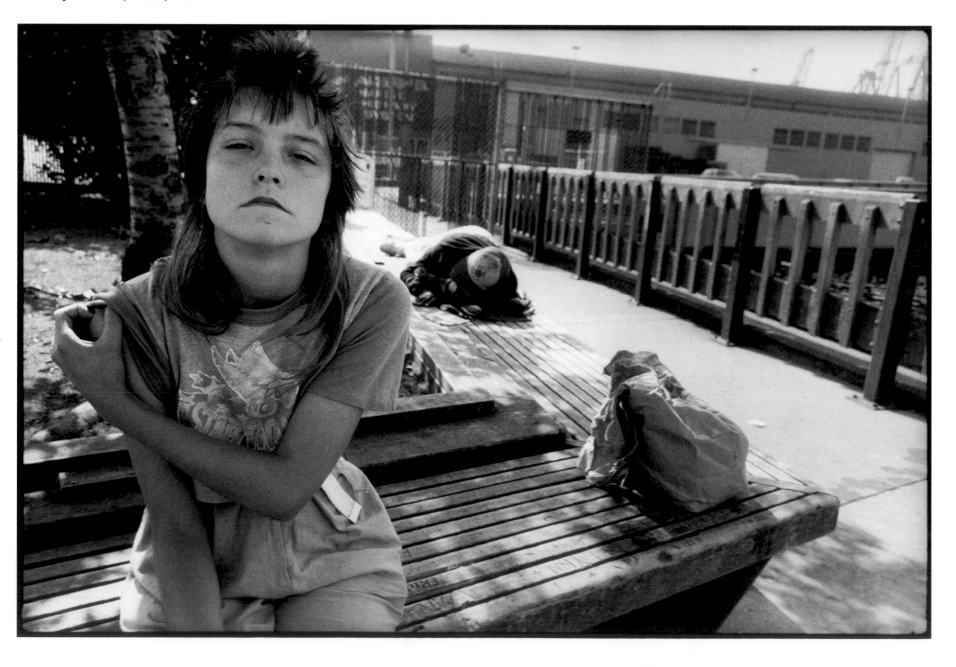

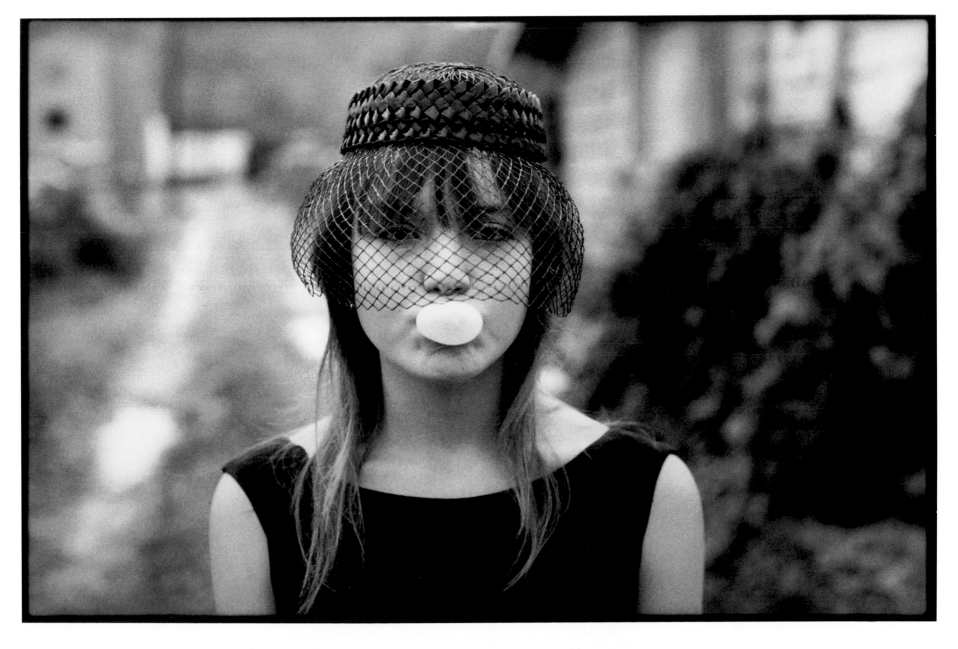

LAUREN GREENFIELD
FAST FORWARD
and GIRL CULTURE

A prominent contemporary photographer working in the long-form essay, as well as an accomplished documentary filmmaker, Lauren Greenfield (born 1966) has built her reputation as a chronicler of mainstream American culture. Her photographs have been regularly published in the *New York Times Magazine, Time, Elle,* and *American Photo,* among other periodicals. The daughter of two university professors, Greenfield was born and raised in Los Angeles. She went on to study film and photography at Harvard University, where she met her future husband, Frank Evers, and graduated with a degree in visual studies (with a focus on visual anthropology) in 1987.

Greenfield began her career as an intern with *National Geographic* magazine, focusing on photography assignments abroad. Among her early projects was a study on modern Mayan life in the Zinacantán village of Nabenchauk in southern Mexico. By 1992, however, Greenfield came to the realization that photographing a culture with which she was intimately familiar could be more fulfilling as an investigative endeavor. She returned to Los Angeles, shifting her anthropological lens to matters that were closer to home. "Los Angeles is where I grew up and formed many of my ideas about myself and the world.... By exploring my own culture, I could begin with a level of access and understanding impossible elsewhere after the most extensive research and fieldwork."[1] Indeed, Greenfield embarked on her new voyage in a place where she had begun her own journey from childhood to adulthood: the Crossroads School in Santa Monica. Gaining approval from the school's principal, Greenfield began photographing students and recording interviews with them. Memories of her alma mater provided the inspiration and initial framework for her visual investigation of what life is like for children growing up in the City of Angels.

Assisted by a grant from *National Geographic* in 1993, she expanded her survey of the city's youth, establishing contacts and photographing in diverse subcommunities, including Beverly Hills, East Los Angeles, and South Central. The project, ultimately published in 1997 as *Fast Forward: Growing Up in the Shadow of Hollywood,* explores Greenfield's persistent sense of an early loss of innocence among Los Angeles youth. As one student put it, "You grow up really fast when you grow up in L.A. It seems like everyone is in a rush to be an adult."[2] The work revolves around Hollywood's role as a homogenizing force in the lives of Greenfield's young subjects, as well as the way in which the entertainment industry has engendered a community of shared values that crosses class and cultural divides. Greenfield concluded in her introduction to the published study that young people "are preoccupied with becoming other than they are. Los Angeles, in her traditional role as the city of dreams, has bequeathed the quest for the dream to her children. The self-consciousness that underlies their aspirations inevitably costs them their innocence."[3]

In 2002, the same year she joined the prestigious cooperative of photojournalists known as VII, Greenfield published her next major project, Girl Culture. The study grew out of her discoveries in Fast Forward and delves more deeply into the way in which consumer society affects the lives of women in America. For Girl Culture, Greenfield photographed the daily lives and rituals of girls around the country, investigating their relationships to their bodies and the effects of popular culture on self-image. Of central concern to Greenfield was the exhibitionist nature of the contemporary American femininity she was photographing. Visiting girls of all ages at home, on visits to doctor's offices, and out with friends, Greenfield delved into personal issues of public consequence, providing an intense

and intimate exploration of problems related to body image—problems easy to take for granted as natural and normal and to participate in without thinking. As Greenfield explained, the project was as much an exploration of herself as it was of her subjects: "*Girl Culture* has been my journey as a photographer, as an observer of culture, as part of the media, as a media critic, as a woman, as a girl....I was...thinking about my chronic teenage dieting, my gravitation toward good-looking and thin friends for as long as I can remember, and the importance of clothes and status symbols in the highly materialistic, image-oriented Los Angeles milieu in which I grew up."[4]

Together, Fast Forward and Girl Culture intelligently, sensitively, and self-consciously explore the way that culture leaves its imprint on individuals. Many of her pictures focus on what she refers to as "body projects," or the grooming rituals of daily life that are undertaken in an effort to express identity through physical appearance. Her subjects have included three teenagers from Minnesota gazing intently at themselves in a bathroom mirror while applying makeup to their faces and wielding a curling iron (pl. 113); and Sheena, similarly gazing critically at herself in the mirror of a department-store dressing room, her face heavily made-up, fingernails painted, and wearing multiple rings, bracelets, and necklaces (pl. 119). In another image (pl. 118), Sheena shaves along the length of her arms in an attempt to eradicate all hair from her body, except for that residing on the top of her head. The social and consumerist influences from which these young women take their cues are also explored. Sisters Violeta and Massiel pose before Greenfield's camera in a San Francisco mall, their likenesses juxtaposed against a monumental advertising mural displaying the carefully airbrushed faces of two models (pl. 115). In another photograph, actress Amy Smart models Versace at the Standard Hotel in Los Angeles, her graceful form echoed by those of a live lingerie mannequin in a glass box behind her and a hotel maid wearing a stylishly high-cut uniform at left (pl. 116).

Greenfield has also explored the lives of those young women who are troubled by the difficulty of living up to such expectations. In the Catskills, she found girls who were too self-conscious of their bodies to wear swimsuits at home and reserved swimming activities to the relative safety of their weight-loss camp (pl. 111). Meanwhile, at an eating-disorder clinic in Florida, a young woman is portrayed being blind-weighed, turned away from the scale so as not to see the progress of her weight gain (pl. 121). For Greenfield, observing the dialectic between the mainstream and the extreme—between dieting and anorexia, dressing provocatively and stripping, or innocent and destructive behavior—is an important part of coming to terms with the problems of contemporary feminine identity.[5]

Greenfield has expanded her investigations of body and consumer culture in more recent studies. In *Thin*, Greenfield's third landmark project, which she directed as a documentary film and subsequently published in book form in 2006, the photographer continued her decade-long exploration of America's cultural obsession with the body (fig. 49). This time, she

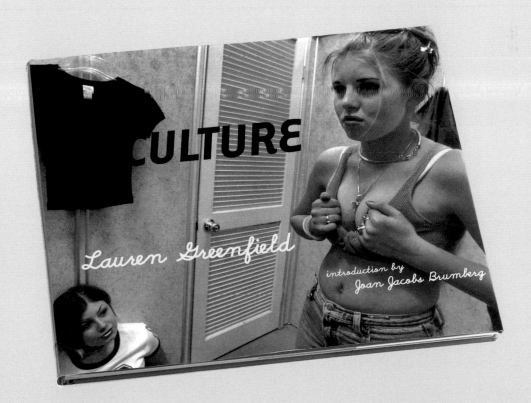

FIGURE 48. Cover of Lauren Greenfield, *Girl Culture* (San Francisco: Chronicle Books, 2002).

FIGURE 49. Lauren Greenfield (American, born 1966), *Shelly near her home in Salt Lake City, Utah, six months after leaving residential treatment for her eating disorder. She lost 17 pounds after discharge and underwent electric shock therapy to treat her depression,* 2005. From the series Thin. © Lauren Greenfield. Courtesy of the photographer.

narrowed her focus even further, concentrating on the devastating effects of eating disorders. Her still photographs and film from the project are built around intimate encounters with women receiving treatment at the Renfrew Center, a residential facility located in Coconut Creek, Florida, that specializes in the illness. In 2008, Greenfield released a short documentary film, *Kids + Money*, which engages with young people from diverse Los Angeles communities to investigate the role of money in their lives and the way in which they have been shaped by a culture of consumerism.

Conducting recorded interviews with subjects has been a consistent component of Greenfield's working method. She routinely edits and includes such material in her final publications, allowing her subjects to express themselves in their own words and thereby providing "a glimpse into the hearts and minds of the girls"[6] photographed. For example, Erin (pl. 121) explains:

I hate being weighed. That is the worst part of my day. I do the blind weights, where I turn backward, but I'm getting to where I can hear the clicks, and I'm afraid to hear that second click at hundred. My total fear for every morning is to hear it slide all the way over. Every morning, I'm waiting to hear that sound.

When I was twelve years old, I started developing, and I was just horrified. No one ever taught me how to deal with the attention I would get with that body, so when I started getting it, it scared me. I would tape my breasts and the inside of my thighs, because I wanted to keep the boyish, preadolescent figure. It got worse in high school, because I was going through a lot of sexual abuse. I wanted my body to be unattractive to people. Plus I had a chaotic

house and a controlling dad. [My body] was the one thing in my life that was mine, and nobody could take it away.

These interviews are considered supplementary to standard image captions, which Greenfield writes and presents alongside every photograph illustrated in her books.

Greenfield does not intend her studies to be judgmental of the specific individuals portrayed. Rather, she approaches her work as an anthropologist might, seeing the actions of her subjects as symptoms of larger cultural values that are worth considering: "I don't think the kids are wrong for trying to survive in the culture we live in. Like when Lindsay got her nose job [pls. 125–26], her nose was really making her unhappy and hurting her self-esteem. I think she made a reasonable choice given the social context. We need to think about what kind of culture we live in to make someone so unhappy about her image."[7] As Greenfield makes clear, her studies are critical of our culture and its values, and not of the individuals who adapt to them.

In photographing mainstream American culture, Greenfield presents us with a mirror with which to reflect upon ourselves. One might imagine that Amelia (pl. 110), standing before Greenfield's camera at a weight-loss camp, could see a beautiful portrayal of her brave and beleaguered face reflected in the photographer's lens, just as Greenfield could see her own shape reflected in Amelia's glassy eyes. But as Greenfield noted, a mirror, like photography, "provides data that, filtered through a mind and moods, are subject to wildly differing interpretations."[8]

NOTES

1. Lauren Greenfield, preface to *Fast Forward: Growing Up in the Shadow of Hollywood* (San Francisco: Chronicle Books, 2004), p. 5. Hardcover first published by Alfred A. Knopf/Melcher Media, 1997.

2. Quoted in preface to *Fast Forward* (note 1), p. 5.

3. Greenfield, *Fast Forward* (note 1), p. 8.

4. Greenfield, *Girl Culture* (San Francisco: Chronicle Books, 2002), pp. 149–50.

5. Greenfield, *Girl Culture* (note 4), p. 150.

6. Greenfield, *Girl Culture* (note 4), p. 152.

7. Greenfield, interview with the author, December 17, 2009.

8. Greenfield, *Girl Culture* (note 4), p. 152.

The pictures selected for presentation on the following pages were culled primarily from the Girl Culture project but include a number of photographs from the Fast Forward series that anticipated Greenfield's interest in the subsequent study.

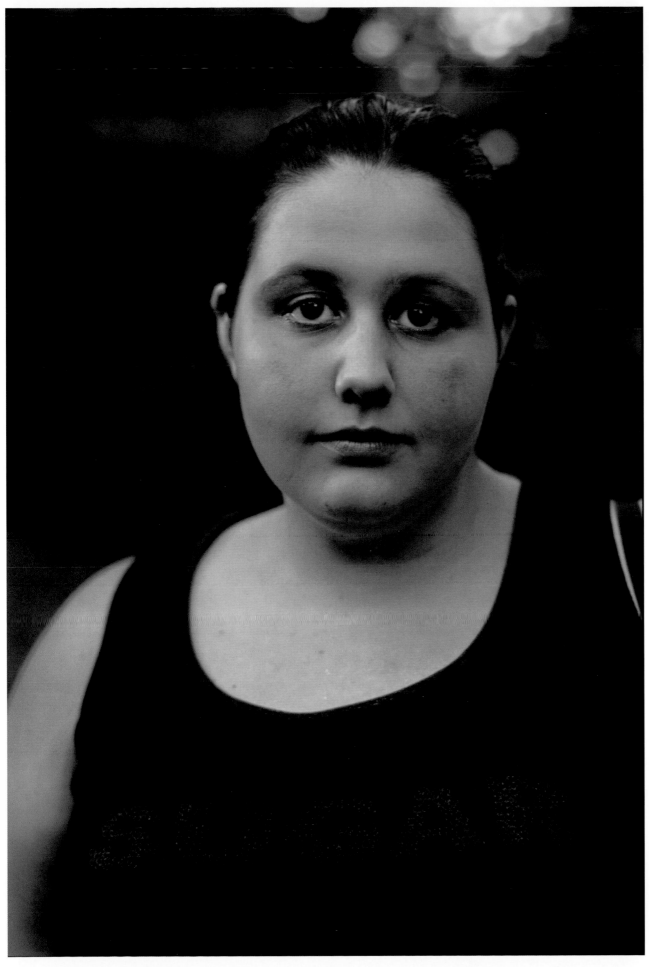

110. *Amelia, 15, at weight-loss camp, Catskills, New York, 2001*

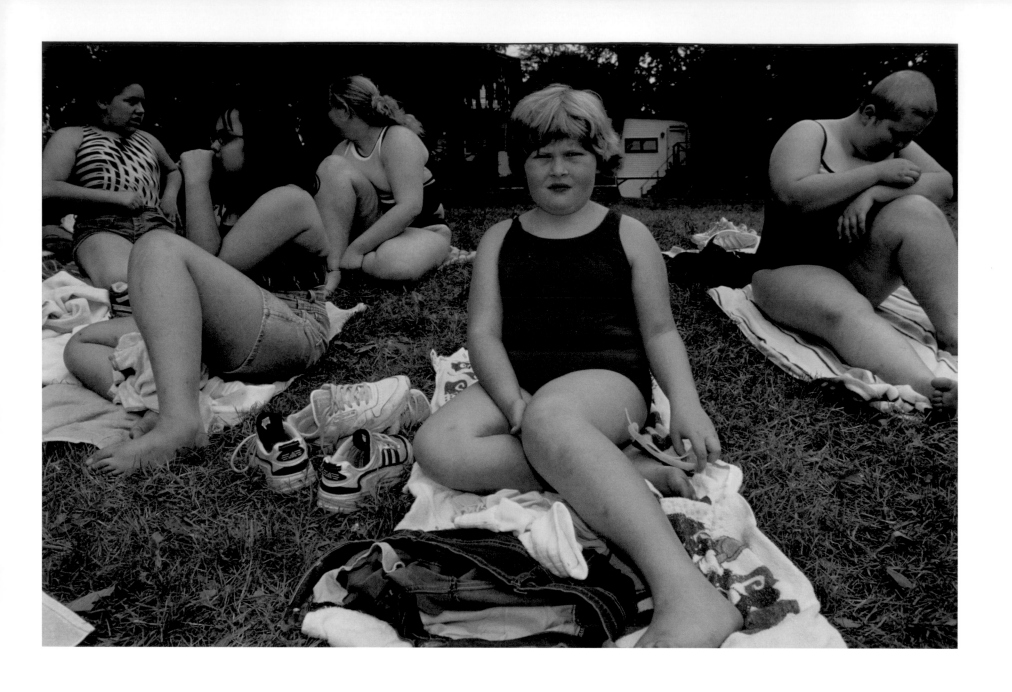

111. *Swimming period at weight-loss camp, Catskills,*
New York. Many kids love to swim at camp but will not
swim or wear a bathing suit at home., 2001

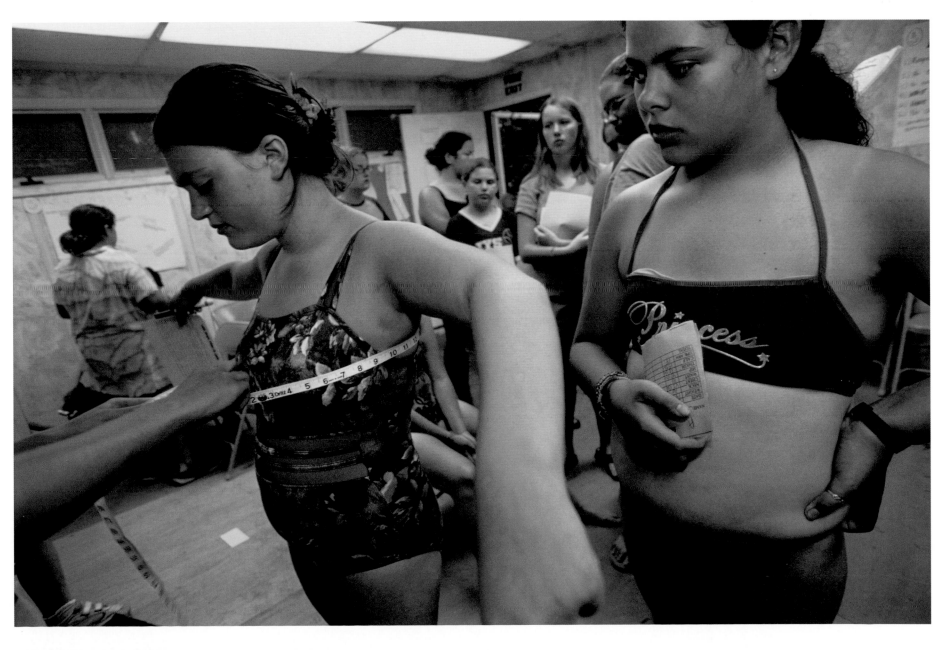

113. *Annie, Hannah, and Alli, all 13, get ready for the first big party of the seventh grade, Edina, Minnesota, 1998*

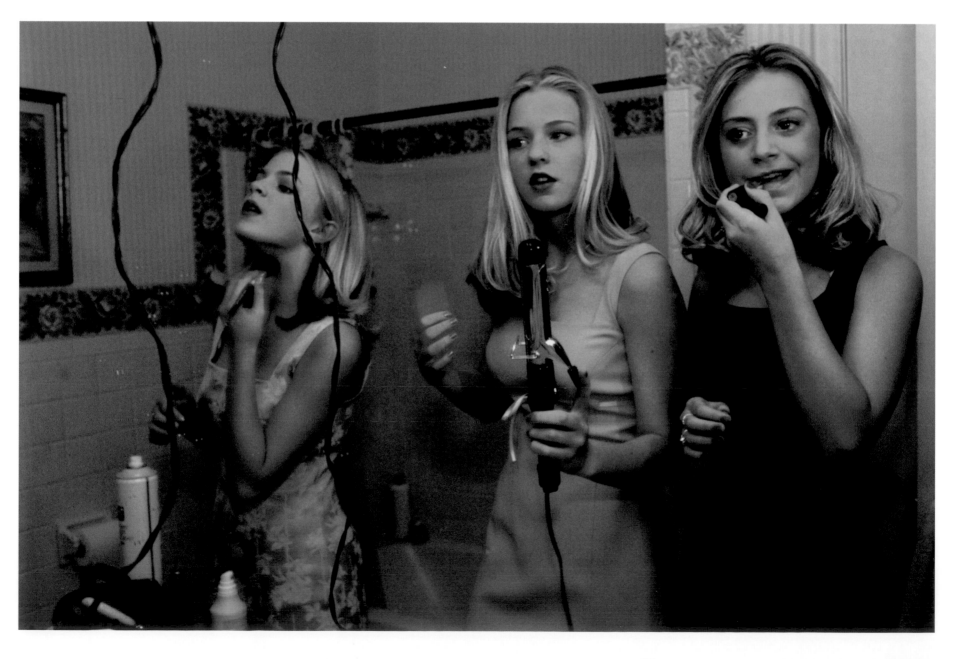

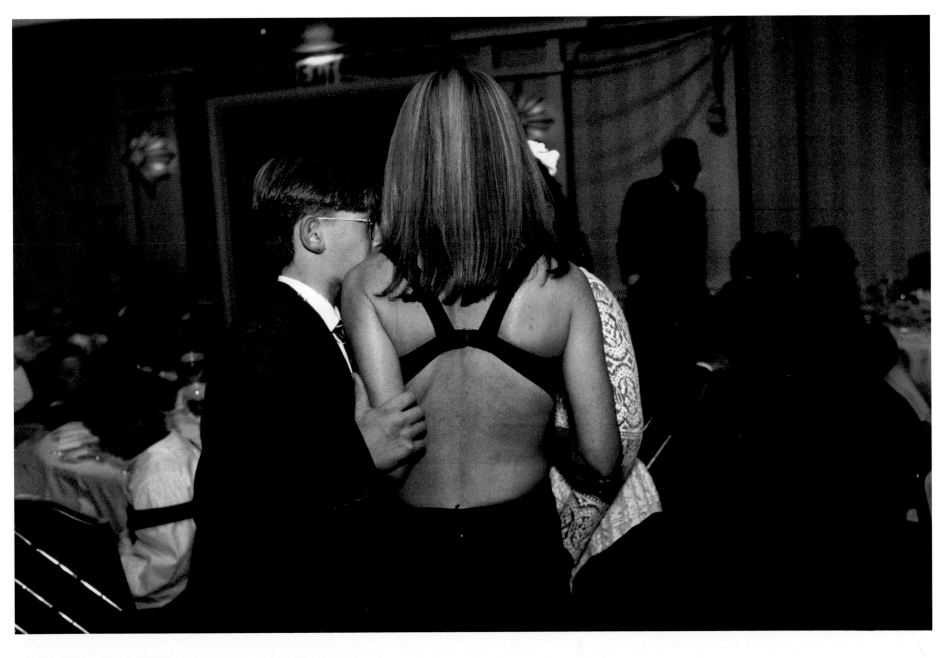

115. *Sisters Violeta, 21, and Massiel, 15, at the Limited in a mall, San Francisco, California, 1999*

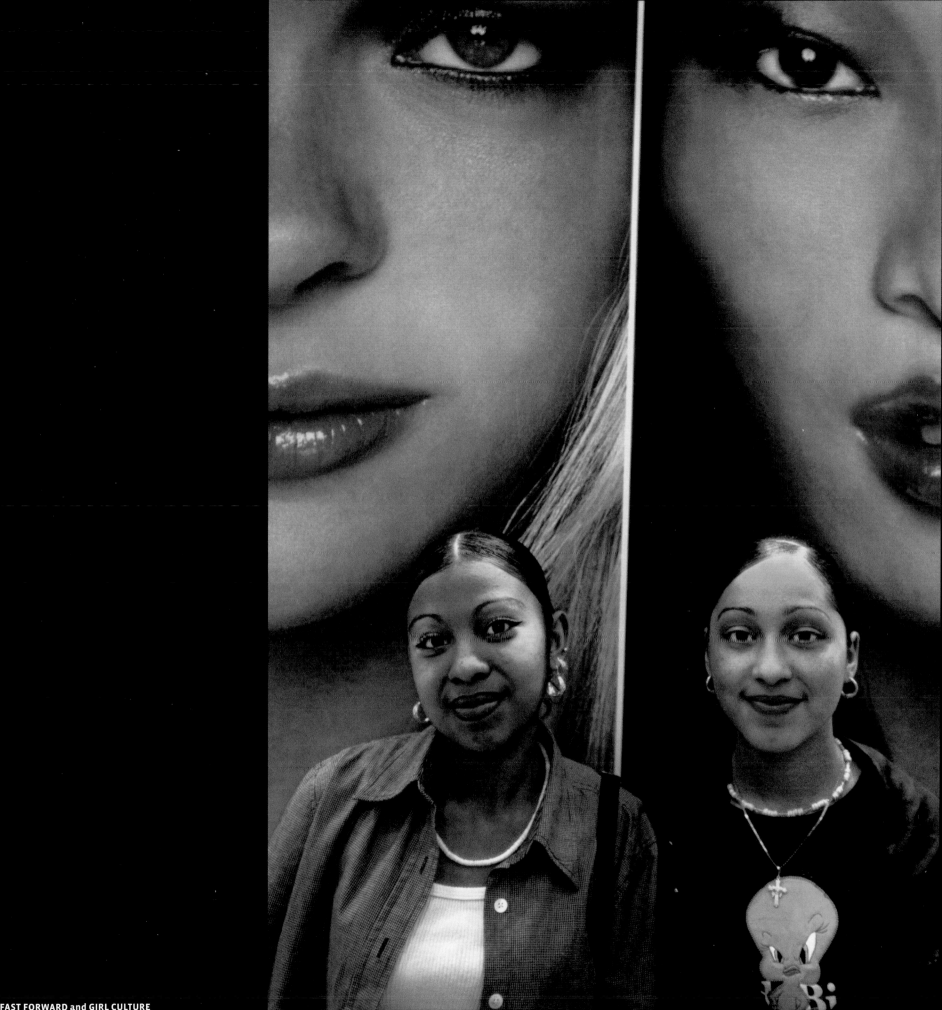

116. *Actress Amy Smart, 24, models Versace at the Standard Hotel, where a live mannequin lounges in a glass box in the lobby, Los Angeles, California, 2000*

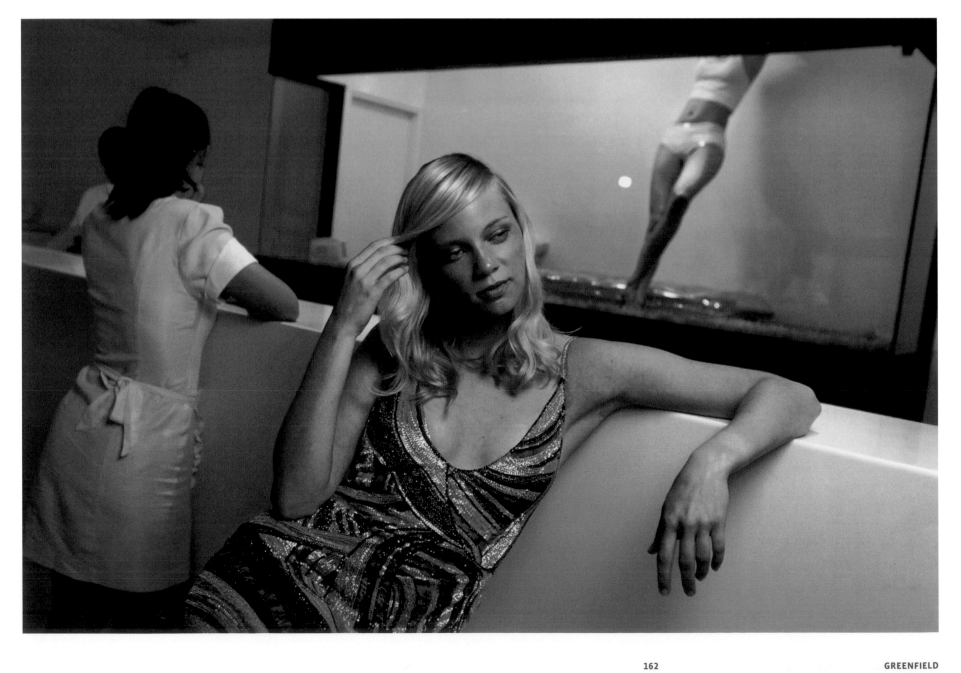

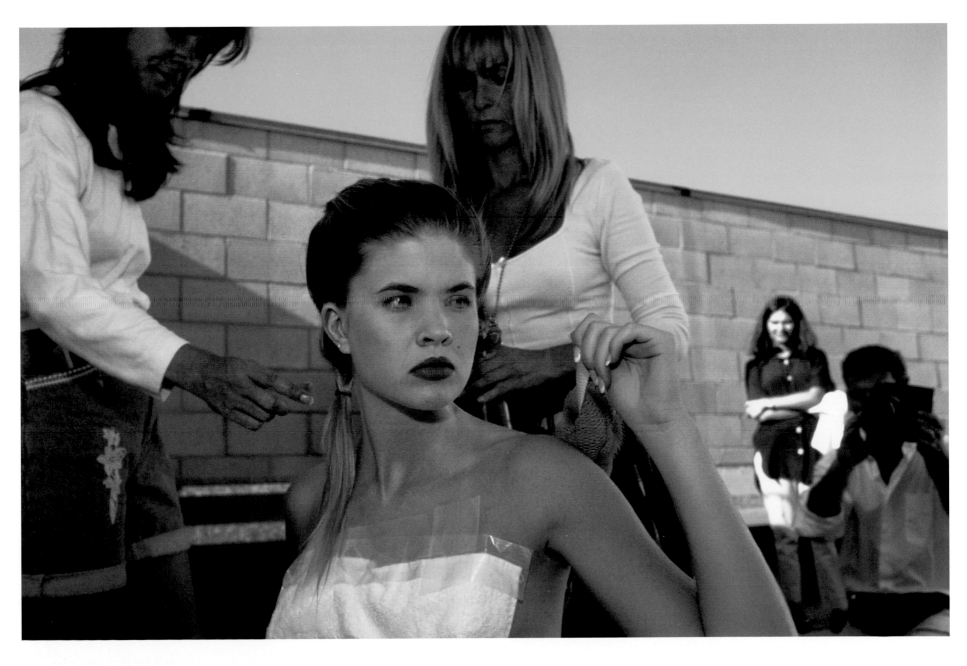

118. *Sheena, 15, shaves outside her house, San Jose, California, 1999*

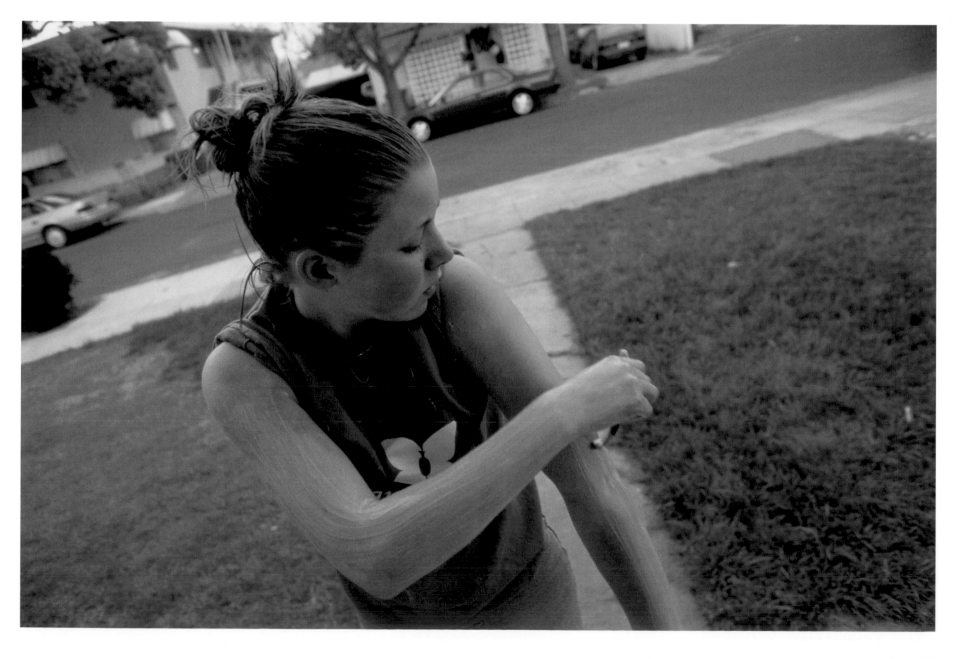

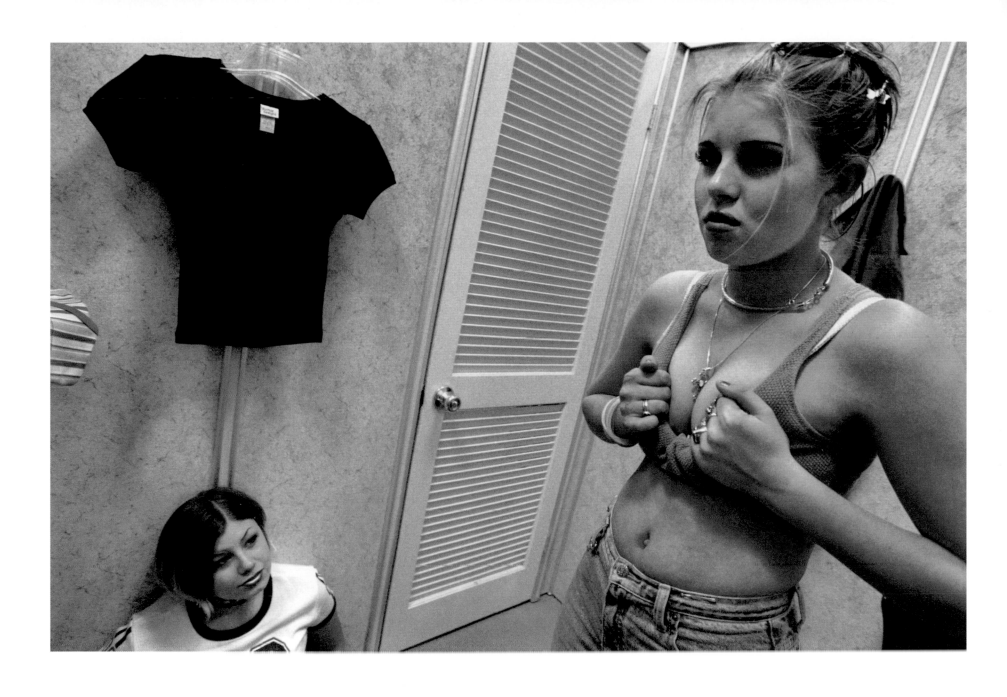

119. *Sheena tries on clothes with Amber, 15, in a department store dressing room, San Jose, California, 1999*

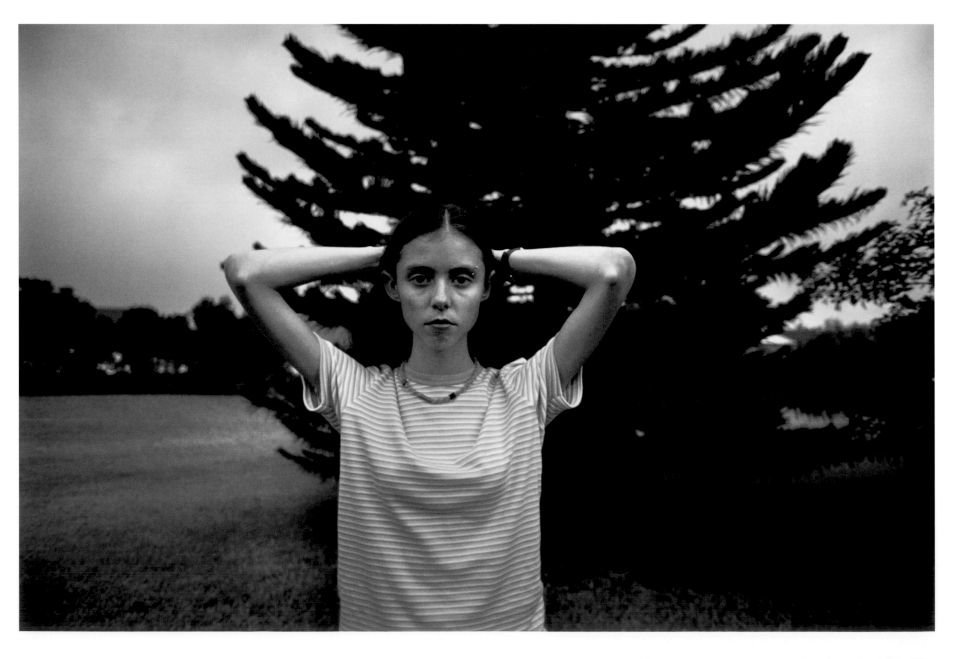

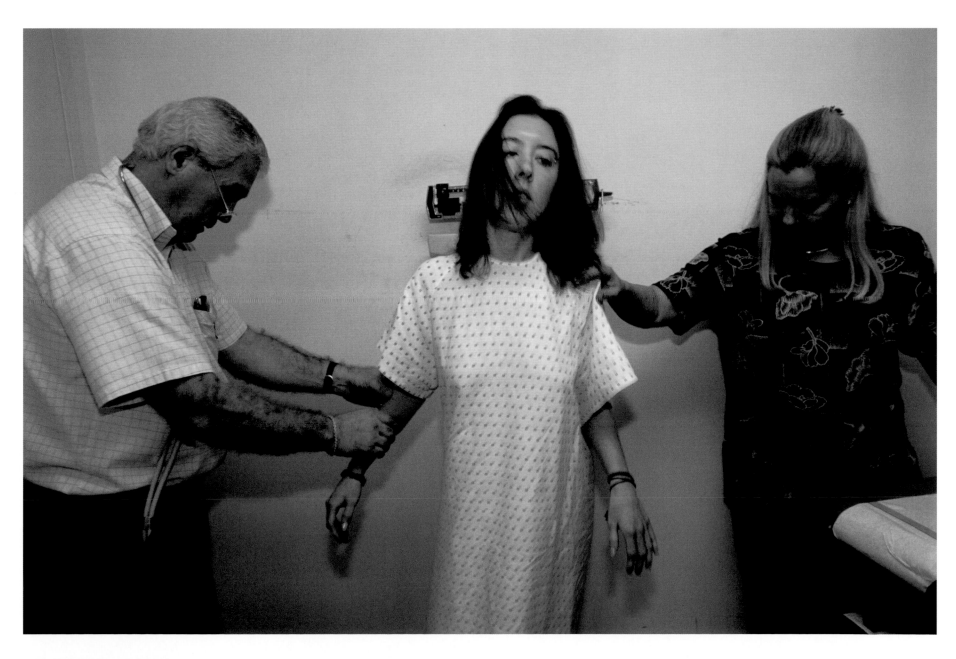

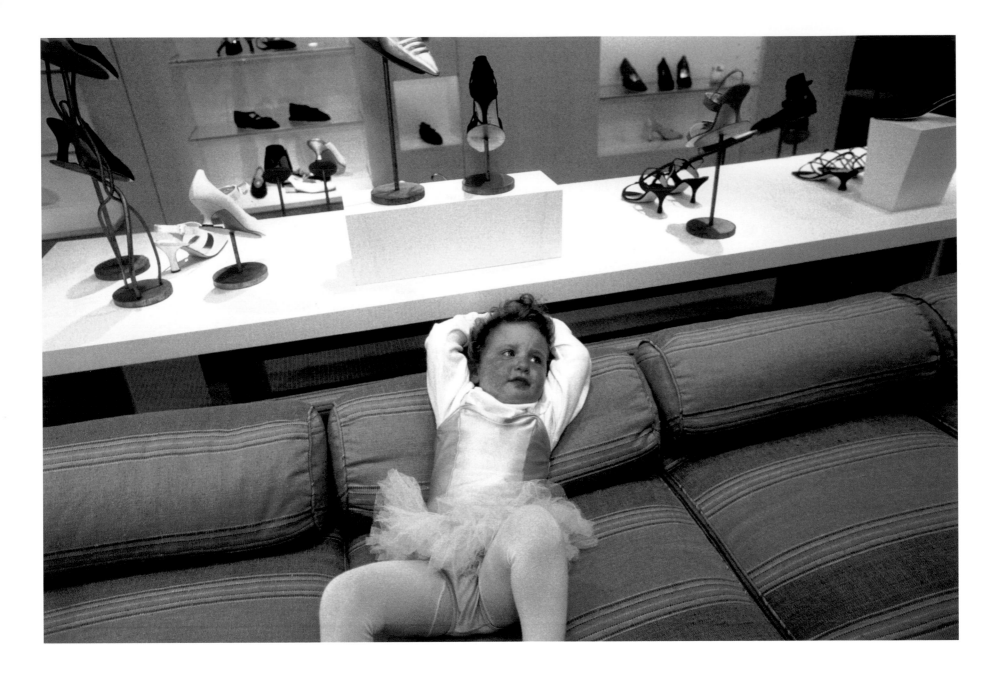

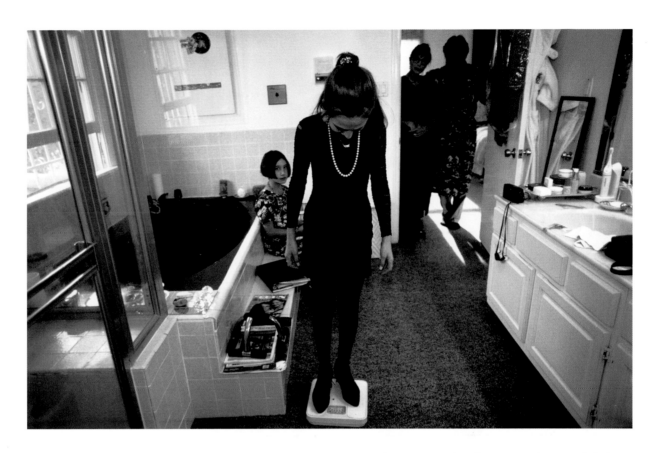

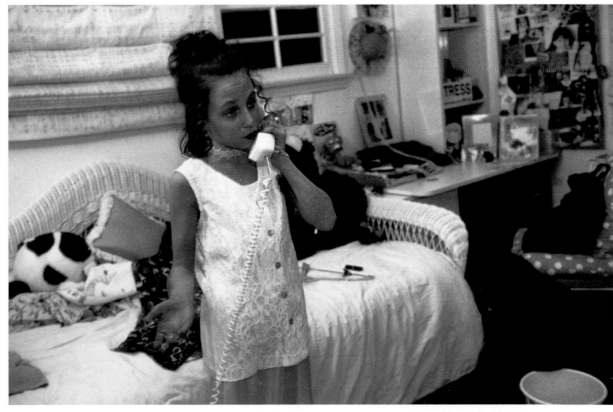

125. *Lindsey, 18, after her nose-job surgery, a nurse holds a photograph of Lindsey's pre-operation nose, West Hollywood, 1993*

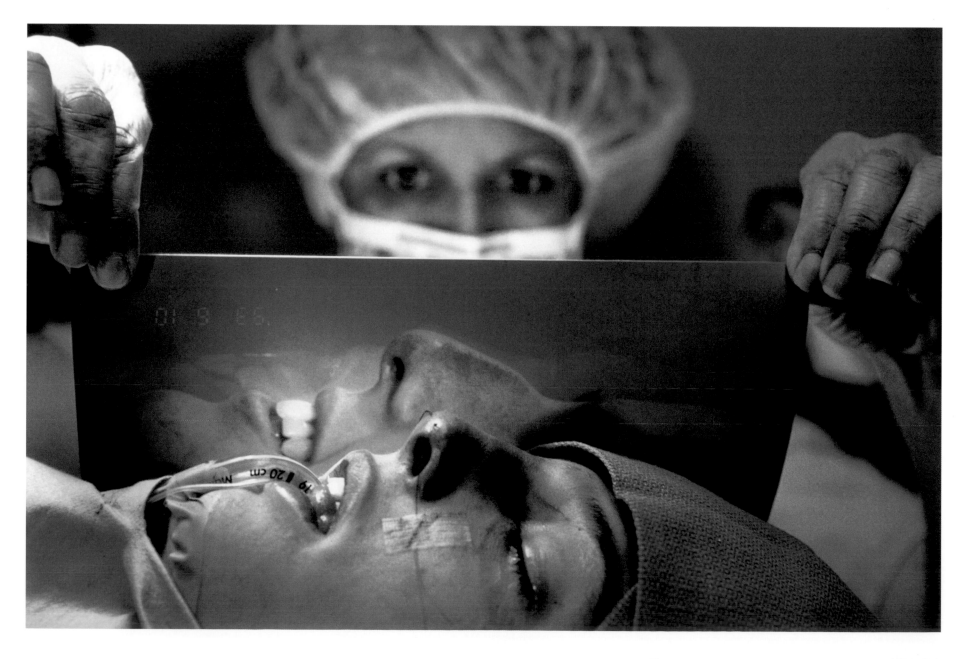

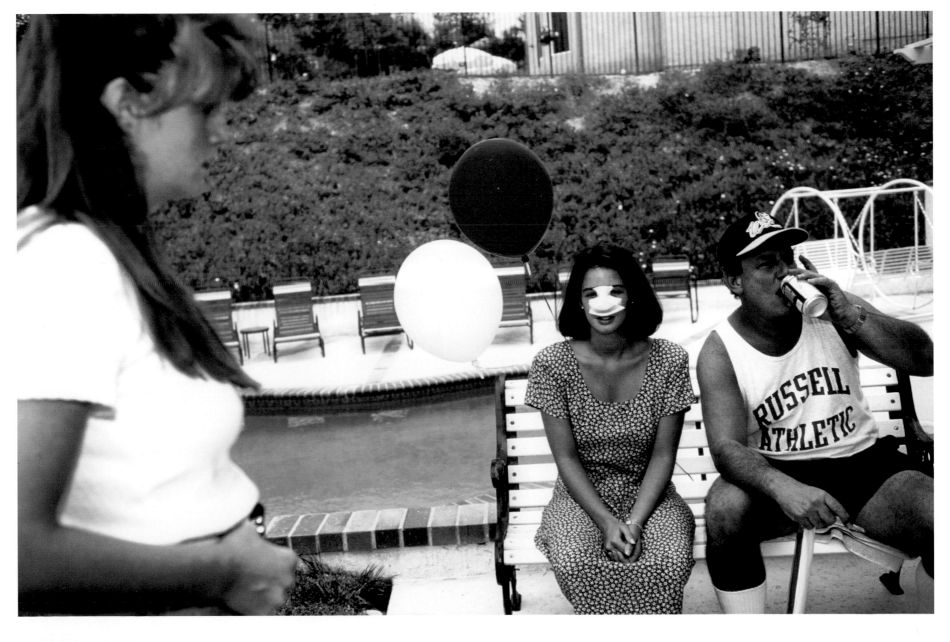

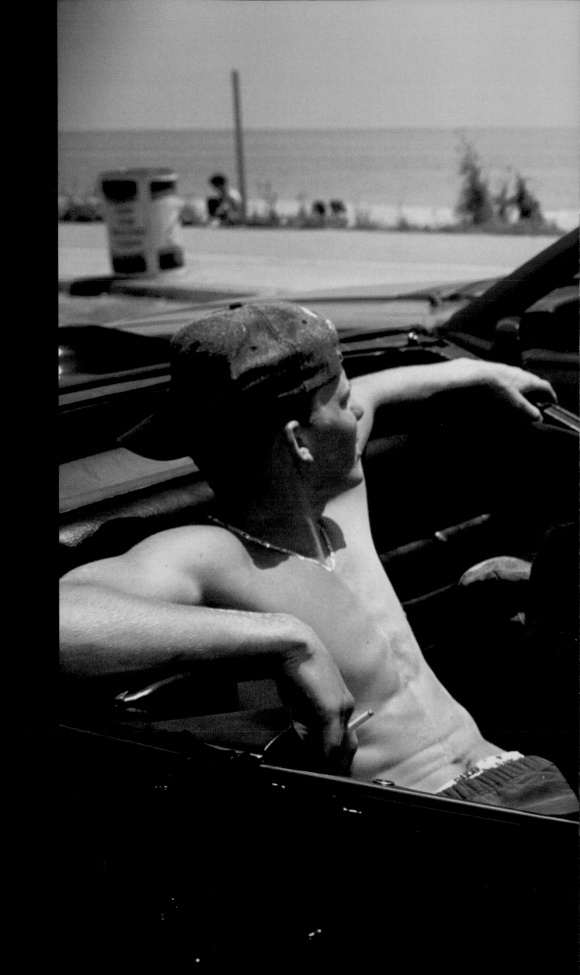

127. *Mijanou and friends from Beverly Hills High School on Senior Beach Day, Will Rogers State Beach, 1993*

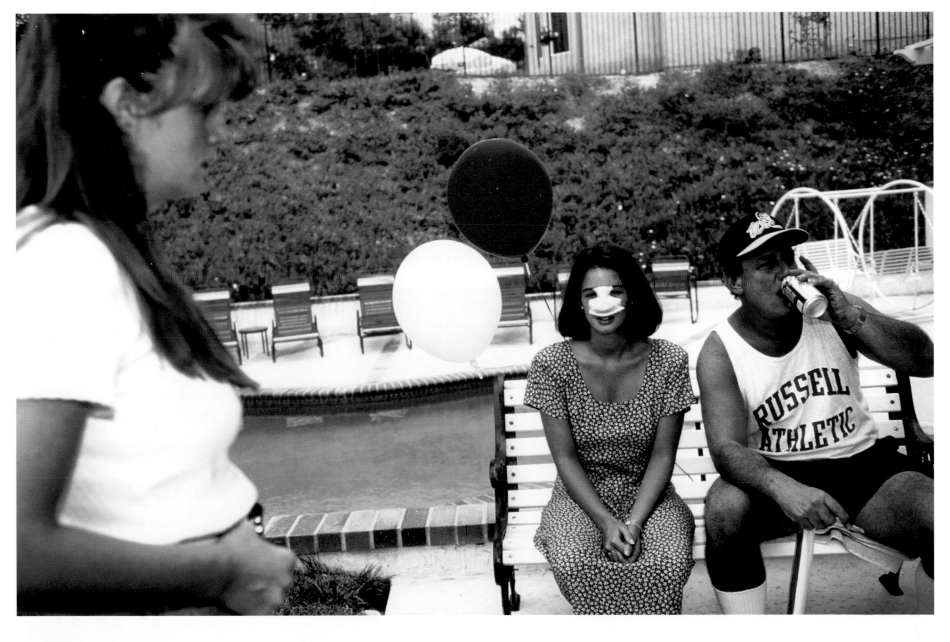

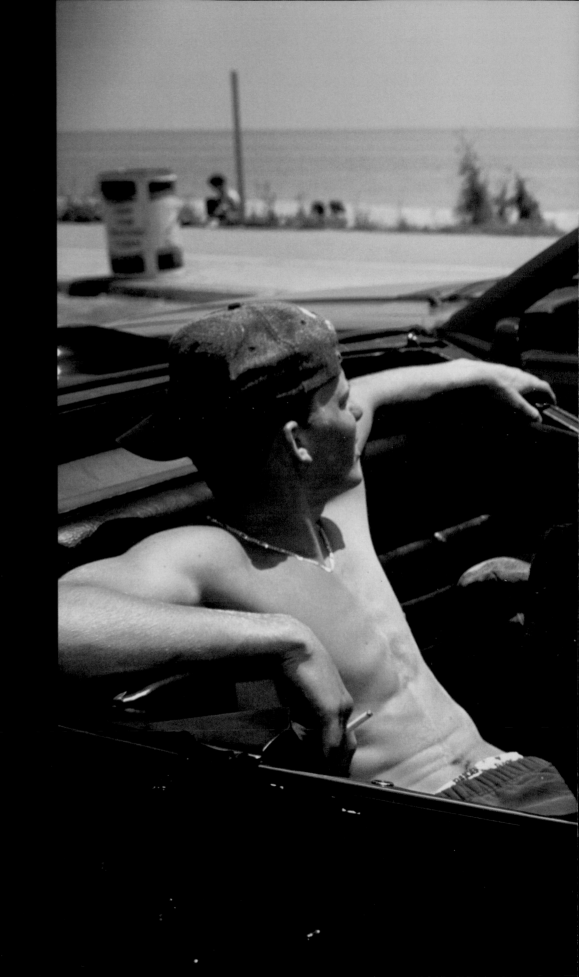

127. *Mijanou and friends from Beverly Hills High School*
on Senior Beach Day, Will Rogers State Beach, 1993

LARRY TOWELL
THE MENNONITES

Many words could be employed to describe Larry Towell's (born 1953) creative gifts. He is a poet; a folk musician who plays instruments as common as the guitar and mountain banjo and as obscure as the musical saw, bodhrán, and bones; an expert whistler who performs internationally as such; a sharecropping farmer of seventy-five acres; a husband and father of four; and an accomplished photographer. His business card is well known in summarizing this eccentric and multifarious combination of skills under a simple title: Human Being. Above all, Towell is an engaged citizen of the world whose photography reveals a deep empathetic concern for those who have encountered trouble in embracing life's diverse possibilities.

Born into a large family in rural Ontario, Canada, Towell studied at York University in Toronto. It was during his studies in the visual arts that he first took up photography, learning how to process black-and-white film. Shortly after graduating, he traveled to India to perform volunteer work in Calcutta. The experience left an impression, marking the beginning of his engagement with the international community. Returning to Canada, Larry and his wife, Ann, were married and started a family. He earned a living by teaching music before committing himself in a serious way to freelance photojournalism and writing. His growing interest in human-rights issues led him to Nicaragua in 1984 as part of a Witness for Peace delegation investigating the Contra war supported by the Reagan administration. After a brief trip home, he returned to the war zone, making pictures and collecting testimonies from those in the conflict areas. Towell found that with the camera, he could address the social and political contradictions of our time, exploring questions of power and wealth distribution and focusing attention on the victims of the struggles associated with it.

In 1986, Towell traveled to war-torn El Salvador as part of a human rights delegation. The trip marked the beginning of what would become his first major photo-documentary project. Over the next nine years, he would return repeatedly to the country, photographing the civil war and its consequences and subsequently publishing a book, *El Salvador*, in 1997. Towell remained with the project three years beyond the signing of the peace treaty between Salvadoran rebels and president Alfredo Cristiani in 1992, focused on recording life in the aftermath of conflict long after the international media had moved on to other stories (fig. 51). His interest in staying on to record the recovery efforts of those whose lives had been disrupted by more than a decade of war, much of it fueled by American arms and money, is a reflection of Towell's belief in depth over breadth of coverage. He is wary of the media's philosophy of speed—of being first in and first out so as to maintain a captive audience and drive profits. He has positioned himself as an important balancing force in relation to that tendency, insisting on the integrity of extended-coverage journalism in a world where the twenty-four-hour news cycle shifts its focus on a daily, if not hourly, basis. One of his aims is to be familiar with an environment so as not to approach it as exotic; this, for Towell, requires multiple trips over many years. Towell wants the process of photojournalism to encompass larger aims and inspire contemplation: "I think we need to reflect on what we are doing and engage with the subject that we're photographing and forget about the news, forget whether or not it's going to sell in a news magazine. Do it for history.... I think the news is killing journalism."[1]

In 1989, a year after joining Magnum and concurrent with the development of his documentary project in El Salvador, Towell came into contact with members of a Mennonite community near his home in Canada.

I discovered them in my own back yard, land-hungry and dirt poor. They came looking for work in the vegetable fields and fruit orchards of Lambton, Essex, Kent, and Haldimand-Norfolk Counties. I liked them a lot because they seemed otherworldly and therefore completely vulnerable in a society in which they did not belong and for which they were not prepared. Because I liked them, they liked me, and although photography was forbidden, they let me photograph them.[2]

As Towell got to know the Mennonites near him, he began to learn about their history and culture, and to identify with the difficulties they faced in the modern world. The Old Colony Mennonites are a nonconformist Protestant sect, related to the Amish, that originated in Europe in the 1500s. Over the centuries, they have migrated between countries and continents to preserve their way of life: from the Netherlands to Prussia in 1547, to Ukraine in 1787, on to Canada in 1874, and finally to Mexico, Belize, and South America during the early- to mid-twentieth century. They have traditionally separated themselves from society at large, living in colonies where faith and tradition are intertwined and modern amenities, such as cars, rubber tires, and electricity, are not welcome.

The Mennonites that turned up in Towell's backyard had migrated back to Canada from Mexico in search of seasonal work. Due to shrinking water tables in Mexico, the effects of international trade (the North American Free Trade Agreement, in particular) on farm commodity prices, and a rising population in the colonies, many Mennonites have found themselves landless and economically marginalized, forced to compromise beliefs in order to survive and sometimes facing excommunication in the process. Towell described the situation eloquently: "When a Mennonite loses his land, a bit of his human dignity is forfeited; so is his financial solvency. He becomes a migrant worker, an exile who will spend the rest of his life drifting among fruit trees and vegetable vines, dreaming of owning his own farm some day. But for these who struggle with God at the end of a hoe, the refuge of land, Church, and community may be at least a generation away."[3]

As Canadian citizens through lineage, many Mennonites from Mexico are allowed to enter the country in their yearly search for seasonal work. Some are taken advantage of by landowners who prey on their illiteracy and lack of education when drawing up farming contracts. Towell's relationship with the migrant families near his home eventually resulted in an invitation for him to join them in their treks back to Mexico for the winters. The photographer spent a good portion of the next ten years photographing their way of life with his unique and intimate access, capturing their joys and challenges, ingenuity and discipline, truths and pitfalls, and, ultimately, their struggle to preserve a lifestyle incongruent with the larger world on which they have become interdependent. "Like literature, photography is best when it looks at ordinary things rather than sensational ones. This gets closer to the truth, just

FIGURE 50. Cover of Larry Towell, *The Mennonites* (London: Phaidon, 2000).

FIGURE 51. Larry Towell (Canadian, born 1953), *San Salvador. Mothers of the "Disappeared" display images of mutilated bodies that were found in the streets and photographed by the Non-Governmental Human Rights Commission of El Salvador. Cadavers were photographed for identification purposes for family members who came to the office to confirm the fate of the relatives. The office was frequently invaded and its members were arrested or "disappeared." The founder of this particular group (CODEFAM) was herself murdered by death squads. She is represented in the poster seen in the background.*, 1986. Courtesy of Larry Towell/Magnum Photos, Inc., NYC13139.

as ordinary people are closer to the truth than politicians and heroes. Anybody can photograph sensationalism because it's exciting and dramatic but it takes a good storyteller to photograph nothing in particular."[4] Towell's quiet, sensitive, and dedicated approach to The Mennonites documents their way of life for the historical record and inspires greater understanding and compassion in the present for a group whose endeavor to embrace life could be easily misunderstood. Indeed, his approach to his craft is not so far from the Mennonites' approach to life. In spending ten years on a subject that would be only of passing interest to mainstream media, he questions the scope and purpose of visual reporting and asserts a photojournalism in which personal values take precedence over profitability, and reflection over immediacy.

Towell's resulting publication, *The Mennonites*, presents 115 of the photographs he made in Canada and on visits to most of the twenty-three existing settlements in Mexico. His pictures are captioned in the simplest of ways and done so in the back matter of his book, noting only the place name and date. The images are complimented in the body of the book by extensive written vignettes, compiled by the photographer from his diary notes and memory, that add dimension to the documentary endeavor. Rather than addressing specific pictures, the texts evoke the context from which the photographs arose:

The first Mennonite I met, more than ten years ago, was David Redekkop who, for minimum wage, was sweeping the floor of my father's auto-body repair

shop in rural Ontario. At the end of the day, he leaned his broom against the wall and drove off in an uninsured and unlicensed pick-up truck.

He and his wife Sarah were renting a run-down farmhouse where they lived with their nine children just down the road from me. Both were in their midthirties. During my first visit, their brood filed in like quiet mice and lined up along the wall, barely an inch apart in height and a year apart in age. When I asked why they liked Canada, one blurted out, "Because there is food to eat."[5]

Towell is concerned with how people draw their identities from the places they live, and what happens when they lose the land they call home. This theme runs throughout The Mennonites and informs Towell's two studies on the Israeli-Palestinian conflict, published as *Then Palestine* (1999) and *No Man's Land* (2005), as well as his project to document the aftermath of Hurricane Katrina in New Orleans. Towell's most recent publication, *The World from My Front Porch* (2008), interweaves pictures from a number of his past projects with photographs of his own family life in Canada, demonstrating the way in which his identity and perspective on the world at large is framed by the place he calls home.

NOTES

1. Larry Towell, interview by the CBC, transcription available at http://www.cbc.ca/beyondwords/towell.html.

2. Towell, preface to *The Mennonites: A Biographical Sketch* (London: Phaidon, 2000), n.p.

3. Towell, preface to *The Mennonites* (note 2), n.p.

4. Towell, quoted in Chris Boot, ed., *Magnum Stories* (London: Phaidon Press, 2004), p. 459.

5. Towell, *The Mennonites* (note 2), n.p.

The reproductions on the following pages were all drawn from Towell's The Mennonites series.

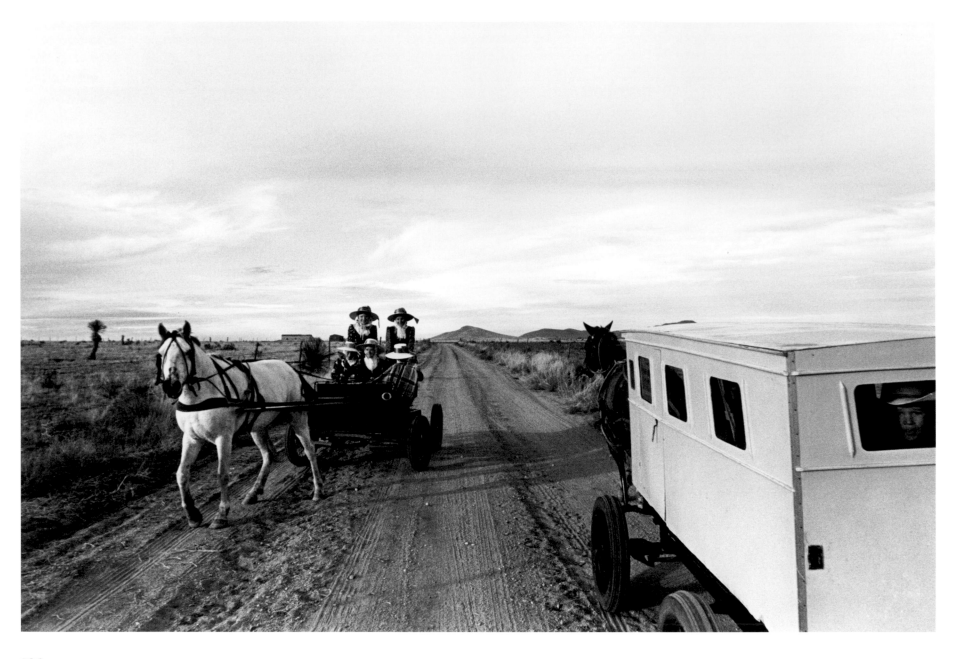

129. *El Cuervo (Casas Grandes Colonies), Chihuahua, Mexico, 1997*

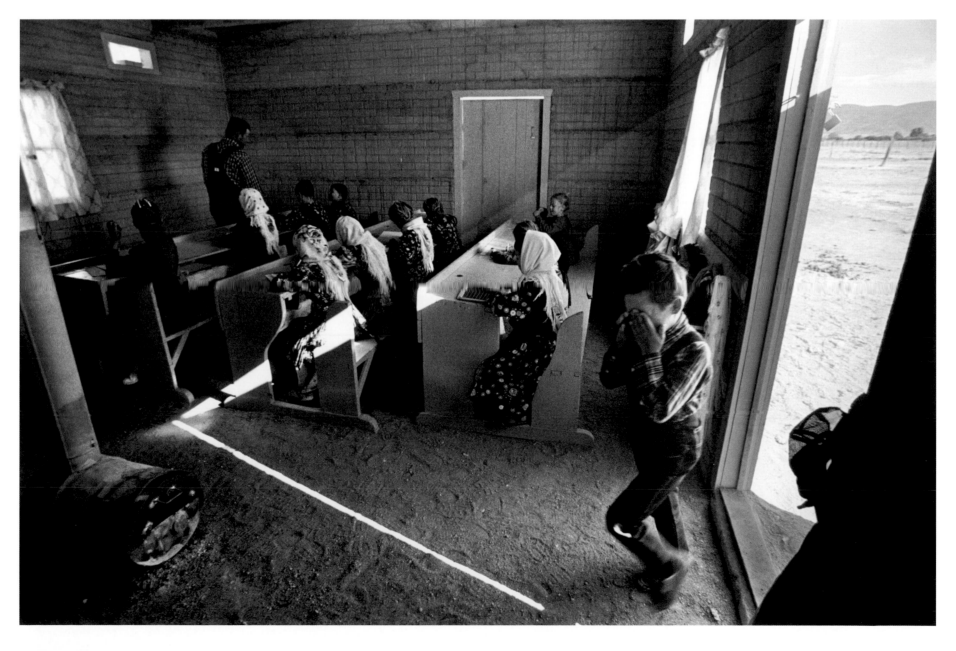

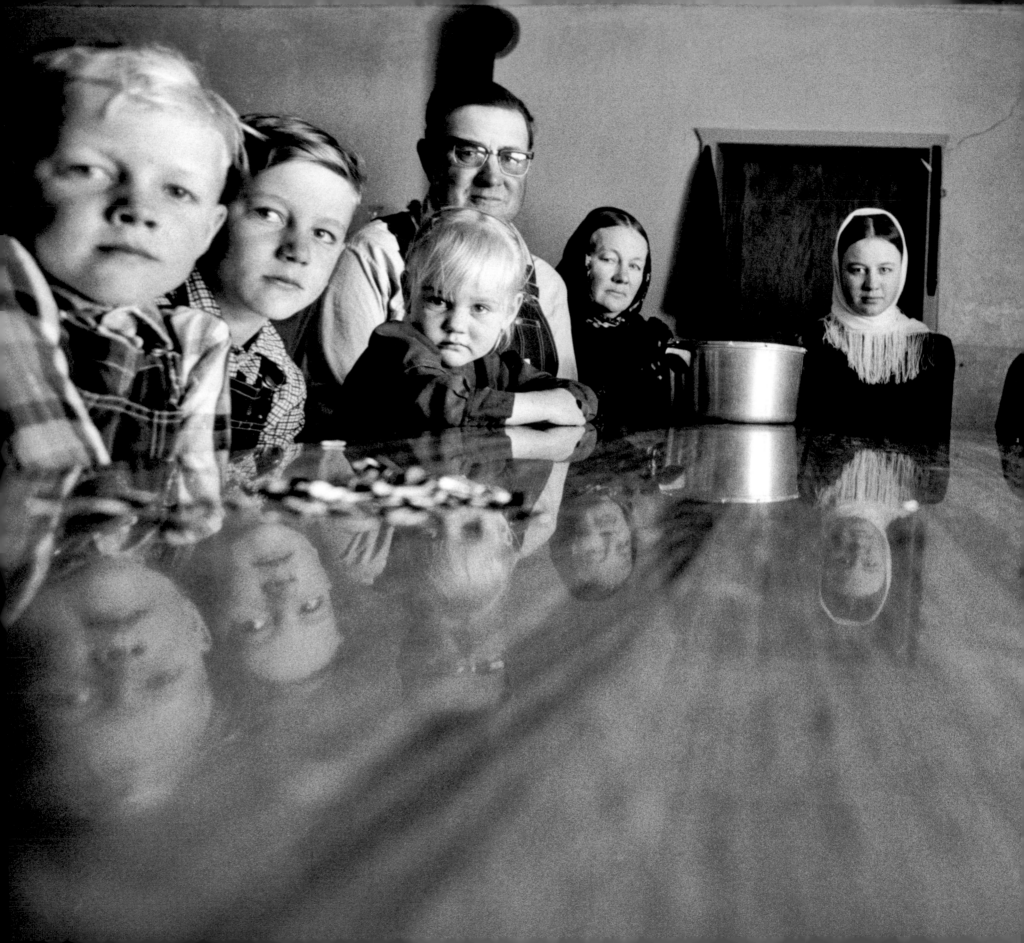

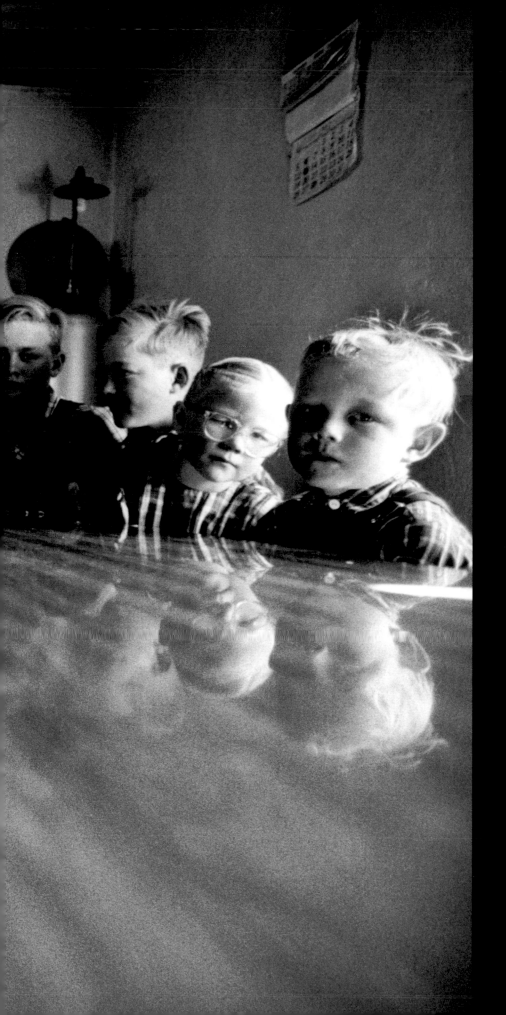

131. *La Batea Colony, Zacatecas, Mexico, 1994*

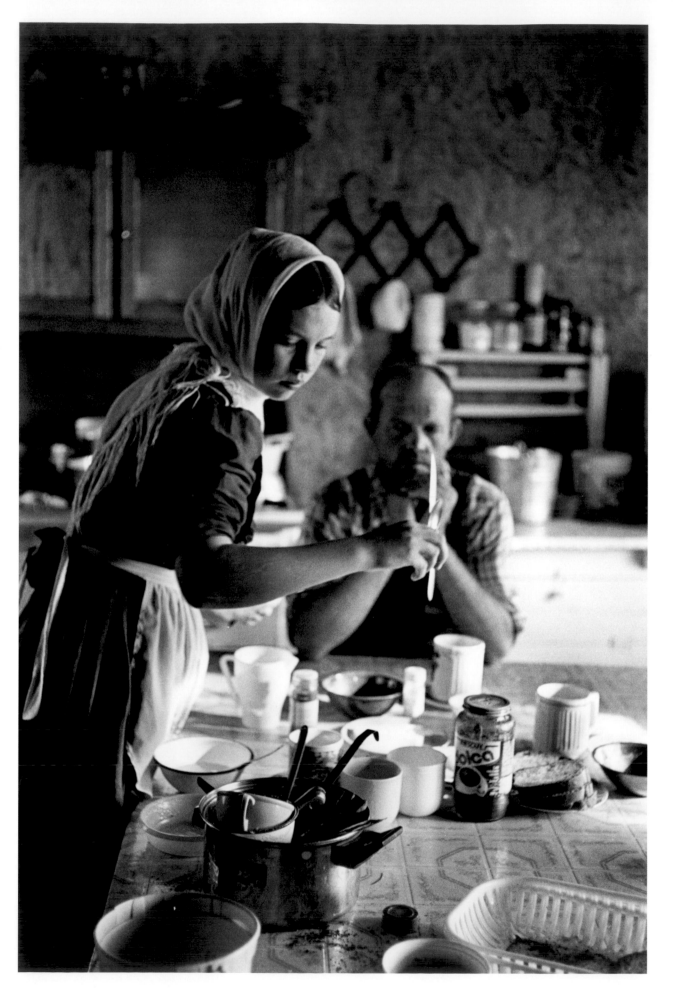

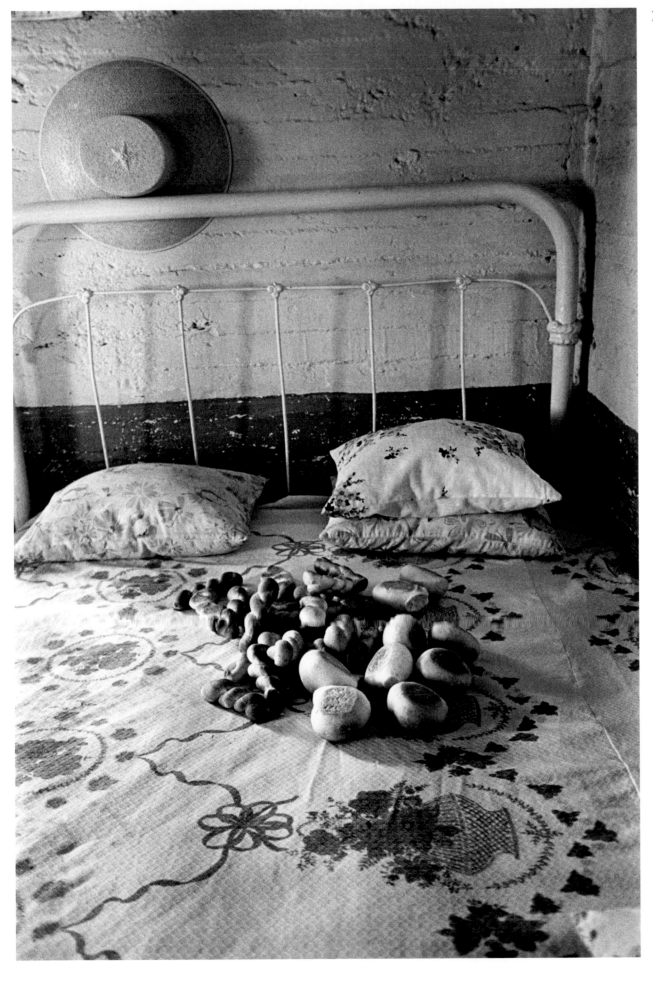

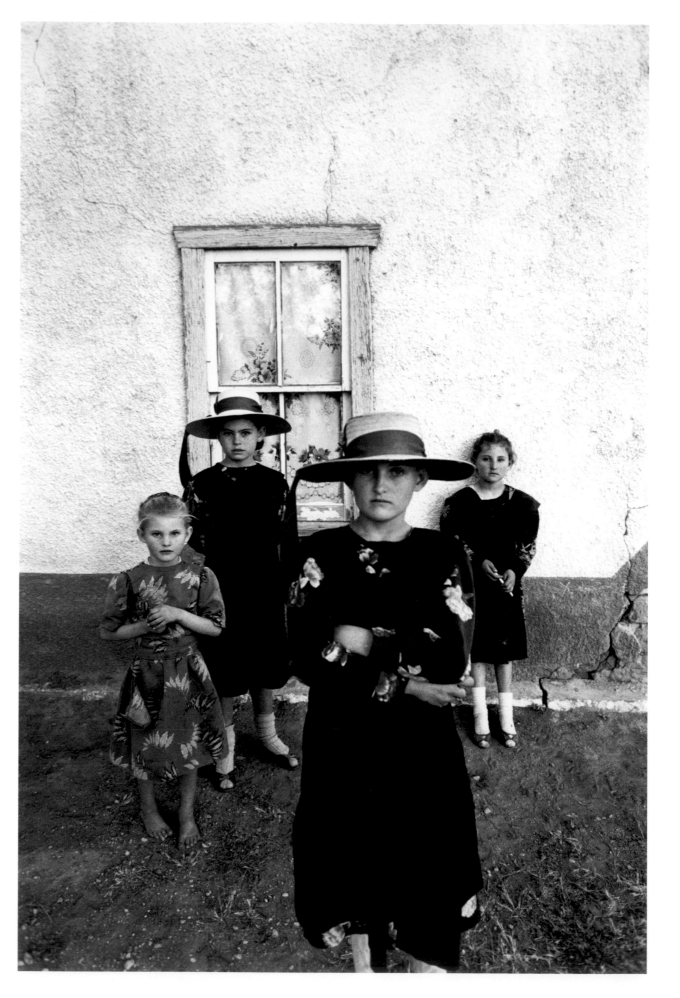

135. *El Cuervo (Casas Grandes Colonies), Chihuahua, Mexico, 1992*

136. *El Cuervo (Casas Grandes Colonies), Chihuahua, Mexico,* 1992

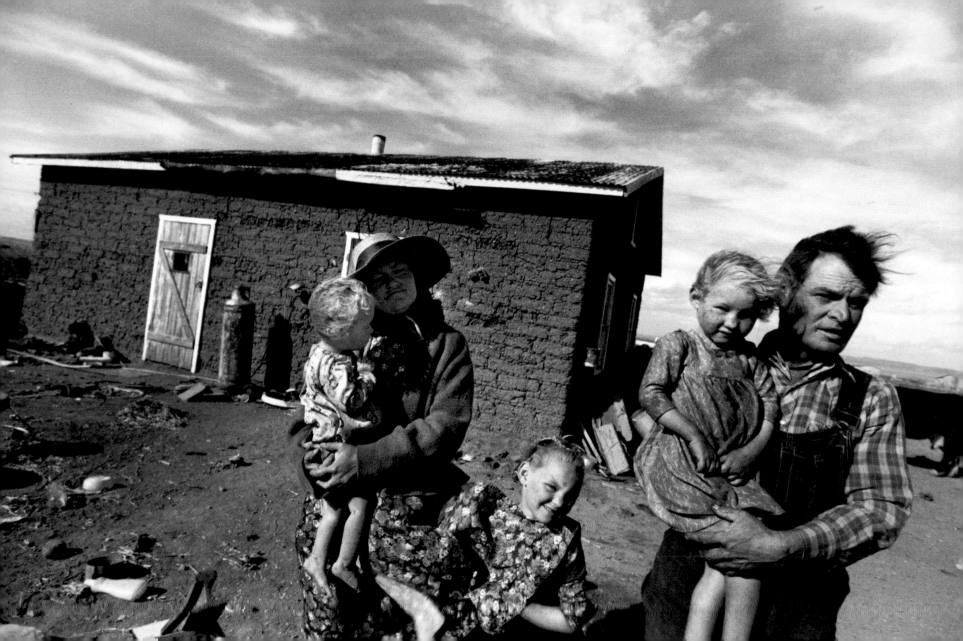

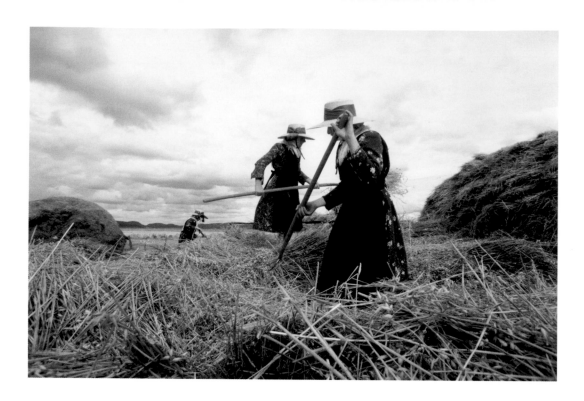

137. *La Batea Colony, Zacatecas, Mexico, 1996*

138. *La Batea Colony, Zacatecas, Mexico, 1999*

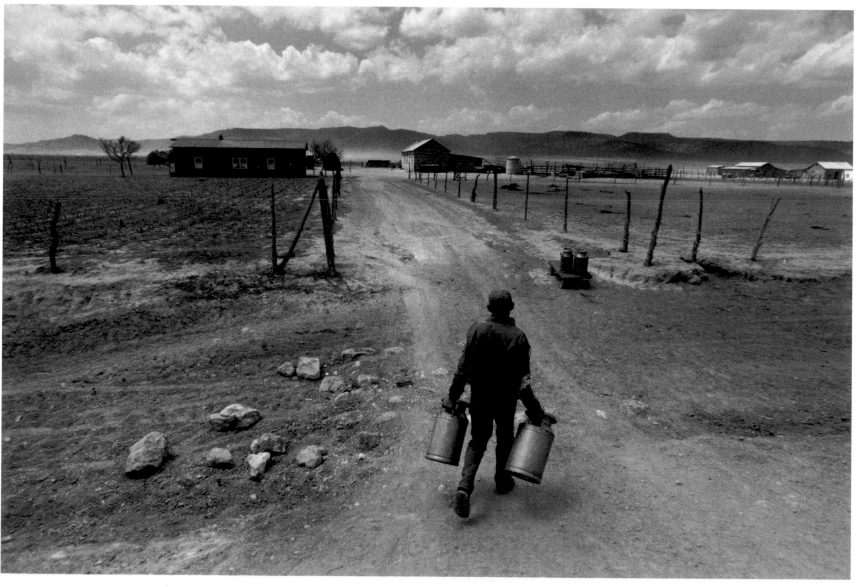

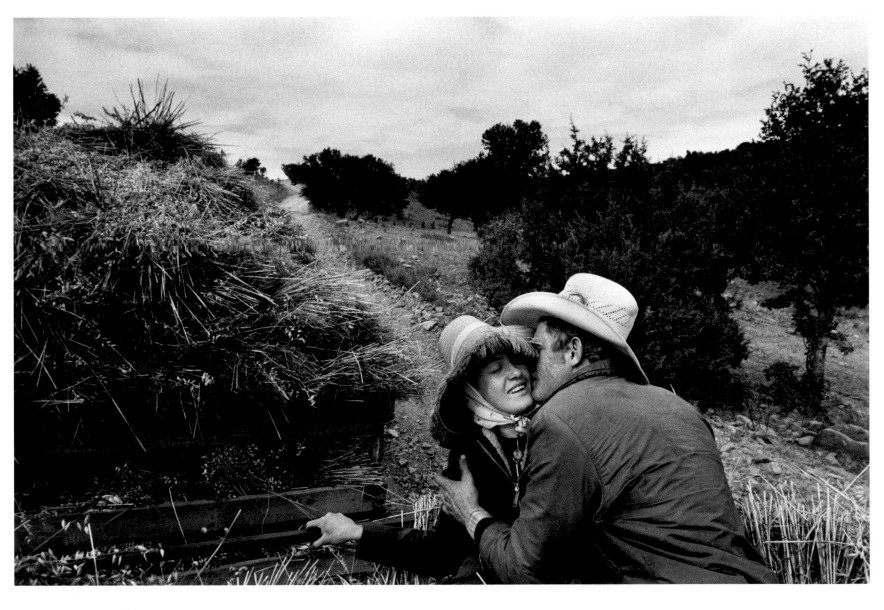

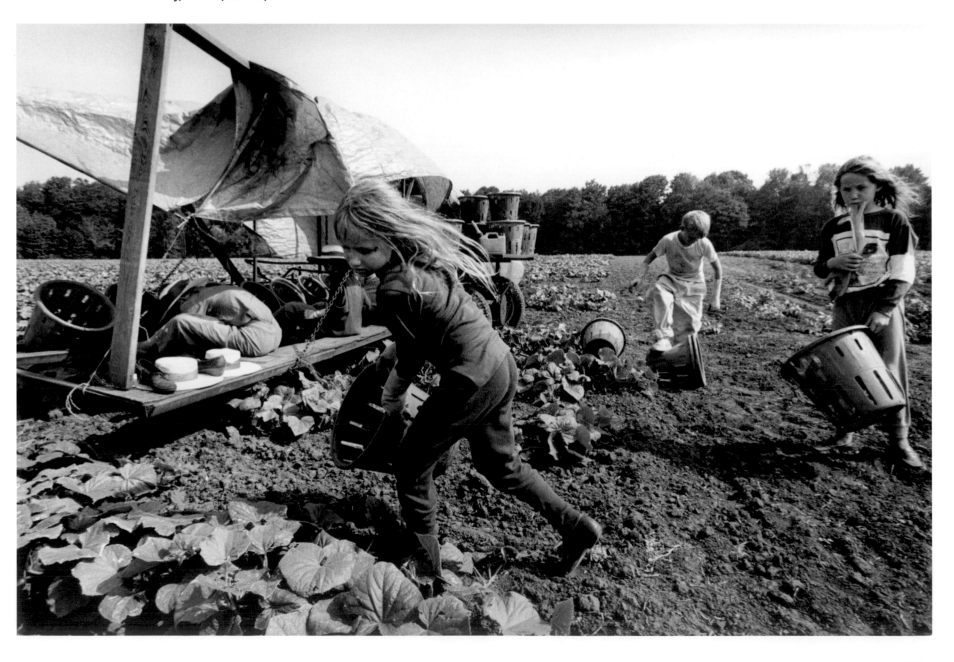

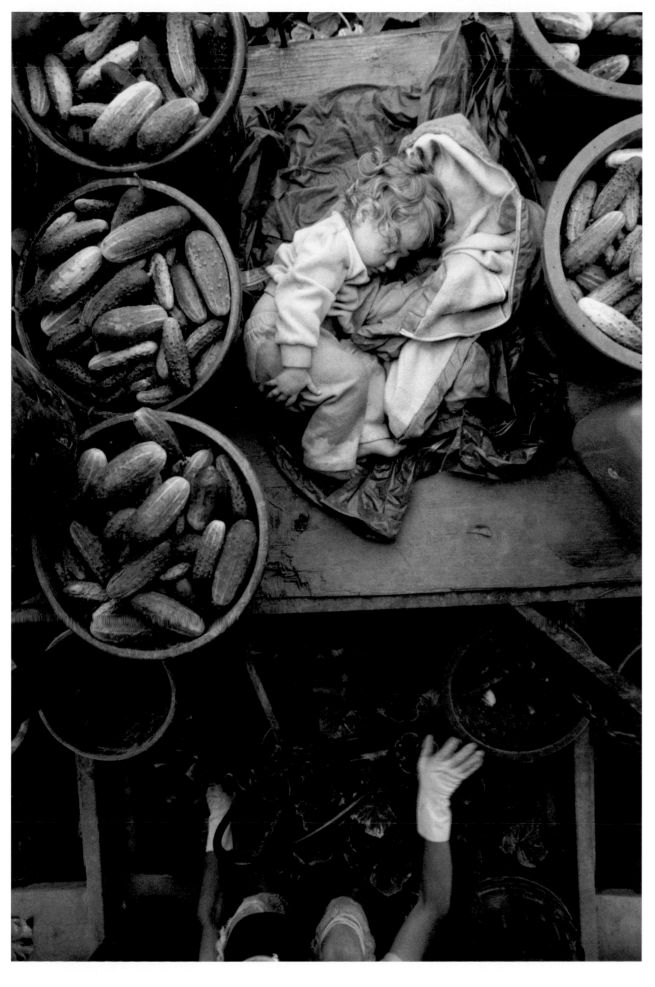

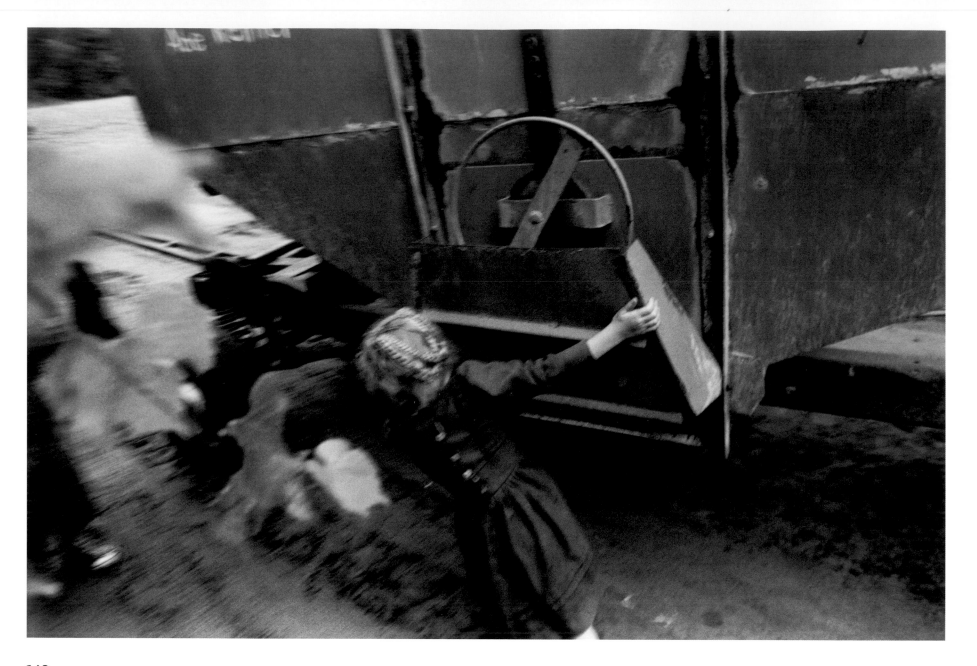

142. *Elgin County, Ontario, Canada,* 1998

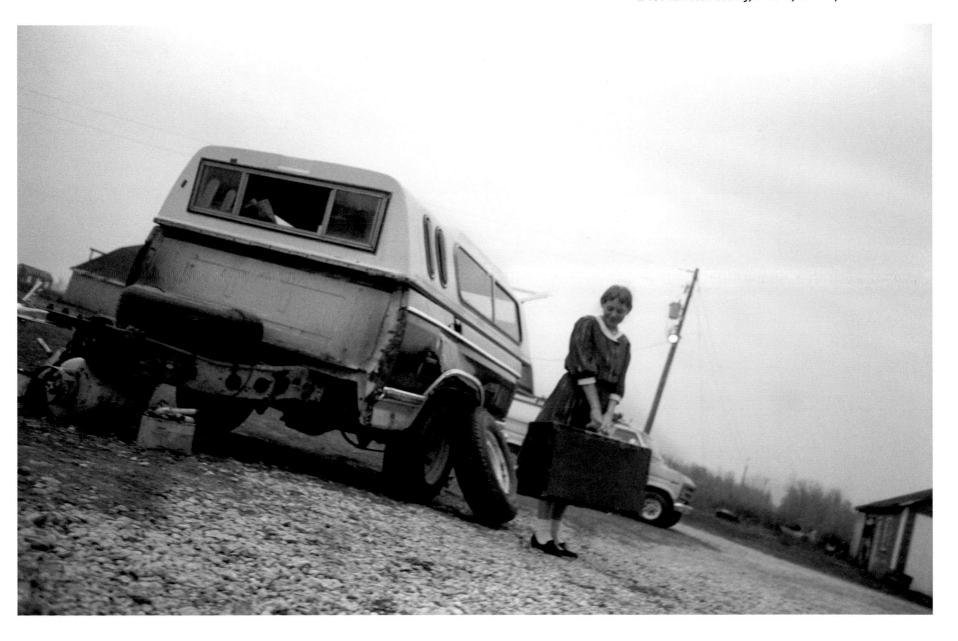

SEBASTIÃO **SALGADO**
MIGRATIONS: HUMANITY IN TRANSITION

Sebastião Salgado (born 1944) is among the most recognized photojournalists of our day, celebrated for his epic and compassionate depictions of the developing world, manual labor, and populations in distress. The photographer's upbringing, educational training, and well-honed aesthetic sensibilities have provided him with a niche approach and characteristic voice for communicating his perspectives on the world.

Born in the small town of Aimorés, Brazil, Salgado was raised in a family that operated a cattle farm. In 1967, he completed undergraduate studies in economics at the Federal University of Espírito Santo, in Vitória, and married Lélia Deluiz Wanick. The couple moved to São Paulo, where he finished a master's degree in economics. He began working as an economist for the state's Ministry of Finance, gaining experience in planning and financing large-scale projects. Opposed to Brazil's military government, which was in the process of evolving into a dictatorship during the late 1960s, the Salgados left Brazil for Paris, where he pursued coursework for a doctorate at the Sorbonne. In 1971, Salgado was hired as an economist for the London-based International Coffee Organization, for which he made frequent trips to Africa on missions affiliated with the World Bank. He first began taking photographs with Lélia's camera, which had been purchased for her architecture studies. By 1973, preoccupied with photography, he gave up his career as an economist to pursue life as a freelance photojournalist. His academic training, however, would contribute in a significant way to his documentary preoccupations, which deal to a large extent with the effects of economic forces in the modern world.

Salgado's first professional affiliation as a photographer came through the Sygma agency in 1974. A year later, he joined the Gamma agency, for which he pursued stories in Africa, Europe, and Latin America until 1979, when he was accepted to Magnum Photos, where he remained for fifteen years. In 1994, the Salgados established Amazonas Images, an agency that is managed by Lélia and was set up with the specific and exclusive purpose of supporting and distributing his projects.

From the start of his photographic career, Salgado has been interested in using his camera to raise awareness of the world's economic disparities and to provoke discussion over the plight of the voiceless and dispossessed. His first book project, published in English under the title *Other Americas* (1986), focused on indigenous populations of Latin America. From 1984 to 1986 he worked with the humanitarian organization Doctors Without Borders, documenting the African famine. And in 1986, Salgado embarked on what was to be the first of his signature projects of epic scale: visiting twenty-three countries over the course of six years, Salgado created a global study of manual labor. The project, published as *Workers: An Archaeology of the Industrial Age* (1993), pays tribute to the people whose toil has supported the industrialized world. Among the most iconic images from the project—indeed some of the most memorable from Salgado's career as a whole—are his depictions of thousands of mud-covered workers toiling en masse amid dangerous conditions at the Serra Pelada gold mine in his home country of Brazil (fig. 53).

Growing out of the Workers series came Salgado's next sustained project, which entailed photographing migrant populations around the world between 1994 and 1999. Published as *Migrations: Humanity in Transition* (2000), this epic work of twentieth-century photojournalism documents people across forty-three countries whose lives have been uprooted by the effects of globalization, persecution, or war. Presently, the photographer is pursuing what he refers to as the last of his epic projects, called Genesis, which aims to inspire conservation of the environment through the

documentation of places in the world that are relatively untouched by human development.

Salgado's interest in people facing dire circumstances is one that finds precedence in turn-of-the-twentieth-century studies by Lewis Hine and Jacob Riis, who investigated the practice of child labor in the United States and the inadequate living conditions of the New York slums, respectively. Among Salgado's self-proclaimed role models is W. Eugene Smith, whose empathetic approach, penchant for dramatic beauty in his portrayal of subjects, and populist point of view bears a strong resemblance to Salgado's heroic depictions of the world. While Smith excelled at honoring named individuals in clearly defined situations (like victims of and crusaders against mercury poisoning in Minamata, Japan), Salgado celebrates his subjects in a more abstract way, transforming individuals into universal symbols of endurance in the face of incredibly complex global problems.[1]

Salgado's work is marked by a heightened attention to aesthetic grace that endows his subjects with dignity, even as it communicates the discomfort of their circumstances. His photographs are constructed with careful attention to dramatic lighting, elegant contours, and striking visual impact. In *Tanzania* (pl. 149), Salgado captured the beginnings of the refugee camp at Benako, which took in some 350,000 people in four days during the Rwandan Hutu-Tutsi conflict of the mid-1990s. Makeshift shelters and their inhabitants are seen strewn across a mist-laden landscape, their forms echoed by the whites, grays, and blacks of the looming storm clouds overhead.

In the publication, Salgado's Migrations pictures are organized in related series, or small photo essays, which are in turn sequenced to constitute chapters that cover broad segments of global migration. This storytelling technique, of building in stages from the specific to the general, can also be seen in individual photographs. Another work from the Benako refugee camp in Tanzania (pl. 148) is a good example. Two boys, who seemingly make eye contact with the viewer, gather water in the sharply focused foreground. Their presence anchors the plight of the refugees at the level of the individual, providing a face, as it were, for the enormous problem. In the partially focused middle ground,

FIGURE 52. Cover of Sebastião Salgado, *Migrations: Humanity in Transition* (New York: Aperture, 2000).

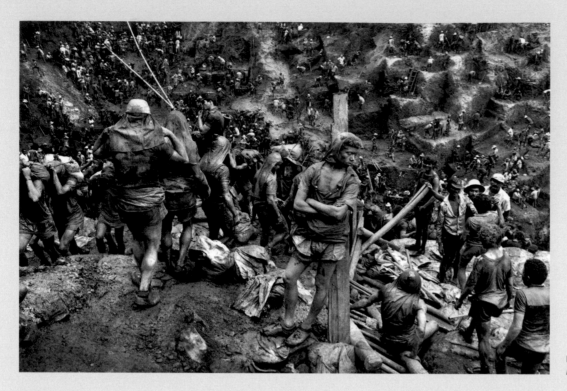

FIGURE 53. Sebastião Salgado (Brazilian, born 1944), *Serra Pelada, Brazil*, 1986. From the series Workers. Courtesy of the photographer.

a larger assemblage of water gatherers stand in the murky water of a shallow lake. Will the calf-deep pool sustain the large group of refugees for any significant period of time, particularly given the steady stream of figures traversing the embankment across the top background of the photograph, their silhouettes framed against the sky? A similar device is used in *Church Gate Station, Western Railroad Line, Bombay, India* (pl. 153), where two stationary individuals on the left-hand side of the composition stand out against the multitudes of passengers whirling around them in the jam-packed train station, which itself is only a portal to a city of mesmerizing proportions.

While Salgado's photographs are constructed individually and sequenced serially in such a way as to tell a visual story, equally important to the photographer is the textual content that accompanies his images. Salgado makes an effort to complement each illustration in his books with an extended caption that assists in the storytelling and demonstrates an intellectual command over the circumstances at hand. Salgado's captions and images are normally presented in isolation from one another in his publications, so that the power of his visual statements can be absorbed independently from the context provided by the written record.

Ultimately, Salgado sees himself as a storyteller and a communicator, a bridge between the fortunate and the unfortunate, the developed and the undeveloped, the stable and the uprooted. Portrayed lyrically and sensitively, his subjects are transformed into

metaphors for complex inequities that exist in the world—problems that must first be recognized and acknowledged in order to be addressed.

NOTE

1. Fred Ritchin, "The Lyric Documentarian," in *An Uncertain Grace: Photographs by Sebastião Salgado* (New York: Aperture; and San Francisco Museum of Modern Art, 1990), p. 148.

The pictures and captions reproduced on the following pages were selected from the published corpus of Migrations. They represent several sub-themes in Salgado's study, including the effects of population surges in developing-world cities (pls. 150–54), the conditions of refugees fleeing war in Africa (pls. 144–49), and the process of migration from Latin America to the United States (pls. 155–57).

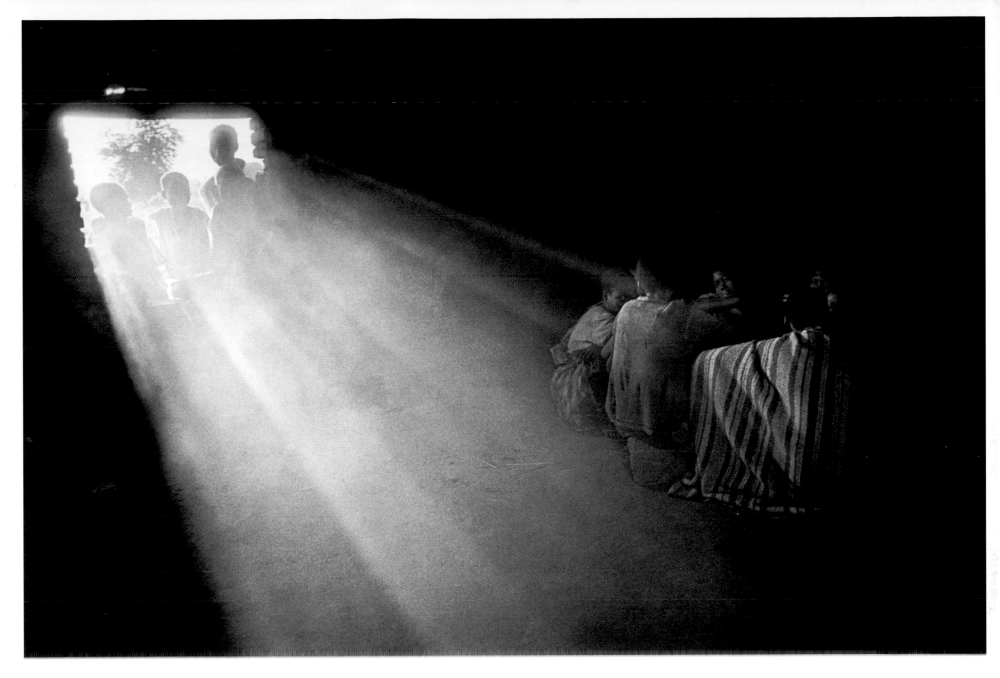

144. *Southern Sudan,* 1993
Boys from southern Sudan, already far from their villages, hide during the day and travel at night toward the refugee camps of northern Kenya.

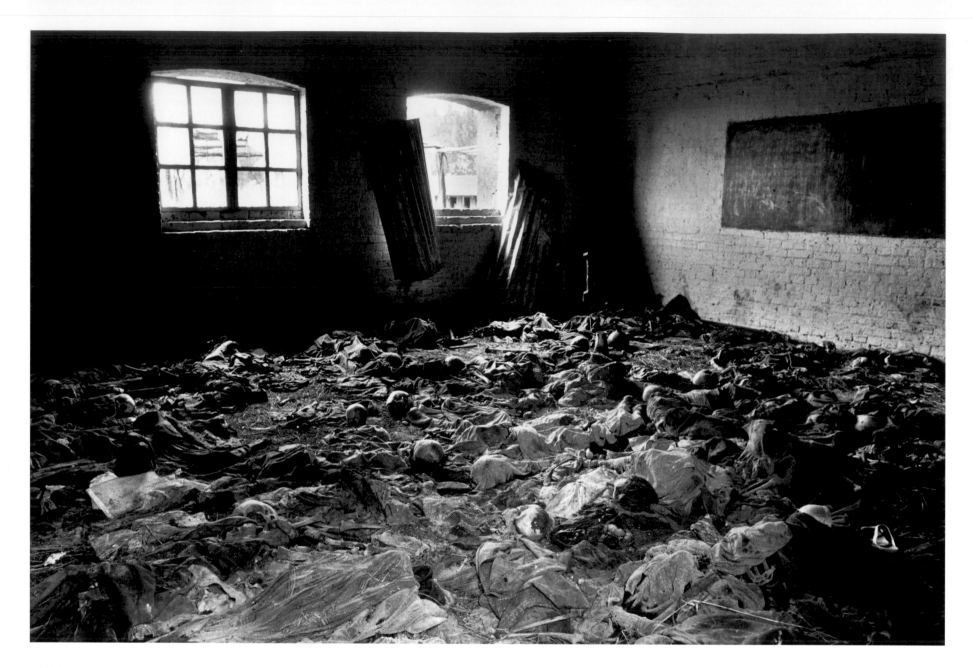

145. *Rwanda,* 1995

This photograph testifies to the terrible genocide that ripped apart
Rwanda. The overwhelming majority of victims were Tutsi, but many
Hutu were also killed, particularly those with liberal views who
opposed the ruling dictatorship. Today, Rwanda is deeply scarred by
this tragedy. Over a period of just four months, one million people (out
of a population of seven million) were killed. Whether Hutu or Tutsi,
whether refugees in camps inside or outside Rwanda, survivors are
haunted by feelings of fear, guilt, revenge, and insecurity.

This photograph was taken in an abandoned school in the village
of Nyarubuye, only a few miles from the Tanzanian border. Thousands
of Tutsi were brutally murdered here in April 1994, their bodies left
unburied, since survivors fled. Most of the corpses were cruelly
mutilated, with pieces of bodies scattered around a room where
children once studied. After the massacres, fearing revenge, Hutu left
for the refugee camp at Benako, across the border in Tanzania. Now
Tutsi soldiers wait for the counteroffensive expected to be launched
from Tanzania.

146. *Burundi*, 1995

In July 1994, around 245,000 Rwandan Hutu fled into Burundi. Moving in the opposite direction were tens of thousands of Rwandan Tutsi, returning to their country after 40 years of exile in Burundi. Most Hutu settled close to the Rwanda border in the region of Ngozi, in northern Burundi, quickly filling refugee camps organized by the United Nations High Commissioner for Refugees and the Belgian branch of Médecins sans Frontières. These camps were peaceful until late March 1995 when ethnic troubles erupted in Burundi. On March 29, 1995, one camp was attacked, with 12 people killed and 20 wounded. The following day, around 50,000 refugees from the camps at Majuri and Kibezi and some from those at Magara and Ruvumu took to the roads again, heading for the border with Tanzania, 70 miles (105 km) away.

Just two days later, on March 31, 1995, Tanzania closed its border with Burundi to prevent another huge influx of Rwandan refugees (it had already taken in some 600,000). The fleeing refugees (seen in this photograph) had already walked 25 miles (40 km), but they were stopped and a precarious new refugee camp was founded. Most of the refugees were still hopeful that the border would soon reopen.

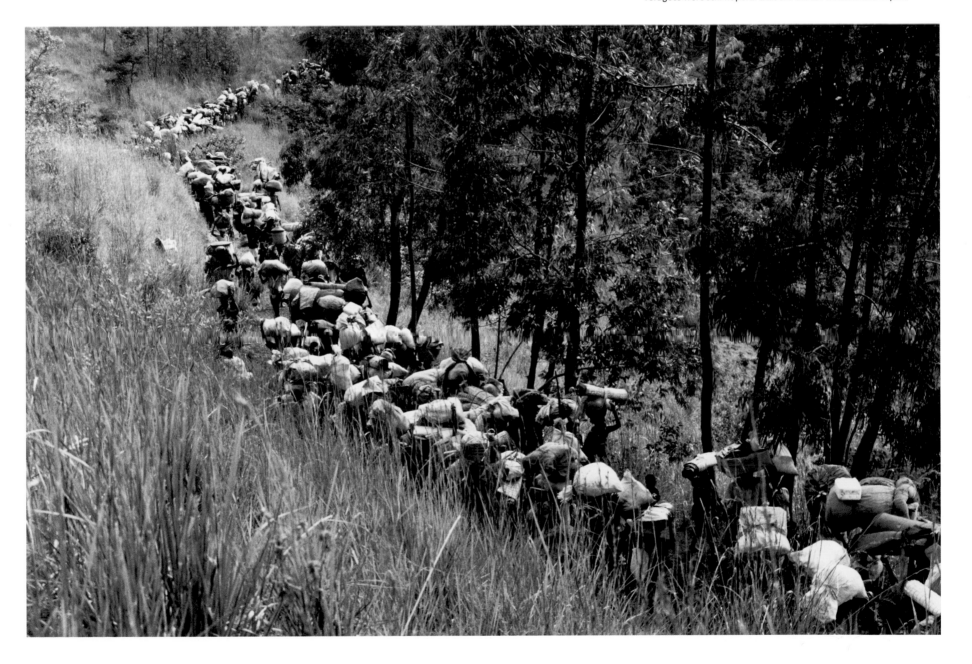

147. *Zaire*, 1994

This photograph was taken inside the orphanage attached to the hospital at Kibumba Number One camp, where medical help is provided by Goal Rwanda, an Irish humanitarian organization. This camp had 350,000 refugees, but it grew even larger when the government of Zaire sent refugees from Goma and from Munigi to Kibumba Number One camp. The camp carries this name because it was settled before the large camp of Kibumba, but within days the two settlements had spilled over into each other.

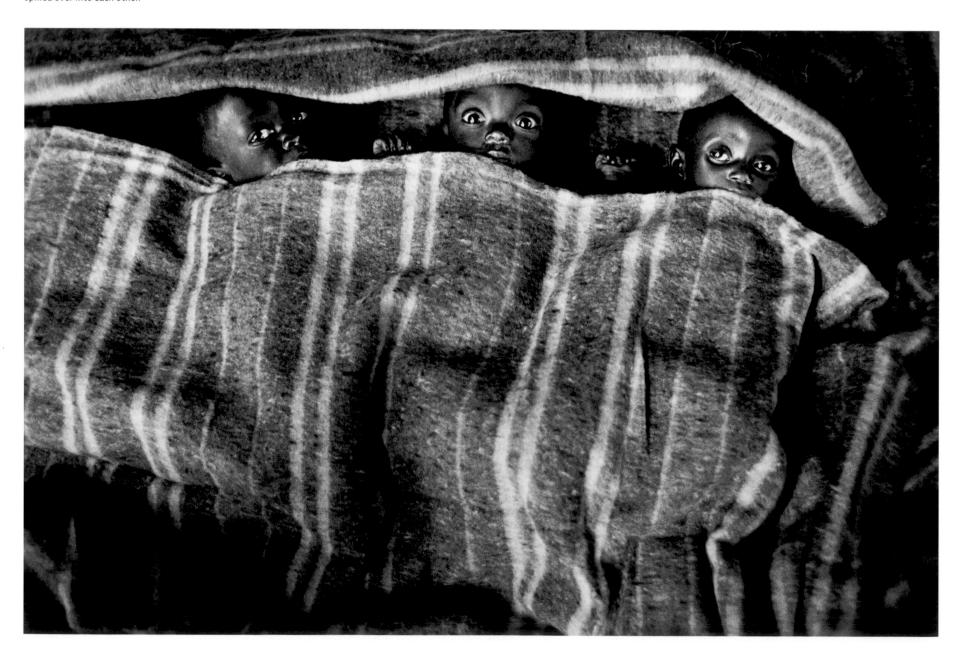

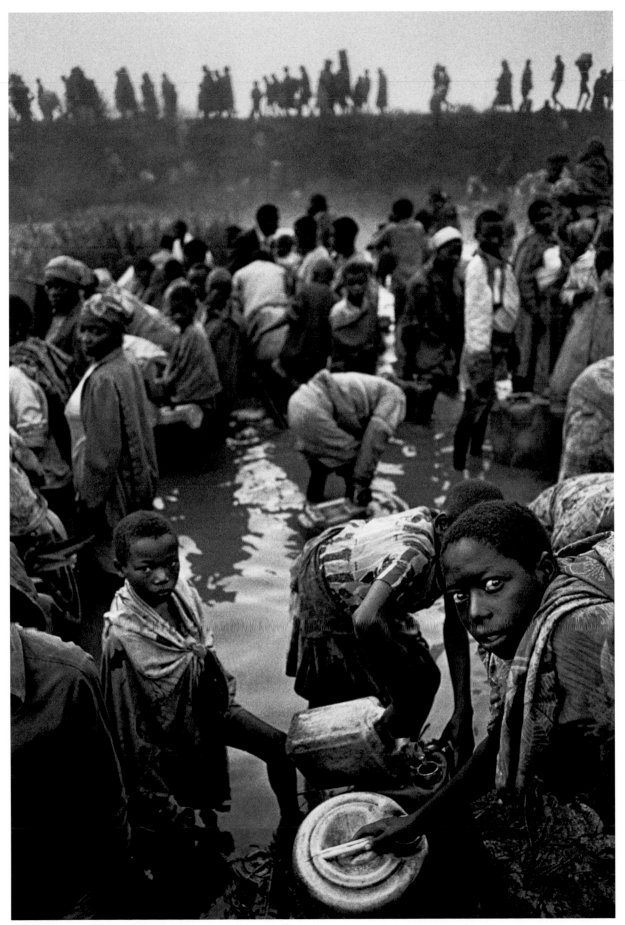

148. *Tanzania,* 1994
The shortage of water is always the most serious problem in refugee camps. In just four days, the number of refugees arriving in the camp at Benako had exceeded 350,000 and water had disappeared from this small lake. The United Nations and the humanitarian organizations had to install a water-distribution system, with water trucked in from elsewhere.

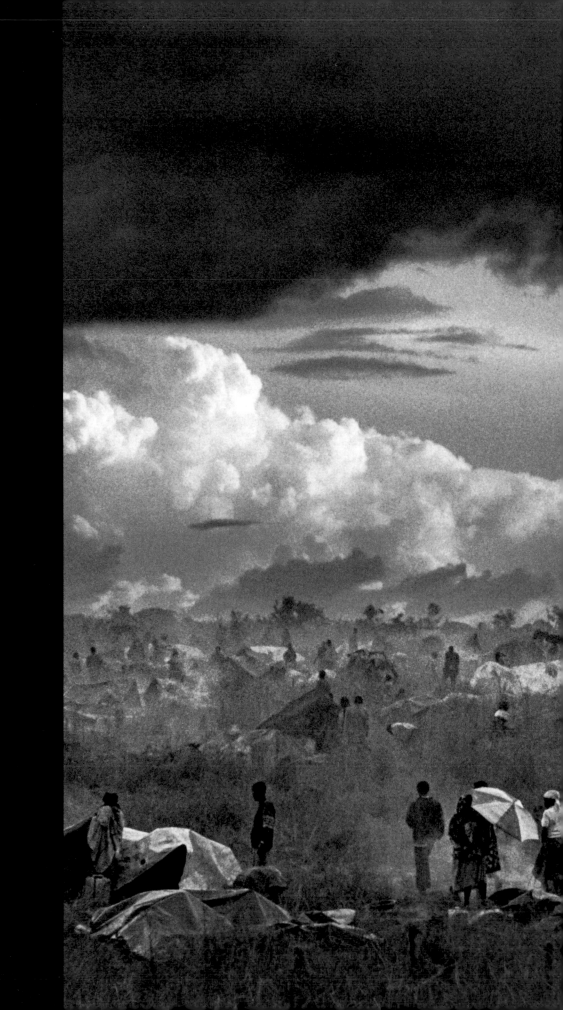

149. *Tanzania,* **1994**
With as many as 350,000 arriving at the refugee camp at Benako in just four days, the initial conditions were deplorable. Most people arrived almost empty-handed. It took several more days for the United Nations and humanitarian organizations to create some semblance of order. As these photographs show, it rained almost every night, forcing refugees to build makeshift shelters out of pieces of blankets, which offered no protection against the strong rains of the region. Thus many people who had arrived here healthy soon fell ill. The lack of drinking water and improper hygiene facilitated the spread of infectious diseases.

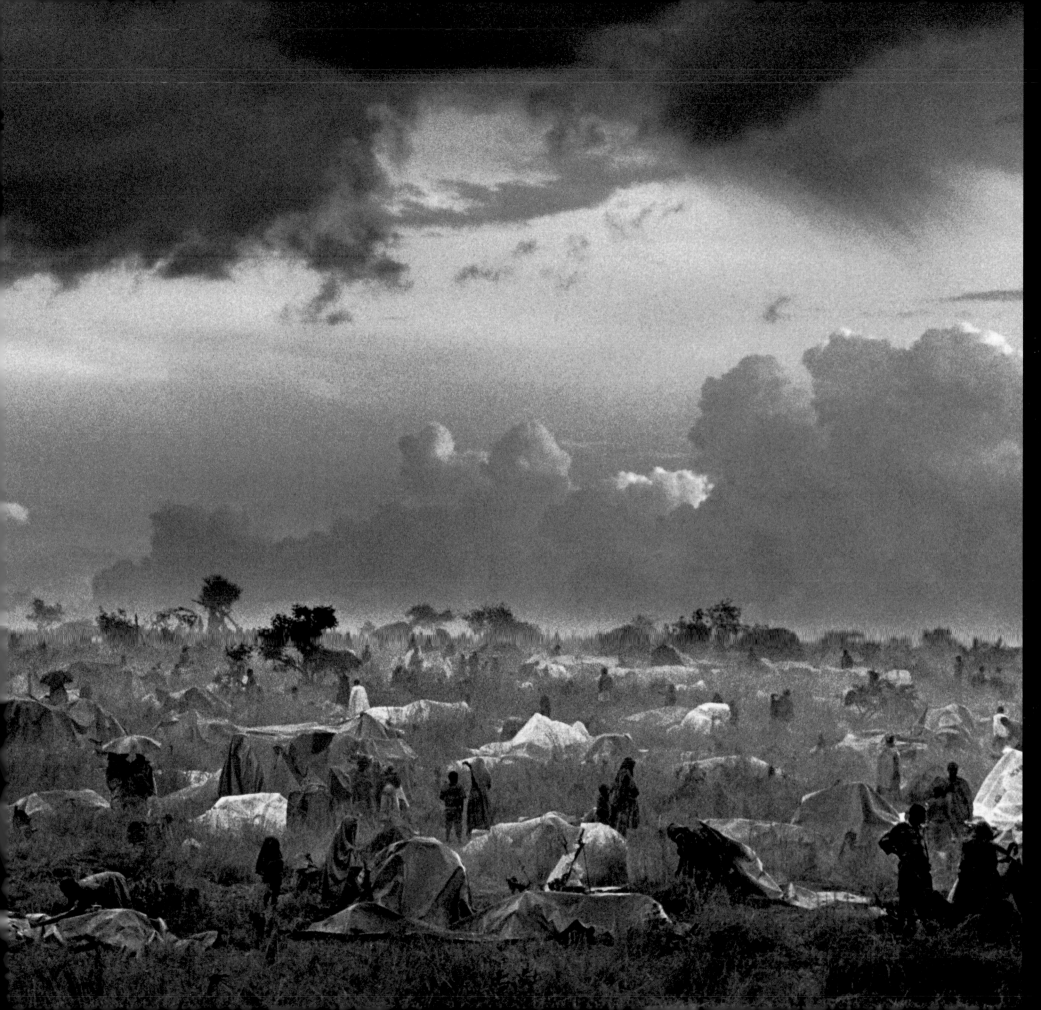

150. *Metro Manila, The Philippines,* 1999

In Manila, the railroad track that cuts through much of the city is now lined with shacks housing tens of thousands of squatters, many of them migrants from rural areas. The risk of accidents is great as the trains pass just inches away from the houses. Sometimes, strong winds shift the shacks a few inches toward the tracks, enough to cause accidents as trains roll by.

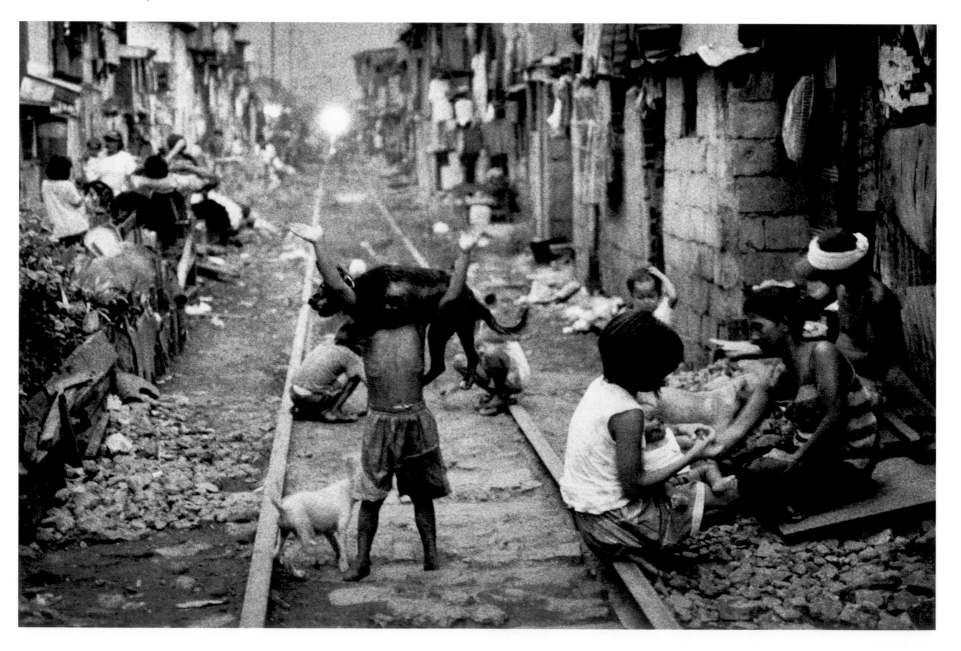

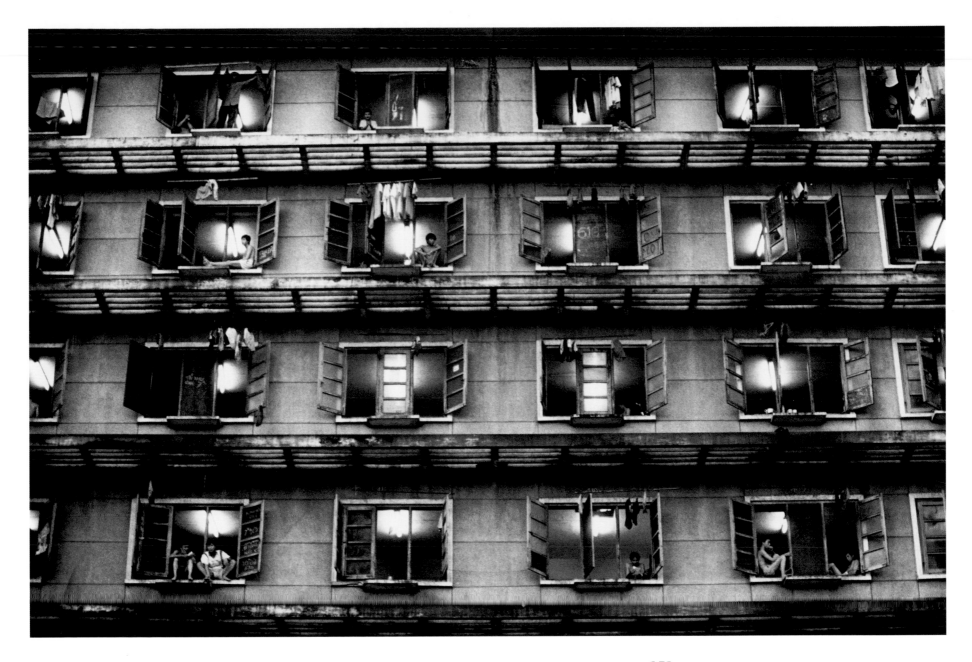

151. *Ho Chi Minh City, Vietnam,* 1995
Habits are hard to change. Peasants who used to sit on the window ledges of their rural homes continue to do so in crowded apartment buildings in Ho Chi Minh City, seemingly unconcerned that they are now high above the ground.

152. *Bombay, India,* 1995
A pipeline carrying drinking water to more prosperous districts
of Bombay passes through the shantytown of Mahim, not far
from the city's airport. Most of Bombay's inhabitants live in slums,
many of them embedded in middle-class neighborhoods.

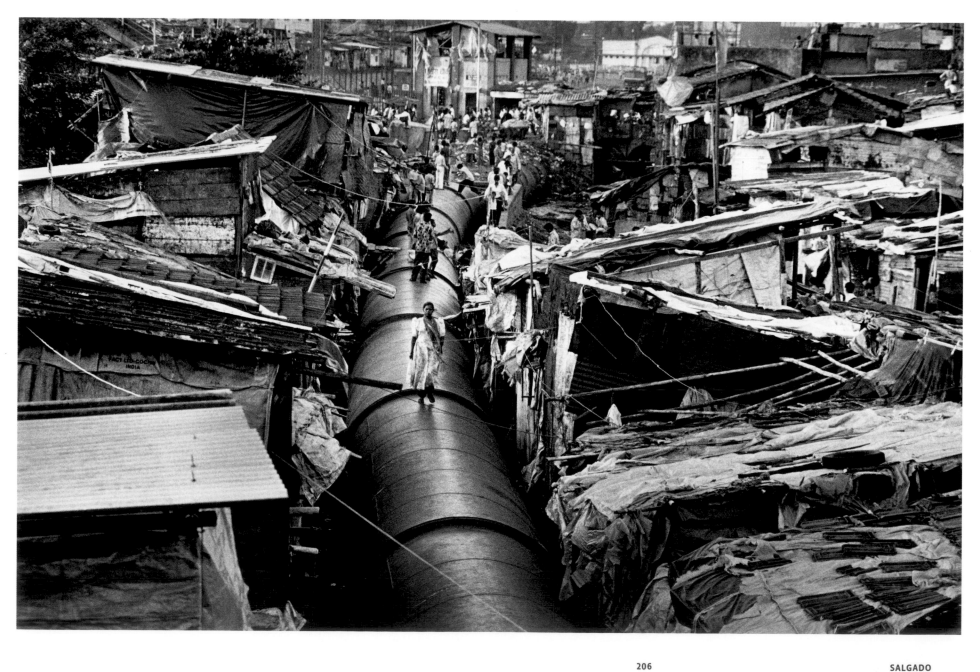

153. *Church Gate Station, Western Railroad Line, Bombay, India,* 1995

Church Gate is the terminus station of the Western Railroad line, which brings 2.7 million commuters into Bombay every day. It is not a large station, but at rush hour trains seem to arrive every twenty seconds. Built by the British, India's railroad system covers much of the country. But now, even with the addition of numerous commuter lines, such is population growth here that the trains are always dangerously overcrowded.

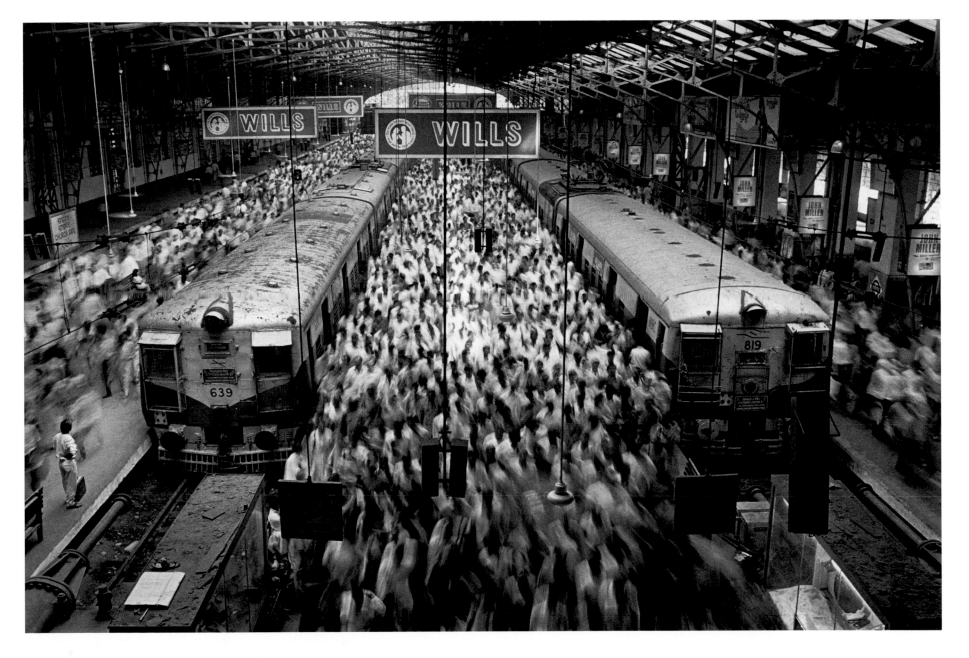

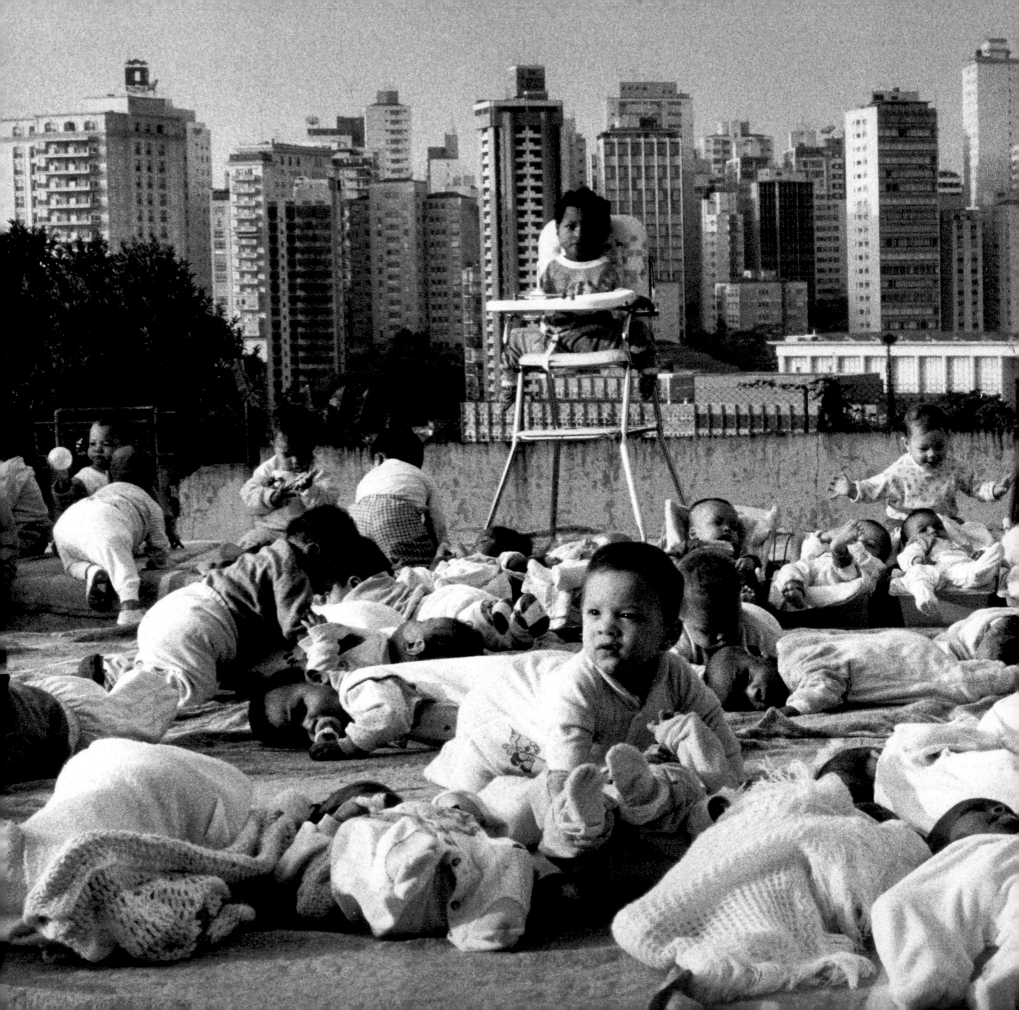

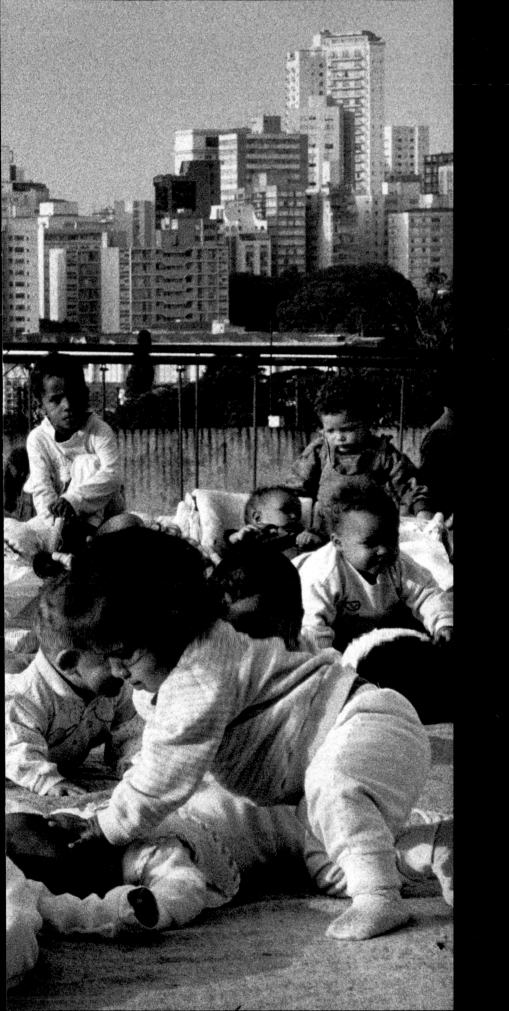

154. *São Paulo, Brazil,* 1996

One of the consequences of sudden migration to a large city is the disintegration of families. At first, families try to maintain their unity, but such is the struggle for survival that families frequently break up in this every-man-for-himself environment where begging, prostitution, and theft become the norm for many youths. Adolescent children leave home and desperate parents in turn abandon their younger children or entrust them to government-run child-welfare institutions, notably the Foundation for Child Welfare (FEBEM).

This photograph shows abandoned babies playing on the roof of a FEBEM center in the Pacaembu district of São Paulo against a backdrop of middle-class apartment buildings. Some 430 children live here, 35 percent of whom were found abandoned on city streets; the others were delivered at the center by parents no longer able to care for them. According to FEBEM, the proportion of abandoned children in the city long averaged 10 percent, but has recently risen sharply.

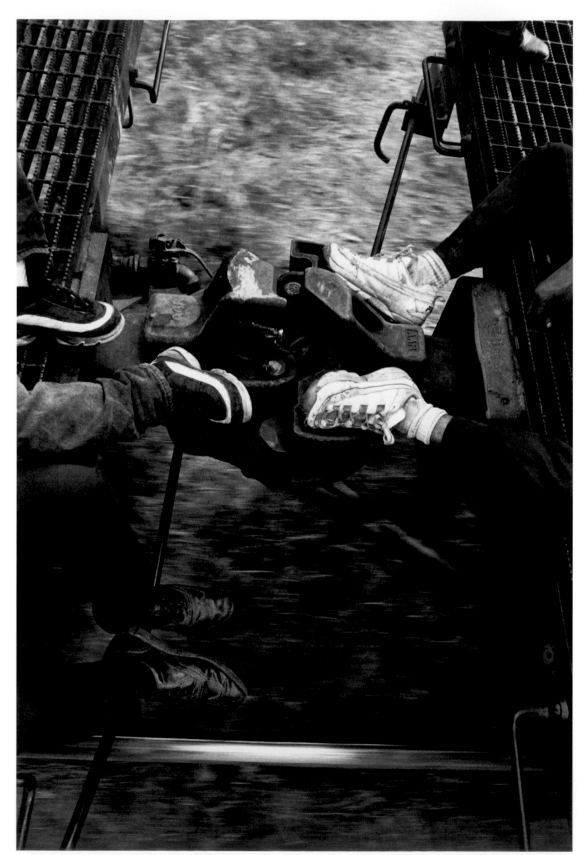

155. *On a Train to Northern Mexico,* **1998**
A favorite hiding place, but also the most dangerous, is between
the wagons. While the train is stopped in the middle of nowhere by
migration authorities, illegal migrants can easily jump off and escape
unseen into bushes. Then, as the train moves off, they jump aboard
again. Few are ever arrested, although if they miss the train they must
walk many miles to the nearest railroad stop in the hope of catching
the next northbound goods train.

Riding between the wagons is also convenient when the train
makes brief stops. The migrants can jump off, find water and return
to their perches. But the dangers are many: besides being tipped off
the train by sudden braking, tiny fragments of metal thrown up by
the friction of the wheels on the track can cause serious eye injuries.
The hot air circulating between the wagons also quickly brings
on dehydration.

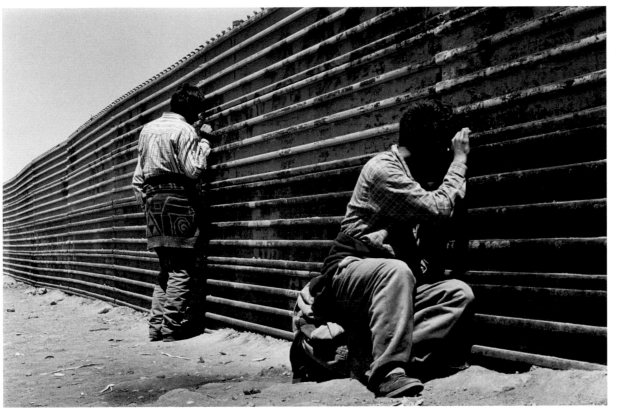

156. *Tijuana, Mexico,* 1997

In recent years, the United States has built steel barriers along urban stretches of its border with Mexico. This photograph shows two migrants in Tijuana looking hopefully into the United States through cracks in the steel fence.

Tijuana used to be the main crossing point for migrants entering the United States. Today, the passage is risky, not only because of the steel barrier, but also because of the increased presence of the United States Border Patrol. Before erection of the steel barrier, there were some 100 Border Patrol agents in the section; now there are more than 2,200 of them patrolling the San Ysidro area opposite Tijuana. Furthermore, Border Patrol agents are working with highly sophisticated equipment that was once reserved for U.S. Army use. After dark, when most crossings take place, the agents use infrared, mobile night-vision devices to detect any human movement in a perimeter of some four miles (six km). They also bury ground sensors along paths known to be used by migrants.

The population of Tijuana has swollen in recent years, largely because of massive foreign investment in assembly plants that have sprung along the 2,000-mile (3,000 km) border to take advantage of the proximity of the United States market. This labor-intensive investment is encouraged by Mexico through assorted fiscal incentives. Since the creation of the North American Free Trade Area (NAFTA) in 1994, agricultural and industrial products have also been free to move across the border without customs duties. Investors in these assembly plants are attracted by cheap labor and reduced transport costs. For Mexico, the principal attraction has been the creation of tens of thousands of jobs in a previously destitute region. But these very jobs serve as a magnet for migration, which has in turn complicated urban management in Tijuana.

157. *Desert of San Ysidro, California, U.S.A.,* 1997

Finding a hole in the steel barrier is not the biggest problem; it is more risky to enter the field of electronic detectors that alert officers of the Border Patrol. This photo shows an illegal migrant who is hurrying back to Mexico after being spotted by a Border Patrol vehicle.

JAMES **NACHTWEY**
THE SACRIFICE

For nearly thirty years James Nachtwey (born 1948) has dedicated himself with astonishing endurance to documenting those around the world affected by war, famine, drought, and severe economic hardship with the intention of bringing their plight to the attention of the international community and with the desire to raise consciousness of humanity's responsibility to itself. His compassionate and exquisitely composed work is crafted to be powerful, confrontational, and intentionally unsettling. Despite the preponderance of disturbing subject matter that passes before his lens, Nachtwey's approach ultimately springs from a position of hope that the mistakes of the present and past can be avoided in the future, and from a positivist belief that photojournalism can play an important role in that process.

Born in Syracuse, New York, Nachtwey went on to major in political science and the history of art at Dartmouth College, a combination of interests that would anticipate, if not directly influence, his later decision to become a photojournalist. Completing his studies in 1970, Nachtwey served in the Merchant Marines before taking up work editing newsreels at NBC in New York. It was during this period that he began photographing, moving on to work for a commercial photo studio and then joining the staff of a newspaper in New Mexico for a short period to hone his skills. He returned to New York in 1980, becoming a freelance photojournalist associated with the Black Star agency. His first international assignment was to cover unrest associated with Irish Republican Army hunger strikes in Northern Ireland. This proved to be an important development in his career, for it was the first time he witnessed history from the "ground level," as he calls it, as opposed to from a removed academic point of view.[1] He developed an interest in the way in which war affects the lives of ordinary people, and his desire to portray this side of conflict for the media is something that continues to drive his work today.

Focusing on the collateral effects of conflict is an approach that can be traced back in the history of photojournalism, at least to the depiction of the Spanish Civil War during the 1930s in the work of photographers like Robert Capa, Gerda Taro, and David Seymour, all of whom demonstrated an interest in covering the civilians targeted by German bombing campaigns. Likewise, during the Vietnam War, a number of photographers—notably Philip Jones Griffiths and Don McCullin for their searing book-length studies of the conflict, but also news photographers Barbara Gluck and Larry Burrows—devoted more attention to the human costs of war than to adrenalin-filled scenes of battle. Indeed, among the war's defining icons is Nick Ut's picture of a civilian girl fleeing napalm attack. Nachtwey, in fact, credits the images that came out of Vietnam as crucial influences on his own trajectory, for it was through that work that he began to see documentary photography as a form of protest. "The photographers were documenting something that was unacceptable and it was clear from their pictures that was the case. Photographers were telling us a completely different story to what we were being told by our political and military leaders: I believed the photographers.... I became a photographer in order to be a war photographer."[2]

Nachtwey spent the 1980s documenting conflict around the world in places like Sri Lanka, South Korea, Northern Ireland, Lebanon, El Salvador, Nicaragua, Uganda, Haiti, Sudan, the Philippines, and the West Bank, publishing the book *Deeds of War* on his decade of color work in 1989, the same year that he became a full member of Magnum.[3] The 1990s constituted another decade during which he witnessed the

grimmest aspects of the human condition. His second major publication, *Inferno*, is a 480-page volume documenting in carefully composed, beautifully rendered black-and-white pictures the horrors he witnessed in Romania, Somalia, India, Sudan, Bosnia, Rwanda, Zaire, Chechnya, and Kosovo (fig. 54).[4] The book is structured by location, with a chapter devoted to each of the nine regions. Sequences of photographs are employed to depict the situations encountered, with related captions in the back matter of the publication, allowing the book to become as much an archive as a story of humanity's darkest moments. Section texts providing context for the situation that gave rise to the images, along with an introduction by Luc Sante and an afterword by Nachtwey, round out the project's written components.

Pulling together ten years' worth of Nachtwey's pictures—which, when published at the time of their creation, were shown fragmented from one another in the pages of *Time* and other news magazines—makes a powerful statement.[5] Their very accumulation together enhances their impact, making the book too overwhelming to absorb in a single sitting and demonstrating that the horrors depicted are not isolated events but rather systemic and ongoing failures of world politics and social determination that will continue without a solid resolve to combat them. The book bears witness to and provides evidence of man's inhumanity to man, with the hope that awareness of and outrage over its contents can ultimately play a part in fostering an environment in which change is possible. Upon its publication, the book was sent to world leaders and non-governmental organizations with that goal in mind.

Nachtwey has come to consider himself an antiwar photographer, which is different from a war photographer in an important way, as Sante noted in the introduction to *Inferno*. Nachtwey's approach as an antiwar photographer allows him to transcend the politics of a particular situation. The work is still partisan, in that it condemns the effects of war altogether, but it is partisan on the part of the victim and not the actual forces in opposition to one another in a given conflict. Nachtwey's point seems to be that human devastation of the kind he witnesses should never be acceptable, regardless of the politics involved. And his job, as Sante puts it, is to

> see on behalf of the rest of the world; substitute individual cases for statistics and to counter ideological justifications with individual costs; to enumerate the human features of the dead; to make suffering palpable so that people far removed cannot overlook or excuse it; to repeat all these things again and again in the face of the human propensity for shutting out bad news especially when it does not represent

an immediate personal threat; to act as a vessel for those who cannot get the attention of the world because they have no voice left, if they ever had one; to appeal, to alert, to upset, to cry out.[6]

In 2001, Nachtwey left Magnum to found, along with six other photographers, the VII agency, a collective that represents a small set of successful and well-respected photojournalists dedicated to photographing environmental, social, and political conflict in its various forms. Among Nachtwey's subjects since that time have been the events of September 11, 2001, which took place just blocks away from his residence in New York; the resurgence of tuberculosis around the world; and the wars in Afghanistan and Iraq. In addition to covering the Iraq war directly as an embedded journalist, Nachtwey found an oblique way of addressing the consequences of the conflict in 2006. Traveling with medevac units to field hospitals and emergency rooms in Iraq, as well as visiting the Landstuhl Regional Medical Center in Germany and the Walter Reed Army Medical Center in Washington, D.C., Nachtwey began reporting on the war's wounded for *National Geographic*.[7]

It was a topic with which he was intimately familiar. In 2003, he had been injured when a grenade was tossed into the Humvee in which he was riding. Taken to a military field hospital, stabilized, and medevaced to a combat-support hospital in Iraq for emergency treatment, he was operated on and then flown to Landstuhl,

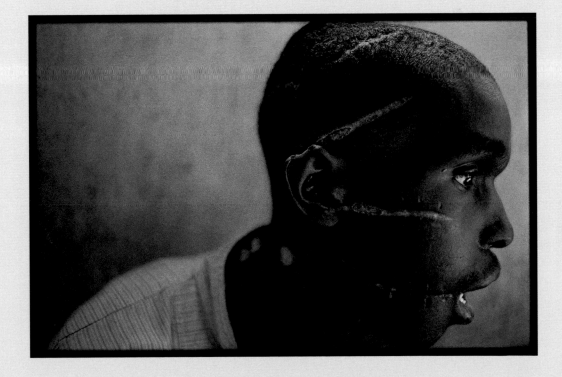

FIGURE 54. James Nachtwey (American, born 1948), *Rwanda*, 1994. From the series Inferno. Courtesy of the photographer.

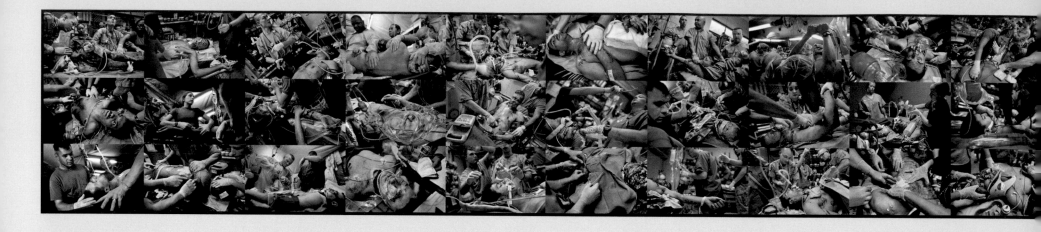

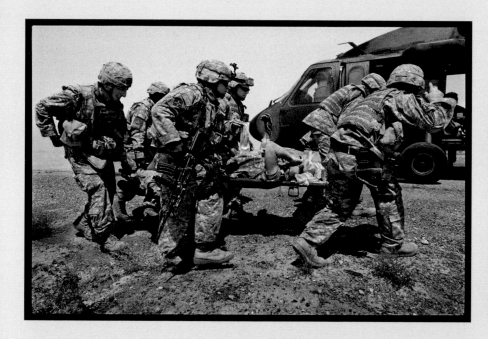

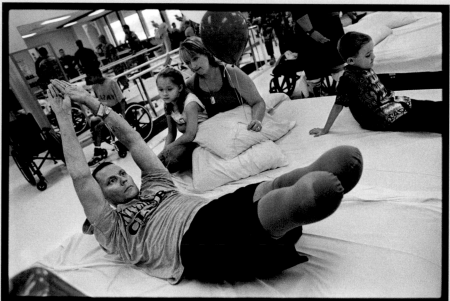

FIGURE 55. James Nachtwey (American, born 1948), *Air Rescue*, 2007. From the series The Sacrifice. Courtesy of the photographer.

FIGURE 56. James Nachtwey (American, born 1948), *Building Strength*, 2007. From the series The Sacrifice. Courtesy of the photographer.

which is the primary care center for Coalition casualties. Inspired by that experience, Nachtwey's essay, which he refers to as The Sacrifice, documents the struggle to save and rebuild lives. The series depicts the helicopter transfers from the site of battle to the treatment centers, the emergency rooms where delicate lives hang in the balance and medics work tirelessly to stabilize their patients, and the difficult process of recovery for those soldiers who survive their wounds (figs. 55–56).

In anticipation of showing the work at 401 Projects, a non-commercial photography gallery in New York, Nachtwey created a monumental installation print, measuring approximately thirty-three-feet long, that consists of sixty individual trauma-center images, digitally collaged into a grid stacked three high and twenty wide (pl. 158, details pp. 216–25). The work stands as a grim reminder of the human costs of war. The object's sheer size, in which one picture gives way to the next in a seemingly unending stream of torn flesh, metal instruments, snaking tubes, and bloodied hands, effectively conveys a sense of the controlled chaos that permeates these medical centers as well as the overwhelming volume of casualties flowing through the medics' hands on a daily basis.

Like the book *Inferno,* this work is confrontational, uncomfortable, and unavoidable. But as a compilation in which images blend together and scenes require effort to parcel one from another, it is effective at simultaneously enveloping and distancing the viewer. One can move in and out of it, seeking reprieve from the gruesome particular to contemplate the gravity of the larger picture. The many images within the print function as a kind of nonlinear photo essay within the

greater thematic project of The Sacrifice. The final picture at bottom right depicts a body covered over by a blanket and attended to by a chaplain, who holds identification tags in his hand. Thus a certain trajectory is achieved within the work, tempering any heroic readings of the larger project with a reminder that not all who enter this maelstrom of medical reparation emerge with the possibility of reconstructing their lives.

While it may be easy to contemplate and even support war in abstract strategic terms, it is difficult to face Nachtwey's portrayal of its inevitable results. His work has particular resonance in the politics of its time, not just with regard to questions over the war's validity but also over what should and should not be shown about it within the context of journalism and art. Made when photographs of flag-draped coffins were prohibited by the Bush administration and the depiction of American war wounded and dead was tightly restricted by the military, Nachtwey's portrayal of American casualties is unusual. It counters the sanitization of war that has emerged ever since the relative freedoms employed by journalists in Vietnam were rolled back.[8] In so doing, it raises questions about the line between respecting privacy and conducting censorship in situations that affect individuals but implicate the public at large. Do we have a responsibility to see the consequences of our military actions? Or should we, and the subjects of such photographs, be allowed sanctuary from them? Nachtwey unequivocally stands on the side of showing and of knowing, on the side that argues for the importance of seeing the consequences of war. In its aggressive scale, his work demands that we reconcile the goals and achievements of armed conflict with its

human costs, that we be prepared to acknowledge in particular visual terms the sacrifice it entails and the valiant work of those who do their best to mend its path of destruction.

NOTES

1. Simon James, "Nachtwey: Images from the Inferno," *RPS Journal* 140, no. 2 (March 2000): pp. 66–68.

2. Nachtwey, quoted in James, "Nachtwey" (note 1), pp. 66–68.

3. He had been associated with the agency since 1986.

4. Nachtwey, *Inferno* (London: Phaidon, 1999).

5. Nachtwey has been a contract photographer for *Time* since 1984.

6. Luc Sante, introduction to *Inferno* (note 4), p. 9.

7. Neil Shea, with photographs by Nachtwey, "The Heroes: The Healing," *National Geographic* (December 2006): pp. 68–105.

8. For more on these changes, see Michael Kamber and Tim Arango, "4,000 U.S. Deaths, and a Handful of Images," *The New York Times,* July 26, 2008.

Reproducing an object that is more than thirty feet long in the context of a book is a challenge, and the experience of it is inevitably different in this context than in the gallery. On the following pages, the object (which can be seen at reduced size in its entirety above) has been parceled into five spreads that, when viewed sequentially, simulate the experience of walking the length of the installation print from left to right.

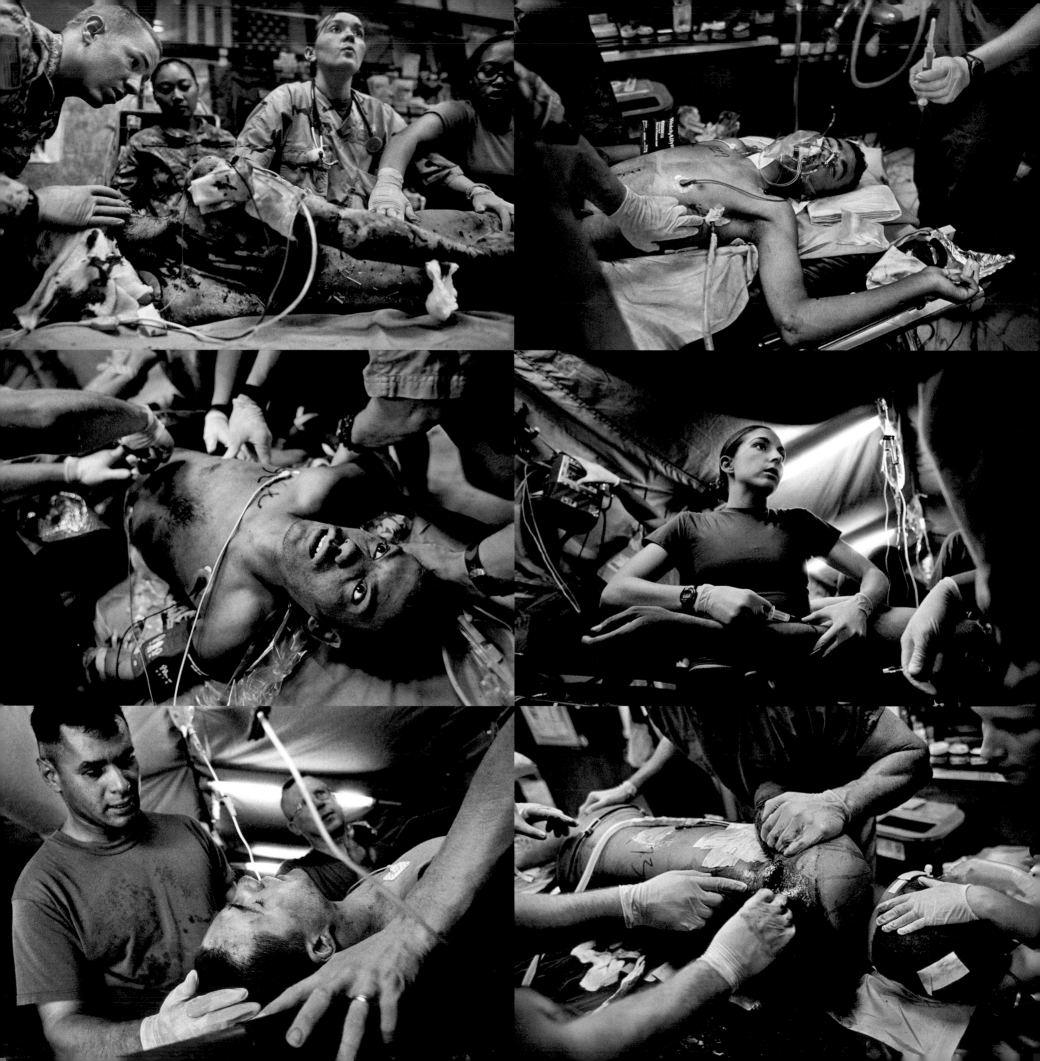

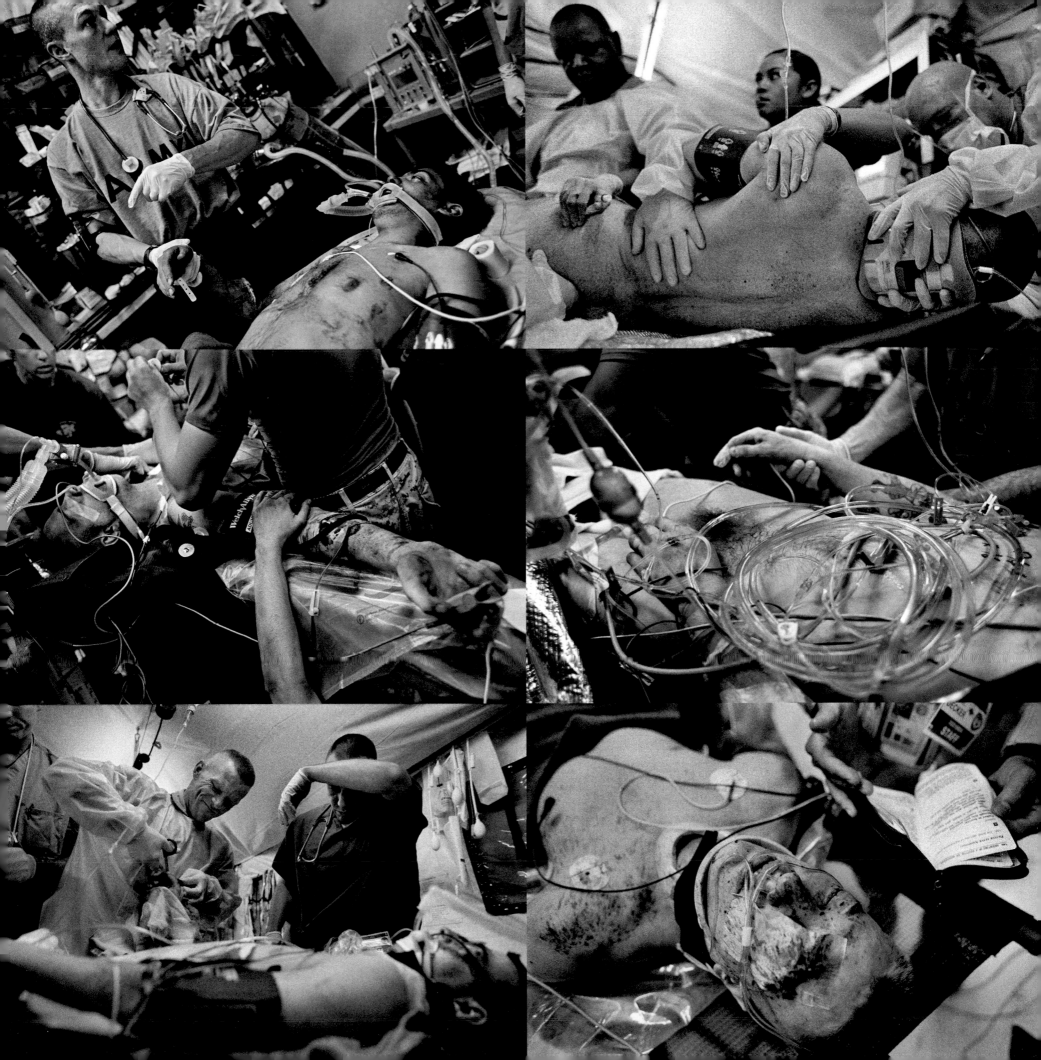

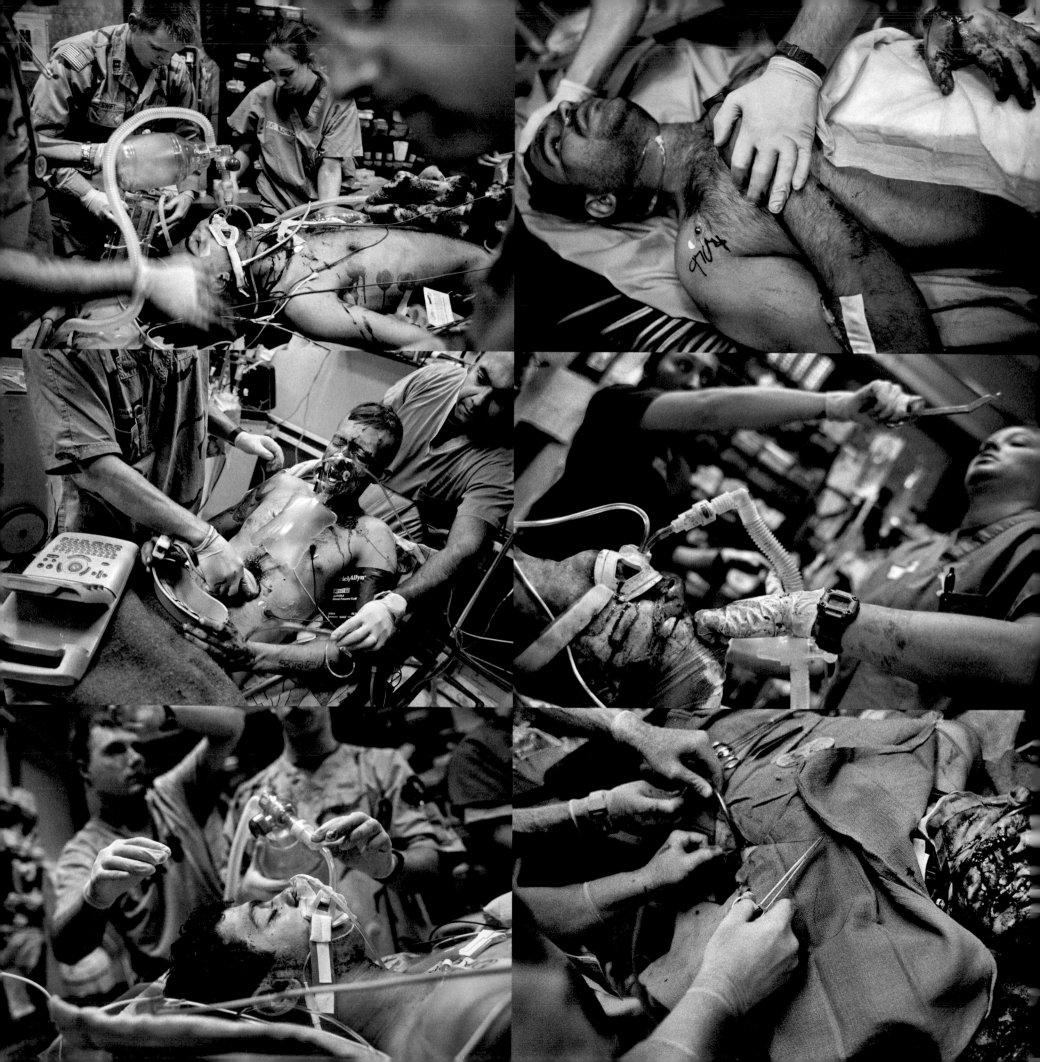

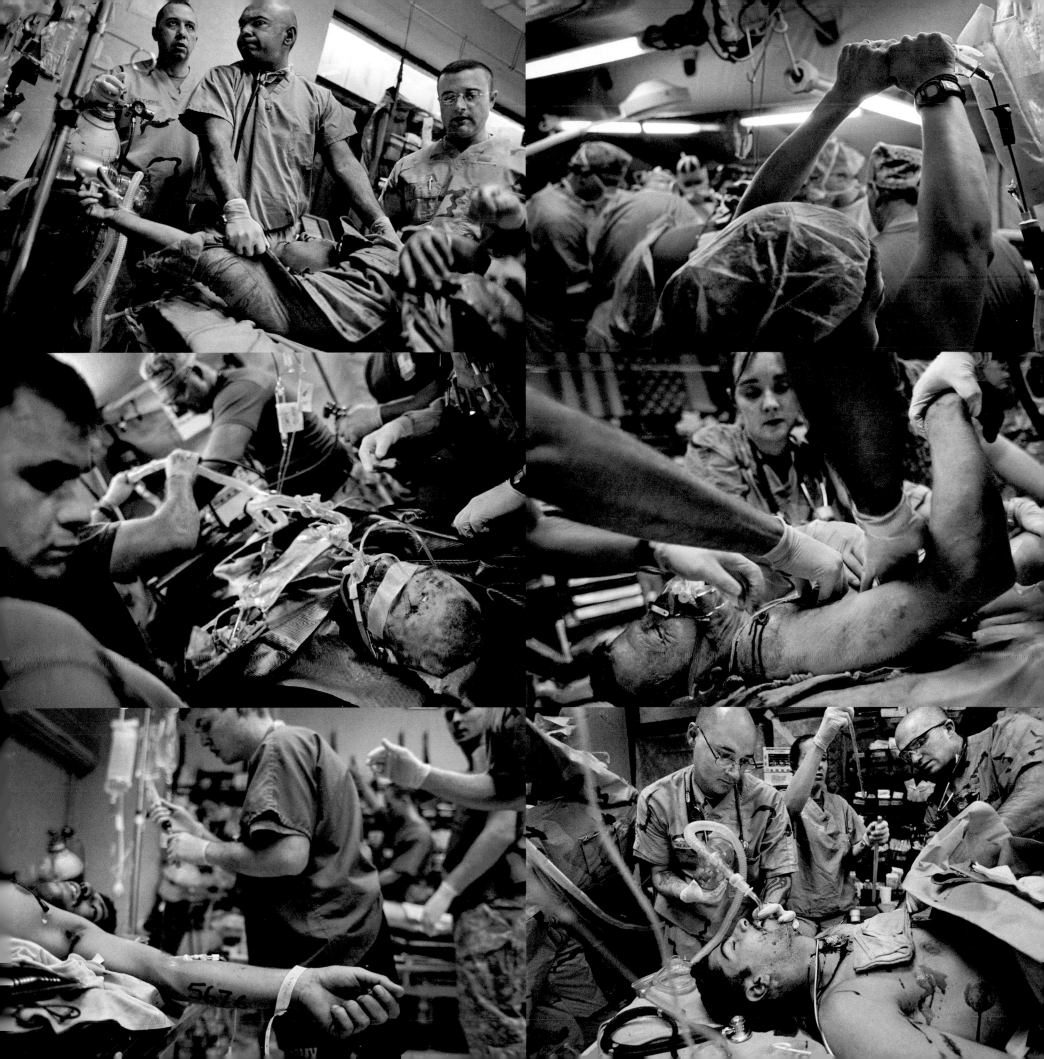

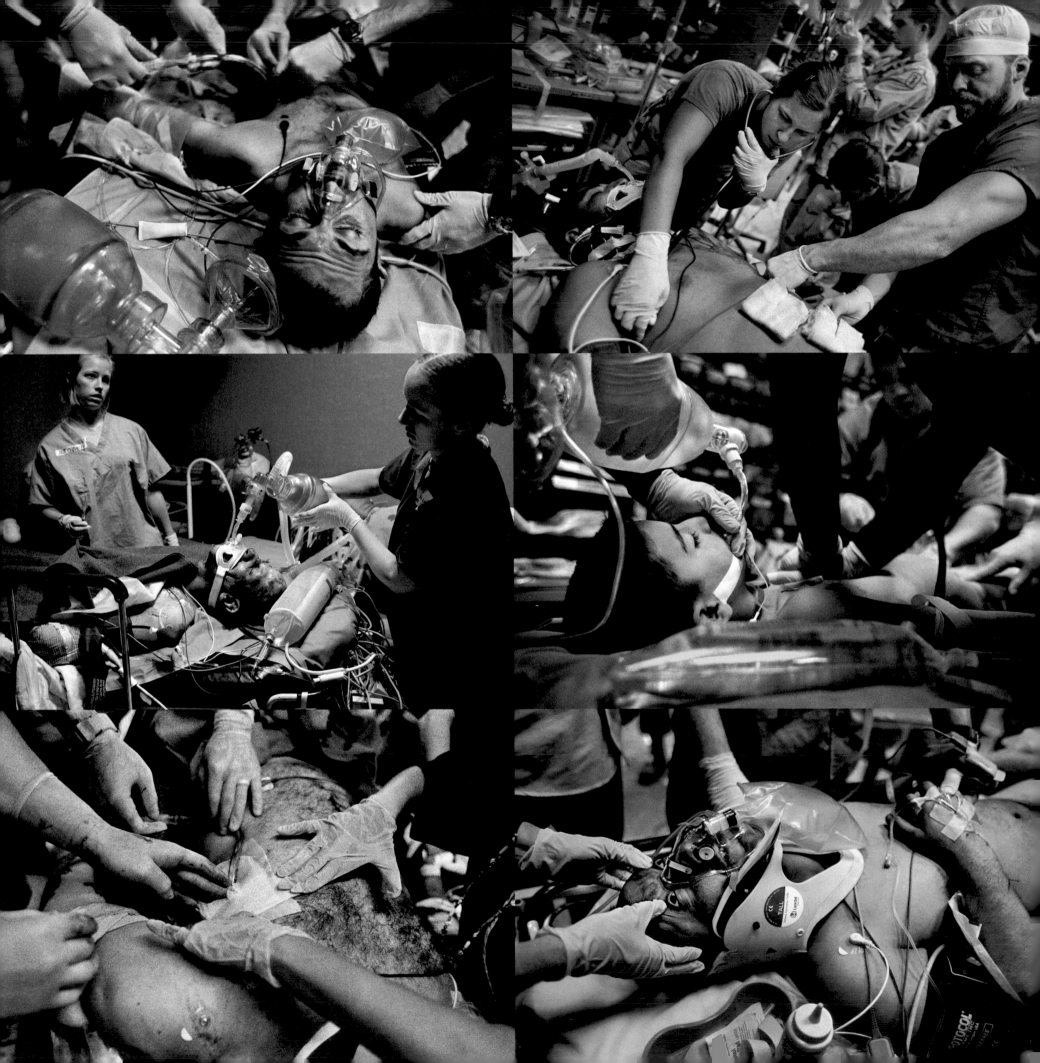

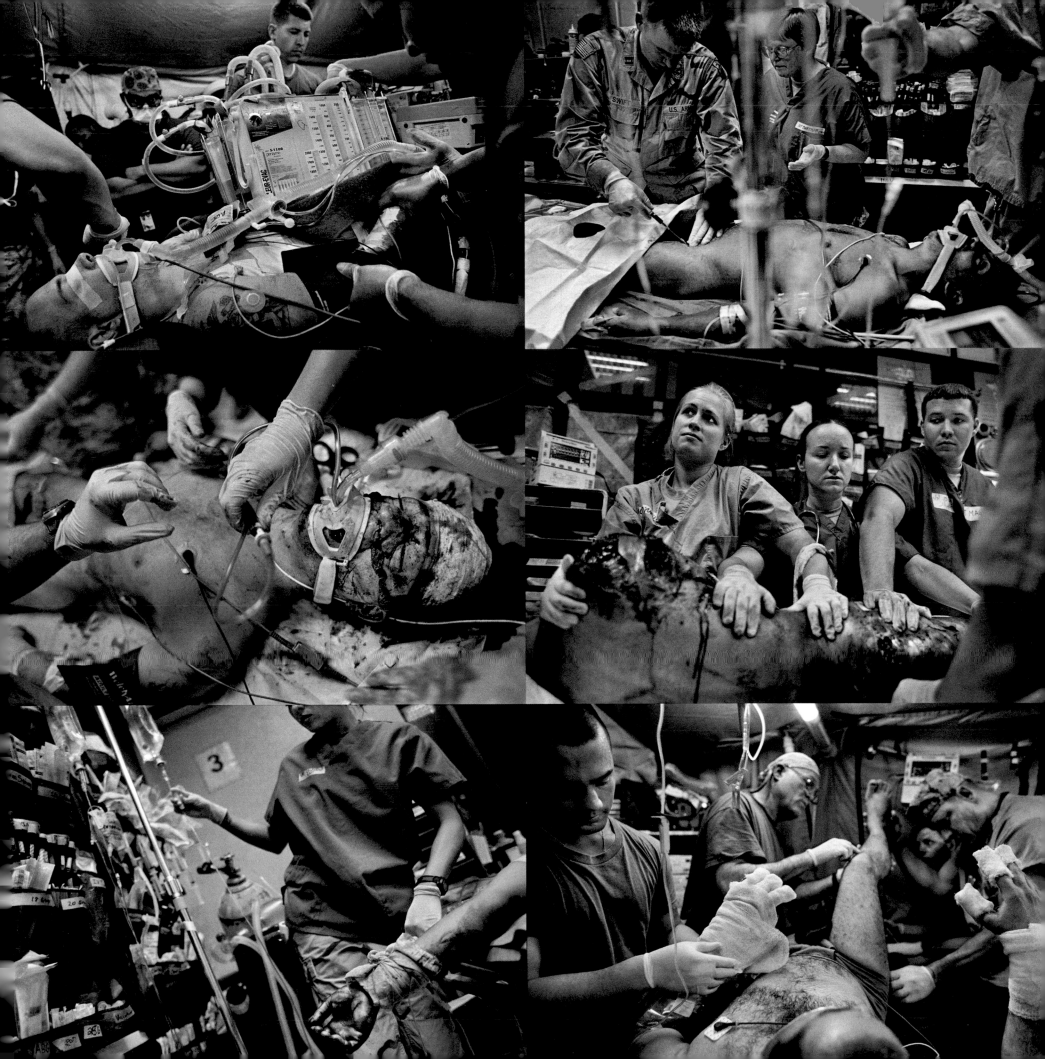

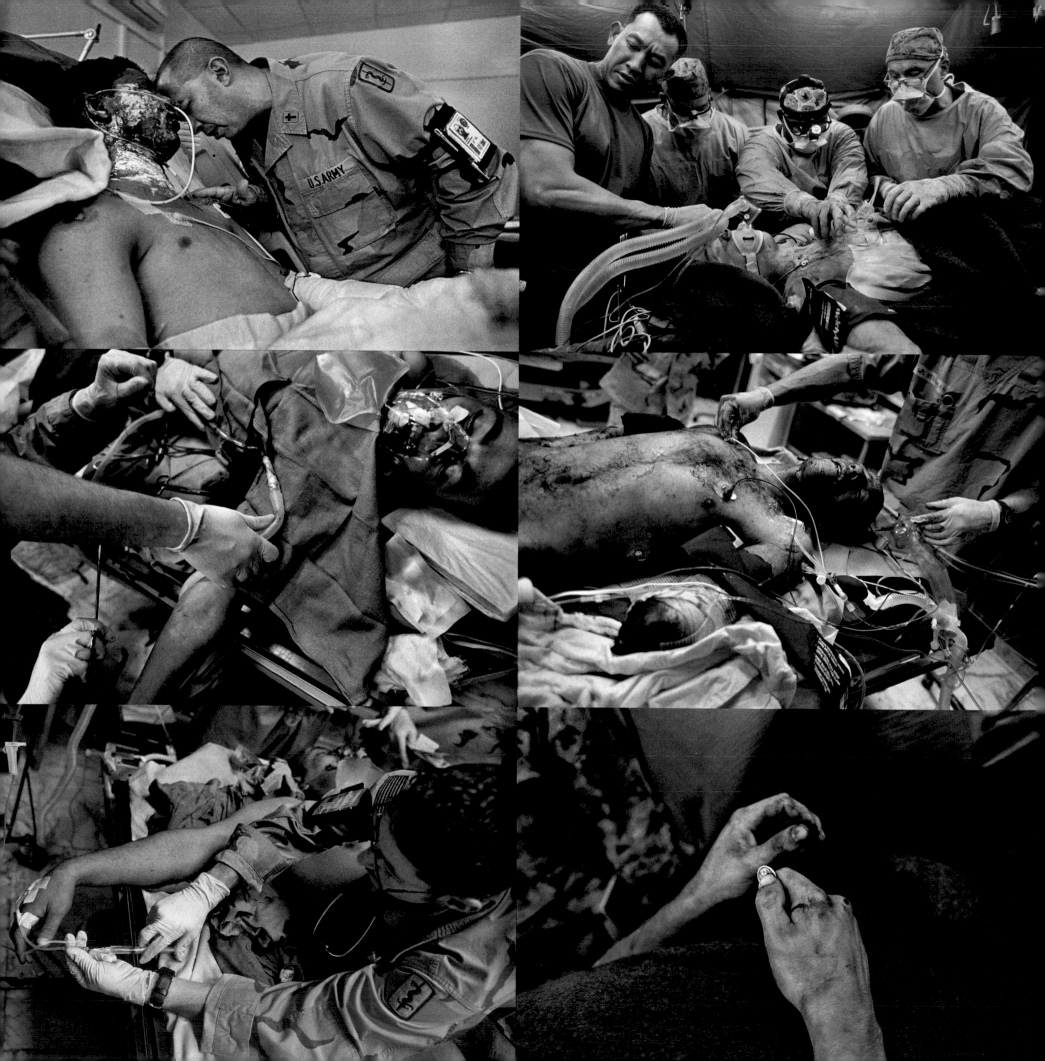

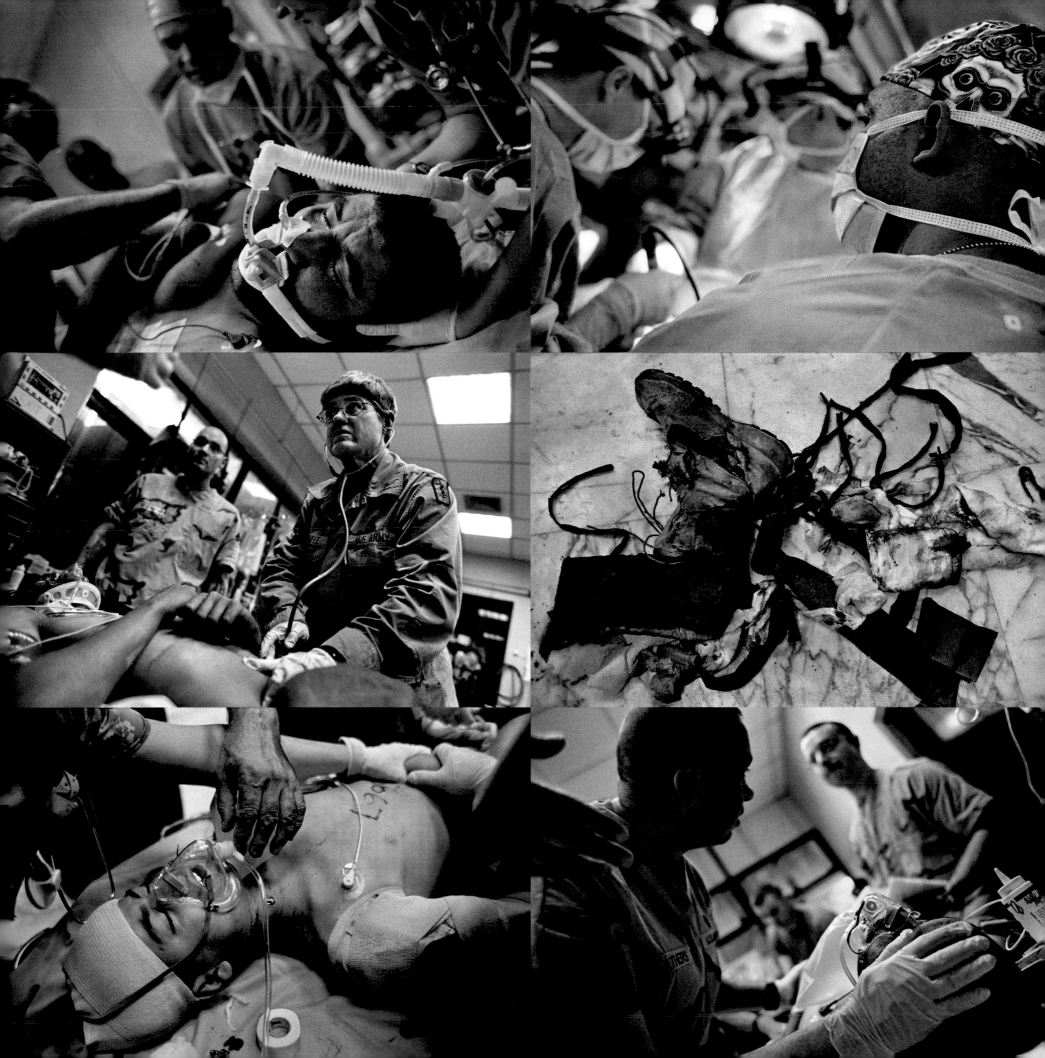

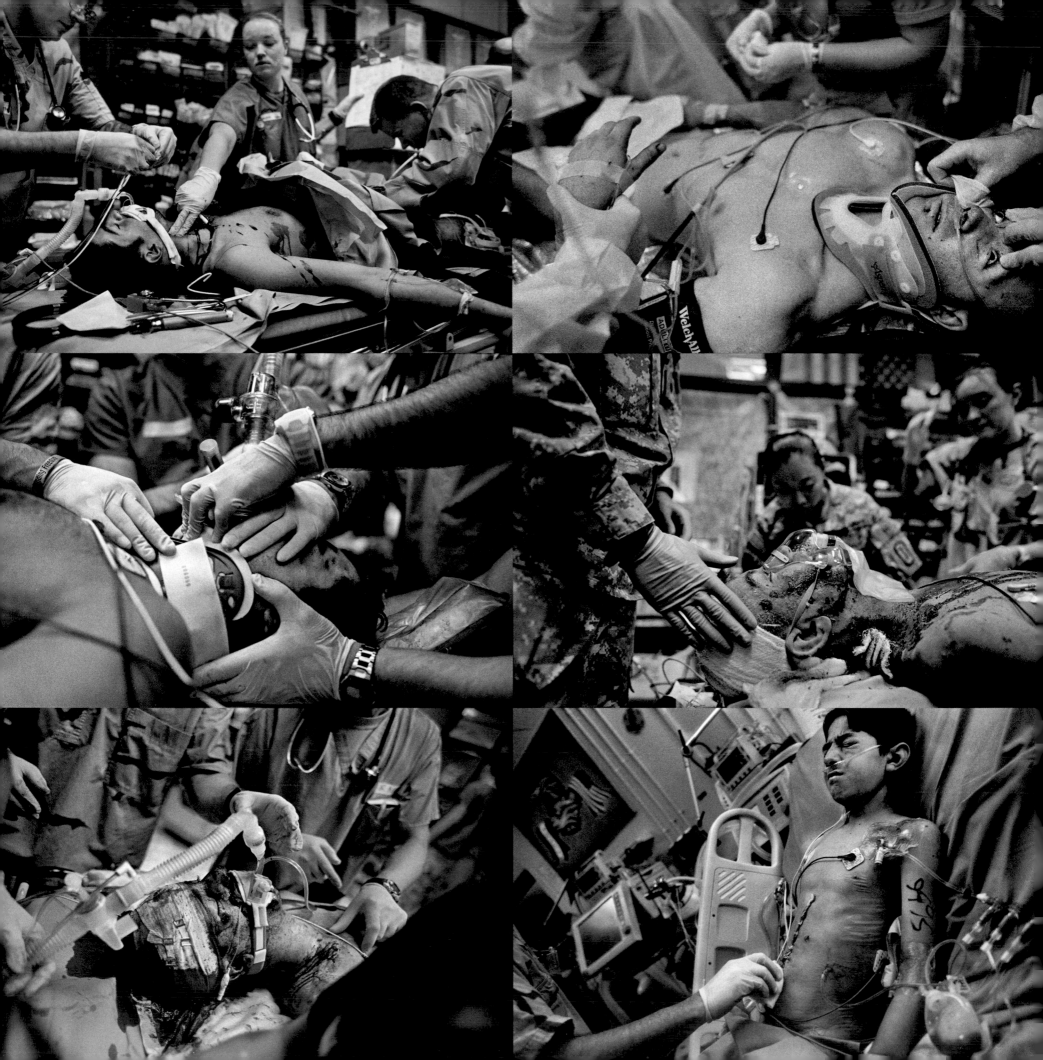

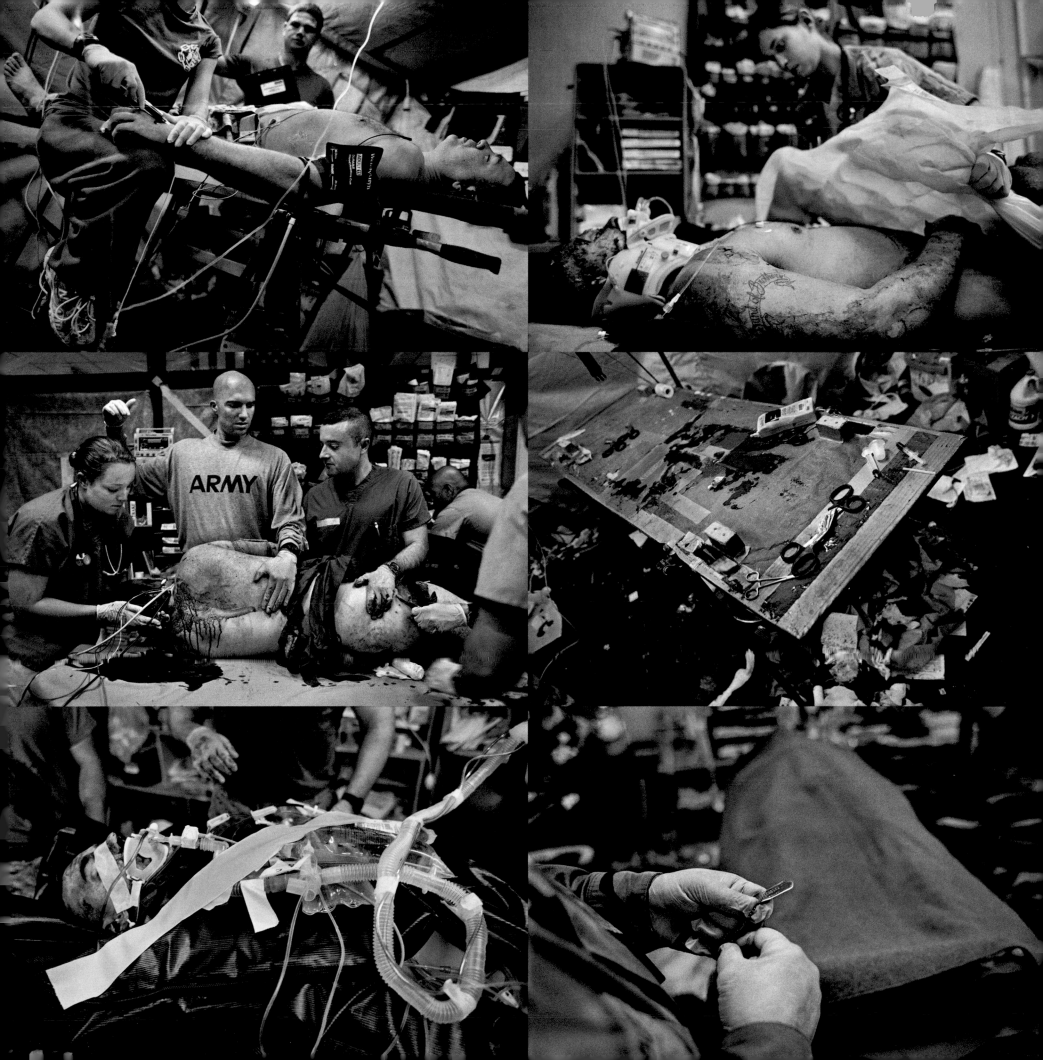

PLATE LIST

Works in the collection of the J. Paul Getty Museum, Los Angeles, are listed with the initials "JPGM."

LEONARD FREED
(American, 1929–2006)
From the series Black in White America

1. *Berlin, West Germany*, 1962
Gelatin silver print
27.6 × 35.6 cm (10⅞ × 14 in.)
JPGM 2008.62.1

2. *New York City*, 1963
Gelatin silver print
25.4 × 38.7 cm (10 × 15¼ in.)
JPGM 2008.62.12

3. *New York City*, 1963
Gelatin silver print
38.7 × 26 cm (15¼ × 10¼ in.)
JPGM 2008.62.14

4. *Brooklyn, New York*, 1963
Gelatin silver print
26.7 × 17.6 cm (10½ × 6¹⁵⁄₁₆ in.)
JPGM 2008.62.16

5. *Brooklyn, New York*, 1963
Gelatin silver print
36.7 × 24.4 cm (14⁷⁄₁₆ × 9⅝ in.)
JPGM 2008.62.15

6. *Brooklyn, New York*, 1963
Gelatin silver print
38.1 × 25.7 cm (15 × 10⅛ in.)
JPGM 2008.62.11

7. *Harlem, New York*, 1963
Gelatin silver print
33.3 × 23.8 cm (13⅛ × 9⅜ in.)
JPGM 2008.62.19

8. *Brooklyn, New York*, ca. 1963
Gelatin silver print
33.8 × 24.9 cm (13⁵⁄₁₆ × 9¹³⁄₁₆ in.)
JPGM 2008.62.18

9. *New York City*, 1963
Gelatin silver print
24.6 × 16.4 cm (9¹¹⁄₁₆ × 6⁷⁄₁₆ in.)
JPGM 2008.62.20

10. *New York City*, 1963
Gelatin silver print
35.1 × 25.6 cm (13¹³⁄₁₆ × 10¹⁄₁₆ in.)
JPGM 2008.62.7

11. *Brooklyn, New York*, 1963
Gelatin silver print
35.4 × 25.9 cm (13¹⁵⁄₁₆ × 10³⁄₁₆ in.)
JPGM 2008.62.5

12. *New York City*, 1963
Gelatin silver print
33.2 × 25.2 cm (13¹⁄₁₆ × 9¹⁵⁄₁₆ in.)
JPGM 2008.62.4

13. *Harlem, New York*, 1963
Gelatin silver print
33.2 × 25.2 cm (13¹⁄₁₆ × 9¹⁵⁄₁₆ in.)
JPGM 2008.62.3

14. *March on Washington, Washington, D.C.*, 1963
Gelatin silver print
37.8 × 25.4 cm (14⅞ × 10 in.)
Gift of Brigitte and
Elke Susannah Freed
JPGM 2008.59.4

15. *Washington, D.C.*, 1963
Gelatin silver print
27.8 × 19.8 cm (10¹⁵⁄₁₆ × 7¹³⁄₁₆ in.)
JPGM 2008.62.21

16. *South Carolina*, 1965
Gelatin silver print
21.3 × 33.4 cm (8⅜ × 13⅛ in.)
Promised gift of Brigitte and
Elke Susannah Freed
JPGM EX.2010.4.103

17. *Charleston, South Carolina*, 1964
Gelatin silver print
38.3 × 25.4 cm (15¹⁄₁₆ × 10 in.)
Gift of Brigitte and
Elke Susannah Freed
JPGM 2008.59.7

18. *North Carolina*, 1965
Gelatin silver print
21.6 × 31.8 cm (8½ × 12½ in.)
JPGM 2008.62.31

19. *New Orleans, Louisiana*, 1965
Gelatin silver print
26.3 × 38.5 cm (10⅜ × 15³⁄₁₆ in.)
JPGM 2008.62.33

20. *New Orleans, Louisiana*, 1965
Gelatin silver print
34.0 × 26.1 cm (13¹¹⁄₁₆ × 10¼ in.)
JPGM 2008.62.36

21. *New Orleans, Louisiana*, 1965
Gelatin silver print
33.3 × 23 cm (13⅛ × 9¹⁄₁₆ in.)
JPGM 2008.62.35

22. *South Carolina*, 1964–65
Gelatin silver print
35.6 × 23.8 cm (14 × 9⅜ in.)
JPGM 2008.62.28

23. *Johns Island, South Carolina*, 1964
Gelatin silver print
25.7 × 34.9 cm (10⅛ × 13¾ in.)
Gift of Brigitte and
Elke Susannah Freed
JPGM 2008.59.5

24. *Johns Island, South Carolina*, 1964
(printed later)
Gelatin silver print
16 × 24 cm (6⁵⁄₁₆ × 9⁷⁄₁₆ in.)
JPGM 2008.62.27

25. *Jazz Funeral, New Orleans, Louisiana*, 1965
Gelatin silver print
24.5 × 36 cm (9⅝ × 14³⁄₁₆ in.)
JPGM 2008.62.40

26. *Jazz Funeral, New Orleans, Louisiana*, 1965
Gelatin silver print
26.1 × 36.6 cm (10¼ × 14⁷⁄₁₆ in.)
JPGM 2008.62.39

27. *Jazz Funeral, New Orleans, Louisiana*, 1965
Gelatin silver print
38.7 × 25.9 cm (15¼ × 10³⁄₁₆ in.)
JPGM 2008.62.41

28. *Florida*, 1965
Gelatin silver print
24.6 × 33.6 cm (9¹¹⁄₁₆ × 13¼ in.)
JPGM 2008.62.30

29. *Johns Island, South Carolina*, 1964
Gelatin silver print
32.9 × 24 cm (12¹⁵⁄₁₆ × 9⁷⁄₁₆ in.)
JPGM 2008.62.29

PHILIP JONES GRIFFITHS
(Welsh, 1936–2008)
From the series Vietnam Inc.

30. *Quang Ngai, Vietnam*, 1967
Gelatin silver print
28.4 × 19.2 cm (11³⁄₁₆ × 7⁹⁄₁₆ in.)
JPGM 2010.3.1

31. *Vietnam*, 1970
Gelatin silver print
24.1 × 34.3 cm (9½ × 13½ in.)
The Philip Jones Griffiths
Foundation/Magnum Photos
PAR94017

32. *Vietnam*, 1970
Gelatin silver print
23.2 × 34.3 cm (9⅛ × 13½ in.)
The Philip Jones Griffiths
Foundation/Magnum Photos
PAR94016

33. *Vietnam*, 1970
Gelatin silver print
22.2 × 33.7 cm (8¾ × 13¼ in.)
The Philip Jones Griffiths
Foundation/Magnum Photos
PAR94015

34. *Danang, Vietnam*, 1967
Gelatin silver print
22.7 × 33.8 cm (8¹⁵⁄₁₆ × 13⁵⁄₁₆ in.)
The Philip Jones Griffiths
Foundation/Magnum Photos
PAR93916

35. *Vietnam*, 1967
Gelatin silver print
21.3 × 31.8 cm (8⅜ × 12½ in.)
JPGM 2010.3.2

36. *Vietnam*, 1970
Gelatin silver print
43.2 × 21.1 cm (17 × 8⁵⁄₁₆ in.)
The Philip Jones Griffiths
Foundation/Magnum Photos
NYC61712

37. *Song Tra, South Vietnam*, 1967
Gelatin silver print
33 × 22.1 cm (13 × 8¹¹⁄₁₆ in.)
JPGM 2010.3.4

38. *Quang Ngai, Vietnam*, 1967
Gelatin silver print
24.8 × 16.5 cm (9¾ × 6½ in.)
The Philip Jones Griffiths
Foundation/Magnum Photos
PAR93948

39. *Cambodia*, 1970
Gelatin silver print
22.1 × 32.7 cm (8¹¹⁄₁₆ × 12⅞ in.)
JPGM 2010.3.3

40. *Quang Ngai, Vietnam*, 1967
Gelatin silver print
17.8 × 26.7 cm (7 × 10½ in.)
The Philip Jones Griffiths
Foundation/Magnum Photos
PAR63320

41. *Cambodia*, 1970
Gelatin silver print
17.1 × 25.4 cm (6¾ × 10 in.)
The Philip Jones Griffiths
Foundation/Magnum Photos
NYC98861

42. *Quin Hon, Vietnam*, 1967
Gelatin silver print
18.1 × 27.3 cm (7⅛ × 10¾ in.)
The Philip Jones Griffiths
Foundation/Magnum Photos
PAR93934

43. *Quin Hon, Vietnam*, 1967
Gelatin silver print
22.9 × 34 cm (9 × 13⅜ in.)
The Philip Jones Griffiths
Foundation/Magnum Photos
PAR93935

44. *Saigon, Vietnam*, 1970
Gelatin silver print
33.7 × 22.5 cm (13¼ × 8⅞ in.)
JPGM 2010.3.5

45. *Can Tho, Vietnam*, 1970
Gelatin silver print
33.7 × 22.7 cm (13¼ × 8¹⁵⁄₁₆ in.)
The Philip Jones Griffiths
Foundation/Magnum Photos
PAR94045

46. *Nha Be, Vietnam*, 1970
Gelatin silver print
21.7 × 32.4 cm (8⁹⁄₁₆ × 12¾ in.)
JPGM 2010.3.6

47. *Salvades Bar, Saigon, Vietnam*, 1970
Gelatin silver print
22.5 × 33.5 cm (8⅞ × 13³⁄₁₆ in.)
The Philip Jones Griffiths
Foundation/Magnum Photos
PAR94055

48. *Vietnam*, 1967
Gelatin silver print
22.5 × 33.7 cm (8⅞ × 13¼ in.)
The Philip Jones Griffiths
Foundation/Magnum Photos
LON93520

49. *Saigon, Vietnam*, 1968
Gelatin silver print
19.7 × 30 cm (7¾ × 11¹³⁄₁₆ in.)
The Philip Jones Griffiths
Foundation/Magnum Photos
PAR93989

50. *Saigon, Vietnam*, 1968
Gelatin silver print
16.8 × 25.1 cm (6⅝ × 9⅞ in.)
The Philip Jones Griffiths
Foundation/Magnum Photos
PAR110833

51. *Saigon, Vietnam*, 1968
Gelatin silver print
15.9 × 23.8 cm (6¼ × 9⅜ in.)
The Philip Jones Griffiths
Foundation/Magnum Photos
PAR93991

52. *Saigon, Vietnam*, 1968
Gelatin silver print
15.9 × 23.8 cm (6¼ × 9⅜ in.)
The Philip Jones Griffiths
Foundation/Magnum Photos
PAR93986

53. *Vietnam*, 1970
Gelatin silver print
22.1 × 32.7 cm (8¹¹⁄₁₆ × 12⅞ in.)
The Philip Jones Griffiths
Foundation/Magnum Photos
PAR94018

54. *Vietnam*, 1970
Gelatin silver print
22.5 × 33.3 cm (8⅞ × 13⅛ in.)
The Philip Jones Griffiths
Foundation/Magnum Photos
PAR94019

55. *Vietnam*, 1971
Gelatin silver print
33.5 × 22.5 cm (13³⁄₁₆ × 8⅞ in.)
The Philip Jones Griffiths
Foundation/Magnum Photos
LON93614

56. *Vietnam*, 1971
Gelatin silver print
22.5 × 31.6 cm (8⅞ × 12⁷⁄₁₆ in.)
The Philip Jones Griffiths
Foundation/Magnum Photos
PAR94066

57. *Vietnam*, 1967
Gelatin silver print
32.9 × 22.2 cm (12¹⁵⁄₁₆ × 8¾ in.)
The Philip Jones Griffiths
Foundation/Magnum Photos
LON93579

58. *Vietnam*, 1967
Gelatin silver print
16.5 × 24.4 cm (6½ × 9⅝ in.)
The Philip Jones Griffiths
Foundation/Magnum Photos
PAR106882

59. *Vietnam*, 1968
Gelatin silver print
20.3 × 30.5 cm (8 × 12 in.)
The Philip Jones Griffiths
Foundation/Magnum Photos
NYC98860

60. *Phu Me Hospital, Vietnam*, 1970
Gelatin silver print
16.4 × 24.1 cm (6⁷⁄₁₆ × 9½ in.)
The Philip Jones Griffiths
Foundation/Magnum Photos
PAR94043

61. *Vietnam*, 1967
Gelatin silver print
26.5 × 18.1 cm (10⁷⁄₁₆ × 7⅛ in.)
The Philip Jones Griffiths
Foundation/Magnum Photos
NYC61719

62. *Vietnam*, 1967
Gelatin silver print
32.2 × 21.6 cm (12¹¹⁄₁₆ × 8½ in.)
JPGM 2010.3.7

W. EUGENE SMITH
(American, 1918–1978)
and **AILEEN M. SMITH**
(American, born 1950)
From the series Minamata

63. W. Eugene Smith
Fishing in Minamata Bay, ca. 1972
Gelatin silver print
23.7 × 34.8 cm (9⁵⁄₁₆ × 13¹¹⁄₁₆ in.)
Center for Creative Photography,
University of Arizona: W. Eugene
Smith Archive/Purchase
82.136.5

64. W. Eugene Smith
Fishing in Minamata Bay, 1972
Gelatin silver print
25.4 × 34.9 cm (10 × 13¾ in.)
Collection of H. Christopher Luce,
Courtesy of Robert Mann Gallery

65. W. Eugene Smith
Mrs. Kama Jumping off Boat, 1972
Gelatin silver print
33.5 × 47.8 cm (13³⁄₁₆ × 18¹³⁄₁₆ in.)
Center for Creative Photography,
University of Arizona: W. Eugene
Smith Archive/Purchase
82.136.7

66. Aileen M. Smith
*The Sugimotos' last day of sardine
fishing*, ca. 1972
Gelatin silver print
28.1 × 41.8 cm (11¹⁄₁₆ × 16⁷⁄₁₆ in.)
Center for Creative Photography,
University of Arizona: W. Eugene
Smith Archive
82.136.141

67. W. Eugene Smith
The Chisso factory in Minamata,
ca. 1972
Gelatin silver print
18.4 × 29.6 cm (7¾ × 11⅝ in.)
Center for Creative Photography,
University of Arizona: W. Eugene
Smith Archive
82.136.20

68. W. Eugene Smith
*Minamata: The edge of the factory,
the dump-way, the bay, and on to
the sea*, ca. 1972
Gelatin silver print
22.1 × 33.6 cm (8¹¹⁄₁₆ × 13¼ in.)
Center for Creative Photography,
University of Arizona: W. Eugene
Smith Archive
82.136.18

69. W. Eugene Smith
*Industrial Waste from the Chisso
Chemical Company*, 1972
Gelatin silver print
34 × 24.4 cm (13⅜ × 9⅝ in.)
Collection of H. Christopher Luce,
Courtesy of Robert Mann Gallery

70. W. Eugene Smith
Bunzo Hayashida, ca. 1972
Gelatin silver print
28 × 38.2 cm (11 × 15¹⁄₁₆ in)
Center for Creative Photography,
University of Arizona: W. Eugene
Smith Archive/Purchase
82.136.31

71. W. Eugene Smith
Mrs. Ikeda lifting her husband up,
ca. 1972
Gelatin silver print
33.5 × 25.9 cm (13³⁄₁₆ × 10³⁄₁₆ in.)
Center for Creative Photography,
University of Arizona: W. Eugene
Smith Archive/Gift of Aileen M. Smith
82.136.47

72. W. Eugene Smith
Bunzo Hayashida, ca. 1972
Gelatin silver print
29.5 × 30.4 cm (11⅝ × 11¹⁵⁄₁₆ in.)
Center for Creative Photography,
University of Arizona: W. Eugene
Smith Archive/Purchase
82.136.32

73. W. Eugene Smith
Cremation pyre of young disease victim, Toyoko Mizoguchi, ca. 1973
Gelatin silver print
25 × 33.9 cm (9¹³⁄₁₆ × 13³⁄₈ in.)
Center for Creative Photography, University of Arizona: W. Eugene Smith Archive/Gift of Aileen M. Smith
82.136.28

74. W. Eugene Smith
Takako Isayama and her mother, ca. 1972
Gelatin silver print
19.5 × 28.9 cm (7¹¹⁄₁₆ × 11³⁄₈ in.)
Center for Creative Photography, University of Arizona: W. Eugene Smith Archive/
Gift of Aileen M. Smith
SMITH #062

75. W. Eugene Smith
Mr. Hamamoto with Stick, ca. 1971
Gelatin silver print
20 × 33.7 cm (7⅞ × 13¼ in.)
Center for Creative Photography, University of Arizona: W. Eugene Smith Archive/Gift of Aileen M. Smith
82.136.48

76. W. Eugene Smith
Tomoko's Hand, ca. 1972
Gelatin silver print
25.9 × 24.4 cm (10³⁄₁₆ × 9⅝ in.)
Center for Creative Photography, University of Arizona: On extended loan from Aileen M. Smith
SMITH #004

77. W. Eugene Smith
Flags of Vengeance, 1972
Gelatin silver print
34.4 × 32 cm (13⁹⁄₁₆ × 12⅝ in.)
Center for Creative Photography, University of Arizona: W. Eugene Smith Archive/Purchase
82.136.1

78. Aileen M. Smith
Protesters in Front of Chisso Factory, Goi, Japan, 1972–73
Gelatin silver print
34.9 × 24.8 cm (13¾ × 9¾ in.)
Collection of H. Christopher Luce, Courtesy of Robert Mann Gallery

79. W. Eugene Smith
Shinobu and her mother preparing to leave the Minamata train station for the United Nations Environmental Conference in Stockholm, Sweden, 1972
Gelatin silver print
37.7 × 27.5 cm (14¹³⁄₁₆ × 10¹³⁄₁₆ in.)
Center for Creative Photography, University of Arizona: On extended loan from Aileen M. Smith
SMITH #055

80. W. Eugene Smith
Patients and Relatives Carry Photographs of the "Verified" Dead on the Last Day of the Minamata Trial, 1972
Gelatin silver print
16.2 × 21.3 cm (6⅜ × 8⅜ in.)
Collection of H. Christopher Luce, Courtesy of Robert Mann Gallery

81. W. Eugene Smith
Tomoko Uemura at Central Pollution Board Meeting, ca. 1973
Gelatin silver print
14.3 × 21.3 cm (5⅝ × 8⅜ in.)
Collection of H. Christopher Luce, Courtesy of Robert Mann Gallery

82. W. Eugene Smith
Verdict Day, March 20, 1973
Gelatin silver print
22.6 × 33.8 cm (8⅞ × 13⁵⁄₁₆ in.)
Center for Creative Photography, University of Arizona: W. Eugene Smith Archive/Gift of Aileen M. Smith
82.136.107

83. W. Eugene Smith
Judge Jiro Saito, ca. 1973
Gelatin silver print
32.4 × 23.9 cm (12¾ × 9⁷⁄₁₆ in.)
Center for Creative Photography, University of Arizona: W. Eugene Smith Archive/Gift of Aileen M. Smith
82.136.108

84. W. Eugene Smith
Shinobu at the entrance of her house, 1972
Gelatin silver print
19.1 × 25.6 cm (7½ × 10¹⁄₁₆ in.)
Center for Creative Photography, University of Arizona: W. Eugene Smith Archive/Purchase
82.136.115

85. W. Eugene Smith
Shinobu used to clean her tray with the other students after lunch at school, ca. 1972
Gelatin silver print
40 × 26.9 cm (15¾ × 10⁹⁄₁₆ in.)
Center for Creative Photography, University of Arizona: W. Eugene Smith Archive/Gift of Aileen M. Smith
82.136.138

SUSAN MEISELAS
(American, born 1948)
From the series Nicaragua, June 1978–July 1979

86. *Traditional Indian dance mask adopted by the rebels during the fight against Somoza, Nicaragua*, 1978 (printed 1980s)
Dye destruction print
49.5 × 33 cm (19½ × 13 in.)
JPGM 2010.5.2

87. *Youths practice throwing contact bombs, Monimbo, Nicaragua*, 1978 (printed 1980s)
Dye destruction print
50 × 33.5 cm (19¹¹⁄₁₆ × 13³⁄₁₆ in.)
JPGM 2010.5.3

88. *Marketplace in Diriamba, Nicaragua*, 1978 (printed 1980s)
Dye destruction print
33 × 49.5 cm (13 × 19½ in.)
Susan Meiselas/Magnum Photos
NYC15580

89. *Leading Los Doce (The Twelve) into Monimbo, July 5, 1978, Nicaragua*, 1978 (printed 1980s)
Dye destruction print
22.9 × 34.3 cm (9 × 13½ in.)
JPGM 2010.5.1

90. *Car of a Somoza informer burning in Managua, Nicaragua*, 1978 (printed 1980s)
Dye destruction print
32.4 × 49.2 cm (12¾ × 19⅜ in.)
Susan Meiselas/Magnum Photos
NYC15584

91. *First day of popular insurrection, August 26, 1978, Matagalpa, Nicaragua*, 1978 (printed 1980s)
Dye destruction print
33 × 49.5 cm (13 × 19½ in.)
JPGM 2010.5.7

92. *Fleeing the bombing of Esteli, Nicaragua*, 1978 (printed 1980s)
Dye destruction print
33 × 49.5 cm (13 × 19½ in.)
Susan Meiselas/Magnum Photos
NYC15601

93. *Nubia carrying her husband home to be buried in their backyard, Nicaragua*, 1979 (printed 1980s)
Dye destruction print
33 × 49.5 cm (13 × 19½ in.)
JPGM 2010.5.5

94. *Returning home, Masaya, September 1978, Nicaragua*, 1978 (printed 1980s)
Dye destruction print
33.2 × 49.5 cm (13¹⁄₁₆ × 19½ in.)
JPGM 2010.5.4

95. *National Guard patrol in Masaya beginning house-to-house search for Sandinistas, Nicaragua*, 1979 (printed 1980s)
Dye destruction print
33 × 49.5 cm (13 × 19½ in.)
Susan Meiselas/Magnum Photos
NYC15608

96. *Awaiting counterattack by the Guard in Matagalpa, Nicaragua*, 1978 (printed 1980s)
Dye destruction print
33 × 49.5 cm (13 × 19½ in.)
JPGM 2010.5.8

97. *Sandinista barricade during last days of fighting in Matagalpa, Nicaragua*, 1979 (printed 1980s)
Dye destruction print
40 × 59.7 cm (15¾ × 23½ in.)
JPGM 2010.5.6

MARY ELLEN MARK
(American, born 1940)
From the series Streetwise

98. *"Rat" and Mike with a Gun, Seattle*, 1983
Gelatin silver print
22.8 × 34.2 cm (9 × 13⁷⁄₁₆ in.)
JPGM 2004.60.5

99. *Seattle*, 1983
Gelatin silver print
20.7 × 30.7 cm (8⅛ × 12¹⁄₁₆ in.)
JPGM 2004.60.8

100. *Pike Street Area, Seattle*, 1983
Gelatin silver print
20.7 × 30.7 cm (8⅛ × 12¹⁄₁₆ in.)
JPGM 2004.60.14

101. *"Patti and Munchkin," Seattle*, 1983
Gelatin silver print
20.7 × 30.7 cm (8⅛ × 12¹⁄₁₆ in.)
JPGM 2004.60.15

102. *Dealer Injecting Fourteen-year-old Customer in Crash Pad for Runaways*, 1983
Gelatin silver print
22.7 × 33.9 cm (8¹⁵⁄₁₆ × 13³⁄₈ in.)
JPGM 2004.60.7

103. *Laurie and Companions at a Table, Pike Street Area, Seattle*, 1983
Gelatin silver print
20.5 × 30.7 cm (8¹⁄₁₆ × 12¹⁄₁₆ in.)
JPGM 2004.60.12

104. *Laurie, Seattle*, 1983
Gelatin silver print
34 × 22.7 cm (13³⁄₈ × 8¹⁵⁄₁₆ in.)
JPGM 2004.60.9

105. *Laurie and the Ferret Man, Seattle*, 1983
Gelatin silver print
20.7 × 30.7 cm (8⅛ × 12¹⁄₁₆ in.)
JPGM 2004.60.11

106. *Laurie and Client, Pike Street, Seattle*, 1983
Gelatin silver print
30.8 × 20.7 cm (12⅛ × 8⅛ in.)
JPGM 2004.60.10

107. *Lillie with Her Rag Doll, Seattle*, 1983
Gelatin silver print
22.6 × 34 cm (8⅞ × 13⅜ in.)
JPGM 2004.60.13

108. *Tiny in the Park, Seattle*, 1983
Gelatin silver print
22.6 × 33.9 cm (8⅞ × 13⅜ in.)
JPGM 2004.60.6

109. *Tiny in Halloween Costume Blowing Bubble, Seattle*, 1983
Gelatin silver print
22.6 × 34 cm (8⅞ × 13⅜ in.)
JPGM 2004.60.17

LAUREN GREENFIELD
(American, born 1966)

110. *Amelia, 15, at weight-loss camp, Catskills, New York*, 2001
(printed 2002)
From the series Girl Culture
Dye destruction print
50.2 × 33 cm (19¾ × 13 in.)
JPGM 2009.20.10

111. *Swimming period at weight-loss camp, Catskills, New York. Many kids love to swim at camp but will not swim or wear a bathing suit at home.*, 2001 (printed 2002)
From the series Girl Culture
Dye destruction print
32.5 × 48.9 cm (12¹³⁄₁₆ × 19¼ in.)
JPGM 2009.20.4

112. *Danielle, 13, gets measured as Michelle, 13, waits for the final weigh-in on the last day of weight-loss camp, Catskills, New York*, 2001 (printed 2002)
From the series Girl Culture
Dye destruction print
32.5 × 49.1 cm (12¹³⁄₁₆ × 19⁵⁄₁₆ in.)
JPGM 2009.20.3

113. *Annie, Hannah, and Alli, all 13, get ready for the first big party of the seventh grade, Edina, Minnesota*, 1998 (printed 2008)
From the series Girl Culture
Dye destruction print
32.7 × 48.9 cm (12⅞ × 19¼ in.)
JPGM 2009.20.5

114. *Brandon, 13, and his mother at his bar mitzvah party, Shutters on the Beach Hotel, Santa Monica*, 1993
(printed 1997)
From the series Fast Forward
Dye destruction print
32.4 × 48.9 cm (12¾ × 19¼ in.)
Promised Gift of Allison Amon and Lisa Mehling
JPGM L.2009.119.21

115. *Sisters Violeta, 21, and Massiel, 15, at the Limited in a mall, San Francisco, California*, 1999
(printed 2008)
From the series Girl Culture
Dye destruction print
48.9 × 32.5 cm (19¼ × 12¹³⁄₁₆ in.)
JPGM 2009.20.6

116. *Actress Amy Smart, 24, models Versace at the Standard Hotel, where a live mannequin lounges in a glass box in the lobby, Los Angeles, California*, 2000 (printed 2008)
From the series Girl Culture
Dye destruction print
32.5 × 48.9 cm (12¹³⁄₁₆ × 19¼ in.)
JPGM 2009.20.2

117. *Lori, 17, models for a Teen magazine article illustrating how to wash one's back, Hollywood*, 1993
(printed 1997)
From the series Fast Forward
Dye destruction print
32.4 × 48.9 cm (12¾ × 19¼ in.)
Promised Gift of Allison Amon and Lisa Mehling
JPGM L.2009.119.27

118. *Sheena, 15, shaves outside her house, San Jose, California*, 1999
(printed 2002)
From the series Girl Culture
Dye destruction print
32.5 × 49.1 cm (12¹³⁄₁₆ × 19⁵⁄₁₆ in.)
JPGM 2009.20.7

119. *Sheena tries on clothes with Amber, 15, in a department store dressing room, San Jose, California*,
1999 (printed 2002)
From the series Girl Culture
Dye destruction print
32.5 × 49.1 cm (12¹³⁄₁₆ × 19⁵⁄₁₆ in.)
JPGM 2009.20.8

120. *Jennifer, 18, at an eating-disorder clinic, Coconut Creek, Florida*, 1997
(printed 2002)
From the series Girl Culture
Dye destruction print
33.3 × 50.2 cm (13⅛ × 19¾ in.)
JPGM 2009.20.1

121. *Erin, 24, is blind-weighed at an eating-disorder clinic, Coconut Creek, Florida. She has asked to mount the scale backward so as not to see her weight gain.*, 2001
(printed 2002)
From the series Girl Culture
Dye destruction print
32.5 × 49.1 cm (12¹³⁄₁₆ × 19⁵⁄₁₆ in.)
JPGM 2009.20.9

122. *Phoebe, 3, at the VIP Opening of Barney's Department Store, Beverly Hills*, 1994 (printed 1997)
From the series Fast Forward
Dye destruction print
32.2 × 48.9 cm (12¹¹⁄₁₆ × 19¼ in.)
Promised Gift of Allison Amon and Lisa Mehling
JPGM L.2009.119.5

123. *Ashleigh, 13, with her friend and parents, Santa Monica*, 1993
(printed 1997)
From the series Fast Forward
Dye destruction print
32.4 × 48.9 cm (12¾ × 19¼ in.)
Promised Gift of Allison Amon and Lisa Mehling
JPGM L.2009.119.13

124. *Ashleigh in her bedroom, Santa Monica*, 1993 (printed 1997)
From the series Fast Forward
Dye destruction print
32.4 × 48.9 cm (12¾ × 19¼ in.)
Promised Gift of Allison Amon and Lisa Mehling
JPGM L.2009.119.20

125. *Lindsey, 18, after her nose-job surgery, a nurse holds a photograph of Lindsey's pre-operation nose, West Hollywood*, 1993 (printed 1997)
From the series Fast Forward
Dye destruction print
32.4 × 48.9 cm (12¾ × 19¼ in.)
Promised Gift of Allison Amon and Lisa Mehling
JPGM L.2009.119.25

126. *Lindsey at a Fourth of July party three days after her surgery, Calabasas*, 1993 (printed 1997)
From the series Fast Forward
Dye destruction print
32.2 × 48.9 cm (12¹¹⁄₁₆ × 19¼ in.)
Promised Gift of Allison Amon and Lisa Mehling
JPGM L.2009.119.26

127. *Mijanou and friends from Beverly Hills High School on Senior Beach Day, Will Rogers State Beach*, 1993
(printed 1997)
From the series Fast Forward
Dye destruction print
50.8 × 76.8 cm (20 × 30¼ in.)
Promised Gift of Allison Amon and Lisa Mehling
JPGM L.2009.119.24

LARRY TOWELL
(Canadian, born 1953)
From the series The Mennonites

128. *Capulín (Casas Grandes Colonies), Chihuahua, Mexico*, 1999
Gelatin silver print
31.8 × 47 cm (12½ × 18½ in.)
JPGM 2010.4.5

129. *El Cuervo (Casas Grandes Colonies), Chihuahua, Mexico*, 1997
(printed 1998)
Gelatin silver print
31.3 × 46.8 cm (12⁵⁄₁₆ × 18⁷⁄₁₆ in.)
Larry Towell/Magnum Photos
NYC6407

130. *Durango Colony, Durango, Mexico*, 1996 (printed 1999)
Gelatin silver print
31.1 × 46.8 cm (12¼ × 18⁷⁄₁₆ in.)
Larry Towell/Magnum Photos
PAR92276

131. *La Batea Colony, Zacatecas, Mexico*, 1994 (printed 1999)
Gelatin silver print
31.4 × 46.5 cm (12⅜ × 18⁵⁄₁₆ in.)
JPGM 2010.4.3

132. *Temporal Colony, Campeche, Mexico*, 1999
Gelatin silver print
47 × 31.3 cm (18½ × 12⁵⁄₁₆ in.)
Larry Towell/Magnum Photos
NYC6421

133. *La Honda Colony, Zacatecas, Mexico*, 1998 (printed 1999)
Gelatin silver print
46.7 × 31.1 cm (18⅜ × 12¼ in.)
JPGM 2010.4.4

134. *Durango Colony, Durango, Mexico*, 1994 (printed 1999)
Gelatin silver print
46.4 × 31.1 cm (18¼ × 12¼ in.)
Larry Towell/Magnum Photos
PAR92347

135. *El Cuervo (Casas Grandes Colonies), Chihuahua, Mexico*, 1992
(printed 1999)
Gelatin silver print
46.7 × 31.4 cm (18⅜ × 12⅜ in.)
JPGM 2010.4.1

136. *El Cuervo (Casas Grandes Colonies), Chihuahua, Mexico*, 1992
(printed 1999)
Gelatin silver print
31.1 × 46.8 cm (12¼ × 18⁷⁄₁₆ in.)
JPGM 2010.4.2

137. *La Batea Colony, Zacatecas, Mexico*, 1996 (printed 1999)
Gelatin silver print
31.8 × 47 cm (12½ × 18½ in.)
Larry Towell/Magnum Photos
NYC6402

138. *La Batea Colony, Zacatecas, Mexico*, 1999
Gelatin silver print
31.3 × 46.8 cm (12⁵⁄₁₆ × 18⁷⁄₁₆ in.)
Larry Towell/Magnum Photos
NYC6416

139. **Ojo de la Yegua Colony (Cuauhtémoc Colonies), Chihuahua, Mexico**, 1992 (printed 1998)
Gelatin silver print
31.1 × 46.7 cm (12¼ × 18⅜ in.)
JPGM 2010.4.6

140. **Haldimand-Norfolk County, Ontario, Canada**, 1995 (printed 1999)
Gelatin silver print
31.4 × 47 cm (12⅜ × 18½ in.)
Larry Towell/Magnum Photos
PAR92325

141. **Kent County, Ontario, Canada**, 1996 (printed 1999)
Gelatin silver print
46.4 × 31.1 cm (18¼ × 12¼ in.)
Larry Towell/Magnum Photos
PAR136676

142. **Elgin County, Ontario, Canada**, 1998 (printed 1999)
Gelatin silver print
31.1 × 46.7 cm (12¼ × 18⅜ in.)
Larry Towell/Magnum Photos
NYC6437

143. **Lambton County, Ontario, Canada**, 1991 (printed 1999)
Gelatin silver print
31.1 × 46.7 cm (12¼ × 18⅜ in.)
JPGM 2010.4.7

SEBASTIÃO SALGADO

(Brazilian, born 1944)

144. **Southern Sudan**, 1993 (printed 2009)
From the series Migrations/
Southern Sudan, A Population
in Distress
Gelatin silver print
34.3 × 52.1 cm (13½ × 20½ in.)
Lent by the Peter Fetterman Gallery

145. **Rwanda**, 1995 (printed 2009)
From the series Migrations/Rwanda,
A Torn Nation
Gelatin silver print
34.4 × 51.4 cm (13⁹⁄₁₆ × 20¼ in.)
JPGM 2009.33.5

146. **Burundi**, 1995 (printed 2009)
From the series Migrations/Rwanda,
A Torn Nation
Gelatin silver print
34.4 × 51.4 cm (13⁹⁄₁₆ × 20¼ in.)
JPGM 2009.33.6

147. **Zaire**, 1994 (printed ca. 2008)
From the series Migrations/
Rwandan Refugees in the Area
of Goma, Zaire
Gelatin silver print
34.1 × 51.4 cm (13⁷⁄₁₆ × 20¼ in.)
Lent by the Peter Fetterman Gallery

148. **Tanzania**, 1994 (printed 2009)
From the series Migrations/
Rwandans Take Refuge in Tanzania
Gelatin silver print
51.4 × 34.1 cm (20¼ × 13⁷⁄₁₆ in.)
JPGM 2009.33.8

149. **Tanzania**, 1994 (printed 2009)
From the series Migrations/
Rwandans Take Refuge in Tanzania
Gelatin silver print
33.5 × 51.4 cm (13³⁄₁₆ × 20¼ in.)
JPGM 2009.33.7

150. **Metro Manila, The Philippines**, 1999 (printed 2009)
From the series Migrations/
The Asian Mega-Cities
Gelatin silver print
34 × 51.4 cm (13⅜ × 20¼ in.)
JPGM 2009.33.3

151. **Ho Chi Minh City, Vietnam**, 1995 (printed 2009)
From the series Migrations/
The Asian Mega-Cities
Gelatin silver print
51.4 × 34.3 cm (20¼ × 13½ in.)
JPGM 2009.33.4

152. **Bombay, India**, 1995 (printed 2009)
From the series Migrations/
The Asian Mega-Cities
Gelatin silver print
33.3 × 51.4 cm (13⅛ × 20¼ in.)
JPGM 2009.33.2

153. **Church Gate Station, Western Railroad Line, Bombay, India**, 1995 (printed 2009)
From the series Migrations/
The Asian Mega-Cities
Gelatin silver print
34.3 × 51.4 cm (13½ × 20¼ in.)
JPGM 2009.33.1

154. **São Paulo, Brazil**, 1996 (printed 2008)
From the series Migrations/Exodus
to the Cities (Mexico City, Mexico,
and São Paulo, Brazil)
Gelatin silver print
34.8 × 51.8 cm (13¹¹⁄₁₆ × 20⅜ in.)
Gift of the Peter Fetterman Gallery
JPGM 2009.107

155. **On a Train to Northern Mexico**, 1998 (printed 2009)
From the series Migrations/Passage
through Mexico
Gelatin silver print
51.4 × 34.1 cm (20¼ × 13⁷⁄₁₆ in.)
JPGM 2009.33.9

156. **Tijuana, Mexico**, 1997 (printed 2009)
From the series Migrations/U.S.–
Mexico Border
Gelatin silver print
33.8 × 51.4 cm (13⁵⁄₁₆ × 20¼ in.)
JPGM 2009.33.10

157. **Desert of San Ysidro, California, U.S.A.**, 1997 (printed 2009)
From the series Migrations/
U.S.–Mexico Border
Gelatin silver print
34.4 × 51.4 cm (13⁹⁄₁₆ × 20¼ in.)
JPGM 2009.33.11

JAMES NACHTWEY

(American, born 1948)

158. **The Sacrifice**, 2007
Inkjet print
111.8 × 983.6 cm (3 ft. 8 in. × 32 ft.
4 in.)
Collection of the artist, Courtesy
Fahey/Klein Gallery

ILLUSTRATION CREDITS

The following sources have provided photography materials and/or granted permission to reproduce illustrations in this book. Credits are listed below by figure/plate number. Some images may appear courtesy of more than one source.

Cover; figures 39, 41; plates 30–62: © The Philip Jones Griffiths Foundation/Magnum Photos

Figures 1, 9, 13, 16: Research Library, The Getty Research Institute, Los Angeles (93-S551, 89-S484 v.44 1935, 2575-989 v.11 1941, and 2774-681)

Figure 2: Provided courtesy of HarpWeek., LLC

Figures 3–8, 11, 12, 14, 15, 18, 19, 20, 21, 24–27, 28, 29, 33, 36, 38, 40, 43; plates 1–29, 64, 69, 78, 80, 81, 98–127, 144–57: The J. Paul Getty Museum

Figure 10: Bildarchiv Preussischer Kulturbesitz/Art Resource, NY

Figures 11, 12, 20: © Cornell Capa/Magnum Photos

Figure 13: Copyright 1941 LIFE Inc. Reprinted with permission. All rights reserved.

Figure 14: Copyright 1948 LIFE Inc. Reprinted with permission. All rights reserved.

Figure 15: © Joe Schwartz

Figure 16: *Death in the Making* by Robert Capa and Gerda Taro © Covici-Friede Publishers, New York/Random House, Inc.

Figure 17: Art © Estate of Margaret Bourke-White/Licensed by VAGA, New York, NY

Figure 17: © Estate of Erskine Caldwell

Figure 21: © [1948], 2010 The Heirs of W. Eugene Smith

Figures 22, 23: © Horace Bristol, Courtesy Horace Bristol Estate/Corbis

Figure 24: © 1984 The Estate of Garry Winogrand

Figures 25–27: © Henri Cartier-Bresson/Magnum Photos

Figure 28: © Bob Adelman/Magnum Photos

Figure 29: Associated Press/Malcolm Browne

Figures 30, 33, 37, 38; plates 1–29: © Leonard Freed/Magnum Photos

Figure 31: Copyright 1983 LIFE Inc. Reprinted with permission. All rights reserved.

Figures 31, 46, 47; plates 98–109: Courtesy of and © Mary Ellen Mark

Figure 32: © Paris Match

Figure 32: Courtesy of the University of Southern California

Figures 32, 52, 53; plates 144–57: © Sebastião Salgado

Figure 34: Page layout reprinted courtesy of National Geographic Magazine © December 2006

Figures 34, 54–56; plate 158 and details (pages 216–25): © James Nachtwey

Figure 35: The J. Paul Getty Museum, Villa Collection, Malibu, California

Figure 39: © Simon & Schuster

Figure 40: © Larry Burrows Collection

Figure 42; plates 63–85: *Minamata*, photographs by W. Eugene Smith & Aileen M. Smith

Figure 43: © [1951], 2010 The Heirs of W. Eugene Smith

Plates 63, 64, 65–68, 70–77, 79, 82–85: Collection Center for Creative Photography, University of Arizona

Plates 63–65, 67–77, 79–85: Photos by W. Eugene Smith © Aileen M. Smith

Plates 66, 78: Photos by and © Aileen M. Smith

Figure 44: © Susan Meiselas, from the publication *Nicaragua, June 1978–July 1979* (Aperture, 2008)

Figures 44, 45; plates 86–97: © Photographer Susan Meiselas/Magnum Photos

Figure 46: © Mary Ellen Mark, from the publication *Streetwise* (Aperture, 1992)

Figure 48: From *Girl Culture* by Lauren Greenfield; introduction by Joan Jacobs Brumberg; produced by Melcher Media, Inc. Photographs and Text © 2002 by Lauren Greenfield/INSTITUTE. Used with permission from Chronicle Books LLC, San Francisco. Visit www. ChronicleBooks.com.

Figures 48, 49; plates 110–27: © 2009 Lauren Greenfield/INSTITUTE

Figure 50: © Phaidon Press Limited

Figures 50, 51; plates 128–43: © Photographer Larry Towell/Magnum Photos

Figure 52: © Sebastião Salgado, from the publication *Migrations* (Aperture, 2000)

TEXT EXCERPTS

Pages 41, 46, 51, 55, 56, 58, 61: © Leonard Freed/Magnum Photos

Pages 71–88, 90–94, 96, 97: © The Philip Jones Griffiths Foundation/Magnum Photos

Pages 107, 113, 115: Courtesy Aileen M. Smith

Pages 197–202, 204–7, 209–11: © Sebastião Salgado, from the publication *Migrations* (Aperture, 2000)

INDEX

Note: *Italic* page numbers indicate illustrations other than plates. ***Bold italic*** page numbers indicate plates. Some titles of works have been shortened in the index but appear in complete form in the text.